The Way
of the Brush

The Emperor praised the painting highly and asked him the secret of his art. Bowing low the famous scholar-painter replied: "I am unworthy of your praise. My pictures are nothing but brush traces and ink stains."

—From a traditional Chinese anecdote

The Way
of the Brush

*Painting Techniques
of China and Japan*

Fritz van Briessen

TUTTLE PUBLISHING
Tokyo • Rutland, Vermont • Singapore

Published by Tuttle Publishing, an imprint of Periplus Editions (HK) Ltd. with offices at 364 Innovation Drive, North Clarendon, Vermont 05759 USA. and 61 Tai Seng Avenue, #02-12, Singapore 534167.

LCC Card No. 62-014119
ISBN 978-0-8048-3194-9

First paperback edition, 1998

Printed in Singapore

Distributed by:

North America, Latin America & Europe
Tuttle Publishing
364 Innovation Drive
North Clarendon, VT 05759-9436
Tel: 1 (802) 773 8930; Fax: 1 (802) 773 6993
Email: info@tuttlepublishing.com
www.tuttlepublishing.com

Japan
Tuttle Publishing
Yaekari Building, 3rd Floor
5-4-12 Osaki, Shinagawa-ku
Tokyo 141-0032
Tel: (81) 3 5437 0171; Fax: (81) 3 5437 0755
Email: tuttle-sales@gol.com

Asia Pacific
Berkeley Books Pte. Ltd.
61 Tai Seng Avenue, #02-12
Singapore 534167
Tel: (65) 6280 1330; Fax: (65) 6280 6290
Email: inquiries@periplus.com.sg
www.periplus.com

13 12 11 10
9 8 7 6 5

TUTTLE PUBLISHING ® is a registered trademark of Tuttle Publishing, a division of Periplus Editions (HK) Ltd.

To
Pʻu Chʻüan
Teacher and Friend

■ *TABLE OF CONTENTS*

Part 2

NOTES ON TECHNICAL MATTERS

■ *LIST OF ILLUSTRATIONS*

MAIN CATEGORIES

10

FORMAL WORKS

■ ACKNOWLEDGMENTS

THIS BOOK is really the work of many minds. Its inception goes back to the year 1944, when my friendship with the Peking painter P'u Ch'üan began, and with it the slow but steady growth of this study. It would never have come into being at all without P'u Ch'üan's constancy in devoting his time, his artistic mastery, and his great gift as a teacher to the undertaking. Many artists, scholars, and art lovers in Peking and Tokyo, in Munich and Rome have each, at one time or another, contributed something—a word, a sentence, some small but significant nuance—to its finishing.

Finished and yet unfinished: for I am sure no one is more conscious of the study's failings than I myself. But if these failings are less numerous and less obvious than they were in the first draft, it is because of the suggestions and advice so kindly offered by Professor Herbert Franke, of Munich University, and Mrs. Elise Grilli, of Tokyo, who have patiently read the manuscript; by Professor Peter Olbricht, of Bonn University, and Professor Walter Fuchs, of Cologne University, who have contributed valuable corrections of fact.

My original German manuscript was translated by Helga and James Herbert, in collaboration with myself. The English version then went to the publisher's, where it was edited by Meredith Weatherby, who improved it with excellent clarifications and rearrangements of parts. This process, again carried out in close collaboration with me, has resulted in the substantially rewritten form presented here.

For permission to use illustrations and quotations I wish to express My thanks to Methuen and Co., Ltd., London; Macmillan and Co., London; Dietrich Reimer, Berlin; Mr. T. Tafel, Stuttgart; the Department of Archaeology, Government of India (for permission to reproduce the picture from Sir Aurel Stein's *Ancient Khotan);* Mr. Chiang Yee, of Riverdale, New York; the Oxford University Press; Ōtsuka Kōgeisha, Tokyo; Tōyō Bijutsu Taikan, Tokyo; Shina Meiga, Tokyo; Geien Shinchō, Tokyo; T. Hasegawa and Son, Tokyo; National Museum, Tokyo; Nezu Museum, Tokyo; Sumitomo Collection, Ōiso; Mr. J.-P. Dubosc, Paris; and Mr. Sōfū Teshigahara, of Tokyo.

▪ *INTRODUCTION*

ORIENTAL ART is less familiar to us than we assume, for we are always comparing it with our own, never making any serious attempt to understand it on its genuine terms. As a matter of fact, we like it to remain obscure so we can regard it as some exotic bloom whose very strangeness excites us. The Western mind often finds Japanese and Chinese psychology quite incomprehensible, and it is almost as if we were trying to prove their art equally incomprehensible. Thus we are inclined to fall back on the artistic conventions and aesthetic traditions of our own hemisphere.

Being only too happy to accept Oriental art, and particularly painting, as finally inexplicable, we agree to call its works beautiful or impressive or masterly merely because they seem so by our Western standards. In consequence we necessarily miss certain essentials of this art.

There is a danger both of not understanding and of misunderstanding. I believe, however, that a key does exist which not only opens the door to this strange world, but also charts a way through it.

Admittedly, attempts have been made, often and successfully, to promote an understanding of Oriental art, but only dealing with its more superficial characteristics. Using Japanese and Chinese sources, the historical evolution of Oriental art has been investigated and described. Its aesthetics have been analyzed through studies of the works of Oriental painters and scholars, and co-ordinated into a system. Efforts have been made to discover the common

traits within Japanese and Chinese culture and philosophy on the one hand and their artistic expression on the other. Finally, certain studies have been devoted to the techniques of Oriental art, though these were not very thorough. But all this explorative work which is accessible to us in the West still remains incomplete. Besides, most of it was intended for those who already had some previous knowledge on the subject. It ignored the wider circle of educated laymen who wish to understand Oriental art not merely from the base of their familiarity with its Western counterpart, but also as an expression of Oriental thought.

Since the major works of Oriental art are known in the West almost exclusively through reproductions which obscure practically all the essential features of that art, we have very little real acquaintance with it. The educated man who is impulsively attracted by these works might become disillusioned if presented with yet another book only repeating, with slightly different emphases, what has already been said before. He may not feel that he is getting any closer to the understanding he is seeking.

The Western art lover looks at a Western work of art and asks certain questions: What style is it? What is its historical date? Who is it by? What does it mean? How good is it? But when he looks at a work of Oriental art, he does not dare to ask such questions. Confronted with a Chinese painting, he has the depressing feeling that he can neither judge whether the painting is good or bad, old or new, an original or a copy, nor tell whether it is Chinese or Japanese. There is hardly a book on the subject which will help him. To this day even our university seminars cannot solve these problems without a great deal of fumbling and innumerable qualifications. Admittedly, a circumspect solution is often impossible, and usually difficult. In fact, one ought to be rather suspicious of any Western expert who, when examining an early Chinese painting, will pass unhesitating judgment on its origin or even on its genuineness.

In spite of this situation there are many ways of helping the educated Westerner to achieve closer understanding of Oriental art. We Westerners are not necessarily confined to taking Japanese or Chinese painting at its face value, muttering vaguely how beautiful it is, quite unable to express adequately what we like about it, and without the least comparative notion of how a Japanese or a Chinese would react toward it. We are not compelled to remain so ignorant that we have to content ourselves with the mere impression a painting makes, without ever understanding its symbolic value or the charm of its technical perfection.

It is interesting to note that a Chinese work of art is more often mis-

taken for a Japanese one than the other way round. This can probably be explained by the fact that most judgments on Chinese art accessible to us in recent years have been Japanese. Hence, even for Chinese art, Japanese terms are used. Chinese scrolls are often referred to as *kakemono,* and people still occasionally call a Chinese landscape painting a *sansui,* which is nothing but a Japanese version of the Chinese word *shan-shui.* This is true also of many other technical terms. As a result, changes in the evaluation of Chinese art have occurred either merely through the use of Japanese versions of Chinese terms or through their normal change of meaning in a new environment.

In our consideration of Oriental art, especially painting, we find ourselves faced with two alternatives. We can abandon all attempts to gain deeper understanding as a seemingly unattainable goal or, starting from the very simplest level, we can try to work our way toward better knowledge in the hope that we shall finally uncover at least part of that art's secret. It is the second alternative that has been chosen for this book.

There is no reason why Chinese painting should not, for once, be approached in this modest way: from the very beginning. The course of its development and the pageant of its great names have often been set out and will be repeated here only to the extent necessary for dealing with the specific questions that shall concern us: What technical means does the Chinese painter use to produce his paintings? What does he mean by style? What are the basic conventions he follows in his painting? What meaning does he wish his paintings to have? And, finally, what purely technical or symbolic methods does he use to express that meaning?

All of these questions, of course, as well as their answers, are equally germane for Japan, or at least for that large part of Japanese painting that found its first and greatest inspiration in China. Even though the Japanese thereafter assimilated and subtly transmuted this borrowing, enlarging and transforming its techniques until the art became a true expression of native Japanese genius, even to this day the painting of the two countries, and their calligraphy as well, retains such fundamental affinities as to justify our considering them as similar aspects of a single artistic tradition, a single river of art only occasionally separated into two main streams by numerous small islands and a few large ones. Hence the reader should keep in mind that, with the exception of certain differences to be discussed hereafter, when we speak of Chinese painting we are likewise including its Japanese manifestations. Needless to say, however, our main emphasis shall be upon the Chinese origins of this river, since it was there that the tradition had its birth.

My attempts to approach Oriental painting from the new angle suggested by these questions were met by the invaluable co-operation of the Peking landscape painter P'u Ch'üan or, to use the studio name by which he is commonly known, P'u Sung-chuang. Starting in 1944, we spent countless hours in discussion. With unending patience and the subtlest insight he then translated the verbal results of our sessions into pictorial terms. Thus we assembled well over a hundred sketches illustrating in a modern and easily understandable manner the elements, techniques, and principles of traditional Chinese painting. The sketches were intended to assist those art lovers who had never had any contact with Chinese life and culture, who had never handled for any length of time the Chinese brush. It must be admitted that these sketches, although done with the purpose of illustrating traditional elements, also contained much of the painter's own unique personal style, the unmistakable trait which even the finest copyist can never entirely suppress, however hard he may try. For us, who intend to use P'u Sung-chuang's sketches as a means of explanation, this proves to be a fortunate accident, since it provides graphic illustration of one of the chief objectives of the present inquiry: the ability to recognize with utmost precision that very difference between the traditional and the contemporary styles, between convention and personal expression—a difference that often escapes even the critical Chinese eye.

More than half of these sketches by P'u Ch'üan are reproduced in the following pages. (They are indicated in the captions by the name P'u, whereas the artist's full name is used for his finished pictures.) These sketches supply a sort of backbone to the entire book, and their influence is traceable even in those chapters which seem to be linked to them only by the finest nerves. In this way the present work—which is intended more for the layman than for the expert—will perhaps convey some of the inner relationships between the backbone and the nerve-ends of a Chinese painting, thereby bringing the imaginative reader closer to the painting of the East.

PART \blacksquare 1 \blacksquare *ELEMENTS, TECHNIQUES, AND PRINCIPLES*

CHAPTER ▪ 1 ▪ *THE POSITION OF CHINESE PAINTING*

▪ 1 ▪ *PAINTING AND MAGIC* THE STUDY OF THE TECHNIQUES of Chinese painting has been rather neglected in the West, perhaps because technique has been regarded more or less as a handmaiden in the service of the idea, which could therefore be ignored as of secondary importance. Painting, it has been assumed, must be the same kind of art everywhere, and consequently the same ways of looking at and judging Western painting must be equally applicable to Eastern and Chinese painting. This supposition has led to misunderstandings and misinterpretations, because Chinese painting, in contrast to its Western counterpart, cannot be fully appreciated without some knowledge of its techniques and methods.

I shall try to demonstrate here just why technique plays such a decisive part in Chinese painting. This involves not only an explication why, fundamentally, Chinese painting reaches its culmination in absolute identity of idea and technique, but also requires an introduction to various of the essential techniques and principles by which a Chinese picture—its style and form already inherent in it from the very first brush stroke—comes to completion.

To illustrate this unity of technique and idea, a unity which seems essen-

tially to be an identification of opposites, it is necessary to start a long way back. To begin with, it will prove helpful to recount four of the most famous out of countless legends attributed to Chinese artists.

Wu Tao-tzu, the great master painter of the T'ang period, was once journeying and decided to spend the night in a temple. The monks received him without enthusiasm and grudgingly supplied a small bare room. Wu Tao-tzu retired. The following morning he was up early, intending to leave his unfriendly hosts in a hurry. From the doorstep he cast a glance back at his somber lodging. And then with one sweeping motion of his brush the master painted a donkey on the wall of the cell. He had hardly left when the donkey stepped out of the wall, kicking right and left until the cell was a shambles. When the monks came running, the donkey quickly jumped back into the picture. But the monks understood how this was Wu's revenge for their unkindness.

The following story has been ascribed to several early masters, and we pick the version linked with the name of the great Ku K'ai-chih. Ku one day decided to paint a dragon on the wall of his house. He guided his brush with full confidence, and after a while the dragon was finished except for its eyes. Suddenly the master's courage failed him. He simply did not dare to paint those eyes. When, many months later, he at last felt brave enough, he groped for his brush and with swift strokes dashed in eye and pupil. Within an instant the dragon broke into loud roaring and flew away, leaving a trace of fire and smoke.

Another legend attributed to the same painter tells of a girl he loved but who did not return this emotion. Ku K'ai-chih painted a picture of the disobliging young woman, hung it in his room, and stuck a thorn into it. From that moment the girl became sick and faded away. She did not recover until she had responded to the painter's feelings and he eventually pulled the thorn out of her portrait.

The most revealing of these legends about Chinese painters is the one which deals with the end of Wu Tao-tzu. The emperor had asked Master Wu to paint a landscape on the palace wall. Wu set to work and was soon able to lead the emperor to a magnificent painting in whose center he had drawn a gaping cave. The emperor was still expressing his admiration when Wu Tao-tzu directed firm steps toward the cave and vanished inside it. After the shape of his body had melted into the shadow of the cave, the entire painting disappeared into the palace wall.

Diverse as these stories may be, they all have one common trait: the assumption of an extraordinarily close relationship between painting and

magic, and of the resulting conclusion that a great painter is also a great magician—the greater the painter the more powerful his magical capacities. It seems that a demonstration of magic was proof of a painter's genius.

The fact that such legends were still taken seriously as late as the seventh, eighth, and ninth centuries suggests the persistence of the Chinese belief in the supernatural. In a world dominated by the supernatural, people could not possibly conceive of the brush stroke and the idea as being two distinct things, nor as existing on different levels, nor as representing the opposite poles of material and spiritual. In fact, this dichotomy has rarely existed in Asia. It is an expression of the Western mind and is most probably linked with the death of the world of magic. This is not the place to investigate the reasons for the overthrow of the belief in magic throughout the West. But surely we can surmise that is was partly due to the influence of Christianity, which turned its face against magic. There was never any similar development in the East, because the Eastern religions did not divorce themselves from magic and philosophy.

Of course, in early times magic visions were known in the West too. Most scholars today believe the great neolithic cave paintings of Altamira in Spain or Lascaux in France to be magic paintings done in those dark, cold caves during the interglacial period by tribal witch doctors to appease the dangerous world and the wild animals that surrounded them and to charm the game they hoped to feed on. A distinction between technique and painting was then probably nonexistent. In an age of magic, technique is completely identified with the power to make magic. The greatest technician is also the greatest magician. The strength of the spell grows with the ability to paint. The equation may be put in another way: the magician of those bygone times was indeed the painter, but his artistic skill was only regarded as the measure of his power to make magic. The more authentically he could reproduce the appearances of the world around him—and his power was directed at these appearances—the stronger was the spell. He felt no artistic urge as such, for he was only a magician, and his painting craft proved itself by its effect.

Though we have no knowledge of Chinese counterparts of Altamira and Lascaux, it seems most likely that the Chinese also went through this most primitive stage of art and magic. And the earliest Chinese paintings which have come down to us lend additional weight to the belief that the magic tradition in China followed much the same pattern as did that of the West. At the time of these earliest paintings, however, magic as such was already but a general background from which the artist had emerged as the dominant personality, though possessing magical powers—a complete reversal of

the situation that we must presume to have existed in the prehistoric period. The Chinese painter was by now first and foremost an artist. If he was a great artist, he acquired magical power, and he was able to cast spells even though this was not any more the primary purpose of his art. Note that in China supernatural legends concerning artists are linked only with the names of great masters. As explained, magic was a proof of great genius. But genius was the essential factor, and magic no more than a manifestation of it, whereas in prehistoric times the opposite had been true: magic was then the essence, and artistic excellence merely a means of proving it.

It may be argued that at the time when legends about the great masters began to be told, the belief in magic was already dead, and those legends were nothing more than an attempt to interpret the present in terms of the past. As a matter of fact, however, in the Asiatic world, belief in the supernatural power of the artist remained alive over greatly prolonged periods. In evidence of this, more recent examples can be supplied from Japan, a country which may be called the immediate artistic extension of China.

There is, for instance, the story translated into English by Lafcadio Hearn under the title "The Boy Who Drew Cats" and charmingly illustrated in *Japanese Fairy Tales,* published at Tokyo by T. Hasegawa and Son in the late nineteenth century. Although it seems likely that the story goes back to more ancient Chinese sources, it still has a well-established tradition in Japan, and one is justified in believing that the Japanese accepted it as a matter of historical fact. The boy of the tale, from an early age, showed unusual talent in drawing cats. He drew cats on every slip of paper within his reach and also on the walls and sliding panels of his parents' house. At long last he was apprenticed to a very severe master in the hope that he would be dissuaded from ruining walls. Alas, the urge to paint triumphed over discipline, and the disgusted master dismissed his apprentice as a hopeless case. On his subsequent wanderings the boy one night entered an abandoned temple. Before lying down to sleep in one of the lonely rooms, he swiftly sketched a few cats on an old discarded screen (Fig. 1). During the night he was harassed by the sound of terrible yowling and screeching, and when he finally awoke in the morning, he found a huge ghost rat dead on the floor (Fig. 2). The cats on the screen had blood smeared all over their claws and fangs—and very pleased looks on their faces.

Another legend concerning a Japanese master painter dates from the sixteenth century, extracting its essence from within our own historical period. It is the story of young Sesshū, who was made a Zen acolyte in boyhood but displeased his abbot by a constant unruly preference for drawing

over prescribed religious duties. As punishment the abbot one day bound the boy to a tree. Sesshū at first cried and wailed, but then after a while, with his toe, he began drawing pictures in the tear-wet sand. It was mice that he drew, and so lifelike were they that when he had completed a good number of them they sprang to life and gnawed through the ropes that bound him (Fig. 3).

Dated even later than Sesshū's magic is that of Maruyama Ōkyo (1733-95), who is credited with originating the ghost-picture genre in a painting commissioned by a leading daimyo. Incidentally, one delightfully ironical feature of the story consists in the detail that he used his aunt as model for the ghost. This much only by the way. The important part of the tale lies in its relation of what happened after the master had completed his last brush stroke. The master, it is said, had hardly stepped back from his picture with a satisfied grunt when the painted ghost detached itself with a gliding motion and disappeared from the room.

Today the usual interpretation of such legends places primary emphasis upon the extraordinary realism of the paintings and explains the events in reference to this realism, deducing it to be the very cause that made the paintings come to life. Such conclusions entirely miss the point of the legends, which should no more be thus interpreted than should the story of Myron's cow or of the cherries of Apelles. The afore-cited stories are all tales of magic, pure and simple.

In the East, until as recently as the turn of the nineteenth century, art and a belief in the magical powers of the artist were intertwined concepts. Even in our own age, therefore, the painter in Japan, just as in China, has not doubted that great art and magic are one and the same. Whether this has been explicitly admitted or not is of no importance. An implicit acceptance of the basic idea has been rooted so deeply in the Oriental mind that there has been no need for conscious expression. Mention may here be made of the magazine *Tien Shih,* a forerunner of the modern illustrated, which was published in Shanghai during the early years of the present century, just before the founding of the Republic. It reported contemporary events in a traditional style, with lithographs, and featured many "authenticated" instances of magic and the supernatural.

In a comparison between Chinese and Western painting, the unity of technique and idea in the former becomes more obvious. Western art lost its magical elements at an early date because of the influence of Christianity. It is true that certain aspects of the supernatural continued to be expressed, but only insofar as they had been transfused into the body of Christian thought.

Technical skill, though, no longer had anything magical about it: it evolved from no formula of magic but rather from the search for ways of overcoming the problems presented by the various materials of artistic expression—a search that has always produced a different answer in each epoch. And once the unity of technique and idea had ceased to exist, doubts and perplexities concerning technique began to arise. It is precisely such doubts and perplexities that have destroyed more works of art, by preventing their creation, than have all the fires and floods and wars of history. The East has suffered from an equally destructive mechanism in that the almost ritualized technique which necessarily developed out of magic resulted in the mass production of skillfully executed but mediocre paintings.

From this short and incomplete survey we can see that until our own times no distinction was made between technique and idea in Chinese painting. The two concepts were one and the same. Hence those who seek to know the art of the East must study the technical significance of forms with just as much determination as they study the finished compositions. Most essentially, they must persevere until they reach the point of perceiving the real identity of those apparent opposites: material appearance and spiritual essence. Only from that point on will the world of Eastern art truly open itself to the Western observer.

■ 2 ■ PAINTING AND TAO

BESIDES MAGIC, THERE IS YET A SECOND approach to an understanding of Chinese art: one which leads through Chinese philosophy. And this we may now try. We have already stated that in the East, and especially in China, there was no absolute division between magic, religion, and philosophy. Doubtless they were never, as in the West, fundamentally opposed to each other, even if in certain points differences or distinctions were recognized.

Some scholars assert that Taoism is the typically Chinese philosophy, having been the primitive philosophy of the Han race. They also suggest that Chinese Buddhism has taken over some essentially Taoist features. And one can agree that the *Book of Changes,* in the version which we know (until recently attributed to Confucius), in fact expresses a thoroughly Taoist attitude within the framework of its Confucian ethos, at least in the sense of presenting a typically Chinese state of mind.

In the works of the Taoist philosopher Chuang-tzu there occur two passages that are worth noting for our purposes. The first is the often-quoted

parable concerning Prince Hui's cook; in the translation of H. A. Giles it goes as follows:

Prince Hui's cook was cutting up a bullock. Every blow of his hand, every heave of his shoulders, every tread of his foot, every thrust of his knee, every *whshh* of rent flesh, every *chhk* of the chopper, was in perfect harmony—rhythmical like the dance of the Mulberry Grove, simultaneous like the chord of the Ching Shou.

"Well done!" cried the Prince. "Yours is skill indeed."

"Sire," replied the cook, "I have always devoted myself to Tao. It is better than skill. When I first began to cut up bullocks, I saw before me simply *whole* bullocks. After three years' practice, I saw no more whole animals (but saw them, so to speak, in sections).

"And now I work with my mind and not with my eye. When my senses bid me stop, but my mind urges me on, I fall back upon eternal principles. I follow such openings or cavities as there may be, according to the natural constitution of the animal. I do not attempt to cut through joints; still less through large bones.

"A good cook changes his chopper once a year—because he cuts. An ordinary cook, once a month—because he hacks. But I have had this chopper nineteen years, and although I have cut up many thousand bullocks, its edge is as if fresh from the whetstone. For at the joints there are always interstices, and the edge of a chopper being without thickness, it remains only to insert that which is without thickness into such an interstice. By these means the interstice will be enlarged, and the blade will find plenty of room. It is thus that I have kept my chopper for nineteen years as though fresh from the whetstone.

"Nevertheless, when I come upon a hard part where the blade meets with a difficulty, I am all caution. I fix my eye on it. I stay my hand, and gently apply my blade, until with a *hwah* the part yields like earth crumbling to the ground. Then I take out my chopper, and stand up, and look around, and pause, until with an air of triumph I wipe my chopper and put it carefully away."

"Bravo!" cried the Prince. "From the words of this cook I have learned how to take care of my life."

The second parable from Chuang-tzu concerns a certain "man from Ying" who had a scab on his nose no thicker than the wing of a housefly. He sent for a stonemason to have it cut away. The stonemason wielded his adze with such skill that afterwards the man's nose was quite unharmed, and he had not even changed color.

These and many other passages from Chuang-tzu have often been taken for Taoist parables. But, adequately interpreted, they have a much wider significance. They suggest that, although technical skill alone is not enough, a mastery of technique leads the artist beyond the material limitations of this

world to a higher knowledge, a perception of Tao. So skill is not simply a necessary step toward Tao but rather a part of it. The command of technique leads, through assiduous practice, through the reconciling of the inward and outward, through the conquest of material difficulties, toward a final liberation. A mastery of technique that has become so instinctive that it is absolutely unconscious makes possible a transcending of technique, a liberation into the world of the mind and—from our point of view—into the world of art.

Just as brushwork and magic were earlier shown to be integrated, so now idea and execution, which on one level look like opposites, become identical on a higher level. And here we touch on a principle enunciated by Chuang-tzu and many other Chinese: the principle of the identity of opposites. This basic principle seems to be very typical of Chinese thought. It permeates Chinese philosophy, Taoist religion, Confucian ethics, and everyday life and language as well.

Within the philosophic sphere, the two contraries are known as Yang and Yin, the two primary elements, which are united on a higher level in the great creative principle of T'ai-chi, the father of all things. The contraries of Yang and Yin are found in a vast number of parallel contraries, of which we shall name only a few here: masculine and feminine, sun and moon, day and night, hard and soft, rise and fall, unyielding and yielding, solid and liquid. One cannot think of these separately. The one always posits the other, and the relationship of each to the other defines the limits of their influence, the resultant of the forces they exert on each other. This is Tao, two opposite forces in equilibrium, and hence reconciled.

That this philosophy remained influential in China right down to recent times is proved by countless word formations in colloquial Chinese which are fairly new. The word *tung-hsi,* a combination of the characters for east and west, means " the object "; that is, presumably, whatever lies between east and west, between the borders of the Chinese world. *Ta-hsiao,* a combination of big and small, means "size" or "format"; that is, the big-small. *Yüan-chin,* a combination of far and near, means "distance," particularly "perspective." There are numerous other examples.

The philosophy of the identity of opposites, this matter of equating contraries, penetrated to the furthest reaches and the minutest details of Chinese art. Indeed one might almost say that Chinese painting, particularly landscape painting, is a projection in visual terms of Chinese philosophy, or of the Chinese mind. It is a demonstration of the endless process of harmonizing opposites which goes on, producing ever new combinations.

This concept is found in the Chinese art vocabulary even on the purely

material level. The brush stands for the masculine principle, the ink for the feminine. The brush is masculine, too, in relation to the feminine paper. The straight line is masculine; the hooked line is feminine. Then we have the brush held perpendicularly and the brush held at an angle, the linear and the nonlinear. These are only a few of the pairs of opposites which stem from the same principle.

The principle is also found at work in the way the Chinese critics classify paintings by their subject matter. The Chinese mind loves to catalogue and systematize, but always on the basis of recognized maxims. Some of the more important subject-matter categories of Chinese art will make this point clear.

Jen-wu is portrait painting; literally the term means " people and things," the contraries of animate and inanimate, what lives and what only exists. *Ling-mao* is animal painting; literally, "feather and fur," the contraries of the flying and the earth-bound. *Ts'ao-ch'ung* is the painting of insects and small plants; literally, "grass and insects." Like *ling-mao,* this last term refers to the contraries of things growing on the earth, bound to one place, and those creatures which fly freely.

The most interesting category, and for us the most important—because we are concerned here mainly with landscape painting—is the word *shan-shui.* Translated literally, the two syllables mean "mountain and water," opposing what is hard, solid, and resistant in mountain and rock to the feminine element of water, which is yielding, pliant, and changing. Water obeys the laws of gravity and yet—this is a typically Chinese attitude—its ceaseless flux forms mountains and rocks and occasionally conquers them. Out of these fundamental opposites, Chinese landscape painting was born. It is an attempt to show in visual terms the identity of Yang and Yin, their interplay and their unity at a higher level. As will be seen later, this idea pervades the whole of Chinese landscape painting at all stages from the lowest to the peak. The world of art is held together by it, bound tightly by the invisible threads which run all through it.

▪ 3 ▪ *PAINTING AND TECHNIQUE*

WE HAVE EMPHASIZED THE UNITY OF IDEA and technique in Chinese painting, pointing out, in contrast, how preoccupied Western art is with the separate problem of technique. But this is in no way meant to belittle the importance of

technique in Chinese painting. Quite to the contrary: when technique becomes so integrated with idea as to be practically an instinctive process, its role thereby evolves all the more decisively.

If what follows concentrates upon the technical aspect of Chinese painting, it is partly in recognition of this decisive importance and also partly because other aspects have already been thoroughly investigated by Western authors whose works are easily accessible. Chinese painting has been examined from the historical point of view, the aesthetic, and the philological, as well as from the viewpoint of its origins. But there has been no work which has had as its primary object an explanation of the techniques of Chinese painting. Most books have contented themselves with short comments on the special characteristics of Chinese technique, and these have, moreover, been vitiated by misunderstandings. This is natural enough. For the Chinese literature dealing with the problems of technique in painting is extremely vague in its terms and cannot be understood unless the reader already has not only a profound knowledge of the old masters and their techniques but also a wide practical experience in the use of the brush.

For the educated Chinese reader, the technique of brush handling presents no problem at all, because he has learned from his childhood to write with brush and India ink, and perhaps even to paint with them. By the time he develops a critical appreciation of the art of his own people, or has the confidence to set his creative ideas down on paper or silk, he has already had fifteen or twenty years of experience with the brush. Thus for every Chinese artist or writer on art, the use of brush and ink has been, from the beginning of his career, a part of his very being, an instinct of his wrist, a spontaneous, intuitive ability to express his innermost thoughts and feelings.

A Westerner who tries to translate Chinese documents on art therefore finds himself in a labyrinth and manages to worm his way out only by desperate measures. These include both mistranslation, which, though not necessarily deliberate, may be due to a failure to understand, and misinterpretation, which may result from the application of Western categories of thought to Chinese painting. One need only think of attempts to approach Chinese painting through the categories of pointillism, cubism, or chiaroscuro.

One of the most important Chinese works on the technique of painting is the *Chieh-tzu Yüan Hua-chuan,* the painters' manual called *The Mustard-seed Garden.* This was published between the years 1679 and 1701 and has become famous in the West mainly because of its beautiful colored woodcuts. It has been translated into French by Professor R. Petrucci, and those portions he omitted as possibly being additions of a later date are included in the German

translation by Victoria Contag. There is also an English translation by Mai-mai Sze titled *The Tao of Painting*.

The Mustard-seed Garden has often been taken to be a code of laws for Chinese painting, a set of hard and fast rules which could not be broken. This is certainly wrong. Admittedly *The Mustard-seed Garden* is a compilation of all the elements and techniques of Chinese painting known at the time, a sort of collective expression of the traditions of Chinese painting. But it would be an almost fatal misunderstanding to treat it as a rigid code of laws which had to be obeyed. In fact it is exactly the opposite. *The Mustard-seed Garden* in a way makes suggestions as to methods: methods which had developed and proved themselves over a period of a thousand years. But the stating of such methods surely limits no one who feels the urge to be creative, and numerous Chinese painters who worked after the compiling of *The Mustard-seed Garden* have demonstrated that the creative spirit can transcend rules or—and this is far the more common case in China—that the creative artist, while seeming to abide by the rules, really produces something quite new.

It is precisely here, in this delicate balance between abiding by rules and remaining free, that one encounters an important problem of Chinese art. For reasons to be explained later, the stylistic differences between periods, and also between individuals, are much subtler than in the West; and it is almost impossible for a Western expert, unless extremely experienced, to distinguish the individual style in the style of the period.

This, then, provides yet another reason why it is essential to study the techniques of Chinese painting in the minutest detail. It is only when one has an intimate knowledge of how a certain painter in a certain period applied his brush stroke or his wash, his outlines or dots, letting them flow from the brush onto the painting surface with a unique fluency, only when one's eye is trained to the point of distinguishing the "big-axe cut" shaping lines of a Ma Yüan, Ma Lin, or Li T'ang, or the dots of a Mi Fei or Mi Yu-jen—only then can he hope to undertake with meticulous care the enormous task of judging the genuineness of a painting and of pinning it down to this or that period, to this or that painter.

If in addition one remembers that one of the six principles of Chinese painting laid down by Hsieh Ho (of which more later) is: "Copy the old masters"; that almost all the great painters have carefully copied the great masterpieces of the past or of their own times; and that, generally, Chinese painters did not feel impelled to produce original work but rather to emulate the great ones of the past; it then becomes clear how difficult it must be to recognize stylistic differences. For the copying was not confined to an ap-

proximate imitation of composition. The attempt was often made to follow in the most exact detail the brush technique of the originals. One can safely state that Chinese painting hardly ever tried to create a new style, usually basing itself instead on the past. If a painter left the main stream of tradition, he was looked upon as an oddity, a fate which overtook the great Pa-ta Shan-jen. But since he was a monk and loved solitude, Pa-ta Shan-jen could defy his critics with roars of laughter.

Whenever in the history of Chinese art a new style emerged, it was usually without any conscious idea of breaking away from tradition. Innovations in style were sometimes made so gradually—deriving as they did from the conditions of the period and education—that neither the age nor the individual painters were aware of them. It was not until later that these developments could be recognized in their proper perspective.

For example, today we can look back over many centuries of Chinese art and realize what an enormous influence the revolutionary work of the painter Mi Fei had on his and subsequent ages. As will be explained later, he gave a kind of sanctity to the dot, using it rather than the traditional shaping line for his magnificent mountain ranges. But dots had been used earlier, though in a much more limited way, and thus, in those days before the technical rules of Chinese painting had been so elaborately codified, it was possible for Mi Fei and his contemporaries to regard his radical innovation as a technique already sanctioned by tradition.

The Mi Fei technique must indeed have answered a real need of the time, because it was adopted immediately, and from then on, almost every great painter would employ the Mi Fei dots at some period of his artistic career. The "shaping lines like the dots of Mi Fei," if one may for once cite this paradoxical and therefore typically Chinese expression, thus became a generally accepted technique, even a style, in Chinese landscape painting.

This example shows how the inevitable individuality of a single person can —if at the same time it foretells the latent ideas, aspirations, and possibilities of an age—unintentionally produce a lasting impression and bring with it changes in style, even when the age and the artist are both convinced that they have only been guided by the past.

To Western eyes, there has seemed to be an extraordinary sameness about Chinese painting, both in style and in subject matter, and this has been considered a weakness. But it can only be classified so if judged according to Western standards of what art and painting ought to be. Originality, whether in technique or composition, in outlines or in colors, in the extent to which it is realistic or abstract—originality of this kind is not absolutely unknown

in the East, but it is not felt as an urgent need by the painter, nor is it taken as a mark of worth. On the contrary, the Chinese painter usually tried to suppress the originality of which he was undoubtedly capable. Otherwise he would have been departing too much from the master on whom he modeled himself. A further deterrent to radical originality lay in the fact that the painters of those days were always scholars and often poets at the same time, occupying an honored position in society, and no one wanted to be shunned by his colleagues as a man lacking in taste. Because the Chinese painter repeated the same motifs and themes time and time again with only minor variations, the Westerner may come to the conclusion that he had no creative imagination. But the most important issue for the Chinese painter was to express, within the strict limits imposed by tradition, his motif or theme in an immediate, personal yet universally recognized way. The "Pavilion on the Riverbank," which made the fourteenth-century painter Ni Tsan immortal, has been repeated thousands of times in Chinese landscape painting. And some of these repetitions, like that by Wen Cheng-ming, are perhaps as good as the original. The untrained Western observer will find it very difficult to tell these two, and other similar ones, apart, or even to suggest the name of a likely painter. An Eastern expert will at once be able to distinguish them, although the differences between them may seem very slight. He looks at the two paintings, so identical to Western eyes, and finds them as diverse as a Caravaggio and a Rembrandt.

Inevitably one is reminded of the analogy of music. A Chinese painting is like a piece of music brought to life again by a brilliant pianist or violinist—coaxed out of an orchestra by the conductor's baton, as splendid and beautiful as ever, but in clumsy hands painfully bad. Chinese painting is often nothing more than a new rendering of a well-known piece, a variation on a theme, or even simply an étude. The important thing is the quality of the performance.

And at this point there is a second analogy between Chinese art and music: only when the technical problems have been mastered will the artist be able to express himself lucidly, for only then will the material differences which hinder pure expression have vanished. Of course, original compositions have also been produced in Chinese art at all times, but, once created, they became part of the repertoire of all painters, to be reproduced again and again with new variations.

It is certainly possible for a Westerner to get something from a Chinese painting by applying, consciously or not, criteria which are familiar to him. But if he does this, he will absorb only a fraction of the total idea of the paint-

ing and will be unable to claim that he has gained anything even resembling a complete understanding of it. One might almost say that the expressiveness, the wealth of associations, the subtle undertones which go into a Chinese painting are all wasted on the Westerner who will not take the trouble to delve into the secrets of technique. It may even happen that the similarities he thinks he sees—behind which actually lie fundamental differences— produce misunderstandings which will prevent his ever approaching the heart of Chinese painting.

Something must be added here to the remarks already made on the concept of originality in East and West. The Western student of Chinese painting may notice what he thinks is a lack of development, and for no good reason he assumes that all art, in every country, must show development. This leaves out of reckoning the fact that until quite recently China had an essentially static culture. And this culture emphasized not progress but preservation, not change but tradition. There was certainly no recognized principle of change. If Chinese culture has undergone some development in spite of this, then it is because the human spirit is naturally given to change, no matter what restrictions are placed in the way. But the Chinese system has discouraged such a predisposition much more strongly than other cultures, and the resulting antipathy to change is undoubtedly one of the reasons for the extraordinary continuity of the Chinese civilization.

Until the overthrow of the Manchu dynasty and the end of the empire, the cultural history of China had rolled on without a break. The wonderful endurance of this civilization, with all the richness of its inner mutations and movements, was the soil in which Chinese painting took root and flowered for nearly two thousand years. In effect, the end of the traditional civilization of China was also the end of its traditional art. Much of what has been produced in art since the year 1911 will probably be thrown away as a late flower of a dying civilization. This need not mean in practice that the values of Chinese painting—if the new regime does not destroy them for ideological reasons—are bound to disappear completely. It may much rather mean that the obstacles which formerly stood in the way of radical changes in the practice of art will now vanish, and that—from a sociological point of view— the painter may find a new freedom to combine his traditions with the spirit of his own age.

So far as Chinese art is concerned, we are living in a final phase from which no strong new developments have yet come forth. There are certain fundamental reasons why such new developments are unlikely to appear. To start with, the great age of the brush has yielded to the banal age of the fountain

pen. This means that young students no longer study the use of the brush during the period when their hands have the full flexibility of youth. In sociological terms, the structure of Chinese society has changed so much that the painter is no longer necessarily a scholar. Most people consider that it takes too long to educate a person in the use of the brush and that it is not possible by traditional methods to express modern ideas on politics, industrialization, and national reconstruction. Finally, the old-style painter, with some exceptions, finds it impossible to exist, because people no longer buy traditional paintings. They are too expensive, and besides, they have a reactionary flavor about them. So the painter is dependent on official commissions. Chinese painting has therefore reached its end, and we have all the more reason to study it in its various forms because we are in a position to survey a movement which is now over.

The Mustard-seed Garden, then, from which all this body of ideas has been drawn, is not a book of rules but a sort of list of suggestions. The academic painter who follows each of these suggestions will paint in a dry, tedious, and uninspired way. But the creative artist who has thoroughly absorbed their meaning thereby wins his freedom. So again we have come back to the same point: technical skill is prerequisite to any advance beyond technique. This does not mean that technique is to be neglected but, on the contrary, that without any apparent effort the technique is inextricably involved in the work of art as a whole.

In order to achieve this degree of facility, Chinese painting has produced an extraordinary variety of basic rules, aids, and methods which the young artist more or less learns by heart, so that he can apply them whenever he wishes, spontaneously and without self-consciousness. As a result, the Chinese painter suffers from none of those Western complexes which arise from asking: "How shall I paint it?" In China the answer to this question is taken so much for granted that it never arises at the moment of artistic creation. Technical inhibitions have seldom stopped a Chinese artist once he has got going. But at the same time—and this has already been noted—the fact that painting technique is something that can be learned has resulted in some rather ordinary works remaining alive, even if anemically so. And the fact that many commonplace or downright bad Chinese paintings are to be found in Western museums and collections is due to the inability of the Western eye to mark the difference between mediocre and good, between second-rate copy and work of art. For these differences are too minute to be recognized at first, or even at second, look.

During the course of centuries Chinese painting has developed innumerable

type forms which can be put together by the painter to form a painting. These forms are something like algebraic ciphers which only become significant when the formula is applied. They are études, but not yet sonatas. One could find many similar analogies. If one remembers that Chinese painting—and this will be more fully explained later—expresses certain fundamental principles of life, then one cannot help comparing it with the *Ars Magna* of Raimundus Lullus, or the *Mathesis Universalis* of Leibniz, or finally with the *Glasperlenspiel* of Hermann Hesse. These are only three of the countless attempts of mankind to create an art of combination which is capable of presenting all the thoughts and feelings of the human spirit and which makes imaginative use of all the symbols of the human spirit in ever new arrangements and ever new relationships.

In such syntheses we are confronted with something quite different from a mere imitation of the outward forms of nature. It is true that this sort of imitation of the world around us is up to a point inevitable, for only in nature can we find the symbols and signs we need in order to play the great Glasperlenspiel. But the reproduction of the visible world was never the only, nor even the main, aim of Chinese painting. The inventing of simplified symbols to stand for the phenomena of the visible world proves that for the Chinese it is more important to interpret things symbolically than to set them down realistically. Nevertheless, Chinese painting has naturally developed forms in which one can certainly recognize definite objects in nature: the bamboo grove or the pine tree, a late homecomer or a bird in flight.

A certain degree of abstractness is reached without, however, completely abandoning objective appearance. Even the painters of the Ch'an (Zen) school, who turned the techniques of brush and ink into a play of self-expression, hoping to gain insight from the movements of the brush inspired by the subconscious mind; even those painters who—to use a modern word—distorted; even these stopped short of pure abstraction in their calligraphy and made their bird, fish, or tree still recognizable. And yet the habit of projecting philosophic ideas into visible terms, of demonstrating Yang and Yin with the brush, was very highly developed.

The possibility of mastering technique, as mentioned already, depends on learning to handle the brush in all its peculiarities. Brush technique, as the Chinese understand it, became an acquired discipline through arduous practice and reached a point where it became instinctive and spontaneous through absolute control. The brush stroke was itself a disciplined spontaneity, as it were. We are here in the presence of Taoist doctrine, the sort of thing we learn from the story of Prince Hui's cook and of the man from Ying.

Here again analogies suggest themselves, though at first sight they appear quite incompatible with this art. A brush stroke resembles nothing so much as a sword stroke, the release of an arrow, the judo grip, the sumo throw, the karate chop. They all have one thing in common: they require an extraordinary discipline and concentration of mind on the stroke, the throw, the blow, the grip, with exact co-ordination of mind and body achieved through controlled breathing. They achieve such incomparable perfection of expression that they go beyond the merely physical purpose into the realm of the spirit, and this the Chinese call Tao. In the West we have at least one activity which approaches this Eastern form of expression, and that is golf. This may seem rather a far-fetched comparison. But in fact a golf stroke involves all the same elements of precision and concentration. If golf does not lead to a spiritual experience in the West, as it may do in the East, the reason lies only in the different attitudes of the players. However, it is worth noticing that the Chinese and, far more, the Japanese have a very special talent for this sport in which long spells of relaxed walking and controlled breathing make possible a perfect performance.

We have reached the stage at which technique takes the foremost place in our minds. It has been shown how important a role technique plays in Chinese painting. The complete fusion of technique and expression is something which can no longer be disregarded. Now we have only to trace the path from the elementary form to the general principle, the path along which the simple brush stroke advances to the finished work.

CHAPTER ▪ II ▪ *THE ELEMENTS OF CHINESE PAINTING*

▪ 1 ▪ *THE MATERIALS*

▪ THE BRUSH. During the course of Chinese history, painting brushes have been made from many different substances. The brush most used at present is a blend of the hairs of the weasel and the hare. It is a little softer than the brush used for writing. The hairs are of varying lengths, bound together in a very delicate operation. The Chinese brush has the property of running into a fine point once it has been moistened. Indeed, it becomes bushy and stiff only after the softer hairs have been quite worn away by the long use. And yet, whenever the artist desires, it can also be made to produce strokes of varying degrees of broadness or even to split into two or more points to produce multiple lines with a single stroke. This explains why, in an ink painting, normally only a single brush is used throughout, this being quite sufficient for the painting of everything from the finest hair stroke to the broadest areas of wash. As a matter of fact it has become axiomatic that, excepting the possible addition of color with other brushes, only one brush should be used for an ink painting, thereby preserving a unity of style in the brushwork.

▪ THE INK. The ink of the Sung period was made from pine soot mixed together with glue and other ingredients, all being compressed into small

inksticks, which were decorated with characters or pictures. This ink was jet black and dull—that is, without luster. Since the Ming period, Chinese painters have preferred ink made from lampblack. This ink is slightly bluish and has an almost metallic gleam. Good inksticks are very light in weight, rather brittle, and, when broken, seem to have a crystalline character.

Before beginning to paint, the artist always prepares fresh ink. This is done by rubbing an inkstick in water on an inkstone, an action which for the Chinese artist has as much psychological importance in the preparing of the mind for the work at hand as it has practical application and has long been regarded as an almost sacred rite.

The finer the grain of the inkstone, the smoother the ink and the longer time needed for grinding. The ink is ready for use when it reaches an almost oily consistency, running heavily and sluggishly back down the trails which the inkstick leaves behind on the sloping surface of the stone. By that time the rather sharp noise of the grinding has become muffled and softer. With the gradual evaporation of the water, the mixture becomes still more concentrated.

Sometimes ink is taken onto the brush directly from the inkstone. But, in order to judge and control the thickness, the more usual practice is to take the ink with the brush from the stone into a small porcelain dish. More water may be added as desired to produce the amazingly rich variety of tones of which India ink is capable, from the deepest black to the most delicate pearl-gray. This richness of tone was perhaps one of the reasons why the Chinese inclined toward ink painting, which produces its pictorial effects not with colors but simply with ink tones and brush technique.

■ THE COLORS. As noted above, ink is the primary medium of Chinese painting. Even when colors are used, with the exception of the boneless painting to be discussed later, they are simply an adjunct to the ink, being superimposed on or filled in between the inked strokes, which usually show through the colors even in the completed picture. For colors, mineral and vegetable pigments are used exclusively. They are available either in the form of color sticks, similar to the inkstick, in which case they already contain glue and are rubbed on an inkstone for colors, or more commonly in powdered form and are made ready by the painter by adding glue and usually hot water just before he wants to use them. Some of the colors, particularly in the more concentrated mixtures, are opaque and do not let the underlying ink strokes show through, thus producing a gouache-like effect, while the thinner colors and mixtures have more of the quality of water colors.

Chinese painting took over the usual mineral and vegetable colors used in all early painting. The most important mineral colors are azurite blue *(shih ch'ing)*, malachite green *(shih lü)*, umber *(chih shih)*, and white lead *(ch'ien fen)*. The main vegetable colors are indigo *(hua ch'ing)* and rattan yellow *(t'eng huang)*. Among the mixed colors *tsao lü*, a mixture of indigo and rattan yellow, and *chih mo*, a mixture of umber and ink, are the most important.

Among the vegetable colors, rattan yellow is obtained from the same kind of reed from which in medieval Europe the color known as dragon's blood was obtained, but the dragon's blood, probably because it was more concentrated, was red in color. Rattan yellow (like dragon's blood) is poisonous, and every Chinese painter is careful not to test the brush with his tongue when it is filled with rattan yellow.

This typically Chinese custom of tongue testing may be briefly mentioned here. Painters control and alter the contents of their brushes with the tongue. They seem to have developed a special aptitude for gauging how much ink or color a brush has by feeling the dampness of it on their tongues. And they use saliva to regulate the ink flow, especially those who paint with a relatively dry brush. It is probably almost impossible to tell whether this method has been used merely by looking at a finished painting. Nevertheless, one Chinese professor of our own time has managed to write a scholarly essay on the control of ink by the tongue in the paintings of Ni Tsan.

The two most important mineral colors, azurite blue and malachite green, are prepared by the artist shortly before use. They settle in four main layers in the mixing dish, the bottom layer being the thickest. This thickest layer, called *t'ou ch'ing* or *t'ou lü* (literally, "top blue" or "top green") is opaque; the second layer is less opaque; and the third and fourth are transparent. The painter reaches the different layers with his brush by shoving aside the upper layers and going down in the paint dish to the layer he wants. This layering effect becomes important when we come to consider such styles as the still to be discussed blue-green style (see page 116).

Other frequently used colors include vermilion *(chu sha)*, mineral yellow *(shih huang)*, foreign red *(yang hung)*, and French red *(mutan hung)*. But lapis lazuli is almost never used.

■ THE PAINTING SURFACE. The painting surface used is paper or silk, placed flat on a table rather than on an easel in the Western manner. Chinese paper is of many qualities and kinds, often sized and treated with glue. Silk is always sized and glued before use. In earlier times the artists sized and glued their own papers and silks, but nowadays these are also available ready for use.

As has often been proved, Chinese painters—particularly the modern ones —prefer paper rather than silk as a painting surface. One explanation that is always given is that paper lasts longer and can better withstand the ravages of time.

■ SEALS AND COLOPHON. In Chinese painting, seals and a colophon have become an integral part of the picture. The artist usually impresses two seals on a painting, one carved to produce red characters and the other to leave the character in white against a red background. Both give different versions of the artist's real and professional names. Owners of paintings also often add their own seals in some corner of the picture. Cinnabar is used for making the red color used for seals and, if of high quality, can be quite expensive. A good seal color will not fade for hundreds of years, and a firm and equal pressure on the seal will insure an imprint that will remain legible practically throughout the life of the painting. As in the case of all other materials, the matter of seals and seal colors is of ritualistic importance to painters and scholars.

The colophon is written with brush and ink. It may contain various kinds of information: the artist's age or family connections, the occasion, style, or subject matter of the painting, and the like. Both the colophon and the seals often play an important role in establishing the authenticity of a painting, although they can be and have been so skillfully forged that they cannot be accepted as proof positive.

■ 2 ■ *THE BRUSH STROKE* THE LINE IS THE FIRST STEP IN ANY attempt to reproduce three-dimensional space on a flat surface. This line is rendered in Chinese painting by a stroke of the brush. There is a direct connection between the brushwork of painting and that of calligraphy. This has been stressed time and time again in China, and Western writers have often accepted this Chinese idea rather uncritically. Certainly in some lower forms of painting, and in some of the higher forms too, the connection is very close indeed. But in a host of forms in between the two extremes, the brushwork, together with all it implies, has undergone many changes. This is particularly true of paintings which achieve their pictorial effect not by using color but by breaking up the brush strokes.

The idea of the reconciling of opposites, which permeates the whole field of Chinese painting, applies also to brush strokes. The expression *chuan chih,*

which literally means "the bent and the straight," is sometimes used as a generic term for painting, for the bent and the straight are the linear means of creating spaces within which the tonal values of ink or color can be effective.

The brush stroke is the first and the deciding step in all Chinese painting. One might even say that the first stroke of the brush decides the whole fate of a painting, for its style will be determined by whether the brush stroke is made with light or heavy ink, with a wet or dry brush, with an even or varying pressure of the hand, with a brush held perpendicularly or at an angle. It is not true, as most people suppose, that a brush stroke cannot be corrected; it can, especially if it has been done in light ink and with a dry brush. Nevertheless, this first brush stroke is presumably made with great deliberation and care, so that actually it is a decisive one.

In applying brush to painting surface it is essential both that the artist be mentally prepared to execute the stroke without hesitation or thought and that he maintain complete control to the tipmost end of the stroke; these are axioms that derive from calligraphy. The brush stroke must have a precisely formed beginning (Fig. 4A), and if there is a tailing off, it must be controlled equally well (4B). The Chinese call the beginning and end of a stroke *ch'u pi* and *ju pi,* and the whole movement between must be executed with the same degree of discipline and precision as that shown by the stonemason in Chuang-tzu's parable or in Miyamoto Musashi's masterful painting "Bird on a High Branch" (Fig. 237), which provides an unusually clear example of continuous brush control throughout the execution of a stroke.

Another rule taken over from calligraphy provides that a line whose direction is changed must be painted in the new direction with the other side of the tuft (Fig. 4c). This is to say that the tuft of the brush is tilted over with the change of direction, no matter whether the change be angular or rounded. To the novice this rule may seem unnecessary and pointless. But anyone who has steeped himself in the character of Chinese brushwork soon realizes that it is precisely on such seemingly trivial details that an essential part of the freshness, lightness, and skill of the brush technique depends.

The theorists of Chinese painting have, during the course of centuries, evolved a nomenclature for a very large number of different strokes; that is, they have given names to all the varieties of lines which the masters have used. So we have names such as "iron wires" (Fig. 4D) and "lines like nails" (4B). One kind of line even carries the imaginative title of "nail-headed rat tail" (4E and 65). Lines may be executed with a dry brush (4F) or a wet one (4G), with continuously equal pressure (4F-G) or with changing pressure (4H).

It may be argued that the christening of lines is a matter for the critic rather than the painter, the primary function of such nomenclature being to communicate the phenomena of brush techniques in words. As a matter of fact, the painter who is interested only in painting generally pays little attention to such distinctions. And for this reason in this book these terms are used as sparingly as possible.

Just as a sword stroke demands a special grip on the hilt, and an arrow shot demands a special co-ordination of finger, arm, and hand, so the brush stroke demands that the brush be held in a certain way. It is therefore essential to understand how the Chinese brush is held before one can grasp the techniques of painting. It must not be forgotten that Chinese characters were not originally written with a brush but were scratched onto bone or tortoise shell with tools of stone, bronze, or iron. Certain forms were developed from this method of writing which were definitely not intended for the brush. In course of time, however, the brush was evolved and came into its own in the writing of Chinese characters. If today the old seal writing or the early scratch writing from the period of the oracle bones is still sometimes reproduced by means of a brush, this is an anachronism which reveals nothing of the real qualities of the brush except perhaps its amazing versatility in the hands of an expert.

The brush is held, not close to the tuft, but in the middle or even at the top of the handle, depending upon the size of strokes to be made. Only for the most detailed brushwork is the hand supported at the wrist; in all other cases it is unsupported and moves freely from the wrist.

For the characteristic Chinese grip (Fig. 5), the brush is normally held perpendicular between thumb and index finger, with the middle finger also touching the brush somewhat behind and below the index finger, while the ring finger, in conjunction with the little finger, supports the brush from the opposite side. It is this combination of support from both sides that permits the artist to move the brush freely in all directions over the flat painting surface and at the same time to maintain constant and complete control over all its movements. Looking again for a moment at Fig. 5, one should note that the brush is being held in a position to produce rather long strokes; for shorter strokes the only difference would be that the brush would be gripped nearer the tuft. The middle finger is here concealed by the width of the brush. This picture, incidentally, comes from the so-called *Ten Bamboos Studio,* the *Shih-chu-chai Shu-hua-p'u* (The Repertory of Writing and Painting from the Ten Bamboos Studio), which was edited by Hu Cheng-yen between 1619 and 1627 and contains a great number of beautifully executed woodblock prints.

The Chinese have always liked to think that their painting and its tech-
niques developed without any outside influences. To say that this view is
mistaken and that they in fact owe much to non-Chinese sources certainly
does not in any way lessen the greatness of the Chinese achievement. The
important thing is what the Chinese made of the ideas and techniques they
adopted from other sources. No one can doubt that Chinese painting is among
the greatest that the world has ever produced. And this all-important issue
of the brush grip justifies the conclusion that we here find a purely Chinese
development.

I have a theory that there is a connection between the Chinese brush grip
and that depicted, probably about the seventh century, in the so-called
Painters' Cave at Kyzyl, in Turkestan (Fig. 6). Here the brush is held neither
as the Europeans have long held their writing instruments nor yet in the
Chinese manner. Instead, the grip is somewhere in between the two, but
rather closer to the Chinese. Since, as we shall see in the next paragraph,
there is good reason to believe the Chinese had developed their characteristic
brush grip several centuries earlier, it seems likely that in these cave paintings
we see a transition stage in brush technique resulting either from Chinese
influences or perhaps from the fact that the painters, if actually of Chinese
extraction themselves, were too far from China's artistic center to have pro-
gressed further.

The painted tiles excavated at Lo-yang and now in the Boston Museum
(Fig. 7) provide one of the earliest examples of Chinese painting, probably
dating from the late second or early third century. In their extremely lively
and expressive drawing we find many features that were to characterize later
Chinese painting. The brushwork particularly is very highly developed for
such an early period: the swell and fall of the individual brush strokes, the
terminations of the strokes now broad and now tapering to fine points, the
tilting of the brush to produce both square and rounded changes of direction
—all these are features of a mature technique that could scarcely have arisen
except from the typically Chinese brush grip we have been describing. Even
though we cannot speak positively here, nor state that the Chinese brush grip
developed at precisely such and such a time, we can take it for granted that
in these tile paintings we are not dealing with the work of some provincial
artist who, in style, technique, and taste, limped after the masters of China
proper. They are evidently the work of an artist who had thoroughly mastered
the technique of the brush.

Although the difference between the brush grips of Kyzyl and, if we are
right in our suppositions, the painted tiles may seem slight, it is actually of

greatest importance. We have no way of knowing precisely when the ring finger and the little finger moved in China from the front to the underside of the brush, but it was a decisive moment, comparable to the use of the stirrup in warfare. Through this latter discovery, the Mongols were able to control their ponies so well that they could shoot their arrows from a gallop and sweep victoriously to the very gates of Europe. And once the Chinese painter had gained this complete control over his brush, he too could metaphorically shoot his arrows from a gallop to outpaint the world.

■ *3* ■ *MOUNTAINS AND ROCKS*

■ OUTLINES. Turning from the technical factors which supply the essential backbone to all Chinese painting, we now move to the more specific elements based upon the former: to the building up of a Chinese painting from the first stroke to the last dot. Here we shall be dealing primarily with landscape painting both because it is one of the most typical forms of Chinese painting and because, by common consent, it represents a peak of the Chinese artistic genius.

Rock, mountain, water, and tree grow in many stages, through many layers of ink, to become a finished landscape painting. The four chief stages in this process of growth are, first, the outlines; second, the shaping lines; and finally, in either order, the washes and the dots. These stages often merge indistinguishably into each other and, depending upon the artist and his intentions, may also include certain subsidiary stages. The outlines are the beginning of the structure. They can be superimposed over each other in several layers of ink, either in lighter ink first and then heavier, or the other way round.

The two accompanying figures provide examples of graphic contrast of the light and heavy outlines; Fig. 8 shows light outlines plus many shaping lines. If the outlines are first put in with a lighter ink, then it is possible to make changes or corrections when applying the second layer. The transition from outlines in lighter ink to shaping lines is not so noticeable or so dramatic as the transition from heavy-ink outlines to shaping lines. In applying a first layer of light-ink outlines there is a tendency to render them in the washlike strokes of a kind often used for shaping lines; the danger here is that the forms will remain flat and lack contrast, thereby giving a sketchy impression.

Outlines which are put in first in heavier ink (Fig. 9) make corrections or

changes practically impossible. Therefore it requires greater skill to begin with the heavier ink, particularly since the characteristics of the outlines decide the style of the whole picture. The outlines merge into the shaping lines unnoticeably and without any gradations. However, to distinguish between the two, it can be said that the outlines are usually the longer components, while the shaping lines are mostly put together out of shorter single components.

The untrained eye will scarcely be able to tell the difference between outlines started in heavier or lighter ink. This may be quite irrelevant, and it may seem unimportant to distinguish between them. Actually though, just such apparently unimportant differences occur throughout the whole of Chinese painting; and the quality and genuineness of any work can only be judged by someone who has been trained to recognize them. Unless considerations of style demand a different approach, a master painter will usually begin his original painting with heavier outlines. But the imitator, or the forger, both following the same original, will begin with light ink so they can make corrections as they go along and later put in the decisive shapes with heavier ink.

In Figs. 10 and 11, a superficial examination will fail to reveal in which order the inks were applied. Closer examination, however, reveals certain distinguishing characteristics. Putting on the heavier ink first, as in Fig. 10, tends to give a stronger, harder, more linear effect, and a clear gradation between outline and shaping line is noticeable. When the lighter ink is put on first, as in Fig. 11, the painting becomes generally softer and suggests an immediate transition to a wash. Of course this latter example also contains shaping lines, but they are not so clear as in the first example.

From the above, it becomes evident that the artist's choice of light or dark ink for his outlines—or for any other area—has nothing to do with questions of light and shade, of chiaroscuro effects. Their use is based on an entirely different principle: that of balancing the light and the heavy, the advancing and the retreating, the acting and the reacting. The arrangement of the forms passes beyond the sphere of plastic composition into aesthetics, where we meet once again the principle of the identity or balance of opposites.

■ SHAPING LINES. The outlines which define rock, mountain, and tree as distinct shapes in the landscape slide unnoticeably into other lines which give a modeled texture to flat areas within the outlines. The Chinese word for these lines, *ts'un,* is difficult to translate. In English they have been called "wrinkles" or "shading" or "modeling"; in French, Petrucci calls them "traits." There is no generally accepted German word; one might talk loosely

of "Runzeln," "Schrunden," or "Faltung," but none of these terms describes more than a part of the total function of these lines. The word "shading" wrongly suggests light and shade, while "modeling" is achieved in other ways. So we have called them "shaping lines," feeling that this name most accurately defines the Chinese *ts'un* and is at the same time comprehensive enough to include various types of lines.

Shaping lines constitute the most important element of Chinese landscape painting. In them the collective experience of the Chinese painting tradition and of the individuality of the painter are most purely expressed. One is tempted to say, in modification of Buffon's dictum, "Le style est l'homme même": The style is the *ts'un*.

Shaping lines can either follow strictly traditional rules or express the highly personal conception of an individual master, but the more frequent case is a mixture of traditional and personal qualities. The painter inevitably expresses his own personality in his shaping lines, even when trying most painstakingly to copy the shaping lines of a great master. The process is comparable to an attempt to copy another person's handwriting and, in doing so, leaving certain clues which a trained graphologist could recognize. These clues would be the involuntary expression of the copier's own personality. To carry this figure of speech a bit further, it can be said that one has to examine the brushwork of a master with the precision of a graphologist in order to ascertain a picture's genuineness. Only by equally thorough means can one judge the work of a master beyond any shadow of doubt or distinguish between a copy and the original, a late work and an early one, a master and an epigone. If so many spurious paintings are to be found in our museums, and if paintings ascribed to old masters have recently so often been re-evaluated as belonging to later periods, this results from the fact that hardly anyone, so far, has bothered to provide the tools for a critical analysis of brushwork.

When a painter aims at producing an original composition rather than at reproducing an earlier style, he will deliberately or instinctively adapt the traditional shaping lines to his own use. Or he will effect a new combination of accepted shaping lines of a similar kind. Or, finally, he will create variations of his own in which the original shapes will be hardly recognizable. The Chinese traditionally distinguished sixteen or more kinds of shaping lines, not counting the subsidiary kinds. These were conveniently divided into three large categories by the Japanese art historian Kimbara Shōgo: thread-shaped lines, band-shaped lines, and dot-shaped lines. Benjamin March, in his useful little book *Some Technical Terms of Chinese Painting,* adopted these three

categories and added a few minor kinds of lines to produce the following list (given here in a somewhat different order from the one he used):

A) Thread-shaped lines:
 1) *Luan ma ts'un:* shaping lines like tangled hemp stalks. Also called *luan ch'ai ts'un:* shaping lines like tangled bundles of brushwood.
 2) *Ho yeh ts'un:* like the veins of lotus leaves.
 3) *Chieh so ts'un:* like unraveled hemp rope.
 4) *P'i ma ts'un:* like spread-out hemp fibers.
 5) *Ma p'i ts'un:* like a tangled ball of hemp fibers.
 6) *Luan yün ts'un:* like rolling billows of cloud.
 7) *Niu mao ts'un:* like cow hair.
 8) *P'o wang ts'un:* like a torn net.
 9) *Fan t'ou ts'un:* like lumps of alum.
 10) *Tan wo ts'un:* like the eddies of a whirlpool.
 11) *Kuei mien ts'un:* like the wrinkles on a demon's face.

B) Band-shaped lines:
 1) *Hsiao fu p'i ts'un:* shaping lines like the cuts made by a small axe.
 2) *Ta fu p'i ts'un:* like the cuts made by a big axe.
 3) *Che-tai-ts'un:* like broken bands.
 4) *Ma ya ts'un:* like horses' teeth.

C) Dot-shaped lines:
 1) *Tou pan ts'un:* shaping lines like the two halves of a bean.
 2) *Yü tien ts'un:* like raindrops.
 3) *Tz'u li ts'un:* like thorns.
 4) *Mi tien ts'un:* like the dots used by Mi Fei (included by March under the category of band-shaped lines).

In completion of the foregoing, March also included four additional band-shaped lines which are simply variations of the four given above *(fu tso ts'un,* like the cuts of a chopper; *t'o ni tai shui ts'un,* like bands dragged through mud; *ni li pa ting ts'un,* like nails pulled out of mud; and *t'ieh hsien ts'un,* like iron wire) and two additional thread-shaped lines *(pi ma ts'un,* like tangled hemp balls ; and *chüan yün ts'un,* like towering clouds).

After a painter has developed his own variety of shaping lines, he does not then limit himself to this single variety. Almost instinctively he will select the kind of shaping lines suitable to the style of his specific painting. At the same time every painter prefers such shaping lines as correspond most closely to his own character, and if he occasionally follows the model of some master,

he will be intending to honor him in his painting. The very richness of variety found in the shaping lines of Chinese painting proves that, contrary to widely-held opinion, the rules or propositions set forth in such treatises as *The Mustard-seed Garden* were never regarded as dogma, however slavishly they may have been followed by mediocre painters. They are not intended to restrict the freedom of the master but rather to supply him with that absolute mastery of technique which becomes his passkey to artistic freedom.

Art historians, particularly in Japan, have tried to link each sort of shaping line to some phenomenon of nature. This seems to be a misunderstanding of the special character of the shaping line, as well as of Chinese painting in general, for the mere copying of nature was long ago abandoned by Chinese painters. Even realistic forms were never naturalistic, but only symbolic. They were simplifications which ignored everything but the essentials.

Numerous anecdotes testify to the fact that Chinese painting has long been an art of the studio rather than of on-the-spot execution—in short, of Wordsworth's "emotion recollected in tranquillity," though not at all in a romantic sense. There is one famous story of two painters, Li Ssu-hsün and Wu Tao-tzu, who were commissioned by the emperor to produce paintings showing the thousand miles of the Kialing River. Li worked furiously on sketches and notes while Wu wandered around admiring the beauty and wildness of the country along the great river. Then both artists returned to the capital. Li, the realist, set to work with the help of his sketches to paint the entire length of the river on the palace walls. But Wu haunted the inns, drank wine, and enjoyed the singing girls, doing no work at all. Within the palace, the courtiers began to get worried, but outside, Wu was perfectly happy and without a care. There were only one or two days left until the time limit set by the emperor would expire. Li's painting was already taking glorious shape when Wu finally appeared at the palace and started work. With tremendous zest and great sweeping strokes, he began to throw the bristling spirit of the Kialing onto the walls. Mountains soared into the air on the wings of his brush, torrents roared around the bends in the cliffs, and the solitary footsteps of pilgrims clattered hollowly over the fragile bridges. In two days, Wu had conjured up a masterpiece a hundred times worthier than Li's splendid craft.

Wu had concentrated not on objective reality, but on the essential nature of things; he had filtered the scenes through his own brain and grasped their spirit. It was the spirit of mountain and water which dictated the shaping lines he used, not their physical composition, not granite or gneiss, sandstone or slate.

In dealing with the various types of shaping lines, we shall restrict our discussion to only a few of the more important ones. It is certainly not necessary to go into them all in detail. As already mentioned, the Chinese painter does not consciously choose this or that type of line, nor is he likely even to remember all their names. Unlike the writer on art, who knows the theory, the philosophy, and the vocabulary of painting, the painter himself is primarily concerned with painting. There is in fact an interesting conflict between the painter and the literary man in China, although as usual the two sides meet in one mighty genius, the scholar-painter. Writers who could paint passably if not brilliantly, while recognizing their limitations, charged artists who could paint but not write with being uncultured; whereas the artists who were not good at telling a story or had no education to boast of but did know the secrets of the brush, attacked the writers as men who were at home with theories but all at sea with the brush. Only geniuses like Wang Wei were able to skip lightly and modestly over this squabble. They wrote poems and painted pictures which are immortal, if not in reality then at least in the memory. If, as many such geniuses did, they set down their feelings about painting, they tacitly ignored the conflict between writer and painter. For them, of course, it did not exist, since they could use the brush equally well for writing and for painting.

Shaping lines like unraveled hemp rope (Fig. 12) belong, as the name suggests, to the thread-shaped category. They were especially used by Fan K'uan, and can be executed in a great variety of ways. Our example is painted with a dry, slanting brush, but innumerable combinations of brush and ink are possible—a dry, pointed, perpendicular brush, and a wet, pointed, slanting brush, to name only two. However, the basic shape remains the same behind all these individual variations.

The big-axe cut (Fig. 13) was widely used in Sung times by such painters as Ma Yüan and Hsia Kuei. This type of shaping line is involved in the quarrel between the Northern and Southern schools and is generally associated with the so-called Northern school. Tung Ch'i-ch'ang (1555–1636), who later defined and called attention to the difference between the two schools, suggested that this shaping line was typical of an artisan approach to painting and as such was unworthy of serious consideration by scholarly painters. Actually the art of Ma Yüan and Hsia Kuei was without doubt of an extremely high technical quality, and Sesshū, one of the greatest of Japanese painters, modeled himself on them. Thus it really is not fair to say that their paintings show any inferiority in taste, even though Tung Ch'i-ch'ang and his friend and co-worker Mo Shih-lung were perhaps better scholars.

The Japanese painter Taki Ken (1829–1902), whose son Taki Seiichi has become famous as an art historian, reflected the techniques of Chinese painting with extreme fidelity in his work. In a collection of illustrations he depicted, among other things, the various shaping lines in sample landscapes. His illustration of big-axe cuts, used in a typically Chinese landscape, is shown in Fig. 14. It is almost impossible to tell that this painting was not done by a Chinese.

A variation of the big-axe cut shaping line is the small-axe cut. These two differ only in the relative size of the single brush stroke. The plastic shapings of rock and mountain in Fig. 15 are painted with a relatively wet brush. They have a stronger calligraphic impact, partly due to their smallness. This kind of shaping line was particularly favored by Liu Sung-nien, as well as by the Ming painters T'ang Yin and Shen Shih-tien, and usually forms the ink skeleton of a painting which is completed in color. Here the graphic effect of these lines has already been softened by a wash and by the use of layers of ink in varying thickness. And with the addition of colors the lines would become still more obscured. The landscape of Fig. 16 clearly illustrates the foregoing point. In the cliffs in the foreground the axe cuts are quite visible. But in the background they have almost been submerged in the wash of the mountains and are further covered by the light coloring.

With Sesshū, who modeled himself on these and similar Sung paintings, the axe cut becomes longer and even flatter, while the outlines are on the whole stronger than a Chinese painter would have made them (Fig. 17). In addition, Sesshū tends to use the split brush, so that each brush stroke produces two or more brush lines. This technique, which Sesshū carried to a fine art, is usually rejected by the Chinese masters as an aberration. Nevertheless, it is found in the paintings of such great Chinese masters as Pa-ta Shan-jen.

The shaping lines known as tangled hemp stalks or tangled bundles of brushwood (Fig. 18) were developed in the Yüan period and somewhat resemble the unraveled hemp rope of Fig. 12. They are, however, usually rendered with more pointed and angular strokes, the brush being slanted steeply backward and forward to produce a hard, sharp texture that is almost crystalline in appearance, thus contrasting with the moderately slanted brush and the more rounded strokes of unraveled hemp rope. Taki's example of tangled hemp stalks (Fig. 19) uses a more rounded stroke than is generally the case.

Ni Tsan, one of the great Yüan painters, was very fond of the broken-band shaping line (Fig. 20). Although the band-shaped category customarily

involves a broad line, here the line is very delicate and elegant, being rendered with a smaller brush than usual. The horizontal or slightly dipping brush strokes can move at the end into the vertical plane or into a slant with an angled or rounded turn. Ni Tsan favored not only a dry brush, but also the turn into the vertical. Many variations are possible with this kind of shaping line: in the general relationship of the lines with each other, as well as in the use of light or heavy ink with a fine or a rough brush, a wet or a dry one.

We may at this point anticipate a technical peculiarity whose significance will only become clear later. Generally speaking, a certain kind of shaping line is accompanied by a certain kind of dot, the kind that seems aesthetically suitable to it. Here, as in every other aspect of Chinese painting, the exception proves the rule. Horizontal, almost stroke-shaped dots usually accompany broken bands, but Ni Tsan preferred vertical dots.

The Japanese painter Taki used broken bands in a small landscape (Fig. 21) which obviously evokes a classical landscape by Ni Tsan, "The Pavilion by the River," though it lacks the characteristic vertical dots. This same landscape has been echoed many thousands of times in Chinese painting without any fundamental innovations. But in spite of the fact that these paintings all seem very similar at first glance, there remains at long last no grain of doubt as to which is the authentic masterpiece and which are the secondary performances. The difference lies not only in the disposition of the various parts of the painting, in the beauty of the composition and the use of space, but also, above all, in the brush work, which is an unerring witness of the strength or weakness of a painter, his originality or lack of inspiration, his vitality or his torpor.

Veins of lotus leaves (Fig. 22) are similar to small-axe cuts in that, together with their accompanying outlines, they often form the ink skeleton for a painting which is finished in color. Most shaping lines seem to be sufficient in themselves, but these two kinds give a feeling of incompleteness until overlaid with color. The addition of the color sometimes blurs the clear definition of the ink structure, but if forceful enough, its essence will still be felt through the strongest layers of color. In Fig. 23 Taki renders his lotus-leaf veins with a fine-line brush which is frequently split.

In approaching Kimbara Shōgo's third category of shaping lines, those shaped like dots, an introductory note is called for. As paradoxical as the term "dot-shaped shaping lines" may appear in calling dots lines, it is for all that a typically Chinese solution of the problem of how to classify these transitional forms between true lines and true dots. And even the Chinese recognize their peculiar position when, as we shall see, they place the Mi

Fei dots in a special category of their own; for reasons of convenience, how-ever, we have preferred here to treat these with the other dot-shaped lines.

Raindrops (Fig. 24) are an important kind of these transitional forms between the line and the dot. Usually they appear in an arrangement of dots forming a system of lines which in over-all form rather resembles the lotus-leaf veins, or they may be applied over lotus-leaf veins.

A structure of lines quite similar to lotus-leaf veins actually forms the underlying ink structure for another kind of dot-shaped lines—dots used by Mi Fei (Fig. 25). These are not included by the Chinese in the sixteen or more traditionally named shaping lines, but neither are they classified as dots. Even now they are always considered to be in a class by themselves, a fact that gives them a position of prominence they well deserve: they did in fact pro-duce a sort of revolution in Chinese painting and, ever since Mi Fei and his son, have been an inseparable part of the Chinese painter's vocabulary. Every painter tries them out at least once. Their very name, *Mi tien ts'un* (literally, Mi-dot shaping lines), designates them as partaking of the quality of both dots and lines and indicates their interestingly mixed character. They also have something of the nature of "broken ink" (see page 118) and represent a transition between brush usage and ink usage (see page 177) in the sense that dots need more control of the ink and lines need more control of the brush. Thus the Mi dots, in their form, serve to give shape to the body of a painting, while in their arrangement they delineate the skeleton. In explaining the apparent anomaly of their name one could say that they are dots which, being used to produce both outlines and plastic shape, have the character of the brush strokes that form shaping lines. Therefore they are not simply dotted on the paper, but are in a sense stroked on as well.

■ DOTS. After a painting has been defined in its structural composition with outlines and shaping lines, the next and final stage is the putting in of dots, washes, and tints. These three components are definitely subsidiary and sup-plemental to outlines and shaping lines and are not invariably used, nor are they necessarily applied in the order given here.

The primary function of dots is to emphasize visibly such realities as distant trees, moss, brushlike vegetation, and the like. But they also have two aesthetic functions which are equally important, if not in fact more important. First, they can emphasize the painter's compositional intentions by either stressing or softening the linear forms. And second, with their stresses and accents they can reinforce the invisible connections of a painting, underlining the painting's general architectonic flow.

Here we are introducing an idea which is very important in Chinese painting and will be treated more fully when we come to the section on composition: that of "dragon veins" *(lung mo)*. The dragon veins of a painting are the invisible inner relationships which bind the parts together—the web of aesthetic interdependence, the spatial interlocking, the cohesive strength which draws the observer irresistibly into the depths of the painting. In them shines the inner power of the painting. And it is these dragon veins, especially when they are weak, that are often accentuated and strengthened by the addition of dots.

As has already been noted, dots are not intrinsically necessary to every painting. Whether or not they are used to finish off the structure of a painting really depends on the degree of completeness the painter requires and the character of the painting itself. Occasionally structural or other weaknesses may be concealed by dots.

In the course of its history, Chinese painting theory has identified and listed many kinds of dots, just as it has done with shaping lines. Petrucci, following *The Mustard-seed Garden,* has noted thirty-three varieties, which have all been given imaginative names. But again, as with the shaping lines, painters are less concerned with nomenclature than with trying to paint dots themselves. Scholars, nevertheless, know all about them, and can even identify which master uses which sort in which work.

Generally speaking, dots tend toward the horizontal, the vertical, or the diagonal. They may be painted with a pointed or a split brush, in heavy or light ink. For the painter, this much knowledge is sufficient. The brush techniques used for making the dots in Fig. 26 are illustrated in Figs. 27–30.

Dots like black pepper (Fig. 31) are painted in rounded groups, with a brush not too pointed and with heavy ink. Like the Mi Fei dots, these too can have several layers superimposed on each other. The structural arrangement of the dots in our example can be seen clearly, since the shaping lines have been purposely omitted from the outlined mountain.

The two accompanying sketches show two additional forms of dots—dash shaped (Fig. 32) and plum shaped or rounded (33). These sketches also illustrate how the general structure of mountains is produced by the full integration of their outlines, shaping lines, washes, and dots. The dash-shaped dots follow the rounded contours of the mountains, while in the other sketch the plum-shaped dots are grouped into the wrinkles and intersections of lines.

Fig. 34 proves how the same dot form—in this case the plum-shaped dots shown to the upper left—can at one time be used to express distant vegeta-

tion (the lower mountain) and at another to reveal the artist's intentions by emphasizing the painting's dragon veins (the upper mountain).

It cannot be repeated too often that the Chinese painter attains freedom through the mastery of technique. This mastery enables him to apply his craftsmanship in whatever way suits him and to produce, with the techniques at his disposal, ever new combinations in an eternal Glasperlenspiel.

The dot technique of Fig. 35 is an example of the Chinese master's acquired freedom. Here two dot forms which are usually found seperately are combined to produce yet another technique. Fig. 35A shows black-pepper dots, also frequently called rat footprints. Fig. 35B shows baton-shaped dots, quite similar to the dash shapes of Fig. 32, except that the batons have blunter points. In 35c the two types are combined in a technique which, though not included among the thirty-three traditionally named dots, later generations have called "dots favored by the Sung painters." In 35D the batons are applied along the contours, while black pepper is sprinkled mainly at intersections of the longer brush strokes. (The mountain top shown in 35E was added by the painter not mainly to illustrate the specific point being treated, although it does use black-pepper dots. But even when producing such utilitarian sketches P'u C'hüan often felt the need, for reasons of balance or of other aesthetic considerations, to add an additional element. Here and elsewhere we have retained these additions as examples of the artist's personality and exuberance.)

Note in Fig. 35 that the shaping lines underlying the dots are small-axe cuts and lotus-leaf veins. As already stated, these generally require an addition of color for completeness, When added, such color might partially obscure the ink structure but never quite obliterate it.

■ WASHES. There are two types of washes, called *hsüan-jan* and simply *jan*. Both are rather similar and merge into or accompany each other in such a way as often to be practically indistinguishable. The one usually either involves or develops into the other, and together they serve to produce a stronger plastic quality.

Hsüan-jan implies an application of small areas of wash here and there to a painting. Sometimes the shaping lines seem to be sufficient without the addition of such wash; at other times they seem to require it. Fig. 36A shows a rock formation rendered only in outlines and shaping lines, while *hsüan-jan* has been added to the lines in 36B. Note how the wash gives an increased sense of perspective, with only the sparsest use of shaping lines, and emphasizes the plasticity of the one sketch over the other.

Jan is an over-all wash applied to large areas of a painting. When meant to fill a flat area it should be applied evenly, as in 36D, without producing the unsightly spottiness recognizable in the bad example of *jan* in 36C. It can also be made to weaken to one side, as in 36E, but again evenly, without any spottiness.

When, as is the more common case, the two types of wash are used together, as in 36E-F), the small areas of wash are first applied and then covered with the over-all wash.

■ 4 ■ *TREES AND BAMBOO* LIKE THE ROCKS AND MOUNTAINS WE have been principally considering in the preceding pages, trees too are built up in a series of stages (Fig. 37A–C). The outlines merge into the shaping lines; wash and tint give the tree trunks roundness, fullness, and tone; and dots sometimes complete the whole process.

The outlining of a tree follows an alternative pattern of pushing and yielding, interrupted only by the strong marking of knotholes in the wood. In the interplay of the two lines defining the trunk, we find once again the principle of the two opposites, which the painter knows all about, either consciously or instinctively. It seems as if the two sides of the tree were carrying on a dialogue as they rise upward together. And they rise to a rhythm which convincingly keeps their two sides apart or draws them toward each other.

The outlines of the tree are limited to the sparse essentials; hence their shaping lines are correspondingly few. Again, several layers of ink are applied on top of each other, and the artist must take care not to paint over with a subsequent layer the spaces he has purposely left untouched.

The most difficult part of tree painting is considered to be the painting of the branch forks, the transition from trunk to branch, from branch to leaves, from the double line to the single. From the Chinese point of view, the most important parts of a tree are the roots and the branch forks. The former are usually kept in a light tone, while the latter are often silhouetted against the white painting surface.

But in the use of wash, as in all other painting techniques, it is considered vulgar or in bad taste to take short cuts, to apply obvious tricks in avoidance of more difficult techniques. For example, in Fig. 37D-E wash has been entirely omitted from the highlight areas, producing a desired dramatic effect in an

approved way, whereas in 37ꜰ the effect has been achieved, not by leaving the paper untouched, but by the trick of using a watered brush to remove some of the still-wet wash.

The strokes which are made to indicate the foliage of trees have the same variety of shapes as those employed for rocks and mountains. Technically speaking, there are two main prototypes: leaves painted with double strokes, and those done with a single spread stroke (Figs. 38–44). This second type is called boneless painting because the ink skeleton is dispensed with and the painting surface is straightway entirely covered with ink or color. This boneless technique is usually used in flower painting. In landscapes it only appears in the foliage of trees. One could define this leaf technique as a kind of splashed-ink painting which, dispensing with the ink skeleton and the linear style, requires a more precise control of the brush stroke.

In the way the brush is held and guided there is a clear distinction between the double-stroke and the boneless method of painting leaves. The double-stroke manner, having a linear character, needs a pointed, perpendicular brush, while the boneless manner calls for a brush which is slanted and broader at the tip. But the principles of composition are the same in either case, as may be seen in Fig. 44.

Leaves can be rounded or angular, triangular or oblong, and they can be grouped in patterns of two or three or four. Here we obviously have a great variety of possible forms, in which every mood can be expressed. The leaf technique called black pepper (the term, incidentally, is also used for the similar dot technique in painting rocks and mountains) is done with rapid movements of an almost perpendicular brush (Fig. 45ᴀ). For other leaves the brush is held at a slant and is flicked out to one side (45ʙ-ᴄ). Another kind of leaf, painted in groups of four, is named after the character *chieh* (介) because the grouping resembles the brush strokes for this character (45ᴅ).

The two leaf-groups shown in Fig. 45ᴇ are an example of a very interesting technique which consists of filling the brush with two different tones of ink. The brush is first dipped into a light ink, and afterwards the tip is dipped into a heavy ink. The result is that, in the painting, the dark ink automatically shades off into the light, producing a plastic effect. Both of the groups shown are painted with a single filling of the brush.

Turning from leaves to branches, we again find many different manners in which the natural objects may be rendered, each with its own special name. But here, as always, the artists pay little attention to the nomenclature and tend to develop their own forms, which go into the making of their individual styles.

The painting of branches aims as little at a direct imitation of nature as the shaping lines for rocks do. It is much more a question of creating an aesthetic entity—a tree—by using numerous forms, as seen in Fig. 46, and drawing a rich texture of brush strokes over the whole painting. So branches may be set in groups of two or three, upright or drooping, straight or rounded, painted from the tree outwards or the other way round. With all these possible combinations, a great variety of tree shapes can be produced. Even if these are not always easily identifiable as oak or beech, they nevertheless remind the viewer of the magnificent wealth of forms to be found in nature.

In Chinese painting, aesthetic and philosophic concepts are more important than the desire to produce realistic imitations of nature. Hence relatively few natural phenomena are really "portrayed." It is certainly possible to put an occasional portrait of a tree into the foreground of a Chinese painting, but only a very few trees are considered to be of sufficient dignity to be worth portraying. The important ones thus painted and recognizable as such are pine, cedar (Thuja orientalis), wu-t'ung (Firmiana simplex), willow, plum, and bamboo. We sometimes find palm trees portrayed in southern settings, but they belong to a special group akin to the bamboo.

The characteristic bark of the pine trunk (Fig. 47A) is indicated by lines which resemble tiny ships one on top of another; these produce a very good feeling of pine bark. The pine needles are painted in countless different ways, depending on the style of the picture. They can be done with a number of lines all equally strong or lines running together, short and rounded or long and piercing.

The trunk of the cedar (47B) is spiraled and is painted with a broad, dry brush. The branches are rounded and make grotesque patterns. Leaves are rendered by dots which recall those like black pepper.

The wu-t'ung tree (48A) is extremely important in Chinese painting because, according to legend, it is the only one on which the phoenix alights. Its trunk is painted with sharp, delicate shaping lines drawn across in parallels from the side. The leaves are set in dramatic groups of five at the ends of the branches.

The willow trunk (48B) is executed with a rather dry brush, and the shaping lines are more neutral in character, so that there is no noticeable transition between outlines and planes. There are many different ways of painting the branches and the leaves. Because the willow is a symbol of spring, of grace and elegance, and therefore of femininity, it is almost always painted in spring foliage with long hanging leaves.

In Chinese symbolism the "three friends of the cold season" are the plum

tree, the pine, and the bamboo. The plum tree (48c) is painted either in winter dress or in blossom, never in leaf, for it is considered uninteresting in summer foliage. The trunk is gnarled, expressing its defiance of the elements. The general outlines are zigzag, and the branches long and spiky, as though they were trying to pierce the cold.

Bamboo has long been a subject dear to the heart of the Chinese painter. Bamboo painting has practically developed into a separate art in its own right, standing about midway between calligraphy and the painting of trees. Great masters have devoted themselves almost exclusively to it and have brought the painting of it to a peak of perfection—witness Su Tung-p'o and Wu Chen (Figs. 161 and 198). Famous treatises have been written about it, and many revealing anecdotes are told in its praise. Little wonder, then, that bamboo painting has been elaborated with involved details to the point of being as difficult to understand as the Chinese art of calligraphy or the Chinese taste in jade. In *The Chinese on the Art of Painting*, Osvald Sirén quotes a comment by Li K'an that reveals how severely the Chinese themselves judge the art of bamboo painting: "As old Tung-p'o understood the principle but had not enough training to do the thing, how could later men have had it?" Not wanting to be so esoteric, we ourselves must grant that Tung-p'o is one of the greatest in the field.

One of the later volumes of *The Mustard-seed Garden* devotes an entire section to the bamboo, demonstrating the main elements and principles of bamboo painting as an independent subdivision of painting. The rules set forth there, as well as in many other Chinese theoretical treatises, apply equally to bamboo as an element of landscape painting. In landscape painting, however, bamboo forms but a part of the larger design and thus has to be incorporated into it so far as technique and style are concerned. Therefore, while bamboo ranges close to calligraphy as an independent subject, it becomes more related to the painting of trees when it appears in landscape painting. For example, a grove of bamboo or a grouping of bamboo stalks is handled in the same way as a group of trees, insofar as the arrangement of the stalks and the illusion of depth is concerned.

Turning to Fig. 49, we find bamboo as it would appear in landscape painting. In 49A-B, we see the two kinds of bamboo: that with drooping leaves and that with upright leaves. In these same two sketches we also find exemplified such rules of bamboo painting as those demanding that stalks not cross each other too frequently, that three stalks never cross at the same point, that the sections become longer toward the top, that the ridges not be of equal height, to name but a few. Fig. 49c shows a bamboo stalk such as might

be used in a more elaborate painting, employing double strokes for the stalk and the leaves and possibly adding color. Fig. 49D-E represents two different styles of painting bamboo, the first being done with a wet brush and thick ink to indicate individual bamboo leaves; and the second with a dry brush and thin ink, the leaves being so sketchily indicated that they can be recognized as bamboo only because of the typical bamboo stems.

■ 5 ■ WATER, RAIN, SNOW, AND CLOUDS

THE FIVE ELEMENTS OF CHINESE cosmology begin with water, followed by fire, metal, wood, and earth; and water is also a symbol of femininity. Both as symbol and as cosmological element it appears often in Chinese painting in many diverse forms. In its deepest and widest meaning, water shares its outstanding symbolic position with mountains, the second of two great parts of the entity known as Chinese landscape painting, which is called *shan-shui hua,* "the painting of mountains and water." This expression derives partly from the fact that mountains and water appear so frequently in landscape painting, but the derivation is still more deeply rooted because landscape painting, like all other painting in China, is a demonstration of the philosophical principle of Yang and Yin, of the cosmic idea of the coincidence of opposites which was discussed in Chapter I. The male, hard, unyielding Yang element is represented by mountains, while water provides the female Yin element, which is described in Lao-tzu's *Tao Te Ching,* in J. J. L. Duyvendak's translation, as follows:

"The weakest thing in the whole world dashes against the hardest in the whole world. There is in all the world nothing that is softer and weaker than water, but in attacking what is hard and strong, nothing surpasses it. Without substance it penetrates where there is no crevice; by what-is-not this becomes easy. . . . The weak conquers the strong and the soft conquers the hard."

In keeping with its female character, in Chinese landscape painting water is always less emphasized than rocks and mountains. It remains in the background, in the deepest or most remote places, moving frequently out of sight; although it is clearly the moving and forming force, only in the rarest cases does it hold the stage as a main actor in the picture. It is felt to be there, sometimes even only by omission, sometimes in the form of rain or snow or clouds, always counterbalancing the more rugged, obvious, aggressive forces of rock and mountain. This retiring character of water explains why, despite

its great importance, we shall be able to treat it here within fewer pages than were necessary for the richer varieties of rock and mountain shapes.

Fig. 50 illustrates some of the basic Chinese water techniques. Watercourses which are visible for some distance usually approach in serpentine curves, but in 50A the Chinese painter, with his typical tendency toward simplicity and concentration, prefers to show only a single S-shaped curve. Such a curve resembles the Chinese character *chih* (之) and hence is called *chih tsu shui* (water in the form of *chih*). More than one *chih* curve is possible, but more than three are considered aesthetically unpleasing and are used only in exceptional cases. Thus in 50B, although the watercourse in the background makes many meandering curves, this is only feasible because it is viewed from above at a great distance, and a certain richness of movement is necessary.

Fig. 50C-D demonstrates two main methods of rendering waterfalls. The first is used for more distant cascades and consists in leaving the paper free of ink, showing merely the outlines of the falling water. The second method, employed for much closer views, permits the individual waves to be painted in. There are, of course, many different ways of executing waves, depending upon a painter's taste and talent. For example, note the cascade pattern of 50E, which is repeated as a finished sketch in 50F. And 50G discloses the *shui hua* (water flowers) used to indicate the turbulence of numerous crosscurrents.

Fig. 51 draws attention to an unusual abundance of water in the form of rain over a lake. While the lake is only suggested by the single boat, the rain is very apparent in a wash technique in which the streaks of windswept rain were applied while the painting surface was still wet from an earlier layer of light ink or plain water. This technique is quite similar to that of water-shaping lines described on page 122 and requires exact control both of ink and brush.

Snow demands great reserve with brush and ink. As illustrated in Fig. 52, it is suggested mainly by omission. The spaces left free of ink are larger than would otherwise be the case; the application of shaping lines is sparse; and the effect of snow is heightened by outlining the snowy areas with a wash of deeper tint than would normally be used for the sky. As seen at the left of the sketch, the new snow on the branches of a large tree is indicated by omitting the wash on the tops of the branches. The smaller tree shown at the left would not be combined with the large tree in a finished painting. It was added here to show how a tree would look in a snowy landscape after the snow had fallen from its branches.

Fig. 53 discloses that, just as in Western painting, the Chinese artist has two different ways of depicting clouds. In the upper sketch the outlines of

■ PAINTING AND MAGIC

(see pages 23–28)

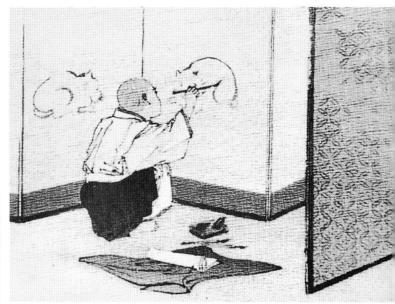

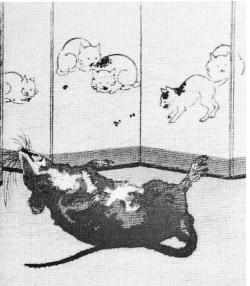

1–2. Cats drawn on a screen kill a large ghost-rat. Illustrations for Lafcadio Hearn's "The Boy Who Drew Cats," from Japanese Fairy Tales.

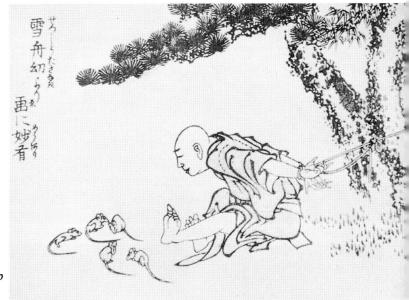

3. Rats drawn by the boy Sesshū come to life. From Hokusai's Manga, *Vol. 10.*

4. Some brush strokes: (A) *precisely formed beginning;* (B) *well controlled tailing off, strokes "like nails";* (C) *change of direction;* (D) *"like iron wires";* (E) *"nail-headed rat tails";* (F) *made with dry brush and equal pressure;* (G) *made with wet brush and equal pressure;* (H) *made with wet brush and changing pressure. P'u.*

5. *The characteristic Chinese way of holding the brush. From* Ten Bamboos Studio.

6. *An earlier brush grip as depicted in the Painters' Cave, Turkestan. Drawing by A. von LeCoq in* Bilderatlas zur Kunst-und Kulturgeschichte Mittelasiens.

7. *One of the earliest examples of Chinese brushwork: a painted tile from Lo-yang. Boston Museum of Fine Arts.*

■ *OUTLINES*

(see pages 48–49)

8. *Light-ink outlines with shaping lines. P'u.*

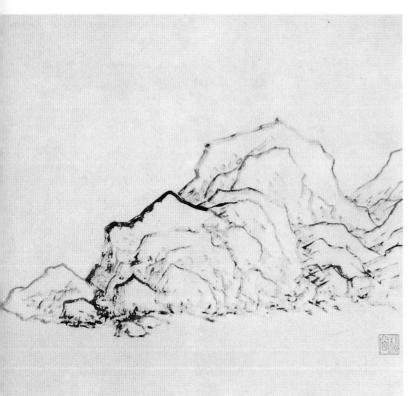

9. *Heavy-ink outlines with shaping lines. P'u.*

10. *Light ink over heavy. P'u.*

11. *Heavy ink over light. P'u.*

■ *SHAPING LINES*
(see pages 49–56)

12. *Like unraveled hemp rope. P'u.*

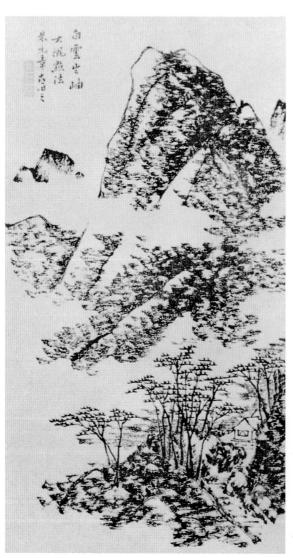

13. *Like big-axe cuts. P'u.*

14. *More big-axe cuts. Taki.*

15. *Like small-axe cuts. P'u.*

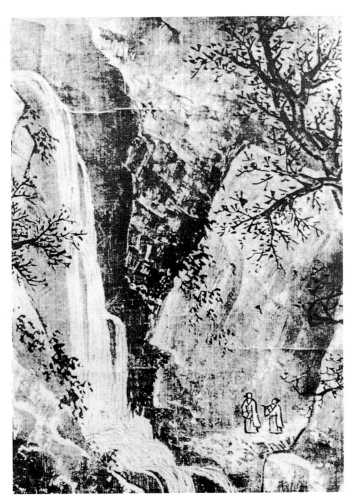

16. Shaping lines, washes, and coloring: detail from a landscape attributed to Li T'ang (late Sung). Courtesy Ōtsuka Kōgeisha.

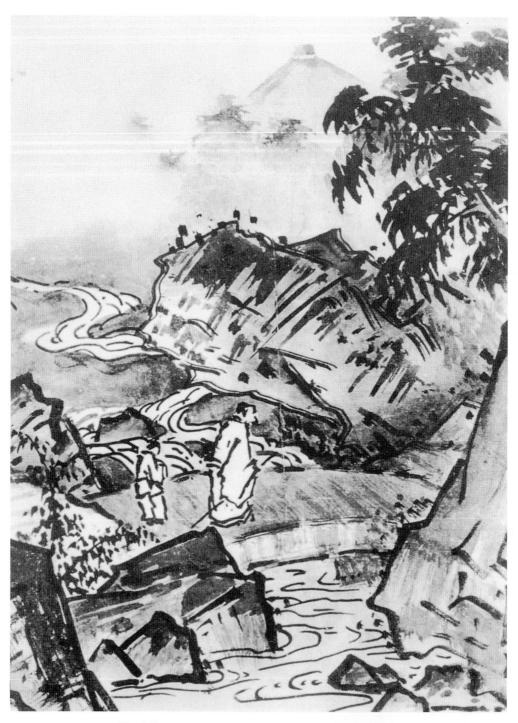

*17. A Japanese version of axe-cut shaping lines : detail from
a landscape by Sesshū (1420–1506). Private collection.*

亂麻
亂麻

18. *Like tangled hemp stalks. P'u.*

溪山狗步
亂麻皴法

19. *More tangled hemp stalks. Taki.*

折帶皴

20. *Like broken bands. P'u.*

谏林遠岫
折帶皴法

21. *More broken bands. Taki.*

74 ■ SHAPING LINES

荷葉皺字正面
山石竹多用之松窗

荷葉皺法

22. Like veins of lotus leaves. P'u.

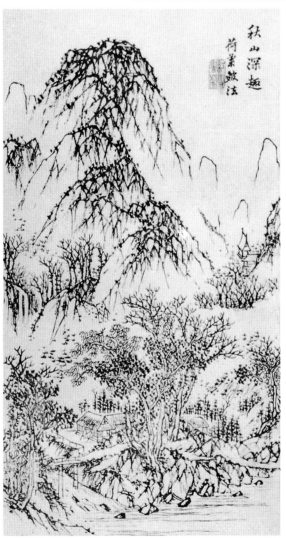

秋山深趣
荷葉皺法

23. More lotus-leaf veins. Taki.

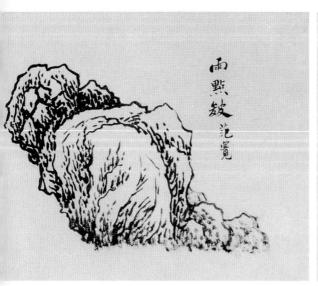
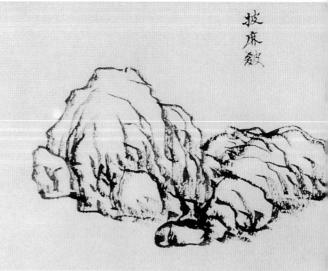

24. Like raindrops: (LEFT) with
sparse underlying structure; (RIGHT)
an underlying structure, of lotus-leaf
veins, that is often used with
raindrops. P'u.

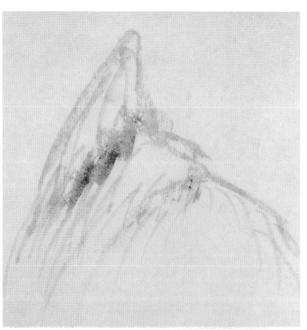
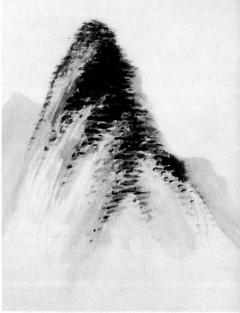

25. Mi Fei's dot-shaped shaping lines:
(LEFT) the underlying structure, resembling
lotus-leaf veins; (RIGHT) Mi Fei dots ap-
plied over the underlying structure. P'u.

■ *DOTS*

(see pages 56–58)

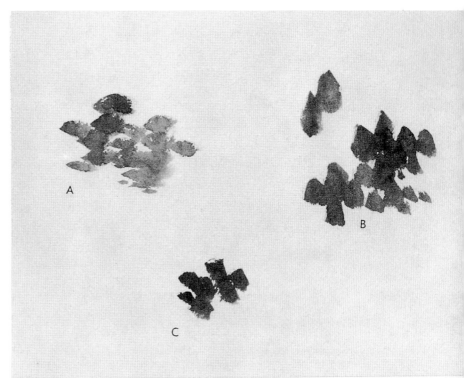

26. Some forms of dots
(A) *horizontal;* (B) *vertical;* (C) *diagonal. P'u.*

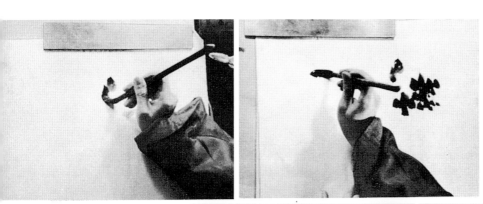

27–30. P'u Ch'üan painting the dots of Fig. 26.

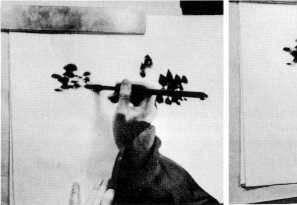

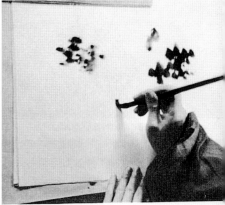

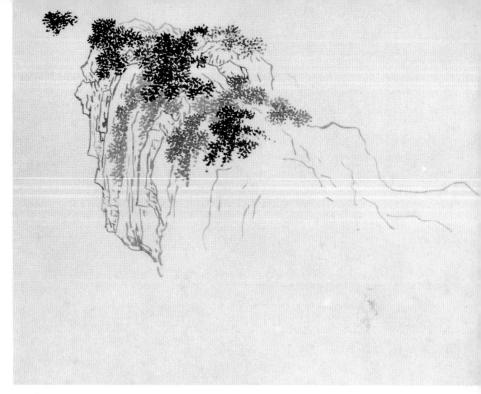

31. Dots like black pepper. Pʻu.

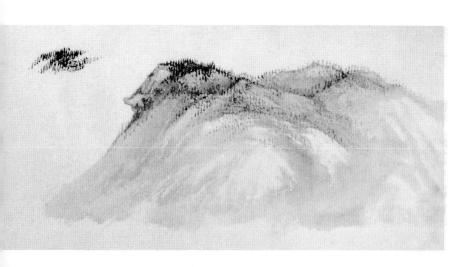

32. Dash-shaped dots. Pʻu.

33. Plum-shaped dots. Pʻu.

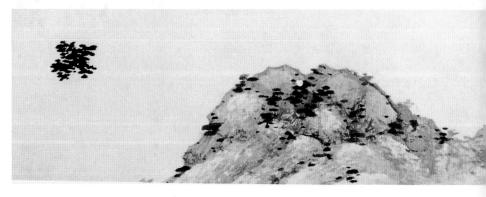

78 ■ DOTS

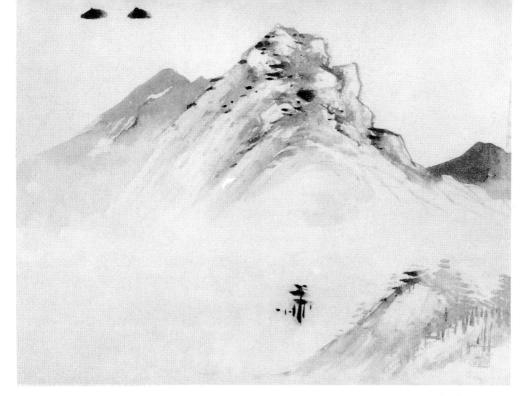

34. Plum-shaped dots used for two purposes: to represent distant vegetation on the lower mountain and to emphasize composition in the upper. P'u.

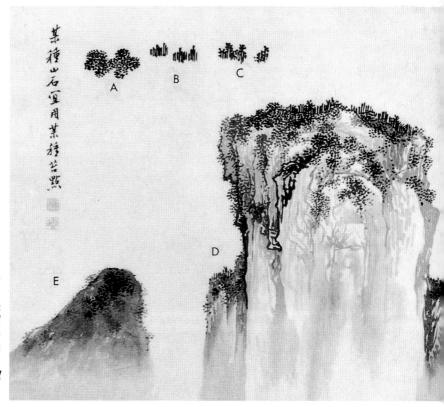

35. Combinations of dots: (A) black-pepper dots; (B) baton-shaped dots; (C) a combination of A and B, called "dots favored by the Sung painters"; (D) A, B, and C applied to a mountain top; (E) black-pepper dots applied to a mountain top. P'u.

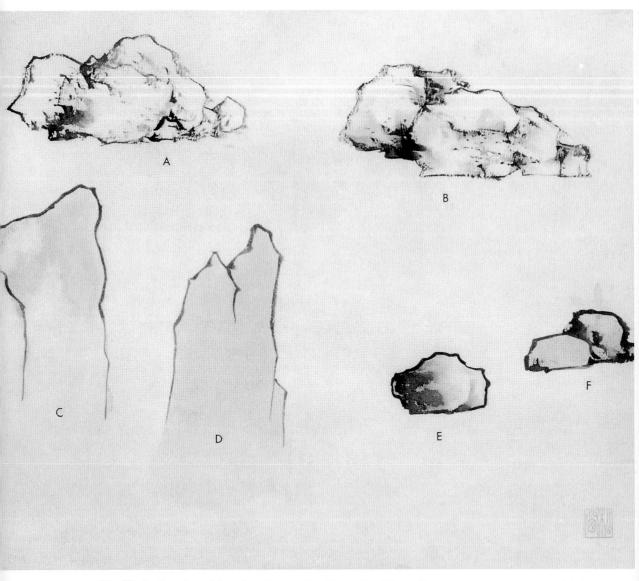

36. *Kinds of washes :* (A) *rock without wash;* (B) *rock with small-area or* hsüan-jan *wash;* (C) *bad example of over-all or* jan *wash;* (D) *good example of* jan; (E) jan *weakening to one side;* (F) *the more common case of* jan *applied over* hsüan-jan. *P'u.*

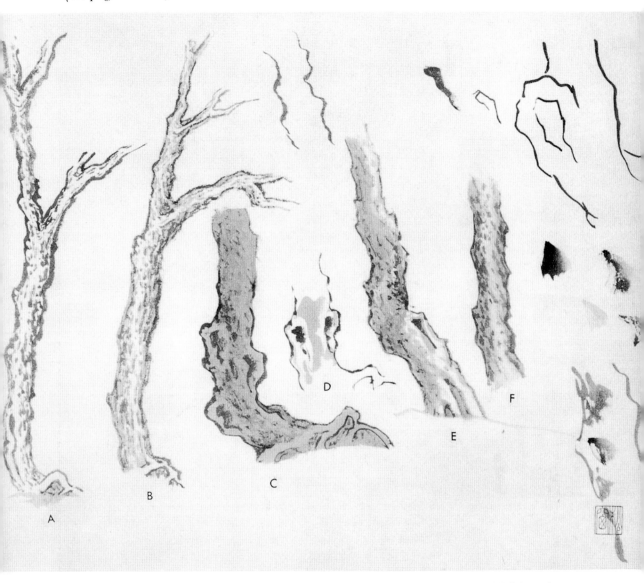

37. Some techniques for tree trunks: (A) outlines merging into (B) shaping lines, over which (C) wash and tint are added; (D-E) effect of omitting washes from highlight areas; (F) trick of removing wash from highlight areas with watered brush. P'u.

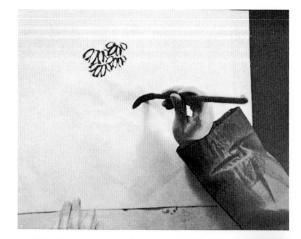

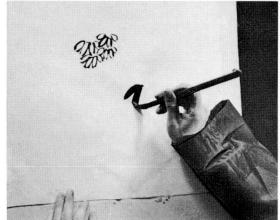

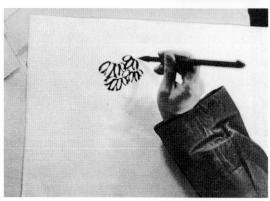

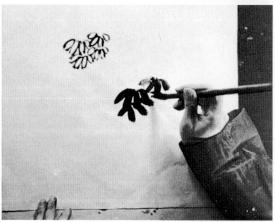

38–44. P'u Ch'üan painting two main types of leaves: double stroke and single spread (boneless) stroke.

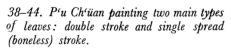

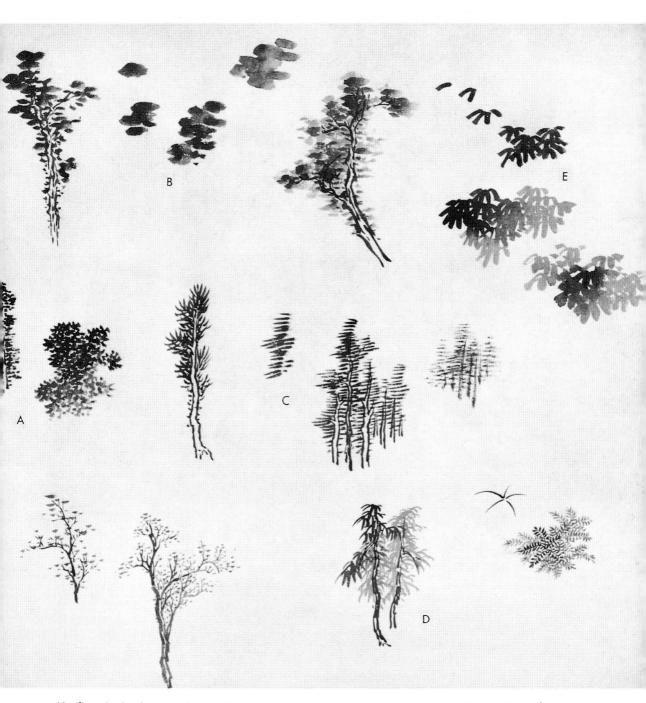

45. *Some leaf techniques :* (A) *black pepper;* (B-C) *horizontals;* (D) chieh *groups of four;* (E) *using two tones of ink. P'u.*

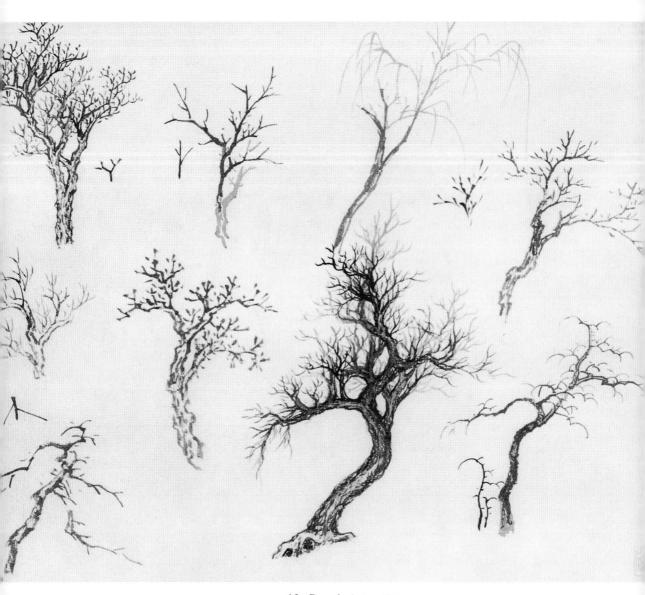

46. *Branch shapes. P'u.*

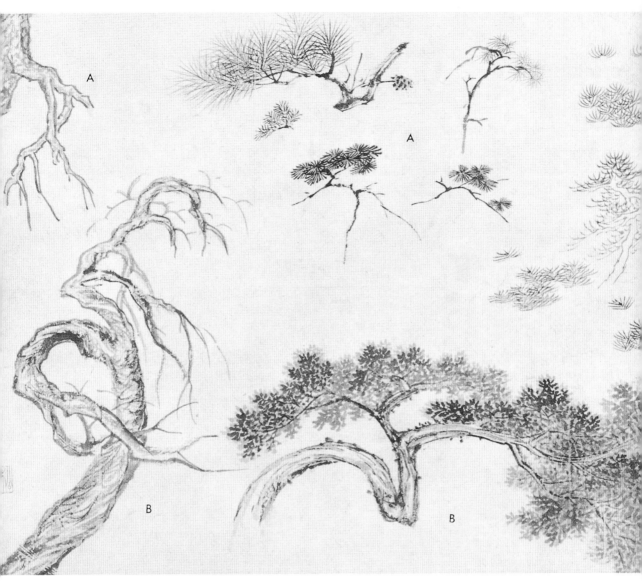

47. *Specific trees:* (A) *pine;* (B) *cedar.* P'u.

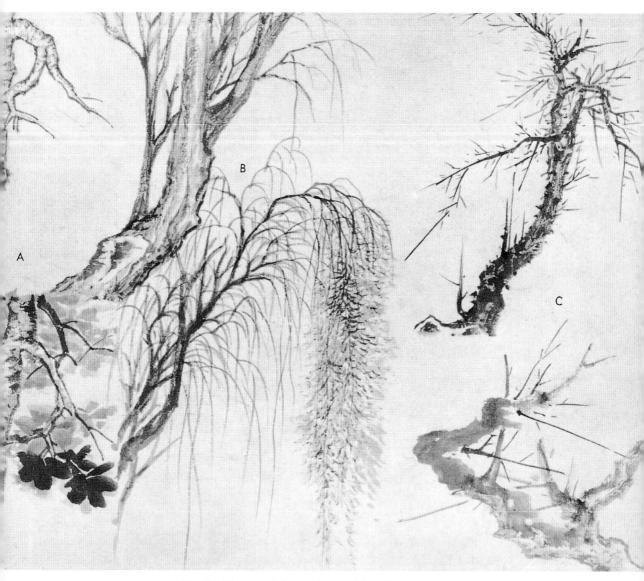

48. Specific trees : (A) wu-t'ung; (B) *willow;* (C) *plum. P'u.*

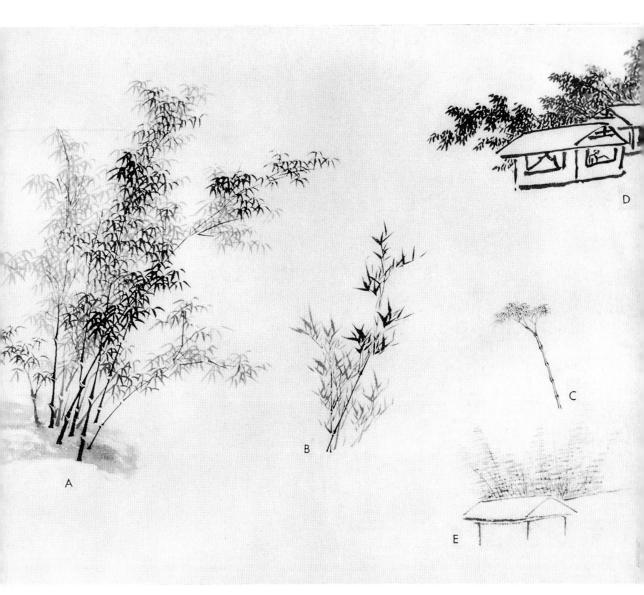

49. *Some bamboo techniques:* (A) *drooping leaves;* (B) *upright leaves;* (C) *with double strokes;* (D) *with wet brush and thick ink;* (E) *with dry brush and thin ink. P'u.*

■ *WATER, RAIN, SNOW, AND CLOUDS*

(see pages 63–64, 103)

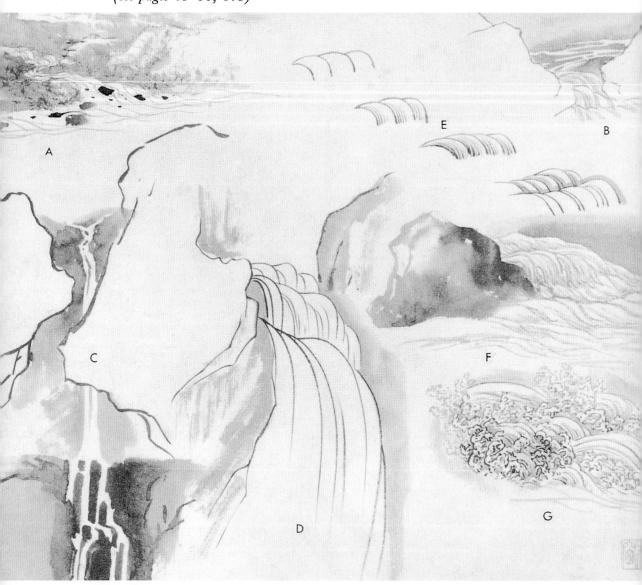

50. *Some water techniques:* (A) *single S-shaped* chih *curve;* (B) *multiple S-shaped curves;* (C) *distant waterfall;* (D) *close-up waterfall;* (E) *basic cascade pattern;* (F) *cascade pattern in finished sketch;* (G) *crosscurrent water flowers.. P'u.*

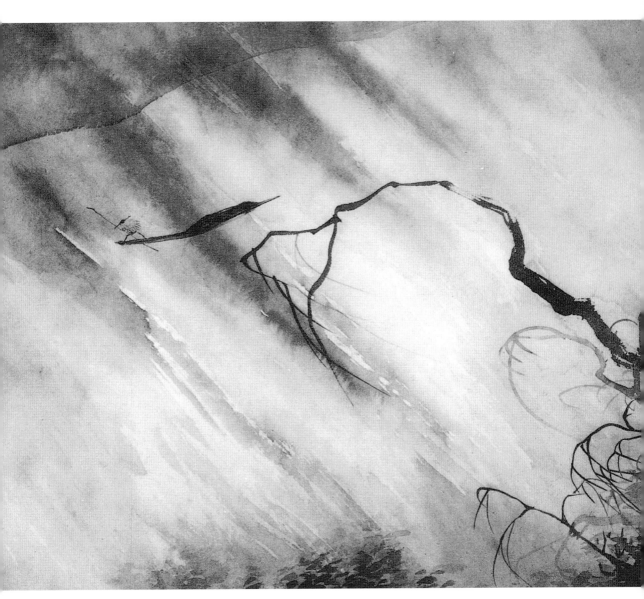

51. Rain over a lake. P'u.

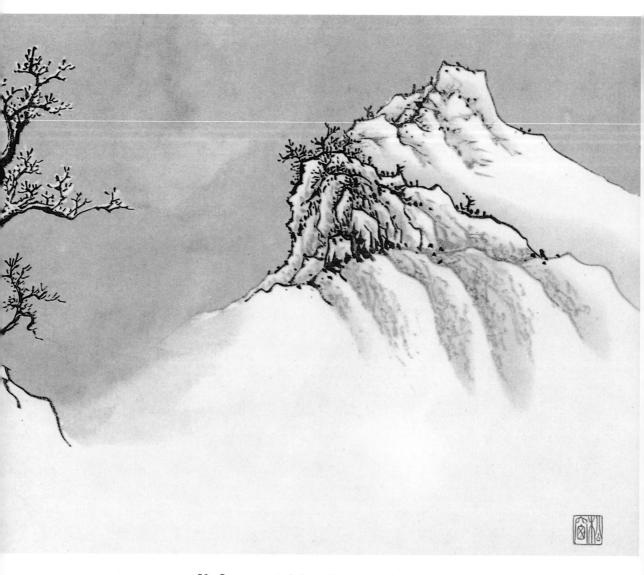

52. Some snow techniques for trees and mountains. P'u.

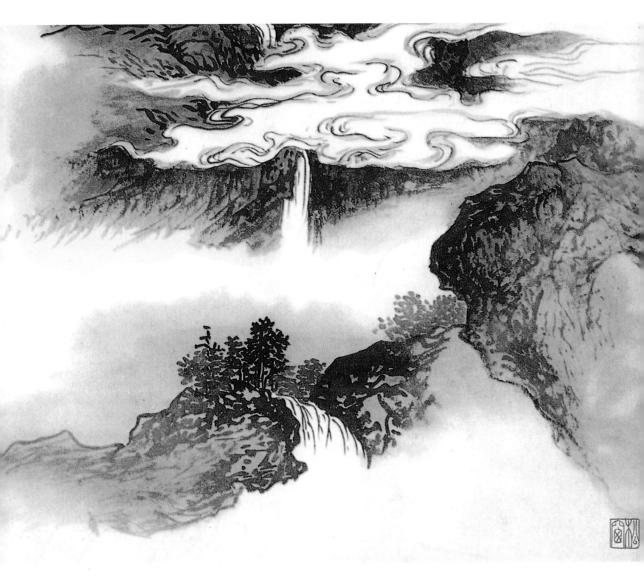

53. Some cloud techniques: (UPPER) *by drawing in;* (LOWER) *by leaving paper blank. P'u.*

■ THE HUMAN FORM

(see pages 103–5)

Note: Figs. 54–69, showing various outlines used in figure painting, are details from Taki Ken's *Gasan*.

54. *Like willow leaves.*

55. *Like scudding clouds or running water.*

57. *Like angleworms.*

56. *Garment lines used by Ts'ao Pu-hsing.*

58. *Like bamboo leaves.*

59. *Like water waves.*

60. *Like wasp bodies.*

61. *Like a series of date stones.*

62. *Like a series of olive pits.*

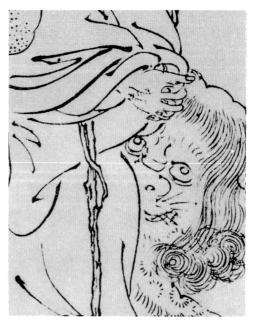

63. *Like iron wires.*

64. *Like broken weeds.*

65. *Like nail heads with rat tails.*

66. *Lines with fewer strokes.*

68. *Double lines.*

67. *Like pieces of brushwood.*

69. *Like orchid leaves.*

70. *Human figures for landscape painting.* P'u.

■ COLOR

(see pages 105–8)

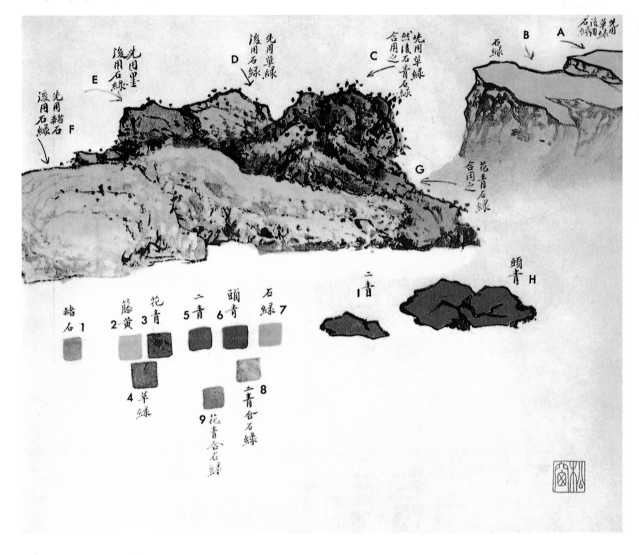

71. Basic colors and color combinations applied over ink skeleton; P'u:

1. chih shih=*umber brown*
2. t'eng huang=*rattan yellow*
3. hua ch'ing=*indigo*
4. mixture of 2 and 3, ts'ao lü=*herb (or plant) green*
5. erh ch'ing=*second azurite blue*
6. t'ou ch'ing=*top azurite blue*
7. shih lü=*malachite green*
8. mixture of 5 and 7
9. mixture of 3 and 7

A. *herb green (4) under malachite (7)*
B. *malachite (7)*
C. *herb green (4) under azurite-mala-chite (8)*
D. *herb green (4) under malachite (7)*
E. *ink wash under malachite (7)*
F. *umber (1) under malachite (7)*
G. *indigo-malachite (9)*
H. *wash in top azurite (6)*
I. *wash in second azurite (5)*

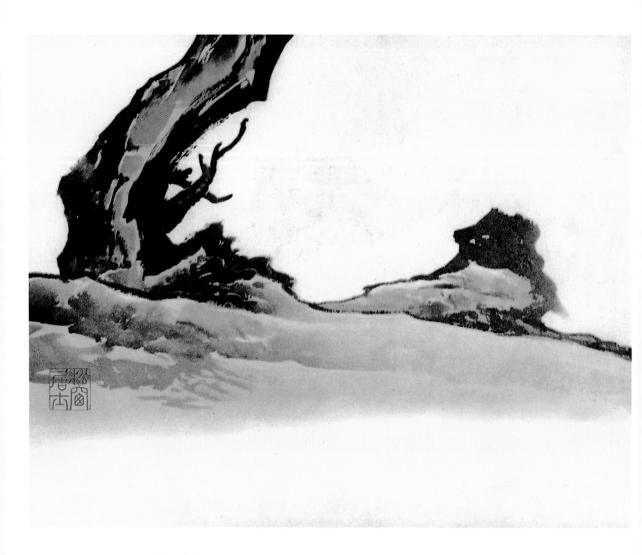

72. Umber and plant-green transparent washes over splashed-ink skeleton. P'u.

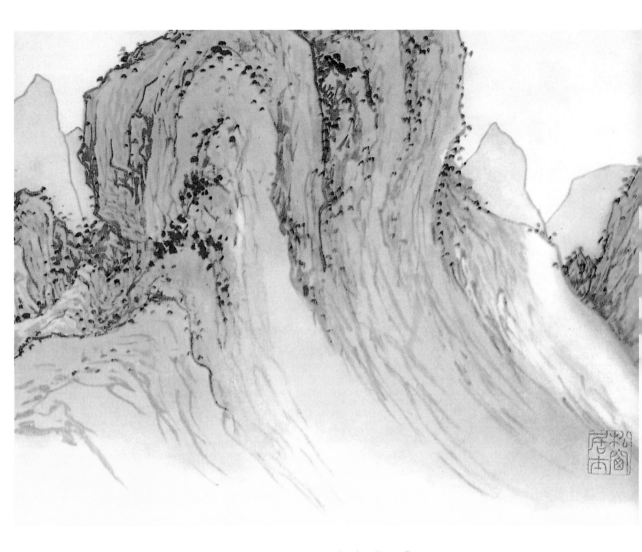

73. Color washes with sparse shaping lines. P'u.

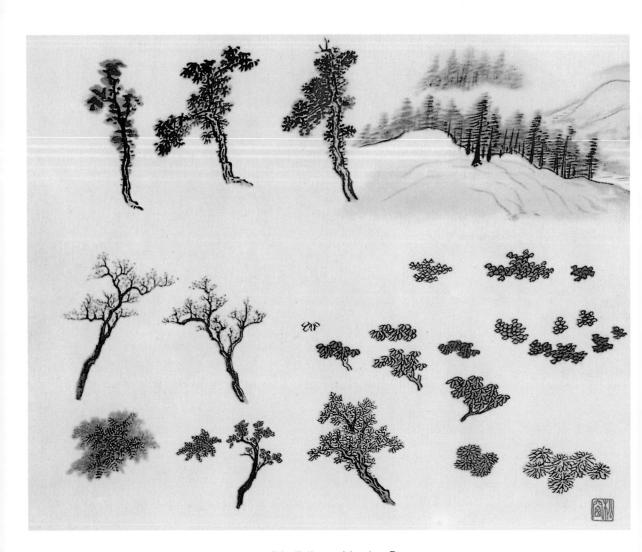

74. Foliage with color. P'u.

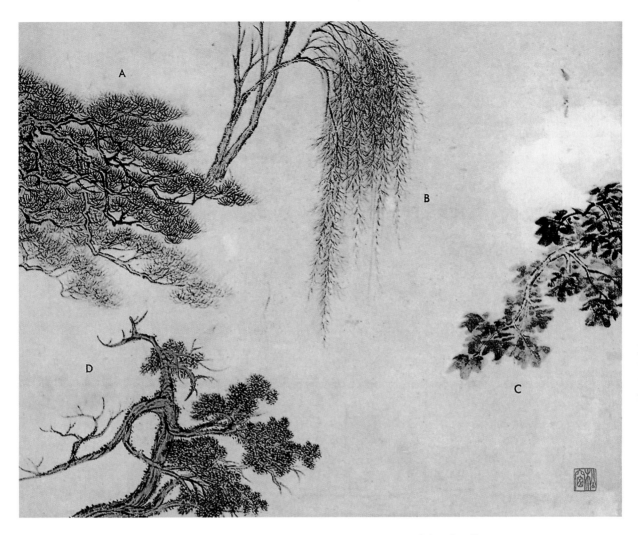

75. *Trees with color :* (A) *pine ;* (B) *willow ;* (C) wu-tʻung; (D) *cedar. Pʻu.*

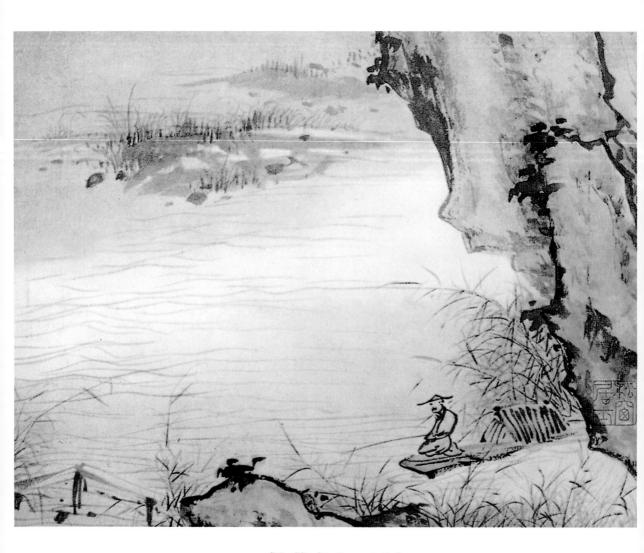

76. The "indigo style." P'u.

the clouds are drawn in, while in the lower the clouds are rendered by leaving parts of the painting surface untouched by wash.

Clouds play an important part in Chinese landscape painting, both because they express mood and at the same time supply important compositional elements. Therefore the painter devotes much attention to them. Of the many possible shapes, the stylized ones have frequently been preferred. But these are appropriate only in paintings with clearly defined contours. Because of the general form of the lines rendering them, outlined clouds are called "hook clouds," and they are positioned in the landscape in symbolic layers between heaven and earth. Extreme stylization of clouds is often found in the paintings of the blue-green and gold-line styles, of which more will be said later. It was these stylized types that the Japanese took over and developed to the point of decoration, as in the so-called finger clouds of the Yamato school.

The method of painting clouds by omitting wash produces an airy, light, floating effect. Being a less academic technique, it is typical of the spontaneous style of painting to be discussed in a later chapter.

■ 6 ■ *THE HUMAN FORM* To simplify a complex matter, there are three main categories of Chinese painting classified according to subject matter: landscape painting *(shan-shui hua)*, figure painting *(jen-wu hua)*, and flower painting *(hua-hui hua)*. This study has been devoted almost entirely to landscape painting, which in many cases naturally borders on the other two categories. Among the illustrations are many paintings of figures and flowers. And one can easily see that most of the techniques applied to landscape painting could also be meaningfully excuted for figure and flower painting, whether in modified or pure form.

Often the same terms, or similar or corresponding terms, are used to describe the techniques of figure painting, and we need not list them all here. The importance given to shaping lines *(ts'un)* in landscape painting corresponds to that given to the outlines of clothing *(jen-wu i-wen)* in figure painting. Again scholars have gone to work and named many different kinds of outlines. Both Benjamin March (in *Some Technical Terms of Chinese Painting*) and the Japanese painter Taki Ken (in his book of illustrations called *Gasan)* identify eighteen of these, and Taki gives yet a nineteenth, but leaves this unnumbered to suggest that it is but a variation. Some of these are illustrated in Figs. 54–

69. The following list is arranged in the same order followed by Taki, while March's numbers are added in parentheses:

1) *Kao ku yu ssu miao:* lines like long, waving strands of a spiderweb (262).
2) *Chan pi shui wen miao:* lines like water waves (266), Fig. 59.
3) *Hun miao:* double lines (276), Fig. 68.
4) *Ch'in hsien miao:* lines like lute strings (260).
5) *Chüen t'ou ting miao* or *chüeh t'ou miao:* lines like driven stakes (273).
6) *Kan lan miao:* lines like a series of olive pits (269), Fig. 62.
7) *Hsing lün liu shui miao:* lines like scudding clouds or running water (263), Fig. 55.
8) *Ma huang miao:* lines like wasp bodies (267), Fig. 60.
9) *Liu yeh miao:* lines like willow leaves (264), Fig. 54.
10) *Che lu miao:* lines like broken weeds (271), Fig. 64.
11) *Ts'ao i miao:* garment lines used by Ts'ao Pu-hsing (261), Fig. 56.
12) *Ch'iu yin miao:* lines like angleworms (259), Fig. 57.
13) *K'u ch'ai miao* or *ch'ai pi miao:* lines like pieces of brushwood (275), Fig. 67.
14) *T'ieh hsien miao:* lines like iron wires (270), Fig. 63.
15) *Chu yeh miao:* lines like bamboo leaves (265), Fig. 58.
16) *Chien pi miao:* lines with fewer strokes (274), Fig. 66.
17) *Ting t'ou shu wei miao:* lines like nail heads with rat tails (272), Fig. 65.
18) *Tsao ho miao:* lines like a series of date stones (268), Fig. 61.
Extra) *Lan yeh miao:* lines like orchid leaves, Fig. 69.

The human form in Chinese landscape painting is, where style and expression are concerned, treated as an integral part of the scene. The rules of figure painting apply only in a limited and simplified manner to figures in a landscape. The enormous wealth of stroke varieties for figure painting need therefore concern us here only insofar as they are employed in landscapes. Whether they are perfected in detail or done only sketchily, the style of the figures is supposed to correspond with the style of the landscape as a whole.

A representative group of figures for landscapes is shown in Fig. 70. By such figures the Chinese painter often indicates the subject matter of his composition, which is then emphasized by the inscription that he usually inserts at one side of the picture. But apart from this, the figures in a landscape reflect a certain artistic sensibility which expresses itself through the relating of human figures to the world of nature. The two extreme methods of achieving the desired effect are, first, to confine the figures to insignificance in relation to the overwhelming power of nature (typical of the Sung period); and second, to use figures to humanize the foreground of nature (this was

often done in the Ming and Ch'ing periods). An artist like the Ch'ing-period Shih T'ao used to paint his figures over-large (even those in the far background), while the Sung painter Kuo Hsi said: "Distant people have no eyes," and made his people small or distant.

Figures can also be used to give a more exact definition of the subject. Their clothing can suggest rank or season; their accessories, their jobs or occupations. Their companions indicate the social level to which they belong. Women are less frequently represented in landscape painting than men, for their place is in the home, and they are consequently considered fitter subjects for figure painting. This genre includes a special subgroup called *mei-jen,* or "beautiful women." Outdoor work, such as fishing, woodcutting, portering, or ferrying, is generally done by men. But the closer one approaches a human dwelling, house, or farm, the more likely women are to be depicted in the landscape. Finally, to anticipate here what will be dealt with later, the size of the figures is one of the ways of indicating perspective.

■ 7 ■ COLOR

CHINESE PAINTING IS FUNDAMENTALLY INK PAINTING, which is to say that it is done in shades of black and gray. Even when added, color is simply filled into the ink structure. There is only one single style of painting which is true "color painting"—the boneless painting which has already been mentioned and the discussion of which will continue in a later section. On the whole the Chinese prefer to paint in ink.

This statement suggests a famous anecdote concerning that all-round genius Su Tung-p'o. One evening Su was sitting in his studio. The moonlight fell on the bamboo in front of his house, and its shadows played over the white window paper. Su hurriedly began to copy the shadowy shapes onto a piece of paper with his brush, although he had nothing at hand except red ink. A friend who dropped in just then watched for a while in silence. "Why on earth are you painting the bamboo red?" he at last demanded. "How else should I paint it?" retorted the master. "Why, with black ink, of course," his friend stated with determination.

To the Chinese painter, ink supplies all colors. "Whoever masters the use of ink can paint with it in all five colors," goes a saying. Similar ideas have also been expressed in the West, and Daumier is quoted as having made more or less the same observation (see Lionello Venturi's *Modern Painters,* New York, 1942, p. 169).

Ink, then, is the basis of all painting in China. But there are very many

Chinese paintings which use color. Color helps to produce greater realism, and those schools of painting which aimed at realism tended to emphasize color. The spontaneous style mentioned above generally does without it, but when it turns to color, as in flower paintings, it dispenses with ink altogether. On the other hand, there is an opposing style called *kung pi,* which roughly means the " careful style," and this relies very much on color.

In Fig. 71 the colors and color mixtures shown at the bottom of the sketch are put on over the ink skeleton to disclose their different possibilities. It is only for the purposes of illustration that different ways of applying the colors are demonstrated in one and the same sketch; in actual painting this would usually not be the case. The color squares draw attention to some of the commoner colors and their most frequent mixtures, while in the sketches above them these same colors and mixtures are applied in various ways to ink skeletons.

Whether a Chinese painter applies color or not depends upon several factors. The artist may have planned to use color from the very beginning. Or the painting may appear to demand a finish of color at some stage of its execution. The painter certainly does not always know beforehand whether he is going to produce a painting done with nothing but ink and water, in which case it will be called *shui mo,* or one in which color is added to the ink structure, called *she se.* The color may therefore be more than something merely added to an ink painting: it may be inherent in the original conception of the work, or it may become a necessity during the course of the work. But, with the single exception of boneless painting, the ink always remains as the skeleton on which the rest of the painting is based. This ink skeleton, which the Chinese call "ink bone" *(mo ku)* already has strong painterly elements, thanks to the qualities of the ink and brush: it is painterly (in the sense of colorful) insofar as it does more than simply outline or shape. So the color may only have the effect of intensifying or emphasizing the original structural elements. However, it can do more and can claim an independent pictorial value.

Chinese color painting is a mixture of the water-color technique (which usually implies transparent colors) and the gouache technique (which usually implies opaque colors). Transparent colors predominate for the simple reason that the Chinese painter is reluctant to hide what he considers his real achievement, the ink bone or the ink skeleton.

In Fig. 72 one can see the transparent water color as well as the ink work. Over an ink skeleton which is painted in the splashed-ink style the colors are put in purely as a wash, without pretending to have any independent ex-

istence. The mineral color of umber and the mixed vegetable color of plant green are used to emphasize the realism which has already been outlined in ink.

A large painting in which azurite blue and malachite green are to predominate—but without making it a painting in the blue-green style (see page 116)—is based upon an ink skeleton fairly complete in its details (Fig. 73). The first step is to apply to the inked outlines and shaping lines an umber wash which follows their general design. This wash, however, cannot be considered as a priming, for a priming in the Western sense of the word does not normally occur in Chinese painting. Malachite green is an essential color only in the blue-green style; elsewhere it is merely an auxiliary color.

In parts of Fig. 73 malachite green seems essential because the sparse use of shaping lines calls for the addition of color. First, a light wash of umber brown was applied, and then a layer of herb or plant green was laid on in such a way that the umber predominated in some parts and the green in others. Where shaping lines are plentiful, a transparent plant green is preferable, so that the ink skeleton remains completely visible. If great importance is attached to leaving ink visible, then malachite green is taken from the third layer of the mixing dish. In fact, even the thickest green can be watered down enough to allow the ink to show through.

Distant mountains are normally painted in indigo, though sometimes in umber if this seems more suitable in a particular painting.

Color is employed less for the purpose of producing a realistic portrait of nature than to give variety and a coloristic balance. This is shown clearly by the color treatment of foliage in Fig. 74. Blue and red, yellow and green leaves do not simply reproduce the maple, nor autumn or tropical vegetation; they create a harmony of colors in the foliage of groups of trees. The outlines of leaf and trunk are formed exactly the same way as they would be in pure ink painting, although the double-stroke style is more usual. The importance of the ink structure is demonstrated by the care with which opaque colors are put in without obliterating it.

Ink can quite unmistakably characterize the differences of specific trees, but the use of color seems to stress these differences (Fig. 75). The leaves of the wu-t'ung tree owe their unique character to the opaque emerald color of malachite green. Willow, pine, and cedar each come to life in their various shades of plant green. The trunks are individualized by umber or indigo washes.

A special group of styles in which indigo is the main color is called the "indigo style," as illustrated in Fig. 76. Here a very light wash of umber was

first laid over the finished ink structure, in parts being replaced by an indigo wash. Sky and water were then lightly washed in with indigo. The control of color, which is very important in this technique, is often achieved by using a small piece of unsized paper as a blotter to absorb any surplus or excessive color at the painter's judgment. The path, the boat, and the human face were tinted with a mixture of umber and ink. And finally, to complete the increasing dominance of indigo, the whole picture was given a very delicate wash of indigo.

These same techniques are also applicable to flower painting, though with modifications. Wang Fang-chuen, in his book *Chinese Freehand Flower Painting,* published in 1936, names four main kinds of flower painting:

1) Painted in ink, without color.
2) Painted in ink outlines, with colors filled in.
3) Painted in color from the beginning, without ink contours.
4) Painted in the "flying white" method.

Actually flying white (see page 120) is not a separate method, but one of several techniques. It should really be included under the first category if painted only with ink, or under the third if executed only with color. The first and third categories employ the technique of boneless painting (see page 112) with a tendency toward the spontaneous style. In the second category, on the other hand, the careful style is obviously involved.

Undoubtedly the commonest kind of flower painting is that done in color only, without outlines. Yün Shou-p'ing painted in this manner, and in our own times Ch'i Pai-shih developed this method to a very high artistic level.

CHAPTER ▪ III ▪ *THE TECHNIQUES AND PRINCIPLES OF CHINESE PAINTING*

▪ 1 ▪ *THE SIX PRINCIPLES OF HSIEH HO*

THE "SIX PRINCIPLES OF HSIEH HO" have already been mentioned, but they must now be considered in more detail. Hsieh Ho lived during the Southern Ch'i dynasty (479–501) in Nanking. He is said to be the author of the essay *Ku-hua p'in-lu* (Notes on the Classification of Old Paintings), in which the six principles were first set forth. During the course of centuries, these principles have been subject to many different interpretations and recently to many translations into Western languages. These translations differ even more than the various Chinese interpretations, as may be seen from the following tabulation, which quotes several leading translations in the following order:

1) Osvald Sirén: *Early Chinese Painting,* Vol. 1, p. 32.
2) Herbert A. Giles: *Introduction to the History of Chinese Pictorial Art,* p. 29.
3) Friedrich Hirth: *Scraps from a Collector's Notebook,* p. 58.
4) Raphael Petrucci: *Philosophie de la Nature dans l'Art de l'Extreme Orient,* p. 89.
5) Taki Seiichi: in *Kokka,* No. 244.

6) Laurence Binyon: *The Flight of the Dragon,* p. 12.
7) Benjamin March: "Linear Perspective in Chinese Painting," *Eastern Art,* 1931, p. 131.

FIRST PRINCIPLE

1) Resonance of the spirit; Movement of Life.
2) Rhythmic Vitality.
3) Spiritual Element, Life's Motion.
4) La consonance de l'ésprit engendre le mouvement (de la vie).
5) Spiritual Tone and Life-movement.
6) Rhythmic Vitality, or Spiritual Rhythm expressed in the movement of life.
7) A picture should be inspired and possess life itself.

SECOND PRINCIPLE

1) Bone Manner (i.e., Structural) Use of the Brush.
2) Anatomical structure.
3) Skeleton-drawing with the brush.
4) La loi des os au moyen du pinceau.
5) Manner of brushwork in drawing lines.
6) The art of rendering the bones or anatomical structure by means of the brush.
7) The framework should be calligraphically established.

THIRD PRINCIPLE

1) Conform with the Objects (to obtain) their Likeness.
2) Conformity with nature.
3) Correctness of outlines.
4) La forme représentée dans la conformité avec les êtres.
5) Form in its relation to the objects.
6) The drawing of forms which answer the natural forms.
7) In drawing the forms of things one should confirm to their natural proportions.

FOURTH PRINCIPLE

1) According to the Species, apply the Colours.
2) Suitability of colouring.
3) The Colouring to correspond to nature of object.

4) Selon la similitude (des objets) distribuer la couleur.
5) Choice of color appropriate to the objects.
6) Appropriate distribution of the colors.
7) Color should be applied in accordance with the nature of the subject.

FIFTH PRINCIPLE

1) Plan and Design; Place and Position (Composition).
2) Artistic composition.
3) The correct division of space.
4) Disposer les lignes et leur attribuer leur place hiérarchique.
5) Composition and grouping.
6) Composition and subordination, or grouping according to the hierarchy of things.
7) In planning the composition one should observe consistency and propriety in the realization of things.

SIXTH PRINCIPLE

1) To transmit Models by Drawing.
2) Finish.
3) Copying Models.
4) Propager les formes en les faisant passer dans le dessin.
5) The copying of classic masterpieces.
6) The transmission of classic models.
7) The drawing should be guided by former masters.

These contrasting translations, all of which are rather general and even obscure, reveal how difficult it is to find a reliable and valid interpretation of Hsieh Ho's six principles. The problem lies, of course, in the terseness of the original Chinese, where each principle is stated in but four characters. For example, the important first principle reads *Ch'i yün sheng tung,* and the literal but well-nigh meaningless translation is "spirit rhythm life movement" or "spiritual rhythmical living moving." A multitude of other versions would be possible, depending on which meanings and nuances of the characters one chooses. Or one could equally well combine the translated versions quoted above into a single general statement for each principle—still without closing in on the heart of the matter.

But to pursue this enigma any further would lead beyond the scope of this book and the knowledge of the present author. Suffice it to say, then, that each period of Chinese painting has its own special way of interpreting the

six principles. Despite such differences in interpretation, it must be stressed that these principles are mentioned frequently in Chinese writing on art, being taken very seriously as ideals toward which a painter should strive. Western writers on Chinese art, also, have seriously endeavored to extract some guidance from these principles, or canons as they are often called, in the interpretation of Chinese painting. Many of the individual canons, particularly the first, have been the subject of independent essays. It is likely, however, that a certain obscurity will always remain, since their idealistic blurriness seems to defy clear definition and translation. Numerous Western authors have dealt with them and discovered that their application is fluid, varying according to period and artist.

∎ *2* ∎ *BONELESS PAINTING* SEVERAL REFERENCES HAVE ALREADY been made to boneless painting *mo ku hua*. It is the only style of Chinese painting which bears any significant resemblance to the techniques of Western painting: it is the only one which is painted in color in the real sense of the word painting; only colors are used, and the important element of the ink bone is dispensed with. It is, then, color painting, not ink painting.

Here we are speaking of whole and complete paintings in this boneless technique. It should be noted that the expression "boneless" painting is sometimes also used to describe a technique of ink painting in which ink is applied without outlines in the shape of splashes and planes, thus somewhat resembling the splashed-ink technique (see page 118). In such cases ink is not used to form an ink bone by creating spaces which can thereafter be overlaid with color or other shades of ink, but on the contrary is used to make color unnecessary.

Although not completely apt, there is an analogy from Western painting that may help to explain how in Chinese painting even ink can be used in a boneless manner. The relation between an ink-bone painting and a boneless ink painting is somewhat like that between a drawing which has been over-painted in color and a pure water color without any preliminary sketch. Now, supposing that the Western painter were to use brush and ink instead of a pencil for the preliminary sketch, applying it broadly to create planes rather than just outlines and not covering the sketch with color, then in Chinese terminology he would be painting in the boneless way.

The usual implication of the term boneless painting is that no ink at all is

used to establish the painting's skeletal structure, which is to say there is no ink bone. The painting may or may not contain a linear framework even complete with outlines and shaping lines; these latter not being classified as bone or skeleton, the painting is still considered boneless as long as nothing but color is used. Thus Fig. 77A is not boneless, for color has been added to an ink skeleton. Fig. 77B, on the other hand, is boneless: over a layer of color which outlines its general shape a second darker layer has been added to delineate the tree.

The boneless rock of 77C is outlined in herb or plant green; the skeletal or shaping lines of malachite green and umber have been applied over a lighter layer of the same colors. The technique of the small tree of 77D is particularly obvious: it is really "painted" in the Western sense of the word. And the mountain and clouds of 77E-F are also boneless; their main color is malachite green, and the umber structure has been added on top of the green, thus reversing the process of ink painting, in which the structure is first created.

Again we note the similarity between the boneless style and Western painting. Even the usual order of working is often abandoned, and outlines and shaping lines may well follow rather than precede the preliminary wash. This is "painting" in our sense of the word.

The painter P'u Ch'üan, whom we have to thank for most of our examples, has put forward an interesting theory about the origin of this boneless style. Although it somewhat anticipates our discussion, in the following section, of the gold-line and broken-ink styles, it can be more logically dealt with here. P'u's theory is that boneless painting developed mainly from the gold-line technique of the T'ang period, the time when this technique was at its height, and that it, like the gold-line technique, was a kind of opposition to the broken-ink style. The gold-line style actually obliterates the ink bone to a certain degree by using opaque colors, thereby giving the impression of "true" painting without an ink bone. Thus boneless painting only carried the technique a step further, actually dispensing with the ink bone which the gold-line style had already practically made invisible.

But the apparent similarity is probably more one of outward impression than of reality. As the history of Chinese painting discloses, at least in landscape painting the boneless technique never rose from the level of an unimportant variant; by and large the Chinese painters preferred to retain the ink bone even though it might be invisible. In the next section we shall discuss how this tendency to escape the strongly linear style and find more painterly modes of expression was also manifested in the realm of pure ink painting.

Whether P'u's theory is correct or not, it nevertheless serves to suggest that boneless painting provides a bridge of understanding between the gold-line style, which retained strongly linear elements, and the broken-ink style, which tended to do away with pure line in favor of splashes and planes, to become, in short, more painterly.

Although, as noted above, boneless landscape painting is rather rare, the boneless style is very much used in flower painting. Thus we find the same boneless style of flower painting by the seventeenth-century painter Yün Shou-p'ing as by Ch'i Pai-shih, who died in 1957 at the age of nearly a hundred.

■ *3* ■ *GOLD-LINE AND BROKEN-INK STYLES*

■ NORTHERN AND SOUTHERN SCHOOLS. In Chinese one of the synonyms for painting is *chuan chih,* meaning the art of the "rounded and straight." Rounded (or bent) and straight lines create the spaces within which the tones and shades of ink or color have a chance to thrive and develop. But the life of a picture may begin even earlier, within the line itself, which may go far beyond being merely a fine hairline to become a spatial phenomenon possessing a texture and character of its very own.

In 1915 the Swiss art historian Heinrich Wölfflin published his *Kunstgeschichtliche Grundbegriffe* (Basic Principles in the History of Art). In it he provided a terminology which art critics have found most convenient. It distinguished between the linear and the painterly *(malerisch)* as opposite forms of expression in painting, or even in sculpture for that matter. Since these terms are used frequently in this book, it may be worthwhile to quote a few of Wölfflin's remarks concerning them:

> In the case of the linear, the contour is running around the form in continuity and equivalence on a track to which the observer can trustfully leave himself; in the case of the painterly, however, it is the dark and the light that govern the picture, not quite without boundaries but without a stress on them. . . . As soon as the line has been devaluated in its capacity to delineate boundaries, the painterly possibilities are beginning. . . . The difference between the two styles can furthermore be defined by saying that the linear way of seeing differentiates clearly between form and form, while the painterly eye aims at the movement which concerns the whole of things. There, equally clear lines, which have the effect of separation; here, unstressed bound-

aries, which favor the connections. . . . The linear style is one which gives the definite feeling of plasticity. The equally clear and definite delineation of objects gives the observer a feeling of security, as though he could actually touch the objects with his fingers, and all modeling shadows follow the forms so completely as to actually challenge the sense of touch. The painterly style, however, has more or less renounced things, objects as they really are. Here there is no longer any continuous contour, and the touchable planes have been destroyed. A series of splashes or planes have been put side by side in seeming discontinuity. Drawing and modeling are no longer identical with the plastic objects of form in a geometrical sense, but only give the optical appearance of things. . . .

Now, though without being named or consciously applied, this same concept of linear *versus* painterly was also developed in China. The linear style may be identified with the so-called Northern school, which is the more academic in approach and favors the use of color; while the painterly style belongs to the Southern school, which is freer and prefers to work in nothing but ink.

The dividing of Chinese painting into the two grand categories of the Northern and the Southern schools is a relatively late concept, having first been put forward by the scholar-painters Tung Ch'i-ch'ang and Mo Shih-lung in the late sixteenth century. Although a distinction of doubtful value, it is so frequently encountered in Chinese art criticism as to deserve some discussion. It led to numerous disputes and misunderstandings in China itself, and its adoption into Japan greatly intensified the initial problem, calling for additional explanations and producing new misunderstandings in their wake.

The primary distinction arose from Buddhist philosophy, specifically from a schism in the Ch'an (Zen) sect, and it is quite useless to try to explain it on a geographical basis, as the terms Northern and Southern would seem to suggest. The geographical explanation has often been attempted, and as a result the entire issue has become confused. Hence we detect Northern artists painting in the so-called Southern style, and vice versa. On the other hand, landscapes showing Northern scenes are felt to be Southern in spirit. And the oeuvre of almost any painter will be found to contain some works which later generations have classified as Southern and others which have been called Northern.

Actually, the distinction as originally made by Tung Ch'i-ch'ang had nothing whatsoever to do with geography. It was an effort to point out two big stylistic trends which had long existed in Chinese painting, but unfortunately this worthwhile intention seems to have become mingled in Tung's

mind with a need to pass value judgments of a very personal and meaning-less kind. Being a scholar-painter himself, he was convinced that literary painting was the only true art, and he identified it with the so-called Southern school of Zen, which believed in sudden and spontaneous revelations in con-tradistinction to the gradual revelation of the Northern school of Zen, which aimed at its goals through exercise, effort, and work. Adopting the Buddhist terms, he searched about in the history of Chinese art to find painters whom he considered worthy of the accolade of belonging to the Southern school—painters who were, up to a point, also scholars and statesmen and poets, men to fit the measure of the exemplar Wang Wei.

Having thus devised the term Southern for painters of whom he approved, Tung classified all the others as Northern. He would have no connection with the Northern school, being convinced that it was inferior in taste, that few men of culture could possibly adhere to it, and that its members were men who showed their lack of culture by being interested in nothing except pure painting. It may be assumed, then, that Tung preferred badly painted pictures by men of good taste to well painted pictures by painters who were not also great scholars. The very fact that Tung, applying his scholarly cri-teria, relegated such masters as Li Ssu-hsün, Hsia Kuei, Kuo Hsi, Ma Yüan, and Ma Lin to his Northern limbo shows how little bearing his distinction actually had on artistic excellence.

■ THE GOLD-LINE AND THE BLUE-GREEN STYLES. Leaving aside the personal value judgments which Tung Ch'i-ch'ang was expressing with his Northern and Southern categories, this distinction is nevertheless of interest from the point of view of technique, pointing as it does to two divergent trends in Chinese painting. The basic technical difference between the Northern and Southern schools in this context is identical with that between the gold-line style and the broken-ink style. What this means, exactly, is seen at is simplest and clearest in Fig. 78.

In the Northern style of painting, the most important technical aspect was the use of a relatively pointed, perpendicular brush. This produced outlines of such sharpness that the resulting planes somehow demanded to be filled in with color. And its frequent use of heavily accentuated shaping lines—for example, those like the cuts of a big or a small axe—seemed to require softening with color. In seeking to meet these color challenges, such artists as Li Ssu-hsün often used very thick opaque azurite blue and malachite green to fill in or soften the ink structure, thereby producing the style that came to be known as blue-green.

The use of these heavy blues and greens often partially or completely obliterated the underlying ink skeleton or ink bone. But the ink bone was still considered essential and, although the blue-green style in its original form, with some of the ink bone still showing through, continued to be applied, many masters came to trace gold lines over the invisible ink lines, thus creating the so-called gold-line style.

In Fig. 78A the gold-line style is seen in its barest form, having been left as a pure line structure without any color added for purposes of demonstrating the principle. In actuality there would be first an ink bone, then concealing layers of blue and green, and finally the gold lines seen here. And these gold lines would correspond very closely in their design to the underlying ink bone. Thus there is no great difference between the blue-green and the gold-line styles, the gold lines only emphasizing the ink skeleton by repeating it over the colors in a way more or less identical with the skeleton. Since this stress of the ink bone by gold lines, this love of reminding the viewer that there *is* a linear system under the color, seems to characterize the linear style of Chinese painting more than any other technique, the term gold-line style has been adopted to describe the entire tendency.

Fig. 79 again demonstrates how practically identical the gold-line and the blue-green styles are. This painting is in the blue-green style in that opaque azurite blue and malachite green have been applied in such a way as to conceal large and important portions of the underlying ink structure. Then it becomes an example of the gold-line style because the painter added a linear structure of gold lines over the color, repeating in general the linear structure of the original ink bone. One could even say that the gold line is the symbol of the painter's great love for his ink bone, which he cannot bear to have disappear completely. It should be pointed out again, however, that such paintings as these are not to be classified as boneless color paintings; here the blue and green are used only as required by the basic ink skeleton, filling in planes in accordance with the shapes created by the ink lines and then covering the lines with opaque tints. The colors necessary to complete the design and the structure of the ink bone are in reality only additions to the ink, even though they often have the effect of concealing the ink. In some sections of this painting, particularly in the foreground, the ink skeleton becomes quite apparent. The linear ink structure remains visible, for instance, along the borders of the river. The ink skeleton was probably done very sparingly because the artist intended from the beginning to cover it with opaque colors. The ink bone underlying the high mountains in the middle-ground and background was certainly only linear in composition, whereas

in some sections nearer the foreground, where the colors were to be left transparent, the linear outlines have been complemented with shaping lines as well.

■ BROKEN INK. It was probably soon after the development of the gold-line style that a new and revolutionary trend came into being—a trend which in sequence was to characterize the Southern school. This was the creation of the illusion of color, without actually using any color, by "breaking up" the ink lines when producing the ink bone. Such "broken ink," as the technique soon came to be called, consisted of simply opening up the line, sometimes even leaving white spaces within it. The pure line, which had prevailed until then, is executed by making the line completely black, maintaining a fair degree of uniformity of thickness, and covering the entire thickness of the line with the same shade of ink, preferably the blacker the better. Now, in breaking the ink, the line itself was given texture by a broad use of the brush, by not keeping all sections of a line the same tone, by making the line less linear. This, in short, is precisely what Wölfflin calls the painterly style.

Referring again to Fig. 78 one notes that whereas the first sketch is obviously linear in execution, the lines in the second sketch have been broken up into all sorts of shades and forms practically to the point of abandoning lines altogether.

Certainly, the breaking of the ink was an expression of the artistic outline of late T'ang times, when the technique seems first to have been used. It meant a discovery of the fact that it was possible to paint in a painterly way without using color, a reaction against the "colorful" blue-green and gold-line styles. And it is significant that Chang Yen-yüan, who lived during the early Sung period, was probably the first to say that a correct use of ink could produce "all the five colors," implying that, by using ink in a painterly way, one can create the illusion of reproducing the entire color spectrum.

■ SPLASHED INK. Considerable confusion has arisen in the West from the fact that, although the Chinese character for "broken" is entirely different from the one for "splashed" or "spilled" and is pronounced with another intonation, both are transcribed in our alphabet as p'o. Thus both "broken ink" and "splashed ink" become p'o mo. A further source of misconception for Western artists following the lead of Japanese art critics lies in the fact that the Japanese, although possessing clearly differentiated words for the two processes—haboku for broken ink and hatsuboku for splashed ink—have tended to use the terms interchangeably.

Actually, broken ink describes a basic principle of painting by means of which styles and schools can be identified, while splashed ink describes only the one technique of breaking the ink—admittedly a most interesting and important one. It is this distinction that the Japanese have tended to overlook, using the term broken ink in the sense of a style or technique rather than of a principle. For example, one of the most famous Sesshū landscapes, containing big-axe cuts, is generally called the "Haboku Landscape" (Fig. 107), meaning a broken-ink landscape. From the Chinese point of view, however, this would be classified as a splashed-ink landscape because its shaping lines belong to the splashed-ink technique. Recently some Japanese critics appear to be coming around to the Chinese view and have begun calling this painting the "Hatsuboku Landscape."

Strictly speaking, it is of course not wrong to call the famous Sesshū landscape a broken-ink painting, but neither is it very helpful, since many Japanese paintings, and almost all Sesshū's work, do in fact "break" the ink. The important thing to remember is that broken ink stands for a large category, while splashed ink marks a subcategory within the broken-ink style. For example, the sketches of a blossom and a rock formation seen in Figs. 80–81 fall within the general category of broken ink and are rendered specifically in the splashed-ink technique. The same conditions characterize the Sesshū landscape.

Figs. 82–86 illustrate the progressive stages of obtaining the splashed-ink effect of Fig. 81. For this technique, the brush is usually held at a slant and handled with broad and forceful movements. Thereby the distinction between outlines and shaping lines practically dissolves, and the following wash is then employed with the same bold-sweeping treatment. It is a technique which leaps and links, which simplifies and abstracts, and which relinquishes the patient and plodding circumscribing to go straight to the center of things. The technique of splashed ink forces into spontaneous expression what is really inexpressible, and in this respect it comes very close to the abstract painting of our own time. It has been especially popular with literary painters, who in their drive for immediacy and individuality of expression have favored its simplification of forms.

The splashed-ink technique is used in many types of Chinese painting, and in many ways. The sketches shown in Fig. 87 suggest but three of its many possibilities. The little man with a stick over his shoulder is the result of a kind of daubing, in which an accidental ink blot has been made meaningful by a few deft touches of the brush. The donkey, on the other hand, was fully conceived from the beginning and executed by first applying deliberate shap-

ing with splashed blots of ink and then completing them with a few outlining brush strokes. The large mass at the right is a mountain rendered in the splashed-ink technique. None of the shaping lines that we have mentioned are to be found here. Outlines and shaping elements are a unity. Hence the splashed-ink technique could in a way be described as a short cut with a strong abstractionist tendency. It should also be noted that this technique can be executed in many different manners, as will be seen when studying the methods of different painters.

■ FLYING WHITE. The principle of broken ink can be applied in many variations, with each painter dissolving his lines as best suits his intentions. A few of the more important methods have been given names, such as the splashed-ink technique we have just discussed and the flying-white *(fei po)* technique to which we now turn our attention. A similar technique is known to Western painters, though it has remained unlabeled. In China it has developed, together with splashed ink, into one of the commonest painting techniques.

The basic flying-white technique is illustrated in Figs. 88–89, with the photographs in Figs. 90–92 demonstrating how the branch was produced. The brush is held and moved in such a way that the hairs do not consistently touch the painting surface, thus leaving white streaks within the black strokes. These streaks are accomplished, as it were, by the swift flight of the brush over the painting surface. This technique was probably first used in the painting of bamboo, but it may well have existed in calligraphy and have been applied there even earlier than it was used in art. In both its calligraphic and its artistic employment, its introduction represents the beginning of a free painterly element in brushwork: the lines are broken and the brush stroke acquires an inner life and texture unattainable with unbroken ink.

The roughness of the paper or silk surface, combined with the flying movement of the brush over it, opens the delicate brush to create such streaks as give the line its vivid inner structure and texture. This technique, probably descending (as noted before) from calligraphy through bamboo painting to landscape painting, also takes an important place in figure painting, where the graceful sweep of the flying white creates many of the contours.

A variant of the basic flying-white technique is illustrated in Figs. 93–96 showing how it was produced. Here the brush is rolled between the fingers as it moves over the painting surface, producing a rounded effect that is well suited to the painting of many kinds of mountains and rock. It was a favored technique of such painters as Pa-ta Shan-jen.

The tender, graceful little tree in Fig. 97 was created in a matter of seconds

by P'u Ch'üan's brush. Its original purpose was to demonstrate how a given space can be filled artistically by the interplay of branches and twigs, by the pattern of forward and yielding movements of the various elements of the picture. But in a detail from this same sketch, enlarged in Fig. 98, the flying-white technique has become especially clear, and one can see how delicately the ink is controlled by the swiftly moving brush.

The inscription by a Chinese Mohammedan (Fig. 99) shows how flying white can be used in calligraphy. The religious invocation *Bismillah Errahman* in Arabic characters is executed in a very flowing manner, both decorative and painterly.

■ TWO EXAMPLES ANALYZED. Having thus gained some insight into broken ink, splashed ink, and flying white, we can apply our knowledge to two specific examples. Fig. 100 shows a painting of uncertain attribution. Whatever its date, it certainly exhibits a very forceful use of broken-ink principles, which, as we have seen, are traditionally attributed to Wang Wei. Whether Wang was actually the first painter to "break the ink" is a matter of little importance; it was undoubtedly during the T'ang period, and within his time, that Chinese artists acquired this method of coaxing fresh possibilities out of ink. in all likelihood the technique was typical of the period rather than of a single painter, and Wang was presumably but one of many painters who as a group discovered and worked out these rich new potentialities. The waterfall painting, however—at least in the version which has come down to us—can hardly be ascribed to Wang Wei and the T'ang period, for the plain reason that it uses the splashed-ink technique in its big-axe cut shaping lines, and such technique was almost unknown until Sung times. Although one can understand why the strong broken-ink effect of the painting should have led to the Wang Wei attribution, this one technical detail must convince us that it cannot be his work.

Turning to another painting attributed to Wang Wei, the winter landscape of Fig. 101, we find that on the basis of the technical evidence this one, in all probability (if without proof), seems much more typical of Wang's style than the waterfall painting. Original and unquestionably genuine T'ang paintings are extremely rare, and this makes it difficult to speak with any certainty about their techniques. Since it can be assumed that broken ink was then still in its infancy, though there undoubtedly existed a tendency to escape from the domination of the sharp line, the very fact that the revolutionary technique of broken ink is less evident in this winter landscape than in the waterfall painting seems to link it more closely with Wang Wei.

Nevertheless, faint though it may be, the broken-ink principle is traceable in the winter landscape. It shows very obviously in the broadening of the lines shaping the mountains and in the outlines of the trees, which are too broad to be purely linear. Compared with the technique seen in other T'ang paintings, this almost insignificant broadening of the brush stroke and the softness of the lines represent a radical departure from the hard line of the ink structure in the blue-green and gold-line styles.

■ WATERED SHAPING LINES. A certain technique that developed out of splashed ink is worth noting. It is the so-called watered shaping line *(shui ts'un),* illustrated in Fig. 102. Here two brushes are held in the hand at the same time, one containing ink and the other only water. The brushes are alternated in such a manner that the ink brush first outlines the general structure with broad strokes, rather in the splashed-ink manner, and then the water brush works into the still-wet ink, smudging it out into tones and washes, and softening it, varying the light and dark in it until the final shaping has been achieved.

This is an extremely difficult technique and has been mastered by only a few. Its employment always entails the danger of a flabby and shapeless blurring. Fig. 103 shows how the two brushes are held in one hand. The water brush is rolled rapidly between the painting fingers, and in the process the ink brush is pushed away. The same double-brush technique is also used for certain kinds of wash.

An interesting aspect of the watered shaping line is that, in a way, it anticipated two techniques which the Japanese were to perfect. The first of these is the *tarashi-komi* or "dripping" technique brought to perfection by Japanese masters like Sōtatsu and Kōrin. Here the still-wet background, done either in ink or in color, is worked over with color by allowing the wet color to drip from the brush onto the painting. Thus, in contrast to the Chinese painter, who never allows his painting materials to take control, the final shaping of the painting is left to the chance of dripping colors. In the technique of watered shaping lines the water brush determinedly works into the inked strokes to alter their value, while for *tarashi-komi* the second brush actually never touches the painting but leaves the dripped-on color to produce its own random shapings.

This *tarashi-komi* effect is seen quite clearly in Fig. 104, a detail from Kōrins's plum-blossom screen. The Japanese name literally means "dropping" or "dripping," and this is precisely what has happened here. The painter has let drops of color drip onto the still-wet base of ink and color, and

these drops have then been sucked outward into the surrounding areas. The brush did nothing except drop the ink. Such surrendering of control by the painter happens very rarely in Chinese art.

The second Japanese technique is that called *nijimi,* literally "blotting" or "blurring," which is to say letting ink run. It has been developed in Japan from a model that in China never rose above a weakly suggested potentiality and is characteristic of the modern spirit in Japanese painting. This technique is employable on unsized paper only and again involves a strong element of chance. In *nijimi,* the brush is filled with more ink than the paper can absorb in making a clearly defined brush stroke. Or alternatively, the brush stroke is performed so slowly that the paper has time to suck the brush dry. Thus, as seen in Fig. 105, the ink spreads out beyond the actual brush trace, rather as it would on blotting paper. The amount of the running varies with the quality of the paper, the quantity of ink on the brush, and the speed of the stroke.

Both the *tarashi-komi* and the *nijimi* techniques, though centuries older, inevitably bring to mind the methods of the Tâchists, that group of modern "action painters" centering around the American Jackson Pollock and the German W. Schulze who seek to express unconscious movements directly or automatically in spots and blobs of color by renouncing any influencing of the brush to create forms consciously. And one may also note hints of the *nijimi* effect in many paintings by Pa-ta Shan-jen, among others, and in the modern painter Li K'o-jan (Figs. 205 and 248).

■ MORE EXAMPLES OF BROKEN INK. To conclude our chapter on broken ink, four examples are given to show the rich possibilities of the three principal broken-ink techniques that have been discussed—splashed ink, flying white, and watered shaping lines. It would be advisable to compare these broken-ink examples with such examples of the Northern or gold-line style as in Figs. 14, 78–79, 117, 133, 167, 174, 177, 179, 184, 251, 263–64, 280, and the like.

In the landscape of Fig. 106, by Ying Yü-chien, ink and water together have created that wonderful atmosphere of airy vastness and distance that makes Chinese painting so attractive. Note how clearly the ink has been broken in this painting. There are very few lines as such left, for example in the houses and figures. Although lines are still visible in the bridge in the foreground, they have been opened up to attain an inner texture and hence can no longer be called lines in the strict sense of the word. The foreground rocks are in splashed ink, while the splashes representing trees around the roofs of houses or temples approach the abstract. But even though their

foliage consists of general and hardly recognizable forms, they still retain the mood of "trees." Finally the distant mountains are done in a mixture of splashes and washes remarkable in Sung times.

In Fig. 107, his famous "Hatsuboku Landscape," Sesshū uses the same technique as Ying, though with modifications that are typically his own. This is one of Sesshū's most remarkable achievements, particularly since everything in it suggests that it was done in the "Southern" manner, whereas most of his work belongs to the "Northern" school—further proof of the unhelpful nature of this distinction between Northern and Southern, a distinction that is disregarded by the masters anyway. Here again, as was the case in the preceding example, the line has practically disappeared, being retained only faintly in the roofs, the sign pole, and the boat. The rest is vigorously splashed on but, with all its simplification, still remains recognizable as rock and tree and mountain. In both paintings the art of omission reaches great heights. Perhaps the Sesshū has more vigor and contrasts than the Ying, but both are of great purity in style and sentiment.

In Fig. 108 we find that a hundred years after Sesshū, the Japanese Kanō Naonobu was still using this splashed-ink technique. There is no doubt that the technique here, though brilliant, is essentially coarser than it was in the Chinese example of a Ying painting. It is interesting to observe that in Naonobu's work the broad, planelike, heavy-ink areas painted with a splayed brush have spread into a kind of flying white; in other words, we have here a mixture of techniques. Such mixtures, often found in Chinese painting too, demonstrate the degree of freedom which a master painter can reach while remaining faithful to the principles of his art.

Finally, Fig. 109 is a small landscape by P'u Ch'üan in the same broken-ink techniques. There is something very intimate and lovable about it, the splashed ink being used with great mastery and remarkable reticence. Here P'u is not pushing abstraction as far as Ying or Sesshū; he retains more linear elements, as in the temple and the mountain outlines. But the ink is broken, and the splashed-ink technique predominates in such crucial areas as the hillock in front of the temple, the large tree in the right foreground, and the mountain in the right background. In the foreground rock the ink is not only broken by the splashed-ink method but also by a soft unlinear use of the brush, thereby giving the rock shape without the use of any definite lines. The splashing has been done with a very wet brush, and even the grays have been applied very wet.

■ *4* ■ *PERSPECTIVE* THE PAINTER BUILDS UP HIS PAINTING STAGE
by stage. Field and mountain, bush and tree, water and clouds grow into a single whole. At the same time he is faced with the task of giving the landscape its proper proportions, of setting together in a convincing relationship all the visible elements. This is the point at which the artist has to think about perspective.

We know that the impact of perspective was grasped early in the general history of painting, even if at first the artistic means of its expression were rather primitive. The earliest attempts consisted simply of placing objects and people one above the other, the near items below, the more distant ones above. Later, painters occasionally risked placing one element behind the other in an overlap. Finally, the collective intellect of art came to realize that, to the eye, objects in the distance appeared smaller than things near at hand and that things near at hand were sharply visible while things farther off became indistinct and lost detail. This last concept of perspective was well expressed by the Sung painter Kuo Hsi in his treatise on painting, when he said: "Distant people have no eyes."

Perspective is the means by which three-dimensional space is projected onto a two-dimensional surface. For depth to appear on a flat surface is an optical illusion. There are three main ways of producing this illusion. First, one can make similar objects diminish in size as they retreat into the background. Second, one can gradually bring together the retreating straight and visible lines of objects and buildings which are known to be parallel in reality. Third, one can make objects and people increasingly indistinct as the distance increases.

The first two of these methods are closely related, for the lines, in the first case invisible and in the second case visible, draw together in the distance. If in the second case the lines all converge on a common point, we then have central perspective. The concept of central perspective was not recognized in Europe until as late as the Renaissance, and Chinese traditional art has done without it even to this day (apart from a few exceptions still to be mentioned). Thus only two of these three methods are known in Chinese painting: the invisible linear perspective of the first method and the atmospheric or aerial perspective of the third. Chinese art took only the most tentative of steps along the road leading to central perspective; that is, to linear perspective converging on one central point. It developed a modified perspective of visible lines in which rectangular shapes known to contain parallels are allowed to narrow slightly into the distance, though not so markedly as they

in fact appear to do, nor as the rules of central perspective demand. Apart from this tendency, however, the lines of Chinese art run into the distance quite independently of each other, for Chinese painting does not normally require a point of convergency.

Fig. 110 will help us to understand these distinctions between Western and Chinese perspective. Note, for example, how the lines of 110D seem to run apart (even though they are actually parallel) when compared with the lines of 110c. The two groups at the bottom of the sketch illustrate three traditional Chinese ways of creating the illusion of depth: making the more distant trees smaller, making the forms less detailed, and decreasing visibility by painting more distant trees in a paler tone. All three ways are of course also known in the West; the first two are methods of aerial perspective in which invisible lines run together in the distance, while the third is another kind of contraction, a contraction of visibility.

The lack of central perspective in traditional Chinese painting is not entirely a weakness. It certainly makes a painting seem strange to the Western observer, and many Westerners sneer at the apparent naïveté of the Chinese artist in not realizing that parallel lines meet at a point in the distance. But, as it is, this neglect of the point of convergence frees Chinese painting from the restrictions of the eye's logic. Whether one accepts or rejects this particular license, whether one finds it attractive or disturbing, good or bad in one's own system of values, is of no importance. As a matter of fact, this peculiar Chinese attitude towards perspective is one of the reasons why a Chinese painting needs no frame, why in fact a frame generally spoils its effect. The perspective and the composition together make up its special attractiveness. Because there is no focal point, the whole painting is open to the observer, almost inviting him to walk in and look around. Every part of the painting asks to be understood, and can be understood, from a different angle of vision. The looseness of the perspective is more than compensated for by the very tightly drawn web of the composition which holds the parts together.

Although dispensing with central perspective, Chinese painting has nevertheless adopted one of its adjuncts—that of maintaining a consistent "point of view," of being able to stipulate that the viewer of a painting is positioned at such and such an imaginary spot and observing the scene from within that total perspective, visible and invisible, which has been created. And here again the Chinese, with their love for system, have classified the points of view into three main categories.

The first point of view, shown in Fig. 111, is called the "level distance" (p'ing yüan). It designates a perspective arrangement in which the spectator

seems to be looking down from a high vantage point at a landscape stretching away into the distance.

"Deep distance" *(shen yüan)* is a perspective arrangement in which one seems to look not so much down upon as deep into the landscape. This is considered to be the most difficult viewpoint of the three, because in it the illusion of depth is extremely important. Fig. 112 illustrates this viewpoint and at the same time clearly demonstrates the two Chinese methods of producing the illusion of perspective. There is invisible linear perspective in the diminishing of relative sizes, as well as atmospheric perspective in the diminishing of visibility.

"High distance" *(kao yüan)* is seen in Fig. 113. Here the eye is forced to look upward, its upward movement being guided by the dimensions and the lines of the painting.

But whether one looks downward, upward, or into a Chinese landscape painting, the same traditional principles of perspective and composition are valid. It may of course happen that more than one of the points of view, or even all three, are used in one and the same painting. But whatever the circumstances, the unity of the painting remains—a unity founded on principles of composition which will shortly be discussed.

At this point it may be useful to consider a few specific illustrations in relation to their perspective. Fig. 114 is a typically Chinese genre painting showing streets and houses, painted in such a way that one looks down into the scene from above; to give the point of view its proper name, it is of the level-distance type. The retreating lines in the painting give the impression of running apart in the distance, but a careful measurement shows that they either run parallel or even converge slightly. The first impression of diverging lines is due to the fact that we are accustomed to central perspective.

Fig. 115 provides an example of the occasional attempts made, under the influence of Western painting, to introduce the concept of central perspective into Chinese painting. This is one of the woodcuts illustrating a famous book on the cultivation of rice and silkworms, *Keng Chih T'u,* by Chiao Ping-chen, who worked in the Imperial Astronomical Observatory during the time of the Emperor K'ang-hsi (1662–1722) and there learned the methods of Western painting. All these woodcuts used central perspective, but, as seen here, the point of view remained typically Chinese, with the viewer looking down on the scene just as was the case in the preceding example.

Fig. 116, also giving a remarkable illusion of depth, shows the interesting possibilities in mixing the points of view. Again parallel lines converge slight-

ly in the distance, though not necessarily toward one central point. The landscape on the screen produces the same effect as a view through an open window over a wide expanse of nature. And at the same time the scene in the foreground seems to be continued in the background. The picture as a whole has "level distance," the general view being down into the painting. However, the area between the right side of the screen and the tree trunk belongs to the category of deep distance, since the eye is drawn deeper into the picture. The same effect of deep distance is produced by the window effect of the screen, which lends distance to the view.

In Figs. 117-118 we have the same motifs—water, willows, and buildings —contrasted in traditional and modern perspectives, one from the Yüan period and the other from the time of the Republic. In the earlier picture one is looking down from above, even onto the roof of the distant temple, and has to lift his gaze to follow the picture's composition; while in the latter one looks from below up to the distant bridge, and a central perspective allows one to follow the picture's composition from a single point of view. Lines which seem to diverge in the former actually converge in the latter.

Such examples of Chinese painting in the traditional style, but with Western perspective, are comparatively rare even in modern times. By far the greater number of contemporary painters in the traditional manner remain faithful to the laws of perspective which have come down to them from the past. They have not bent to the yoke of central perspective, from which modern Western painters are consistently trying to escape.

Fig. 119 reproduces a Chinese steel engraving showing a scene with an altar on which the emperor will offer a sacrifice to celebrate the victory, in 1760, of General Chao Hui over the Mohammedans in Eastern Turkestan. The engraving is done according to the methods and techniques of Western models. Copper engraving, which was first introduced in China by the Italian missionary Matteo Ripa during his stay at the court in Peking (1711–23) and after his departure faded again into oblivion, was reintroduced by Pater Benoîst around 1770. His Chinese students created at least seven different series of engravings totaling seventy plates. Our example belongs to an early series of sixteen plates which were engraved in Paris in 1772 by Cochin and represent scenes from the campaign for the subjugation of the Mohammedans in the Ili Valley. The original paintings were done by an unknown court painter in Peking and served as models for the designs of Pater Damascène. Two hundred copies of the final prints were sent to Peking, and they have definitely influenced the later series.

Although the over-all effect of the engraving shown here is one of Chinese

"flat distance," it contains noticeably strong elements of Western perspective; for example, the converging lines of the wooden building toward the center of the lower portion and of the two long pavilion roofs next to it. Obviously, these converging lines do not establish a central point of perspective valid for the entire composition, and their effect is further impaired by the lines of soldiers, which are actually diverging. This effect may perhaps be due to the irregularity of the ground or to the lack of military accuracy on the part of the soldiers. The altar, too, is done in Chinese perspective, so that to the Western eye its rounded surface seems to slant toward the observer. Thus this engraving contains two rather opposed attitudes of perspective, the artist having neither broken through to a completely Western point of view nor yet entirely abandoned the Chinese. The comparatively large figure on horseback is presumably the emperor, who will conduct the sacrifice. This rather naïve technique for drawing attention to principal personages, even though perhaps appropriate for the audience for which this engraving was intended, is seldom found in Chinese art at such a late date. However that may be, Pater Damascène and Cochin seem to have followed rather closely the Chinese original, for they reproduced a number of typically Chinese elements which would have caused some discomfort to Western contemporaries.

Oddly enough, the pictures shown in the penny-in-the-slot machines that attract such crowds of children at any Chinese fair, of which Fig. 120 is an example, make an almost desperate use of central perspective. This observation, though seeming to lead astray from the main thoroughfares of art to the pleasant fields of popular entertainment, nevertheless provides reason for speculating that the Chinese artist has always tended to regard Western perspective as little more than a *trompe l'œil* suitable for the amusement of children but not worth the notice of an inheritor of the glorious tradition of Chinese painting.

■ 5 ■ *COMPOSITION* PAINTING NEVER REALLY ESCAPES FROM THE demands of composition, even when endeavoring to be naturalistic and to paint natural scenery as the eye sees it. Composition is always involved in the choice of the scene and in the instinctive alterations and adaptions, however slight, which the painter's mood or character or taste dictates. It is worth noticing that even in such a representational art as photography, which depends entirely upon given facts, one still

talks of composition. In photography this means that the photographer carefully selects a particular scene in which the lines intersect, in which the planes and tones balance, so as to form the desired picture. Or he may alter what he has taken on film, by cropping or toning up during the process of enlargement, and so produce a better composition.

If problems of composition prevail in photography and in naturalistic painting, they become crucial in a form of art which is fundamentally conceptual, whether this concept be of a religious kind as in the great church paintings of Europe; chiaroscuro, as in the transition from Renaissance art to baroque mannerism *(Manierismus)*; one of deliberate distortion, as in many schools of modern painting; or, finally, of a philosophy of nature, as in Chinese painting.

As we have stressed before, Chinese painting derives from, or at least was strongly influenced by, a philosophic contemplation of the world in general. Moreover, from its early days, it was a studio art; the visible world was copied, but only indirectly. The painter, alone in his workshop, reflected the external world in his memory (or occasionally in his sketches); he filtered it through his mind and emotions and changed it in the process. The anecdote about the Kialing River painting (page 52) is a dramatic illustration of the Chinese preference for imagination over naturalism.

A close examination of any good Chinese painting will reveal an intangible quality which can perhaps be best expressed by saying that the painting seems to be knit together by strong invisible threads. This impression will be further strengthened by a detailed examination of the ways in which the various elements of the painting are related to each other. For the principles of artistic composition in China, based upon that identity of opposites which we discussed in the section on painting and Tao, form a tough and complicated web strung across the whole painting. In addition to this, the underground, or invisible, links between visible forms are deliberately emphasized. We shall start our discussion of composition with these invisible connectives.

■ DRAGON VEINS. As mentioned earlier, the Chinese speak of dragon veins *(lung mo)* when they want to describe those invisible threads or connectives which are woven in an ingenious and complex system across a painting. These veins are considered to be strong when the visible elements in a painting are firmly anchored in place. Anyone who has watched a Chinese painter at work will have noticed how, right at the end of this or that stage of the painting, he will add a dot or a bush, a figure or a bird, a sail or a distant

pagoda, and how, after this final touch, the painting will suddenly seem to come to life. The dragon veins have been stretched right. It was such a stretching, for example, that took place when Ku K'ai-ch'ih finally added the eye to his dragon painting (see page 24), rousing the dragon to life and freeing both beast and painting to soar into the sky.

The many elaborate categories of Chinese art have often, in earlier pages of this book, been dismissed as little more than meaningless though amiable pastimes for critics. However, in approaching the principles of composition, the stretching of dragon veins, we encounter a group of paired categories that prove quite helpful to understanding. It has already been explained how the identity of opposites is a principle that runs through the whole of Chinese art. As expressed in the following paired categories, this principle becomes especially evident in the idea of composition, which by its very nature represents a reconciling and a unifying of all opposites, all antagonisms, all contradictions.

■ HOST AND GUEST. The first pair of opposites is that of host and guest, *pin chu* or *chu k'o*. Two parts of a picture are set in a relationship with each other in accordance with this principle. They represent the giving and the taking, the passive and the aggressive, and form a unit which is then set against another part of the painting in a further host-guest combination.

This method of composition can be studied in groupings of trees like those of Fig. 121. The host tree may, as in the two-tree group, be bent, with spread branches, in which case its guest will provide contrast by being slim and straight. When a third tree is added to the group, care is taken to avoid exact parallels and uninteresting curves. Once a group of trees has been created in this way, it is brought as host into relation with another group of trees, a guest group, in yet another part of the painting.

Not an inch within a painting escapes from this fine web which Chinese aesthetics weave over the whole surface. Thanks to this principle, the less talented painter seems to surpass his artistic level, while the great painter is in no way restricted by it.

The Mustard-seed Garden gives a detailed explanation of this host-guest principle. We find it again in the album of rock and tree painting by the calligrapher and painter of landscapes and flowers Shi T'ieh-sheng (1746–1803), from which our Fig. 122 comes. A rough, approximate translation of the directions given with this illustration will indicate the complexities of which the host-guest principle is possible: "Branches can grow upward, sideways, or hanging. The relation of direction and length of branches also in a

group of trees is defined. When trunks are curved or bent, the corresponding ones should be upright. . . . In a group of three trees, usually two trunks have roots. . . . When trunks are bent, roots are large; when they are upright, roots are in the shape of the character for seven."

Again in modern times Hu P'ei-hung, in his *Shan-shui Ju-men* (Principles of Landscape Painting), was still following the host-guest principle, as in our Fig. 123. The text reads: "Section Two. Grouping of Trees. How Trees Are Arranged and Combined. In painting trees with more than two trunks in a group, parallel lines should be avoided. The shape has to be divided, or they must cross. Roots and crown must have back and front and should be irregular in arrangement. Avoid stiffness and monotony. The host tree in relation to the guest tree should be somewhat lower to indicate the politeness of the host toward the guest. The same is true of a greater group of trees; however, any disorder ought to be avoided."

Thus, the composition of a Chinese painting can be said to begin to take shape with the host-guest principle. This principle can be used equally well to relate tree to tree, rock to rock, mountain to mountain, or man to man.

■ HEAVEN AND EARTH. The first principle of composition, host and guest, which was discussed above, refers to the disposition and grouping of single sectors of a painting. Now we turn to the second principle, that of heaven and earth *(t'ien ti),* which deals with the arrangement of the entire painting area from top to bottom.

There has been some confusion over this principle, because the same expression "heaven and earth" is also used for the silk or paper mounting of a painting. In this latter case, however, it refers to the relationship of the areas lying outside the painting proper, that is, to the upper and lower parts of the scroll.

Applied to the composition of a painting, the term heaven and earth involves the relationship between the upper and lower portions of the painting itself. It includes the binding together of all that is anchored to the earth and all that floats free of it; the distribution of space in a vertical plane, and also its vertical cohesion. This means that it is concerned with the representation of the physical world and, simultaneously, with freeing the painting from the dead weight of that same physical world. One could define this basic principle as one of vertical balance. It would be more in conformity with Chinese mentality to call it an attempt to create a harmony between the powers of heaven and those of the earth.

The principle can be applied in countless ways. In Fig. 124 P'u Ch'üan has illustrated three of these methods for the sake of explanation. In each case a threefold division of space is clearly visible: the area of origin, the area of growth, and the area—which may or may not be reached—of aspiration. The two straight-standing trees are actually reaching toward heaven, the area of aspiration, while being firmly anchored in earth, the area of origin. Both trees also reach over into the area of growth, giving compositional lateral balance to the arrangement. The downward-hanging tree shows an apparently paradoxical arrangement with the areas of origin and growth in the top part of the sketch and the area of aspiration in the lower. This is simply another example of the rather free approach the Chinese take toward their own principles, another paradox in a paradise of paradoxes where opposites can also be identical. All three sketches, however, show how the separate sectors of a painting area can be merged into a single whole by the movement of lines which seem to focus on a third area not yet reached.

In this principle, as in all others already treated, we can again detect the philosophic attitude of the artist who tries to give visible form to the age-old Chinese cosmological philosophy of Yang and Yin, of the identity of opposites. It is a philosophic attitude that expresses itself quite spontaneously in Chinese painting, without the necessity for any conscious effort on the part of the artist. It is simply an aspect of the typically Oriental desire to reach out toward the invisible, the recognition that boundaries are fluid or at least not fixed and that to achieve completeness one has to reach down or back or across or up.

From a purely technical point of view, one may note that the general tree shapes in the planes of heaven and earth are like an irregular triangle hung on an axis. This, like everything else in Chinese painting, is not an inviolable law, but again only a piece of helpful advice offered on the basis of centuries of aesthetic experience.

■ OPENING AND CLOSING. What might be called a further, or a higher, development of the host-guest principle, is one called *k'ai ho:* the opening and closing of a painting. In this too we find the opposing pairs which become identical on a higher level. If the host-guest principle deals with the relation of individual parts of a painting, the concept of opening and closing is concerned with the relating of all parts together into one great whole, from the beginning to the end of the painting. If one were to indicate the principles by tracing lines across the face of a painting, it would be found that, whereas the lines of the host-guest principle would be relatively short, those of open-

ing and closing would be quite long, traversing the entire painting surface.

According to this *k'ai ho* principle, some elements open up the painting and let it fly free, while opposing elements close it down again and hold it fast. The elements involved can be as a few as two, or there can be many of them. But always they complete the picture, standing in contrast to each other. *K'ai* and *ho* usually face each other, or turn toward each other. Our examples will perhaps make this clear.

In Fig. 125 a single *k'ai* opens up the picture at the lower left, and a single *ho* closes it again at the upper right. This is the simplest, and perhaps the commonest, form of composition in China. By means of the structure and the turning toward each other of the two elements, the empty space in between is threaded with invisible links—with dragon veins. And the distant forms of pagoda, sail, and moon are used as space symbols to create the illusion of depth, thus producing a third dimension.

In Fig. 126 two pairs of *k'ai* and *ho* stand opposed to each other. The opening *k'ai* in the bottom right corner releases the composition with a scene facing left and upward, the scene then being closed downward by the rocky shoreline reaching from the left into the center of the picture. At the same time the top part of this promontory opens up the top area of the picture facing half right. The picture is then finally closed by the top right area, which is connected with the center by a bridge and faces toward the middle left. Thus it can be said that the center of this picture has a double face, with its downward eyes closed and its upward eyes open.

In Fig. 127 the principle works in a more complicated way. The several sectors of the picture have the Janus-headed character just mentioned. They close one section of the picture in one direction, and open another section in the opposite direction. The separate groups can be put together in such a way that the whole picture resolves itself into several pairs of *k'ai ho*.

As shown in Fig. 128, there may be compositions in which the *k'ai ho* is not at first apparent. In this particular case, one might say that the foreground and the background are related to each other as *k'ai* and *ho*. There is a large space opening toward the background, in which rock, tree, and mountain are bound together as alternating host and guest. So in this sketch the *k'ai ho* principle is identical with the host-guest principle; and it is quite natural that this should be so, since both are products of the same philosophic concept—that of the complementary nature of opposites.

One may add here that the center of a painting never lies exactly in the middle of the painting area. Indeed, it would be disastrous for the geometric and the artistic centers of a painting to coincide. The location of the artistic

■ BONELESS PAINTING

(see pages 112–14)

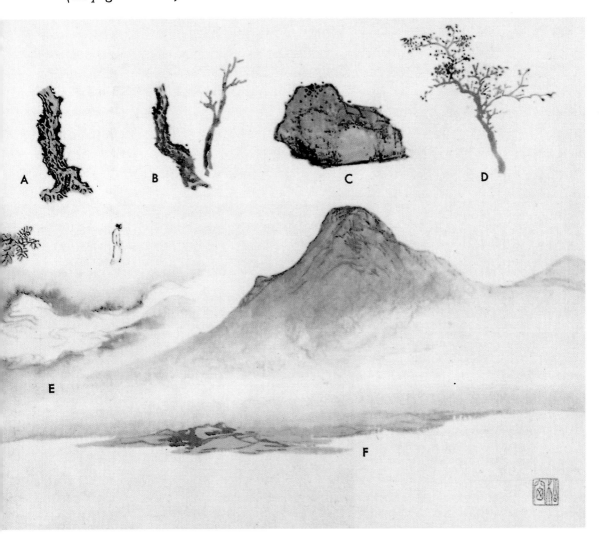

77. *Examples of boneless painting:* (A–B) *contrasting tree trunks, the first not boneless, color having been applied over an ink skeleton or bone, while the trunks of* B *are boneless, darker color applied over lighter color;* (C) *a boneless rock;* (D) *a boneless tree, really "painted" in the Western sense;* (E) *boneless clouds;* (F) *boneless mountains. P'u.*

■ *GOLD-LINE AND BROKEN-INK STYLES*

(see pages 114–24)

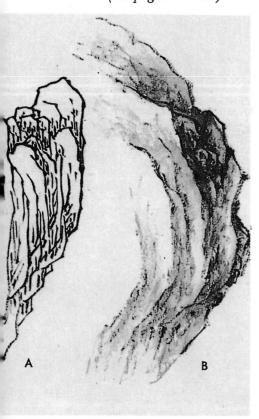

78. The two basic styles contrasted: (A) *gold line;* (B) *broken ink. P'u.*

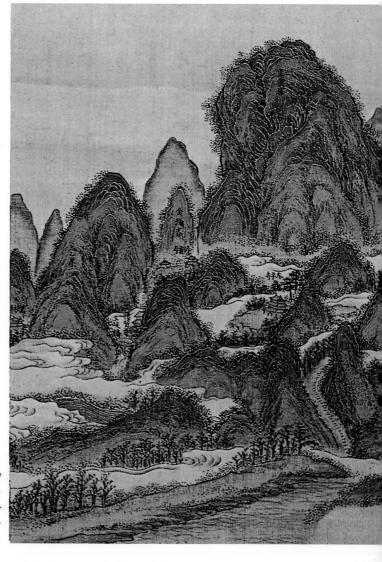

79. Example of the gold-line and blue-green styles, the two being almost identical: section of a landscape by an unknown Ch'ing artist. Author's collection.

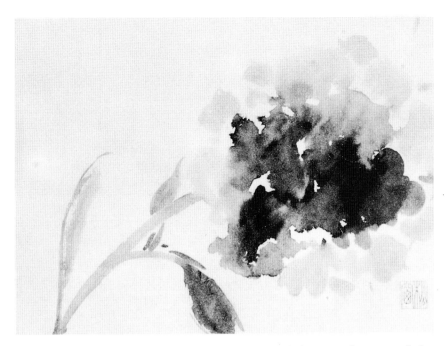

80–81. *Examples of splashed-ink technique, a subcategory of the broken-ink style.* P'u.

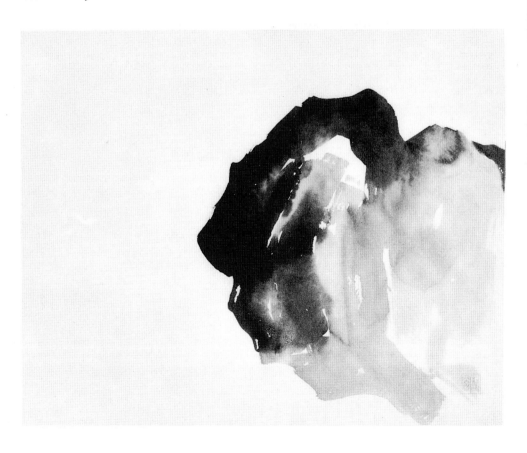

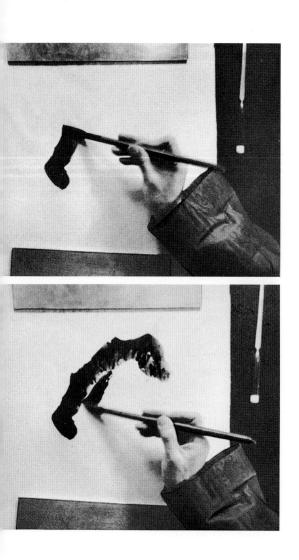

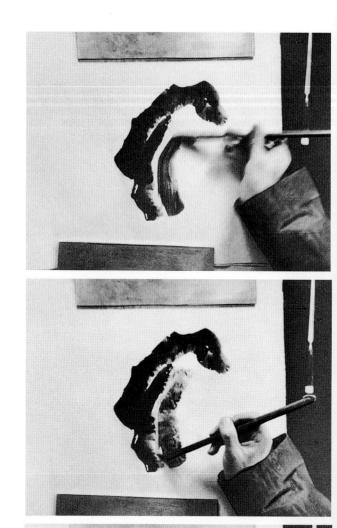

82–86. P'u Ch'üan painting the splashed-ink rock of Fig. 81.

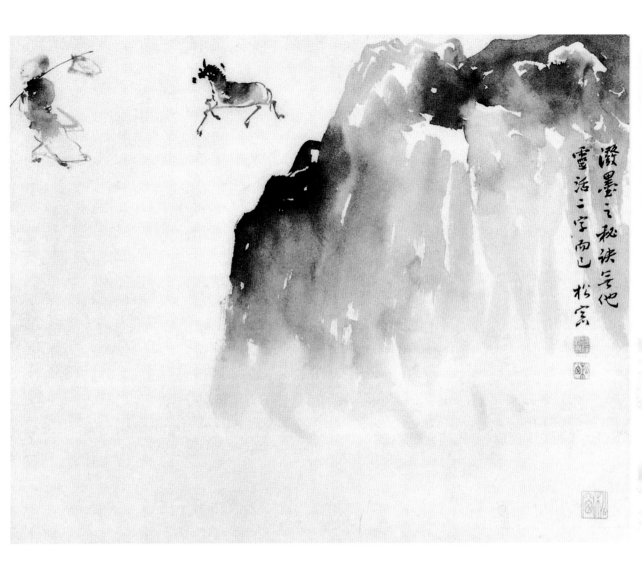

87. *Three of many ways of using splashed ink : man created by touching up an accidental ink blot ; donkey created from deliberate blots and outlines ; mountain in splashed ink without shaping lines, tending toward abstraction. P'u.*

88–89. Examples of flying white, a broken-ink technique. P'u.

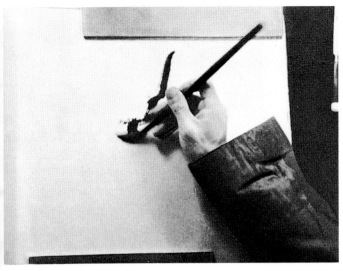

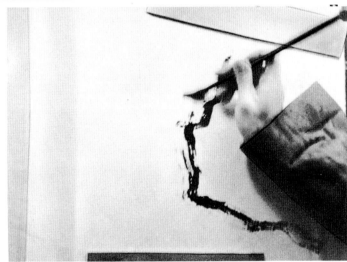

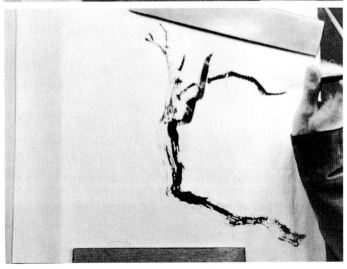

90–92. P'u Ch'üan painting the flying-white branch of Fig. 89.

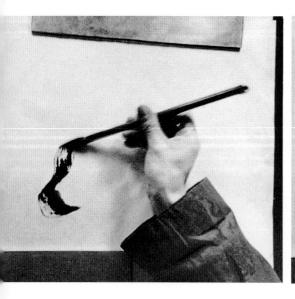

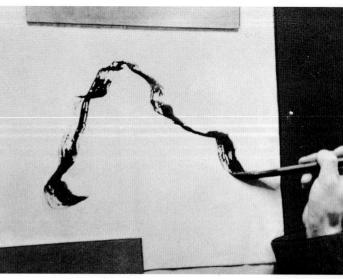

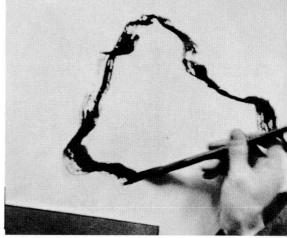

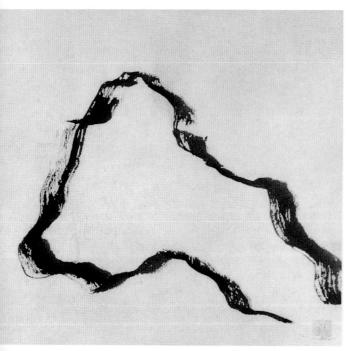

93–96. P'u Ch'üan painting in a variant of the flying-white technique.

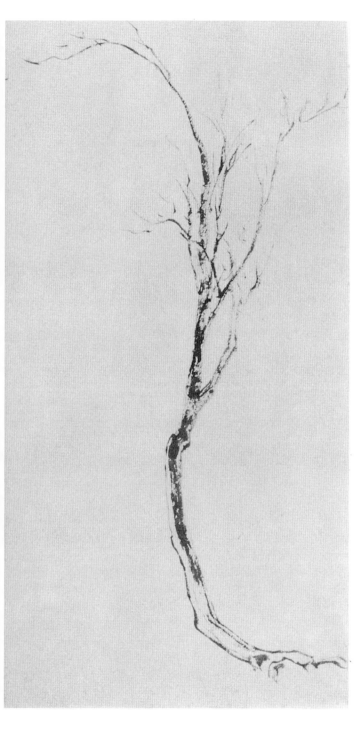

97–98. An especially clear example of flying white provided in a detail from the sketch of a tree. P'u.

99. Flying white used in calligraphy: Arabic script by a Chinese Moslem calligrapher. Collection of T. Tafel.

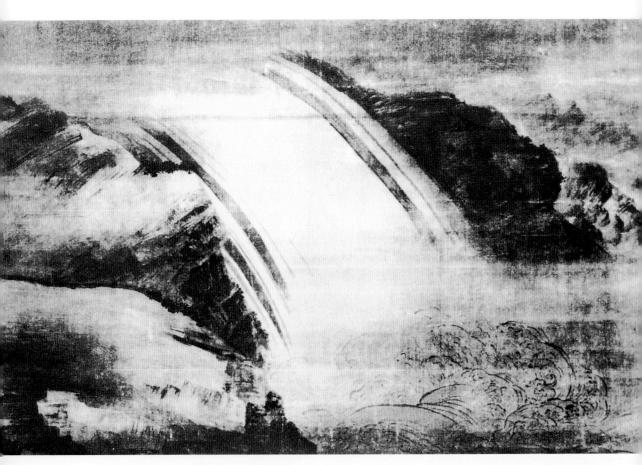

100. Example of broken ink in a finished painting: Waterfall, formerly attributed to Wang Wei (T'ang) but now believed to be of the Sung period. Courtesy Ōtsuka Kōgeisha.

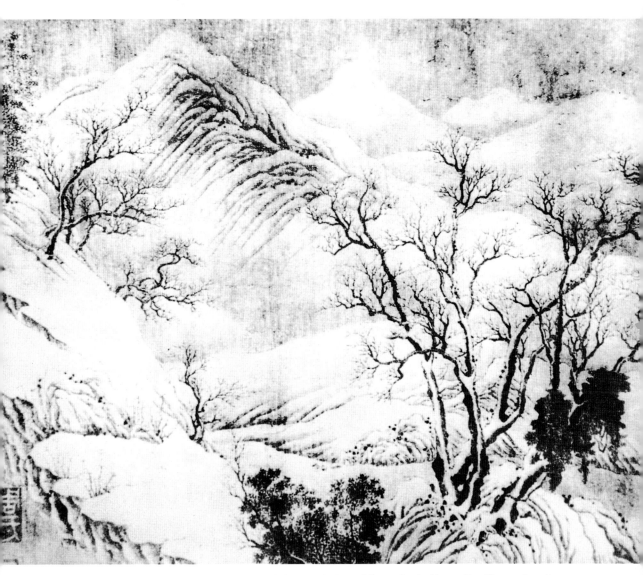

101. Less obvious example of broken ink in a finished painting: Mountains in Snow (detail), attributed to Wang Wei (T'ang). Courtesy Ōtsuka Kōgeisha.

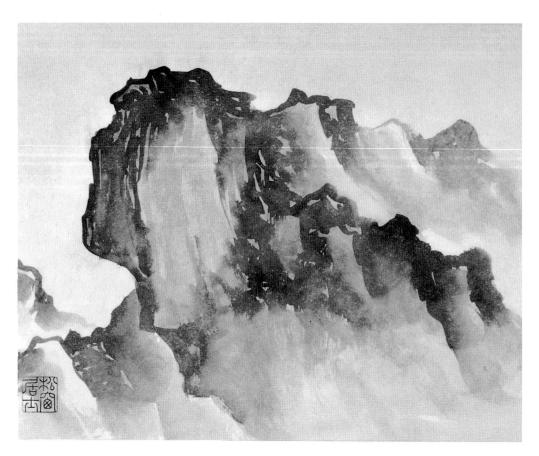

102. An example of the watered shaping line, a technique developed from splashed ink. P'u.

103. P'u Ch'üan painting a watered shaping line; note the two brushes.

104. The Japanese tarashi-komi *or "dripping" technique, which was anticipated by the watered shaping line: detail from the plum-blossom screen by Kōrin (1658–1716). Nezu Museum, Tokyo.*

105. The Japanese niji-mi *or "blurring" technique. From Saito Ryū-kyū's* Japanese Ink-Painting.

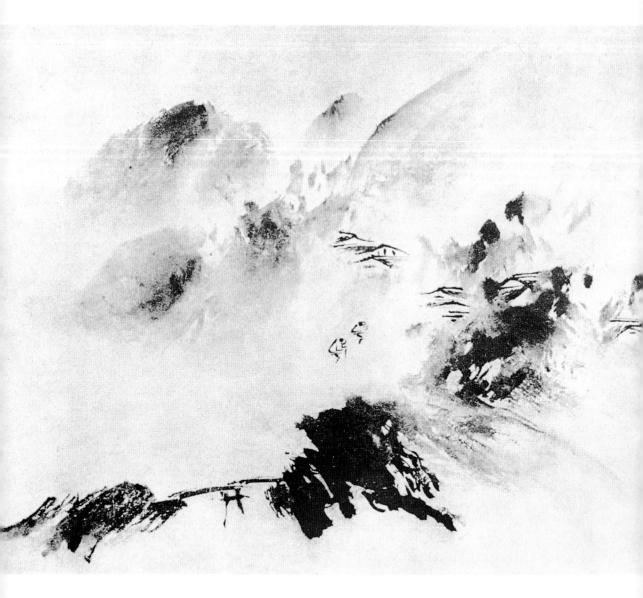

106. *Broken ink: Landscape, by Ying Yü-chien (late Sung). Courtesy Ōtsuka Kōgeisha.*

107. *Broken ink: "Hatsuboku Landscape," by Sesshū (1420–1506). National Museum, Tokyo.*

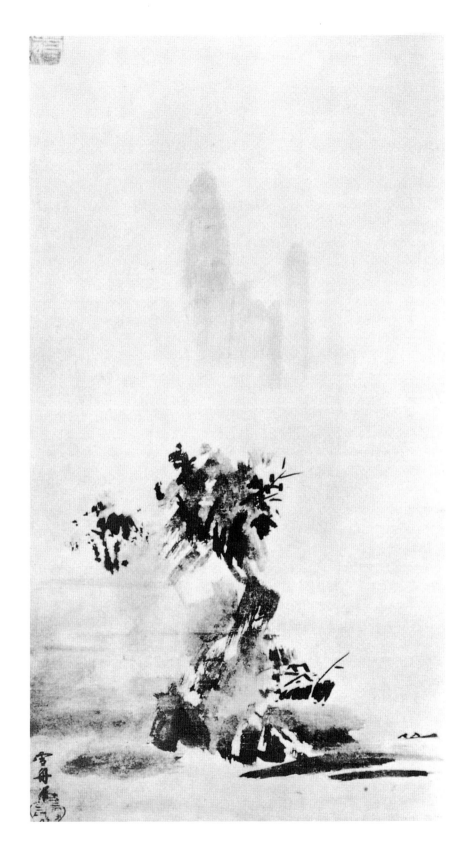

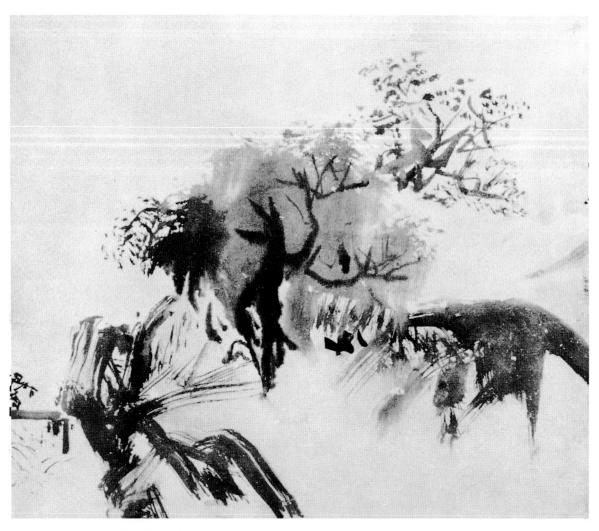

108. Broken ink: detail from a landscape by Kanō Naonobu (1607–50).

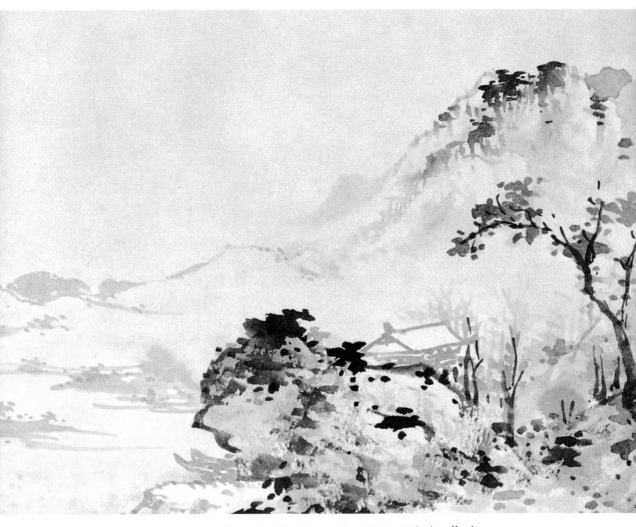

109. Broken ink: Landscape, by P'u Ch'üan (Republic). Author's collection.

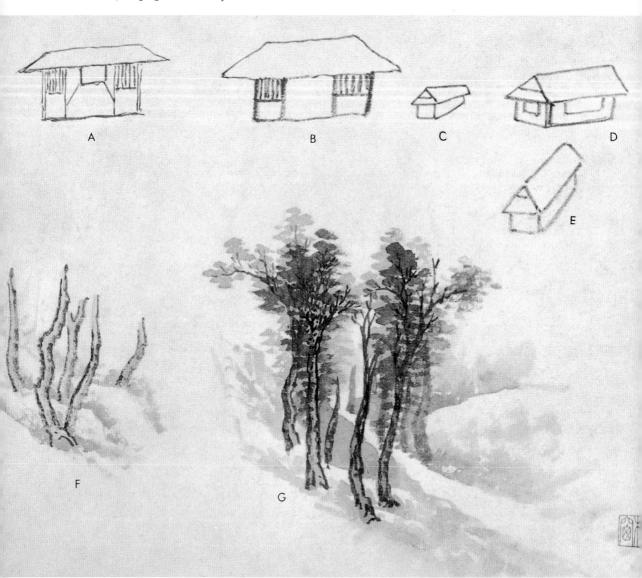

110. Examples of perspective: (A, C) *Chinese interpretations of Western principles of perspective;* (B, D, E) *houses in traditional Chinese perspective;* (F, G) *traditional Chinese ways of creating perspective with trees by making the more distant ones smaller, less detailed, or paler. P'u.*

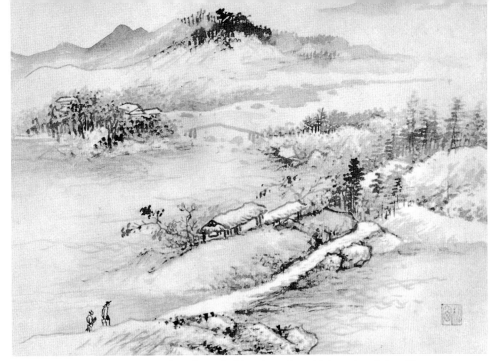

111. Level-distance perspective, viewer looking down from high vantage point. P'u.

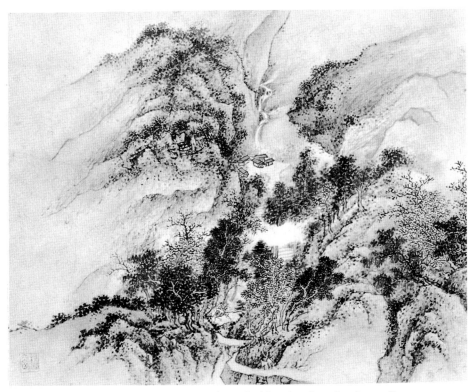

112. Deep-distance perspective, viewer looking deep into the picture. P'u.

PERSPECTIVE ■ 153

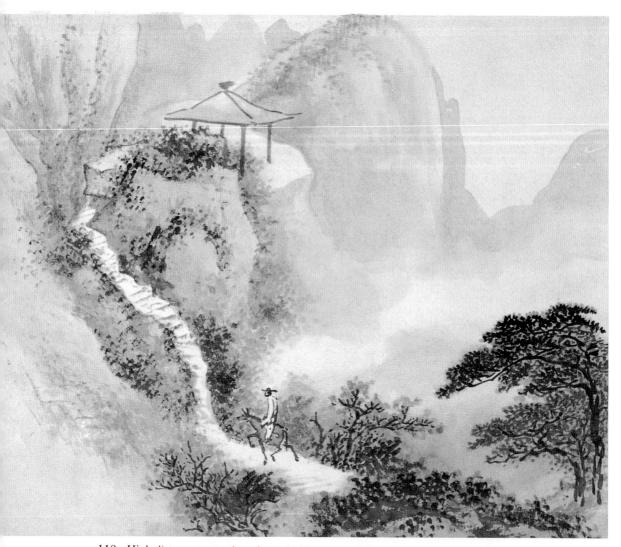

113. High-distance perspective, viewer looking upward from low vantage point. P'u.

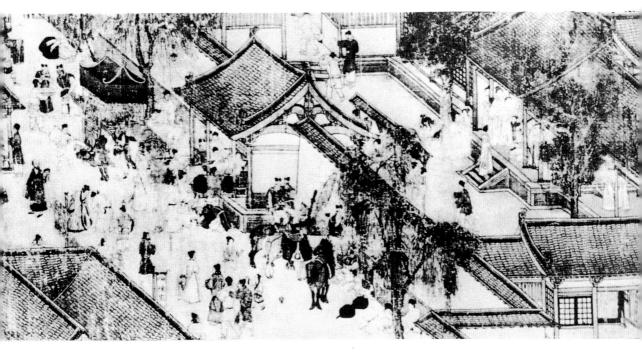

114. Level-distance perspective: Wen Chi Returning from Mongolia, section of a scroll by an unknown Sung artist in the manner of Ch'en Chü-chung. Boston Museum of Fine Arts.

115. Chinese version of Western perspective: woodcut by Chiao Ping-chen (Ch'ing). Author's collection.

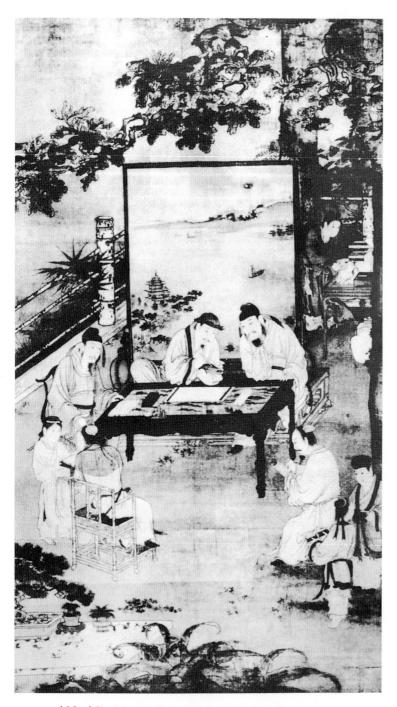

116. Mixed perspectives: Scholars in a Garden, by an unknown Sung artist. Courtesy Ōtsuka Kōgeisha.

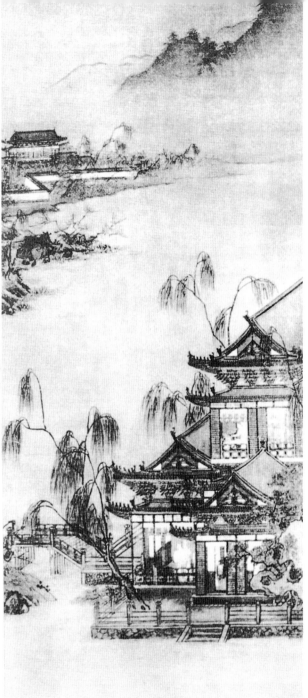

*117–18. Similar motifs with different perspectives: (*RIGHT*) traditional Chinese perspective, Pavilion by the Sea, by Sun Chün-tse (Yüan), courtesy Ōtsuka Kōgeisha; (*LEFT*) modern Chinese perspective influenced by Western principles, Bridge, by Kao Ch'i-fang (Republic), private collection.*

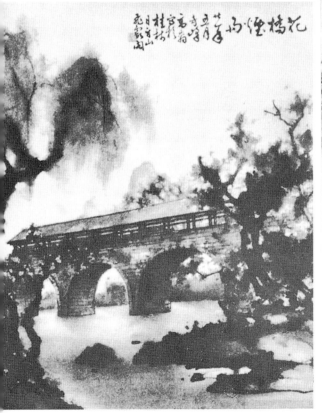

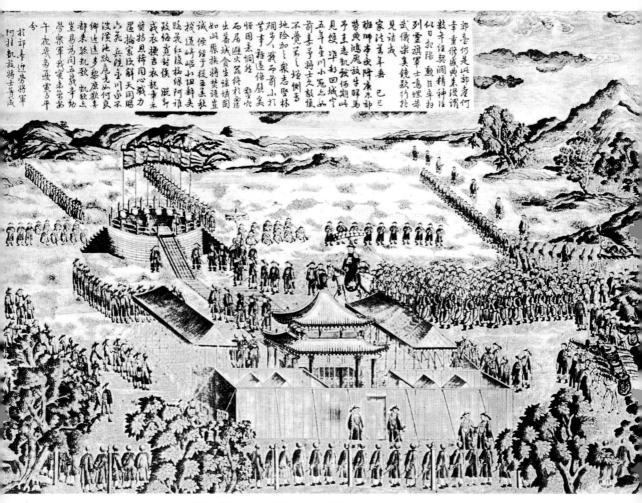

119. *Mixture of Chinese and Western principles: steel engraving after an original by an 18th-century Peking painter. Author's collection.*

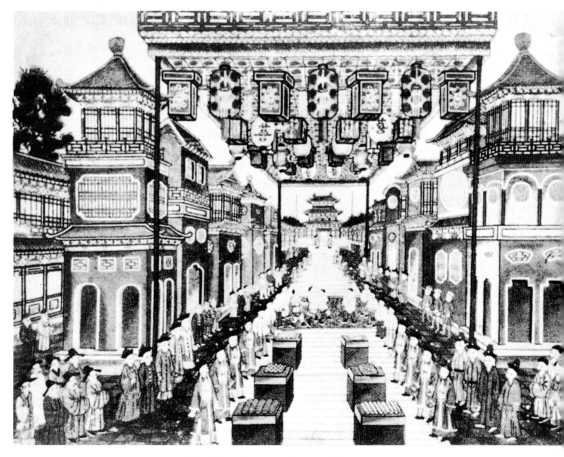

120. *Central perspective carried to extremes: a Chinese peep-show picture. Courtesy J.-P. Dubosc.*

■ *COMPOSITION*
 (see pages 129–34, 177)

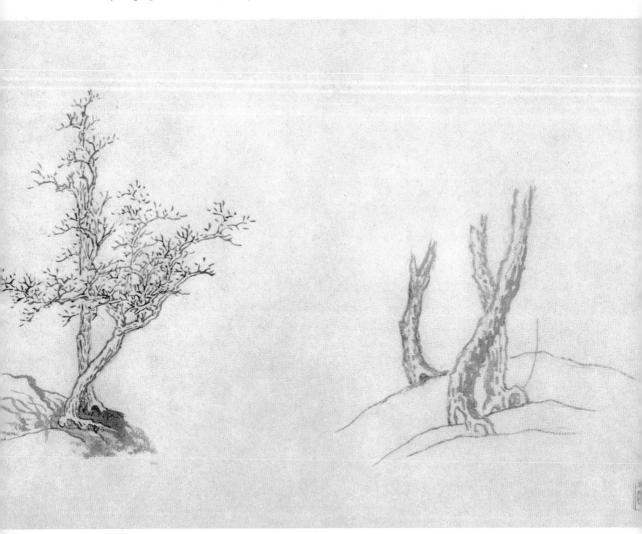

121. Trees in host-guest arrangements. P'u.

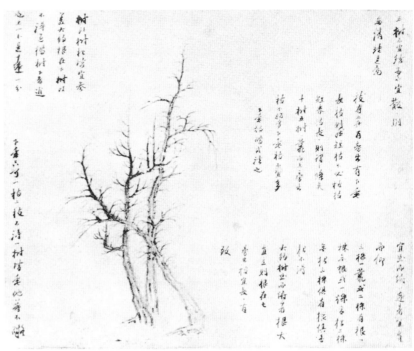

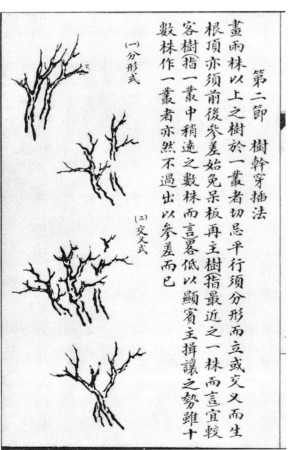

122–23. *Host-guest principle illustrated:* (RIGHT) *from an 18th-century manual;* (LEFT) *from a 20th-century manual.*

第二節　樹幹穿插法

畫兩株以上之樹於一叢者切忌平行須分形而立或交义而生根頂亦須前後參差始免呆板再主樹指最近之一株而言宜較客樹指一叢中稍遠之數株而言畧低以顯賓主揖讓之勢雖十數株作一叢者亦然不過出以參差而已

（一）分形式

（二）交义式

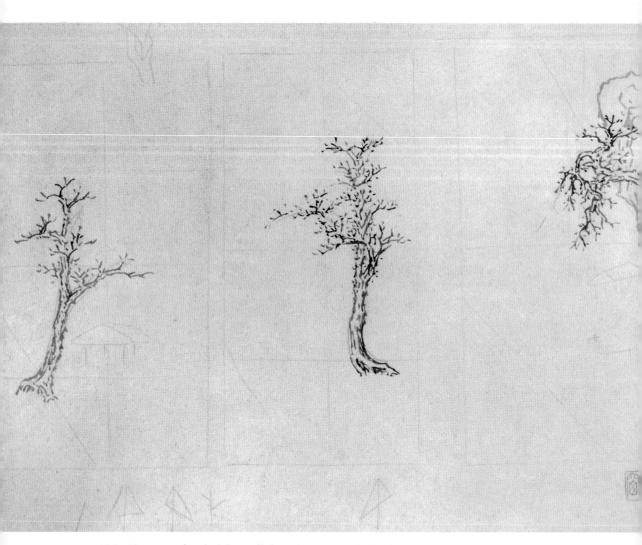

124. Heaven-earth principle applied to three trees, all showing area of origin (roots), area of growth (trunks), and area of aspiration (the sky above in the first two cases, and the air below in the third). P'u.

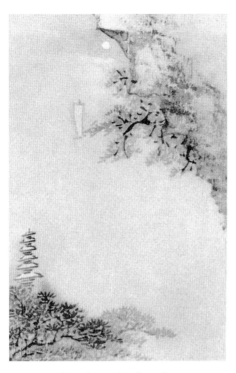

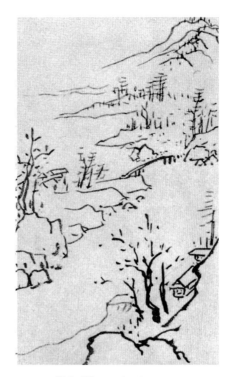

125. One pair of opening-
closing elements. P'u.

126. Two pair of opening-
closing elements. P'u.

127. Several pair of opening-
closing elements. P'u.

128. A fusing of the opening-closing
and host-guest principles. P'u.

129. The compositional ensemble: sketches suggesting how a painting grows from first leaf to completed landscape. P'u.

130. *The compositional ensemble: a finished sketch of tree in leaf* (mao lin) *embodying various elements of composition.* P'u.

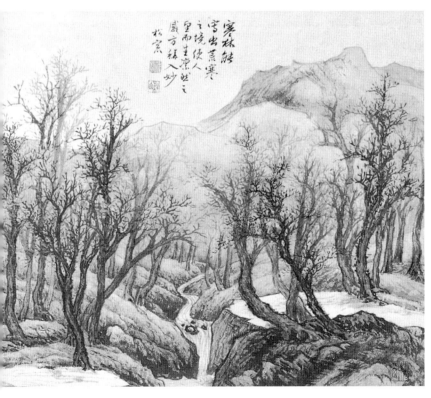

131. *The compositional ensemble: a finished sketch of winter trees* (han lin), *contrasting with the summer trees of Fig. 130.* P'u.

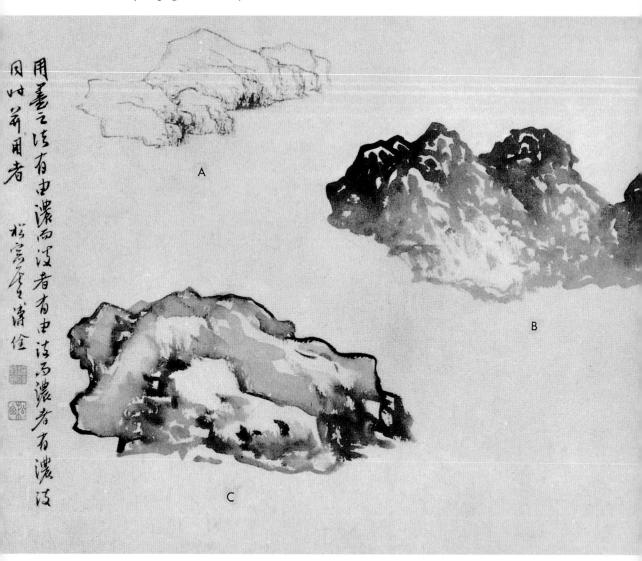

用墨之法有由濃而淡者有由淡而濃者有濃淡
同此筆用者

松壺老人溥佺

132. *The two usages contrasted:* (A) *brush usage predominates;* (B) *ink usage predominates;* (C) *the two usages are of equal importance.* P'u.

■ *CAREFUL AND SPONTANEOUS STYLES*

(see pages 179–82)

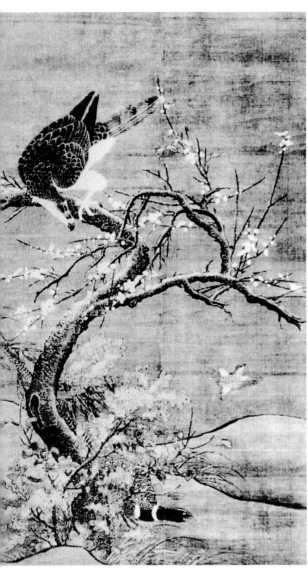

133. *The careful style: Blossoms and Birds, by Chao Tzu-hou (Sung). Courtesy Ōtsuka Kōgeisha.*

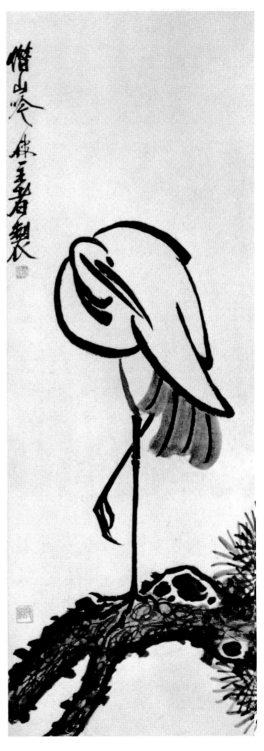

134. *The spontaneous style: Crane on Pine Branch, by Ch'i Pai-shih (Republic). Author's collection.*

CAREFUL AND SPONTANEOUS STYLES ■ 167

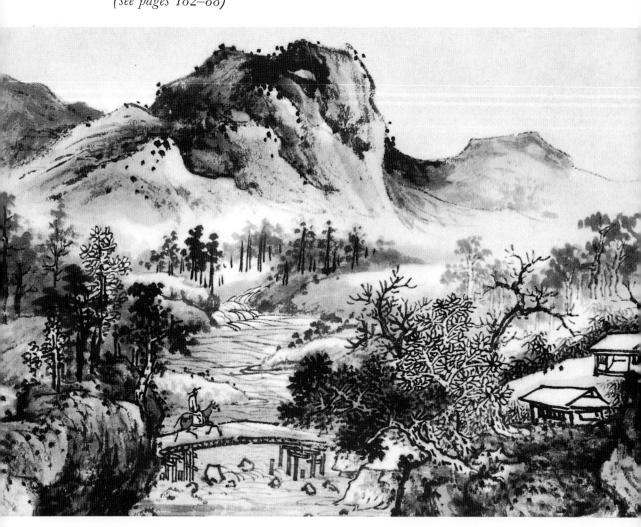

135. Sketch on unsized paper. P'u.

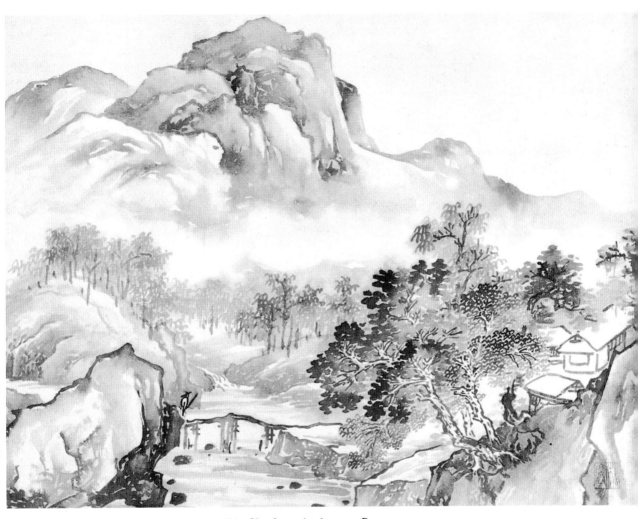

136. Sketch on sized paper. P'u.

137. Unsized paper: 1st enlargement of Fig. 135.

138. Sized paper: 1st enlargement of Fig. 136.

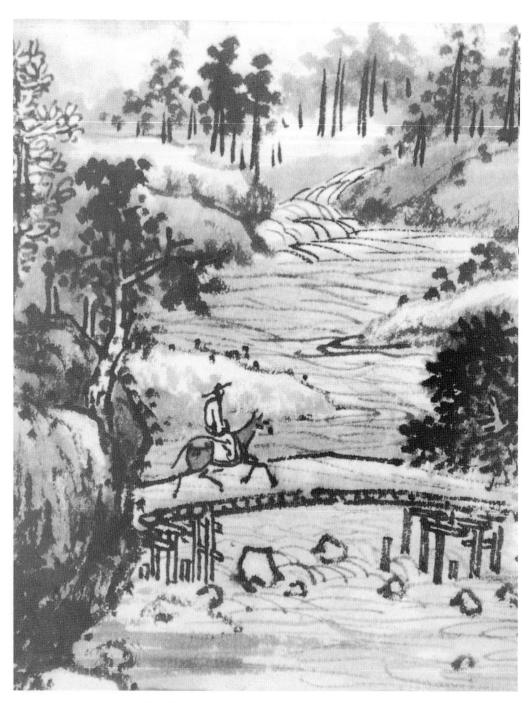

139. Unsized paper: 2nd enlargement of Fig. 135.

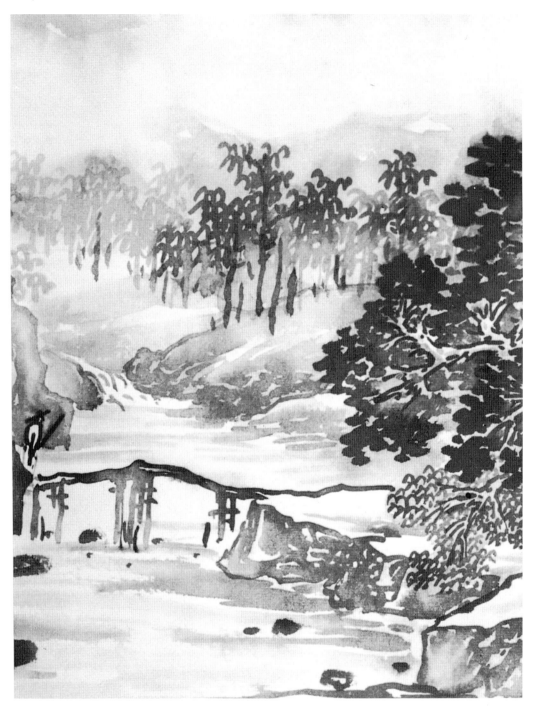

140. Sized paper: 2nd enlargement of Fig. 136.

141. Unsized paper: 3rd enlargement of Fig. 135.

174 ■ PAINTING SURFACES

142. Sized paper: 3rd enlargement of Fig. 136.

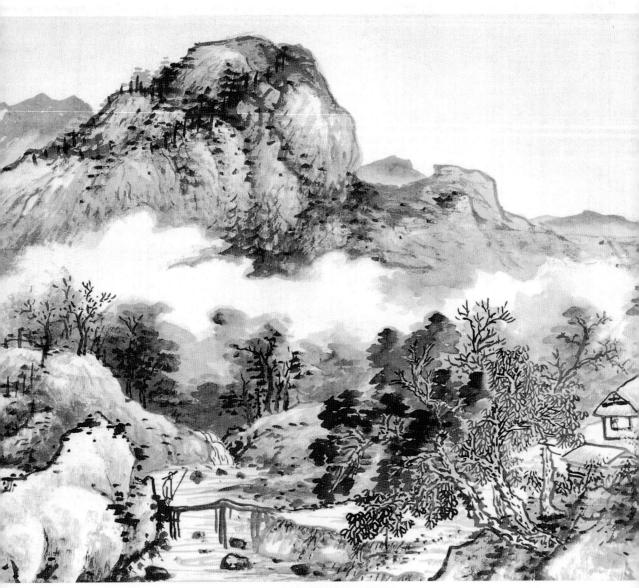

143. Sketch on silk. P'u.

center will depend on the particular application of the heaven-and-earth principle in any painting.

■ THE ENSEMBLE. Heaven and earth, opening and closing, host and guest, brightness and dark, the angular and the straight, the call and its echo, the light and its reflection—all these are forevisioned in a Chinese painting from its very first brush stroke. Composition is involved in the slightest detail of the form. As suggested in Fig. 129, demonstrating how the single brush stroke of a leaf or a twig grows into a whole section of a painting, stroke is added to stroke to produce a group of leaves; tree outlines start their interplay of advancing and yielding; various groups of leaves take their place on the trunks and the branches and form tree groups; and finally the outlines of mountains are brought into relation with the groups of trees and rocks already formed. All this shows the continous process of composition. At every stage the same principles dominate it.

All the features of a painting are now ready to be fitted together according to the principles we have been describing. In Fig. 130 the various elements of composition have been put into effect to produce, if not a completed picture, at least a masterly sketch. The outlines and the shaping lines, leaves painted with dots and leaves painted with lines, trunks and branches go together to form a group of trees in leaf *(mao lin)*. The importance of bright and dark areas, of the grouping of trunks, and of the creation of depth by diminishing size and visibility is clearly seen in the sketch, with the principles of composition also governing the disposition of planes and forms.

By way of contrast, Fig. 131 is a sketch of wood in winter *(han lin)*. Such a scene, because of the absence of foliage, has a greater transparency than one showing trees in leaf and is more difficult to paint. Winter trees require an aerial perspective, while summer trees, with all their variegated foliage, can be distributed flat over the painting surface. But here again the principles of composition we have been discussing are fitted together in an ensemble that well summarizes all our remarks.

■ 6 ■ *BRUSH USAGE AND INK USAGE*

As ALREADY EXPLAINED, CHINESE painting has developed, during the course of centuries, a vast number of techniques for the use of brush and ink in building up a picture. The most important of these is the actual handling

of the brush, the way in which its specific qualities are applied. This is called *yung pi,* or brush usage. When the painter has thoroughly mastered the handling of a brush as such, he is said to "have brush" *(yu pi),* while the term *pi fa* refers to brush method in general.

On the other hand, all the techniques which concern the specific qualities of the ink—its fluidity, its tones—rather than those of the brush which produced the ink shapes, are known as *yung mo,* or ink usage. The painter who has mastered the use of the ink is said to "have ink" *(yu mo),* and the term *mo fa* refers to ink method in general.

Western critics of Chinese painting tend to think of these distinctions as mere word play, as a laboring of the obvious, as *chinoiserie.* But actually they are indispensable for a proper understanding of Chinese painting. Real understanding can only be acquired through an intimate familiarity with Chinese brush and ink techniques. The Chinese has the initial advantage of having been taught to use the brush in his writing. So he can, when inspecting any painting, judge right out: "This painter has brush, but his ink usage is weak" or "That painter has brush and ink." Even individual paintings differ by having more brush or more ink, without any difference in quality being involved. For example, splashed-ink painting may tend to emphasize the quality of the ink more than that of the brush.

Fig. 132A shows a technique in which the qualities of the brush predominate, that is, in which the brush usage is more important. In 132B, on the other hand, it is the ink usage that predominates. And in 132C the technique is one in which brush usage and ink usage are of equal importance.

However, on the borderline between brush usage and ink usage, where the two seem to merge without either gaining predominance, ink usage may still become apparent, although without subduing the brush usage. This may happen, first, in the brush usage itself, for the brush is no good without ink, and the quality, the quantity, texture, and inner form of the ink have their part to play in any brush stroke. It may happen, second, in the composition, for the character of any composition depends largely on the quality, texture, and values of the ink. The two are interrelated, insofar as the style of the composition implies a certain kind of ink usage, and the ink usage helps to determine the style and character of the composition. It may occur, third, in the method of balancing the light and the dark *(shen ch'ien* or *tan chung* or *nung tan)* in which bright and dark are placed in aesthetic contrast to each other. Obviously in this kind of painting technique the brush stroke, or brushwork in general, is not so important as the character of the ink and the way it is applied (Fig. 132B).

Ink usage is the chief concern of the painter in painting with a wet or dry brush in heavy or light ink. And brush usage is his chief concern in painting fine or coarse strokes with rounded or angular lines, with closed or open brush, with sharp or blunt stroke-ends (Fig. 132A).

Many different factors help determine the proportion of ink and brush usages in a specific painting; two of these deserve special mention here. The first concerns the kind of paper used. For example, the color of the paper (brownish or gold, gold-flecked or patterned) will give a painting its special character of age, individuality, or elegance, and these qualities in turn will require special ink and brush technique. Other similarly important characteristics, to be discussed in more detail in the section on the painting surface, are its finish (rough or smooth, fine or coarse, flat or uneven), its structure (fibrous or silky, mat or glossy), and its degree of sizing. All such factors help to determine the style, as the paper can either assist or hinder the use of this or that technique.

The second noteworthy factor that plays a large part in determining the style of a painting is the matter of choosing which old master to copy, not merely in subject matter but also in painting methods—methods which have proved themselves over the years and thereby become permanent elements of the Chinese painting technique. Methods which have been fully worked out by famous masters can sometimes be copied quite easily by repeating every single brush stroke exactly as it stands. This is done especially when a painter wants to paint in a definite style of the past, whether a personal style or a period style. Deliberately or not, he abstains from innovations of his own, trying to produce an exact replica of the master's brush or ink usages. It should be noted that it seems to be easier to copy the brush usage of a given style than to copy its ink usage.

■ 7 ■ *THE CAREFUL AND THE*
SPONTANEOUS STYLES

SEVERAL TIMES WE HAVE HAD occasion to allude to the careful and spontaneous styles. Let us now turn to this important matter.

The opposition between these two styles is a reflection of the opposition on a deeper level between the two extreme attitudes possible for an artist: academic realism and free expression of mood. Technically speaking, the two styles are made possible by the extraordinary versatility of the Chinese brush, which can range from a quill-like hairline to the broad slashing of flying white

or splashed ink—all executed with the same brush. In Chinese the careful style is called *kung pi,* meaning roughly "industrious brush" or "laboring brush." The spontaneous style is *hsieh yi,* literally "writing ideas."

This word *hsieh,* just rendered as "writing," is noteworthy in that it is the verb used to describe both the action of painting and that of writing. Strictly speaking, *hua* is the correct word for "to paint," but in conventional usage this almost always becomes *hsieh,* the seeming identity between writing and painting doubtless arising from the fact that the calligrapher can perform either action with the same brush. This linguistic peculiarity has misled many authors into overemphasizing the close relationship between writing and painting, to the extent of speaking of paintings as being "written down." And the Chinese habit of overemphasizing the twin uses of the brush has lent support to this tendency. But to talk of paintings being written down is just as inaccurate as to talk of the "brushpen," which is sometimes found as a translation of the Chinese word for brush. The brush is and remains a brush, though it is capable of producing delicate quill strokes, and painting remains painting despite all its similarities to writing.

Returning to our subject of the two styles, let us first consider the careful style as illustrated by Fig. 133. This style approximates what we in the West like to call academic painting. Being realistic and more imitative of the visible world, it tends toward the double-stroke technique for rendering twigs or grass, feathers or blossoms, and normally avoids the use of the more impressionistic splashed ink. Since, as we have seen, the double-stroke technique creates spaces which somehow seem incomplete in themselves, this style is often accompanied by color employed in a "natural," realistic way. The brush is held perpendicularly, and only the tip is used, so that effects produced by broad brush strokes are not normally found in this style. Thus the ink foundation has an essentially linear character, and any painterly quality there is comes from the application of color. So far as the painting surface is concerned, the careful style requires a sized paper or sized silk. It does not really lend itself to such brush effects as flying white or splashed ink. It is the style of the academic painter, and also of the painter who tends to produce artisan work. It is the style of the naturalistic painters who work from nature sketches in their studios, and also of the essentially unliterary painters. If one reasons this out in terms of the controversy between the Northern and the Southern schools, one would place the careful style in the Northern school. But again we have to accept the fact that in China these distinctions will inevitably be confuted by many exceptions, as, for example, the work of the Sung emperor Hui Tsung (see Fig. 157), both a great scholar and a painter who used the

careful style brilliantly to produce splendid spontaneous paintings. It often happens that a painting in the careful style owes its existence to a momentary flash of inspiration and has been created in a single session or over a period of uninterrupted work, with only a single version ever seeing the light of day.

All this suggests that the spontaneous style, as illustrated in Fig. 134, is also extremely important, as the following description of it will show. This style tends to use a broad, slanting brush and to produce in the brushwork an exuberance of ink-breaking which conjures flying white and splashed ink onto the paper. It prefers an unsized paper or else silk which has the same roughness as unsized paper and opens out the broad brush. A painting surface which has this rough finish demands broad, bold brushwork—a demand which implies all the possible varieties of broken ink. The spontaneous style does not imitate nature; it simplifies, abstracts, and concentrates. It works by suggestion and by omission. Color is either unnecessary or is applied exactly like ink. It aims to catch the mood of revelation of the scholar or Ch'an monk in communion with Nature and the Ineffable. Whereas in the careful style several brushes are needed for the color alone, the use of more than one brush in the spontaneous style is frowned upon. The artist who paints in this style preserves the unity of his painting by sticking to only one brush from first to last. (This, incidentally, is the origin of the mistaken Western idea that a Chinese painter always uses only one brush for a single painting; it is true enough for the spontaneous style but not necessarily for the careful style.) In this style, the ink triumphs. It takes the place of color and proves the old adage that whoever really knows ink can make it serve as all the five colors.

As will have been gathered from the foregoing remarks, the spontaneous style is the style of the Ch'an monks and the scholar-painters, which is to say, of the nonacademic painters. It is also the style of the Southern school, of the painters who prefer the pure ink picture *(shui mo)* to the adding of color *(she se)* and of those who indulge in ink play.

Here again we come up against the usual paradox, in that most of the paintings done in the spontaneous style are the result of a long and painful process. What seems in the finished product to be so wonderfully immediate, so sure and final, so absolutely right in its construction—all this is the result of a long series of struggles to find the perfect form. But it looks like a spontaneous and genuine explosion of the painter's inspiration. As a result of this long process of creation, there often exist several versions of a spontaneous-style painting. Normally the painter values only the final one, which he either gives away to a friend who happens to be present or else sells at an exorbitant price to some collector whose taste he respects. The earlier drafts he throws

away carelessly. They may be picked up by the painter's son or his servant and taken to the market, sometimes even complete with the painter's name and seal. So it happens that genuine and fine paintings appear in circulation with forged signatures. The connoisseur will reconize them as such but will not be afraid to buy them, provided that the forged writing is not so inept as to spoil the painting.

A painting in the careful style frequently exists in only one single version—the one which the artist considers to be authentic. It may happen, though, that he paints the identical motif several times with small variations. The same phenomenon has also occurred, for example, in Japan, where the Zen monk Hakuin painted hundreds of Bodhidharmas, each one only slightly different from the others. Painters often work on a single motif over a long period, searching for the best way of expressing it, and finding it only after a long and fascinating process of experiment.

A painting in the spontaneous style often uses only a single layer of heavy ink. From this sort of painting comes the sense of inevitability which has led to the Western belief that a Chinese painter can never alter a brush stroke once it has been made. This is certainly the case with paintings in the spontaneous style, especially those painted in a single ink layer. But paintings in the careful style, particularly those using color, can be overpainted with heavy ink and so altered. This is also true of paintings in the spontaneous style which are done in several ink layers (of which the first may be in light ink). Painters who are not sure of their technique will even make a preliminary draft in light ink for spontaneous-style paintings, and then overpaint the lines in heavy ink, so that in fact it only seems to be spontaneous. This procedure is not thought highly of in China, for the ideal to be aimed at always is an absolute mastery of all techniques, which would make any retouching unnecessary. In the paintings where this has been done, only an outstanding expert of painting technique can tell in which places a lighter ink underlies the heavy ink. And spontaneity—in the Chinese meaning of the word, which connotes immediacy of expression even when achieved by means of preliminary exercises—may still abound in such a painting.

■ 8 ■ *THE PAINTING SURFACE* HAVING GAINED AN INSIGHT
into ink and bruh usages, we
can now consider their practical application as controlled by the painting surface. This leads us still deeper into the secrets of Chinese painting—and

by secrets we do not mean something frighteningly inaccessible but simply an esoteric expression for "methods." The secrets to which we now turn our attention are those of the visible structure of Chinese painting—structural secrets, so to speak. These are inseparably linked with the life and spirit of painting, because the Chinese do not make the radical division, insisted on by the West, between spirit and matter, content and form. One may anticipate by saying that what follows is an "open" secret, one known also to Western painters.

It is a question of the painting surface. This is extremely important in the creation of a painting, because up to a point it determines the style. Whether the painting surface is smooth or rough, more or less absorbent, dull or glossy —these factors markedly affect the technique to be used. For any particular painting, the painter will select the paper or the silk which he considers suitable, though of course an unsuitable surface will not entirely prevent him from painting as he wants. Thus the material at hand forces the artist to adopt a particular technique through its limitations as much as through its qualities.

Turning first to paper, we can ignore all the different types, with their beautiful names, and concentrate on the two main groups: sized and unsized.

■ UNSIZED PAPER. Paper which has been left unsized is more absorbent, thus demanding a quicker brush stroke, usually a drier brush, greater control of the ink, and a generous over-all style. Moreover, as seen in Fig. 135, it tends to require thicker brushwork, thereby breaking up the lines and producing broader ink shapes. In short, it generally encourages the spontaneous style, which was described in the preceding section. On unsized paper, the separate layers of ink take a long time to dry, and a subsequent layer can be applied over an earlier one only after a long interval. So this kind of paper lends itself to monochrome one-layer ink painting, although our example is multilayered; if colors are applied, they will be few and sparing. Because the ink runs easily on the paper, exact control is essential. While the individual brush strokes must be made quickly, the whole picture takes longer to complete, for the ink dries slowly. Of course an expert could paint in a strongly linear style on unsized paper. But the linear style is not really suitable for unsized paper, the surface of which is in any case fibrous and rough, thus inevitably tempting the brush to exuberant effects.

■ SIZED PAPER. The sizing and gluing of paper is accomplished in a single operation. Glue made from animal or fish bone is mixed with size made of alum, and the two are then applied with a broad brush. The mixture soaks

so thoroughly into the paper that either side of it can be painted on. The reverse side, however, will generally be rather more dull than the side on which the mixture has been applied; and the painter chooses whichever quality best serves his purpose.

In order to explain this important matter of how the type of paper affects a painting's style, we take the same scene just shown on unsized paper for our example of a painting on sized paper (Fig. 136). In contrast with unsized paper, sized paper lends itself to a linear style. Here the ink does not run but dries relatively quickly, thus allowing fine, sharp detailed work and making it possible to paint several layers of ink or color over each other without long waits. Although the individual brush stroke can be drawn quite slowly over the paper, the whole painting can be completed faster than on unsized paper. It is therefore a suitable painting surface for the careful style. Unlike the spontaneous style, this encourages the linear element and uses color more often.

It must be added that a painter who has mastered the use of ink and brush could certainly also produce a painting in the careful style on unsized paper, and also that a painter who is not an expert in technique tends to use sized paper for the spontaneous style. The literary painter, as often as not associated with the Southern school, generally prefers unsized paper and the spontaneous style.

■ CONTRASTED DETAILS. Let us return again to our two examples, Figs. 135–136 and consider them more in detail, reproducing three progressively enlarged sections of each.

Both paintings are based upon the same sketch, but they are entirely different in style and mood. From what has already been said, the reader will gather that the difference lies in the painting surfaces. To ignore such a difference as being unworthy of notice would be far too simple for anyone seriously trying to get to the roots of Chinese painting. Painting in China, one might say, is an endless philosophizing with a brush, an instinctive worship of one of the central ideas of the Chinese mind—that of Yang and Yin, the opposites which are complementary, the interplay of masculine and feminine.

Like everything else in China, the materials of the painter are classified, in their essential characters, according to the principles of Yang and Yin. The brush, being the giver, is thought to be Yang or masculine, while the paper, being the receiver, is thought to be Yin, or feminine. Brush usage is Yang; ink usage, Yin. Sized paper has a hard masculine quality and unsized

paper has a soft feminine quality. On hard, sized paper (Fig. 136), the contour is sharper, the line stronger. The ink becomes fixed quickly, and is also more distinctly defined. It remains steady, so to speak, and does not swim about. The painting, therefore, takes on a hard, masculine character, with a clearly detailed, well-defined style. In allowing more determined ink shapes to be constructed, the paper gives the brush an easier task, and so the brush usage is apt to suffer a gradual enfeeblement. Up to a point, it can just let itself go.

In short, the more masculine paper can result in more feminine brushwork. There is no need to worry about not having sufficient control. The quantity of ink on the brush does not matter so much, because there is no fear that the stroke will run or become blurred. The brush is free to improvise, while the paper retains the sharp definitions of the ink, and the dots remain clear. Outlines and shaping lines stay firm and almost unalterable. The wash stays obediently in its appointed place. There is no doubt that here the paper helps to determine the style of painting, even though a great master can tone down its hard masculinity.

Sized paper is the painting surface most suitable for the academically inclined painter, for the painter who demands sharp definition of outlines more than anything else, the painter who loves lines and is interested in color. It is the paper of the careful style, of the Northern school.

But, as we have already said, the opposite is also possible—it always is in China—and frequent examples are to be found throughout Chinese art history. Paper of masculine character is more or less overborne by a feminine treatment of the brush. So a painting which one would expect to have been done on unsized paper is found to have been tricked out of sized paper. In Fig. 136 P'u Ch'üan, one might say, has resisted this temptation: he has done his paper justice.

The same landscape painted on unsized paper (Fig. 135) shows how the roughness of the painting surface forces the brush hairs apart. The absorptive quality of the paper sucks the ink out of the brush with a peculiar power. Too much ink or too slow a stroke—and the painting starts swimming along the paper-fibers before it has had the slightest chance of taking proper shape. The feminine paper lies with wide-open arms waiting to receive the brush, and the brush has to summon up all its masculine authority to stay in command. The painter must be sure of his ability to control the flow of ink perfectly and master the speed of the stroke exactly. Only if he succeeds in this will the outlines remain hard; on this paper the ink tends to be broken: the flying white forms mountain, rock, and tree; splashed ink defines clearly

the tones of a flat surface. Airiness comes into this picture almost by itself, as the masculine brush underlines the feminine character of the paper.

But this paper is a dangerous mistress. A person who has once mastered its peculiarities is easily tempted to overdramatize, to indulge in something which the Chinese call *pa ch'i,* a sort of braggart demonstration of skill. It is true, as the apologists of the Southern school assert, that this paper (this style, in other words) demands greater taste, greater self-control—a sort of spiritual discipline, in fact. But one should not conclude from this, as the Southern school advocates have done, that the adherents of the Northern school necessarily have poor taste or feeble discipline.

Thus unsized paper is the proper paper for the scholarly painters, for those who indulge in ink-play *(mo hsi),* for the *shui-mo* painters who renounce the use of color, and for the spontaneous style. But here again we have to reckon with the Chinese fondness for exceptions. For paintings of the Southern school, in the spontaneous style and showing much ink-play, are also found on sized paper.

On sized paper the supple brush can paint layer on layer without fear of blurring, so that the painting goes on with no interruptions. But on unsized paper every layer must be allowed to dry out before another can be added— before leaves can be laid over branches, dots over shaping lines, washes over the distant background. Unless he uses only a single layer in his painting, the artist will need far more patience to complete a work on unsized paper than on sized paper. Here again the paradox must be stressed: the careful style can be painted swiftly and all at one go, while the spontaneous style takes a long time and must go through many separate stages. The idea is typically Chinese—spontaneous carefulness and careful spontaneity.

We go deeper into these two paintings now. Only at this depth does the mysterious world of Chinese technique really begin to reveal itself. On the sized paper (Fig. 138), mists roll where the brush has left the flat surface untouched and merely edged it with a wash. This hardly impairs the representation of the objective world; the single brush strokes recall those which the calligrapher uses for his characters.

But on the unsized paper (Fig. 137) we can see the line and the brush stroke beginning to break up. The movement toward the painterly starts. Flying white comes into its own, in contrast to the strong line and the splashed ink which dominates sized-paper paintings, although this, we must repeat, does not mean that white can never fly on sized paper, nor that ink can never remain linear on unsized paper.

Fig. 140, a detail from Fig. 136, has been enlarged more than twice. Even

so, the stroke on the sized paper is still sharply defined. It has an almost solid character about it. One imagines being able to touch it, lying so hard and firm on the paper. And even the splashed leaves of the trees, which are painted with a certain vagueness, remain clear and tangible. But on the unsized paper (Fig. 139), the breaking-up process is unmistakable. The softness of the paper, with its fibrous surface, seems to have triumphed over the shaping power of the brush. This only seems so, for the masterful power of the brush is visible in the vibrancy of the lines and planes and in the microscopic life pulsing through the brush lines. The form remains even in the breaking up, even in the baring of the molecular structure beneath. On sized paper the lines shine out brilliantly. On unsized paper the brilliance is veiled, but it is still there.

Finally, in the next two figures, we reach a magnification of almost four times. Turning first to the sized paper (Fig. 142), we discover a mysterious fascination. When one looks deeply into the forms here, it becomes startingly apparent that the brush strokes which appear so hard, firm, manly, and austere in Figs. 136, 138, and 140 now quite unexpectedly have an inner texture, a spirit of their own which expresses itself in subtle nuances. We now begin to understand why these seemingly plain black ink lines hold us as if by magic. They look at first as impenetrable as steel, but we come to realize that this steel is throbbing with an inner vitality.

The unsized detail (Fig. 141) also has a surprise in store for us, a paradoxical one in true Chinese fashion. Just as we saw the secret of the sized paper, so now we see its opposite. The painting shows that those lines and planes which seemed to dissolve into nothingness now in fact, and quite unexpectedly, retain their firm outlines. They stand out clearly and sharply.

So on the sized paper we have the wash and the flat shapes trembling from within; and on the unsized paper we have the soft forms suddenly pulling themselves together again into a strong masculinity. Here is another triumphant proof that in China all opposites are identical. It is impossible to state either that the feminine paper has conquered the masculine brush or that spirit has conquered technique. For victory and defeat are the same thing.

A careful study of these two details will have shown how the opposites which are involved meet at a certain profound level and how the methods of creation are quite different in China and in the West. Another point that must have become apparent is that the brush stroke and the ink dominate the art of painting in China, and that the only path to an understanding of this painting leads through an intimate knowledge of brush and ink techniques.

■ SILK. No discussion of painting surfaces would be complete without a reference to silk. Even though not as favored by painters as paper, it still has a long and honored tradition.

Silk cannot be painted on until it has been sized. In addition, it must be rubbed over with chalk dust immediately before use in order to remove the slightest traces of grease, which would interfere with the absorption of the ink and handicap the painter. The only other factors affecting its qualities as a painting surface are the fineness of the weave and, more important, the kind of size and the glue applied. But these are comparatively minor matters, and for our purposes it will be sufficient to consider only a single example, Fig. 143, which again shows the same landscape as that we have just been considering, but this time painted on silk.

Because it is a sized painting surface, silk is rather like sized paper in that the brush strokes remain sharply defined and dry relatively quickly when the ink is properly controlled. However, the weave roughens the surface and makes it less smooth than sized paper. To this extent silk resembles unsized paper in its tendency to break up the brush stroke, and as a result it tempts the brush to exuberant effects.

Thus painting on silk produces a style about halfway between painting on sized and unsized paper. A generally linear character can be maintained without much difficulty, but the brush stroke is roughened by the silk and tends to break up, so that flying white and broader brushwork are found more often. These tendencies are merely suggested by the nature of the painting surface, and the painter certainly is not bound to follow them. Indeed, he may turn to silk for almost every kind of painting possible on either sized or unsized paper.

PART ▪ 2 ▪ *NOTES ON TECHNICAL MATTERS*

▪ 1 ▪ *INTRODUCTION* IN THE PRECEDING PART WE HAVE DEALT with the materials, elements, techniques, and principles of Chinese painting. In the process the reader will have gained some insight into the essence of this art, which can be deepened and made meaningful by careful and studious application of this newly acquired understanding to many examples of Chinese painting.

Now we shall turn our attention to a number of subsidiary observations concerning elements and methods, which might have disturbed the flow of the argument if introduced earlier. The main purpose of the notes that follow is to try to apply cautiously—to individual aspects of Chinese painting and to individual works—the knowledge heretofore gained. But it must be admitted frankly that this is but a first attempt to explore new facets of this amazing art, an attempt which is sure to be cursory and incomplete. If the reader will bear with me, perhaps we both can learn and profit by our mistakes as we move along. I propose to make only some suggestions as a guide to more thorough studies in the future, indicating the angles at which new investigations might be started, and pointing out the natural limits of such investigations. In most cases we shall have to confine ourselves to a few sentences, merely explaining where certain differences of style or technique appear and how certain principles and their resulting techniques manifest themselves.

Once again it should be emphasized that this book is not primarily nor even marginally concerned with a historical survey of Chinese painting. Consequently the periods involved are dealt with rather broadly and out of sequence. This demands the reader's close concentration on the argument if it is to be followed accurately. On the other hand, the contrasting of similar motifs from different periods, of similar techniques as executed in different

times, will make it possible not only to perceive the continuity of Chinese art but also to understand the subtle distinctions that exist between dissimilar styles and techniques or between similar styles and techniques as executed by different artistic personalities.

In these notes there may appear to be no plan, and we may seem to jump haphazardly from one aspect to another, from this phenomenon or appearance to the next. However, to take it this way would be a misunderstanding of our purpose. Briefly, our aim is to throw some light upon Chinese painting as a whole, approaching it from its technical aspects, and to illustrate our findings by reference to the whole body of Chinese painting.

The following sections should be understood in this way. Their method of reasoning rather resembles the preliminary work of a surveyor in laying out a new road. He measures the land with his theodolite from all angles and finally decides on the best route. Once this is done, he can picture the future site even with his eyes closed, whereas we laymen have to follow the red-and-white markers with keen attention until we apprehend just how the road will go and where it will take us.

What has been done in the preceding chapters comprises the general layout on the existing map, the taking of certain measurements, the placing of the striped markers. So now let us take a stroll along the rough track and make a tentative assessment of it, hazardous and incomplete though it may be. From one marker we may not be able to see much farther than to the next one. But by the time we have reached its end, we may have gotten the feel of this road and its final destination.

■ *2* ■ *WRITING AND PAINTING* WRITING AND PAINTING have a common origin in China, as they presumably have in other countries as well. In the matter of technique, their beginnings lie very close to each other, even though painting is perhaps the older art. We have already established that this close relationship is strongly emphasized in China as, for example, by the frequent use of the same word *hsieh* for both painting and writing. In spite of this basic fact, writing and painting drifted further and further apart as the pictorial element developed and as painting came to depend more and more on brush and ink effects which are either incidental to pure calligraphy or else quite foreign to it. Some of these brush and ink effects were first conceived in the rather restricted field of calligraphy, but they broke out of the limitations of this art,

stepped over the line, and more or less pushed their way into painting, even while retaining their calligraphic nature.

The borderline between writing and painting is admittedly fluid, but it does exist. One might say that the more the upright brush is moved to a slanting position to produce special brush effects, the further it departs from calligraphy and the nearer it gets to painting. This is made graphically clear in Figs. 144–47. In 144 the brush is being used for actual writing and is held perpendicularly. In 145 the brush has moved only slightly from the perpendicular, for the method of executing the leaves is similar to writing. In 146, showing the splashed-ink technique, the brush has gone noticeably over to the slant, not only because of the width of the brush stroke but also because the movement of the brush aims at producing certain other effects, which need not concern us here. Fig. 147 illustrates the complete transition from writing to painting; here the brush is being used to begin a wash which will be completed by the water-filled brush held ready in the same hand.

A large number of Chinese characters originated in sign pictures (Fig. 148), which during the course of centuries were worn down to "drawings" of almost unrecognizable abstractions—to characters, in other words. So writing and painting, both being pictorial, are inherently related to each other. But one should not be misled into the assumption that painting originates directly from writing. The early sign pictures were not written at all; they were cut, scratched, and pressed into the bronze mold. They had nothing whatsoever to do with the brush.

Even in the old Chinese seal writing (Fig. 149), there is no trace of the brush, although, later on, this kind of writing was often imitated by the brush and was then accepted as a legitimate kind of brush writing (disciplined and formal writing—*Zuchtschrift*). Similar characters, looking rather like runes, were also scratched into bone and tortoise shell to stand as oracle signs.

Coming to actual brush writing, we can observe in Figs. 150–53 the route that Chinese calligraphy traveled. In Fig. 150 we have the brush imitating the seal writing of Fig. 149. This method is called "iron-wire seal style" because all the lines are of equal thickness; as can be seen, it represents a perversion of the brush to uncharacteristic uses. Fig. 151 shows the same seal characters executed in true brush style, while 152 shows the clear brush characters used today. Fig. 153 represents the other extreme of brushed characters, the so-called grass writing, a sort of cursive or shorthand writing which exhibits definite painterly elements, though it is undoubtedly still calligraphy and reveals the unlimited capabilities of the Chinese calligraphic

brush. One might characterize these two extremes of brush writing by saying that seal writing consists of hard and rigid abstract pictures while grass writing develops the archaic signs into a relaxed and abstract dance.

Far more than in Western calligraphy, the brush stroke in Chinese writing, as well as in painting, follows its own inner life and its own rules. When confronted with character writing that is in some way exceptionally well done, the Chinese tries to discover how the writer has produced each single brush stroke. He not only reads the characters, he tries to "read" the brush strokes as well. But in order to read them, he must first of all learn how to execute them. In the course of time, therefore, very definite ideas have evolved on how each brush stroke should actually be made.

Just as in painting, the history of calligraphy, too, brought about numerous departures from the norm and plenty of personal idiosyncrasies, and many of these, if the work of an acknowledged master, are greatly admired. But certain basic principles may still be perceived. The most important rule is that each brush stroke be made firmly and with continuous control of the movement from its very inception, whether delicate or strong, to its final knob or point. Each stroke has a prescribed form and, as seen in Fig. 154, the hairs of the brush must change direction or tilt over at exactly the right spot with exactly the right pressure to produce that correct form. Calligraphic textbooks often indicate the exact path to be followed by the point of the student's brush in forming the characters (Fig. 155). And the brush, moving in a perfect rhythm up and down, back and forth, executes strokes of extraordinary delicacy, accurately judging their precise form to the final hairsbreadth.

Even the Westerner who never expects to learn Chinese characters, let alone the writing of them, will find his understanding of Chinese painting greatly increased by a careful study of brush movements and of how they produce a genuine living brush stroke. For everything that the Chinese painter produces on his painting surface, in all its thousands of variations, derives originally from exactly the same principles as the simple brush stroke of calligraphy, although in painting the possibilities are far wider and richer. One cannot overemphasize how fundamental is the role of the brush stroke in Chinese painting. This is often overlooked in the West because we usually see Chinese painting in reproductions that do not reveal the individual brush strokes. One should therefore take every possible opportunity to visit museums and exhibitions where the detailed brushwork can be studied in genuine originals.

Our discussion here will have at least led to a better understanding of why

a Chinese painter's handwriting is so closely related to the brushwork found in his painting. Although it would be extremely difficult, if not impossible, to apply principles of graphology to Western painting, this becomes a matter of course with Chinese painting.

The graceful calligraphy of the Sung emperor Hui Tsung (Fig. 156), with its predominantly longer strokes, has been greatly admired for its almost feminine elegance and has often been copied. Note how its quite individual style bears a striking resemblance to details in his painting (Fig. 157), such as the birds' feathers, the long tapering pine needles, and the delicate tracery of the twigs.

Speaking of this same calligraphy in his book on Chinese calligraphy, Chiang Yee said: "The Emperor Hui Tsung of Sung [was] a gifted scholar, painter, and calligrapher. He distinguished himself in calligraphy by a special style to which he gave the name of Slender Gold. [This calligraphy] is an example. His writing shows him to have been a tall, thin, and handsome figure." Whatever one's opinion of Chiang Yee's little digression into graphology—and I, for that matter, admire it—one fact cannot be disputed: there is indeed a striking similarity between Hui Tsung's style of writing and his style of painting.

In Fig. 158 we have an example of calligraphy by Mi Fei, that resolute individualist who, as has been emphasized, introduced a revolutionary dot technique in such paintings as that reproduced in Fig 159. And again one observes an unmistakable connection between his calligraphy and his painting. In the one he used a broad brush and thick black ink, while in the other his dots, so familiar in leaf painting, are densely piled up into mountains with the same directness and strength. Chiang Yee remarks: "One thinks of a striking tubby figure, walking along a road, unaware, apparently, of anyone but himself." From his style we gather that Mi Fei had a powerful and reflective mind, and also probably a sense of humor.

By its very nature, bamboo painting has a particularly close connection with calligraphy. Many techniques originating in calligraphy were further developed in bamboo painting—for instance, the technique of flying white. Su Tung-p'o, incidentally—a statesman and a scholar widely versed in many fields of art—was the famous bamboo painter linked with that story which has become so typical an illustration of the coloristic quality of Chinese ink (see page 105). The richness of tone of this ink is in fact very great, probably making it an adequate substitute for color.

When we compare Su Tung-p'o's calligraphy and painting (Figs. 160–61), we find in both the same distinctness of brushwork and the same forcefulness

of the individual brush stroke. Chiang Yee says of his writing: "Su Tung-p'o was a statesman, writer, poet, painter, and calligrapher of the Sung dynasty. In his style one can discern the loose flesh and the easy manner of a fat person. Su Tung-p'o's reputation as a happy humorist has engendered the saying that one can live longer if one practices Su Tung-p'o's style.

Chu Ta became famous as a monk under the name of Pa-ta Shan-jen. His life was a protest not only against the Ch'ing emperors, who had driven him into seclusion as a member of the family of the last Ming emperor, but also against the narrow conventions of a declining art. His was a negative kind of protest, consisting of a withdrawal into himself, of indifference, and of solitude. The calligraphy and painting of this unusual man (Figs. 162–63) express his originality and his stubbornness. His superb sweeping simplifications place him rather outside the strictly academic conventions and nearer to the moderns, in spite of his odd views and his strange way of living. Pa-ta Shan-jen was a rebel who ignored all rules because he had mastered them and, at the same time, because he despised them—a rebel who isolated himself from human contacts and withdrew into himself, who hated vulgarisms, and who managed without any apparent effort of will to reconcile what he wanted to say with the methods of saying it.

To summarize, three important points will have emerged from this brief comparison of writing style and painting style. First, in China, where writing in itself is an art, there is a fundamental relationship between it and the art of painting, both arts employing the same ink and the same or a very similar brush. However, in the higher stages of its development the art of painting acquired its own characteristic differences while employing the identical tools and materials.

Second, the characteristics of an artist's handwriting are repeated, even if in modified form, in the brush strokes of his painting. If in the West we also sometimes speak of the calligraphy of an artist, thereby suggesting a connection with his handwriting, in most cases we should nevertheless be at a loss if we had to identify a Western painter's work by comparing it with his handwriting.

And third, the individuality of a Chinese painter's handwriting as expressed in his painting is a matter of nuance and necessitates a very careful study of brush strokes before one can recognize the individual touch of a master behind the styles and mannerisms that belong to his period in general. Painting is not nearly as systematized as is writing, particularly in China, with its many thousands of ideographs for an unlimited number of strokes and signs. Hence it may be farfetched to imagine a sort of graphology of painting. But if it be

granted that even the Western painter may reveal something of his character in his brush strokes, then the more likely is this to be the case in Chinese painting. The judging of a painting's authenticity will, in the final analysis, frequently have to depend upon just such intangibles as these, upon comparisons of writing and painting styles. Of course Chinese calligraphers have always been able to imitate many styles of many periods, but it is also true that they are usually best in those styles which suit their own character and temperament.

■ 3 ■ ABSTRACT AND CONCRETE

In chinese painting one often finds curiously distorted, grotesque stone formations which seem to have abandoned the attempt to represent natural stones and to have transgressed into abstraction. *The Mustard-seed Garden* gives numerous examples of abstract stone paintings which suggest pieces of modern sculpture. This tendency evidently arises from the typically Chinese urge to experiment with strange forms. The same urge finds expression in the use (as garden decorations) or the representation (as elements in a painting) of stone formations with a strongly abstract appearance; that is, they seem either not to have been shaped by nature alone and to have somehow gained a design beyond their natural shapelessness, or else to be entirely man-made creations without any reference to natural shapes. For example, see Figs. 164–65, from the *Ten Bamboos Studio*. Many similar examples can be found in other collections, such as *The Mustard-seed Garden,* and in numerous individual paintings.

This love of stone formations—which, incidentally, has been inherited by the Japanese—obviously accounts in part for the frequency with which they find their way into paintings. But there is still another reason: the desire to bring an otherwise isolated natural form more closely to the viewer's attention by a presence which can be interpreted as having been intentionally given its grotesque shape, thus rendering significant an otherwise perhaps meaningless appearance. A counterpart to this is the tendency to project concreteness into merely incidental phenomena as, for example, in finding mountains or waterfalls or trees in the natural cloud patterns of a piece of marble. This urge seems to try to link together disconnected fragments of life and to find correlatives for them in the natural world. Although these unusual forms are not abstractions in the real sense of the word—namely, not results of a

deliberate intention to eliminate a certain amount of concreteness from the appearances, of simplifying things of the visible world into something barely on the verge of recognition—the creation of such forms is really a play on the borderline between concrete and abstract. In this case, however, the tendency seems to be to pull things from meaningless existence into concreteness by giving them meaning. This tradition, as represented in *The Mustard-seed Garden* and the *Ten Bamboos Studio,* may still be recognized as a late echo in the abstract sculpture of Teshigahara Sōfū, who often makes use of it in the so-called abstract flower arrangements of his Sōgetsu school in Tokyo (Fig. 166). A parallel may also be observed in some of the sculpture of Henry Moore.

But while these stone forms indicate a Chinese tendency to pull meaningless and abstract shapes into significance, some of the techniques of Chinese painting seem to have been expressly designed in order to make the abstraction of natural phenomena easier. If the splashed-ink technique helps the painter to represent leaves or rocks with splashes of ink reducing the natural forms into something of a type, a symbol, a cipher, we are obviously confronted with a tendency toward the simplification of abstraction. This tendency is stronger in ink painting, which is in itself an abstraction, than in painting with colors. It is stronger in the broken-ink style than in the gold-line style, although a line too is an abstraction. And finally, it is stronger in the spontaneous than in the elaborate style. Thus we find it more in the literary man's painting of the Southern school. To name only four of countless examples, note the abstract qualities in Ying Yü-chien (Fig. 106), Sesshū (107), Pa-ta Shan-jen (162, 271), and Ch'i Pai-shih (273).

There is one important point to be kept in mind: this fondness for abstraction, for the channeling of natural forms into simplified formulas, never crosses the borderline into complete abstraction but always retains a certain degree of realism. None of the great masters ever entirely abandons recognizable artistic representation for the sake of complete abstraction. There is no doubt that it would be an easy step to take, but, with the possible exception of modern Japanese abstract calligraphy, and leaving aside Japan's Western-style art, it has not yet been attempted.

Perhaps it is the Chinese artist's ability to be abstract within the realm of concreteness, together with his intrinsically conservative nature, that has kept him from taking the final step. Some impulses in this direction seemed to be developing immediately after World War II, but these have been completely suppressed as aberrations during recent years. In many ways the Japanese have been more progressive, more modern, in their explorations

of the possibilities of abstraction and have thereby succeeded in expanding their artistic frontiers.

■ 4 ■ EAST AND WEST

THE INFLUENCE OF THE WEST ON CHINESE painting had been felt even in early times in the gradual spread of Graeco-Buddhist art through central Asia into China. It became really noticeable about a thousand years later in two ways. First, there were the activities of artists like the Jesuit father Giuseppe Castiglione, who arrived at the court of the Emperor K'ang Hsi in 1715 and there achieved fame under his painting name of Lang Shih-ning. Second, there were the Chinese painters who came in touch with Western forms of art through the Jesuits or via other channels and modified their own art under the influence of these contacts. In both cases the impulse was toward greater realism—toward a style of painting which sought, through a study of nature, to approach objective reality, rather after the fashion of the Chinese careful or *kung-pi* style. To adopt the Chinese classification, the impulse was in the direction of the Northern school of painting.

One painter who belongs to the group of artists who were influenced by the West was Shen Nan-p'in, also known as Shen Ch'üan. A contemporary of Castiglione, he is of special interest in that he went to Japan and lived from 1731 to 1733 in Nagasaki. There he helped introduce Western painting methods and the realistic style of Chinese painting to Japan, influencing such Japanese artists as Maruyama Ōkyo.

The paintings shown here by Shen Ch'üan (Fig. 167) and Castiglione (Fig. 168) are closely related to each other both in spirit and form. Castiglione's work shows definite Chinese characteristics in spite of his Western realism. An unwary Western observer might easily mistake the painting for a Chinese one. On the other hand, for a Chinese, there would be certain elements in the painting which to him would seem foreign and almost unintelligible. Note, for example, the strong shaping of the tree bark and the stone in the background, which indicate shading as the consequence of lighting; likewise the shaping of the deer itself and the arrangement of trees, stone, and deer which all converge backward and downward to a single point make a very un-Chinese composition. Then, again, Shen's painting would strike the Chinese observer as far too realistic and detailed. In addition, although the composition as a whole is Chinese in character, certain Western effects of perspective are unmistakable. These two paintings, in fact, represent a

crossing of Eastern and Western art. Perhaps it is symptomatic that at the highest level of Chinese painting no such crossings can be detected.

The last echoes of Graeco-Buddhist art still sound faintly in many of the Chinese temple frescos of the Ming and Ch'ing periods. These frescos, because of the natural conservatism of their painters, have preserved the old traditional forms up to the present. See, for example, the wonderful Dürer-like portrait in Fig. 169, from one of the frescos in the Temple of the Sea of Laws (Fa Hai Ssu) near Peking. Very little is known of their history, but we can imagine this one to be a self-portrait of the painter. It is by far the most unorthodox piece of portraiture in the whole temple, and when compared with the strict forms of its neighboring paintings, this head stands out with an extraordinary individuality and modernity. It furnishes, then, a link with the art of character portraiture—an art which in China began to develop slowly only in the twentieth century.

Continuing to twentieth-century Chinese art, we find the Western spirit very apparent in character portraiture and many other fields. Fig. 170 shows the head of an old man, painted by Chiang Chao-ho in the 1940's, that includes many non-Chinese elements; for example, the almost photographic accuracy with which the planes and lines of the face are worked in. Chiang was, as he himself admits, influenced by the paintings of Kaethe Kollwitz. The result is a kind of realism, but a realism lacking the social purpose and the social protest of Kollwitz's work. During the war Chiang Chao-ho made a sketch for frescos intended for a great community hall. The frescos were never painted, and the sketch has been lost. But it was photographed, and a section of it is shown in Fig. 171. The subject of this long strip of fresco was "The Horrors of War." Although the horror does make itself felt faintly, the general effect of this collection of individual portraits is not one of disaster. There appear a calmness of observation and a detachment in this strangely mixed composition, in which bodies are painted in a manner typical of Chinese brushwork while the heads show a photographic realism. Western technique has certainly influenced this picture profoundly, but again there is only the faintest echo in it of the social outcry of Kollwitz's paintings.

■ 5 ■ *CHINA AND JAPAN* IF EVEN A PROFESSIONAL OBSERVER sometimes finds it difficult to tell whether a given painting is Chinese or Japanese, the layman must feel completely baffled. The problem becomes especially complex for two reasons.

First, at various stages in its history Japanese painting has been strongly, if not decisively, influenced by Chinese art. And second, the differences, although really quite basic, seem to fade away into the merest subtleties when viewed from a distance.

If we compare individual Chinese and Japanese paintings with each other, we may be better able to formulate certain principles by which to distinguish them. But in doing so, we must bear in mind that it is not a simple matter to find pairs of paintings which are comparable in absolutely every way. Thus, in the examples that follow we can observe that the members of each pair were often painted at different periods or were products of different social conditions. What we shall actually be doing is to set against each other paintings with similar motifs and done in similar styles in order to discover some of the special ways in which they differ.

There are other dangers in this juxtaposing of paintings, but if they are kept in mind, we believe the approach will be helpful. First of all, one must take into account the dissimilarities between painting surfaces—paper, silk, or wood. Then there are differences in size, ranging from album sheets to sliding-door panels and frescos. And finally, the artist's intentions may vary—the pure painting or the decorative work. The effects of the qualities of painting surfaces have already been explained at length (pages 182 ff.). The acquired understanding will help the student to judge how far paintings on dissimilar surfaces are comparable and to reckon with the painting-surface effect in his over-all estimate of the combined factors involved.

The diversity in size or format presents a more intricate problem—one which has duly harassed the minds of those who write on art. Ideally, all reproductions of paintings should be done on the same scale, say 1:10. This method would be particularly favorable in cases where the character and quality of paintings are to be compared, for size and the distance of the observer from the painting are factors which affect this. Not to compare paintings simply because they happen to be of unequal sizes would mean to deprive oneself unnecessarily of an insight into them which should basically be oblivious of the size or the viewing distance. But then, if the contrast in size is considerable, as it is, for instance, between a mural and an album sheet, then the fact that they are scaled down in differing proportions can falsify the comparison and be seriously misleading.

Of course much depends on which elements or techniques of the paintings are being compared. The Chinese brush stroke is of a kind that does not lose, in a scaling down, any of its vigor or essential character; therefore a reasonable scaling down of the brush stroke is quite permissible provided it

is not carried too far. Chinese masters have often tried writing characters with a broom on a piece of paper spread out on the floor, without failing to capture all the essential elements of force and beauty. (And in Japan the exuberant Hokusai is said once to have drawn a picture of Daruma on a roll of paper fifty feet long.) The same masters have also written the minutest characters with brushes of very fine hair. Paintings of the same style and by the same hand have often been done on tiny album sheets smaller than playing cards and on sheets so enormous that they could be cut up into as many as ten sections to give ten separate pictures.

Finally a few words ought to be said on the differences in intention. The character of a painting expresses a fundamental trend of its epoch or of the personality of its painter. Just for that reason a finely painted landscape which is typical of a certain painter's style can be compared with a decoratively painted landscape which is typical of another's, provided that the difference between the two truly indicates the stylistic distance between the painters and that their artistic quality is comparable.

The famous seascape by Sesson (Fig. 172) undoubtedly shows certain characteristics of Chinese Sung painting. (Sesshū was greatly indebted to the Sung masters too, and his paintings are very similar in style to this seascape). Li Sung, who lived three hundred years before Sesson, was a typical Sung painter, and his tormented seascape (Fig. 173) bears all the marks of the Sung style. These two paintings are especially well suited to illustrate certain pointed stylistic differences between Chinese and Japanese painting. Both employ a forceful and vigorous brush stroke. But whereas in the Chinese one the technical perfection of the individual stroke is deliberately concealed, in the Japanese painting it is quite visible. Furthermore, the Japanese tends toward a simplification: the broadening of the brush stroke here is not always just a matter of ink technique, but is the result of a deliberate simplification aiming at the dramatic. It would be wrong to imagine that, with these two paintings, we are concerned with two different levels of artistic achievement. On the contrary, we are only stressing, for the sake of comparison, what differences exist. The issue will become clearer as we continue.

It may be mentioned here that Sesson as well as Sesshū (see Fig. 186) generally preferred a stronger brush stroke for their outlines than did the Sung painters. And it seems that the reason for this lies less in the fact that three or four hundred years separate the two styles than in the sociological dissimilarities between the two countries and in the aesthetic tastes of the painters themselves.

In Figs. 174–75 we have similar paintings of pine trees in a misty back-

ground, the first by Hsia Kuei and the second by Hasegawa Tōhaku. No one who has ever studied Oriental painting would have any doubt about which is the Chinese painting and which the Japanese. And yet, setting aside the obvious differences—the broader, more sweeping use of the brush, the stronger simplification in the Tōhaku; the more varied ways of the brush, the detailed work in the Hsia Kuei—close observation is needed to point out the distinctive diversities. One thing is certain, however: Tōhaku's screen impresses us as extraordinarily dramatic. We notice a brilliant heightening of effects. The capacity of the paper to absorb and spread everything out into a misty vagueness is exploited to the full. Hsia Kuei's painting gives the impression at first of being much more modest, even apart from its very much smaller size. For all the clarity of the wonderful brush strokes, the effect is still brilliantly concealed. One senses in it something mysterious and almost epic in contrast to the dramatic sensation of Tōhaku.

We are comparing here two pictures of different sizes: the small one by Hsia Kuei and the large screen by Tōhaku. The size of the latter painting has been drastically reduced in this reproduction; as a result, it looks more delicate or graceful than it really is. However, even on this small scale, its essential qualities are still perceivable: the extraordinary power and sureness of the brushwork, its almost magical evocation of mood, its imaginative design, and its effortless use of so many different methods and techniques. Tōhaku's brilliance in all these capacities puts him on a level with the Chinese masters and with the greatest of the Japanese painters. This claim finds support in the fact that Chinese and Japanese artists have long recognized the special skill which is needed for the large sweeping brush strokes that demand a movement from the shoulder instead of the usual wrist movement of the smaller stroke—a skill much used in China, particularly in early times when the walls of temples and palaces were available to artists. This generous skill was adopted in Japan at a much later period, about the time when the Kanō school was carrying on the old traditions in the painting of screens and sliding doors.

There are of course many cases in which external factors leave no doubt about whether one is dealing with a Chinese or a Japanese painting. The sliding-door from Nijō Palace in Kyoto (Fig. 176) has Japanese metalwork on it. In addition the skillful use of a wooden painting surface is more typical of Japanese painting. The faint sketching of the boat, with the bird standing on its deck, is so effective that we seem to feel it deep down in our minds rather than see it with our eyes. It is quite justifiable to compare this brilliant painting of the Kanō school with Fig. 177, a painting by Ts'ui Po, who lived

in the second half of the eleventh century. In both paintings we have a similar motif. And in both paintings, the aim is decorative: obviously so in the case of the sliding doors, and in the case of Ts'ui Po to be inferred from our knowledge of his other work. So there exists a legitimate basis for comparison of these two paintings in spite of their difference in size and painting surface. The glamorous technique apparent in the Japanese painting and the academic perfection of the Chinese one certainly disclose dissimilarities if one looks below the surface. And there are a number of other distinctions that need pointing out. The Japanese painting contains a certain reduction of elements which also affects the painting techniques. There are not only fewer brush strokes in the whole picture, but also single elements seems to be done with fewer strokes. This economy in strokes, or at least the appearance of economy, seems to be more typical of Japan than of China, although some Chinese painters can boast of equal economy at the same time that some Japanese go to the opposite extreme. But in the over-all view, economy and a tendency toward abstration seem to be Japanese traits, as will be seen in later examples.

One point will thus have clearly emerged: that Japanese painting has developed a degree of simplification and concentration upon essentials which we find in China only with Mu Ch'i (Fig. 178) or with Pa-ta Shan-jen (Fig. 163) and some of the Ch'an painters. This inclination toward simplification produces decorativeness in paintings that are meant to be used as decoration, such as those on screens and sliding doors, while in paintings intended to be enjoyed from a close angle, such as kakemono, makimono, and album leaves, its effect leans toward the contemplative; that is to say, using the word contemplative in the Ch'an sense, the emphasis is on the essential, on the essence which aids recognition.

The lion of the Temple of the Sea of Laws (Fig. 179) is undeniably related to the tigers and leopards of Nijō Palace in Kyoto (Fig. 180), though individual brush strokes are more clearly visible in the Chinese painting than in the Japanese one. One can again recognize the Japanese painting by external factors, such as the metalwork on the sliding doors and the gold-leaf painting surface. Moreover, the simplifying tendency mentioned above is unmistakably present. The planes and shapes, the shading and the lines are without question arranged in an aesthetic rather than a realistic relationship, whereas in the Chinese painting the decorative effect derives to a certain extent from the fact that the lines are used not so much to depict a lion but rather an allegorical creature which has become so stylized that even elements of the dragon have crept into its formation (e.g., the backbone). Making allowances

for the remotest interpretation of that word, realism was not the aim of the artist who put this lion into his picture as a Buddhist guardian.

What is true for these wild animals is also true for the geese painted by the Chinese Wang Hai-yün (Fig. 181) and the bird painting on a wall in the Nijō Palace (Fig. 182). We can set off the cunning use of a gold background to form clouds in the Japanese painting against the skill in pure composition of the Chinese painting. In the Japanese work there is a dramatic correspondence between the shapes of the clouds and the shape of the pond; and in the Chinese work there is a symbolic correspondence between the drooping grass and the standing bird, and between the wind-blown grass and the flying bird. In the Japanese work, the correspondence of forms suggests meaning, while in the Chinese the correspondence of details suggests mood.

One is not likely to hesitate in deciding that the sliding doors of Fig. 183, with their metalwork and gold leaf, were painted by a Japanese, while the painting of the branch overhanging the water (Fig. 184) must be Chinese. Discounting this obvious distinction, there is still another essential difference in these two works with so similar a motif. In the Japanese painting, extra details are added here and there for effect, while the Chinese painting, in spite of its effective interplay of branch and water, seems to be restrained, to be leaving things unsaid. Studying the Japanese painting, one feels that the small bird in profile is perhaps unnecessary; that the sharply jutting twigs near the door-pull of the right center panel accentuate a little too consciously the painter's skill in his brushwork; that the richness of decoration is a little overrich in the gnarled knuckles of the branches. The Chinese painting is not without abundance of forms, but it still has a more restrained effect. This contrast is of course partly due to a disparity in the intended functions of the two works. Sliding doors always need to be more strongly decorative than picture scrolls, because they have to play the role of the wall. Nevertheless, the divergence seems to reflect something quite fundamental. There is an old tradition in Chinese painting that a master ought to avoid *pa ch'i*. And *pa ch'i* means a virtuoso display of technical skill.

To avoid any misunderstanding, it should be repeated that we are not trying to make value judgments—although they creep in unawares—but are mainly concerned with analyzing differences. That this is not easy in a limited space as part of a larger argument will be understood. The dissimilarities in question are probably in part explicable as a consequence of different national temperaments. China, conceived on such a huge scale, so vast, so prodigal of human life, developed a class of scholars (many of whom were also painters) who were liable to be posted anywhere in the emperor's

service. Wherever they settled, they would try to adjust their personal id-
iosyncrasies to their new milieus. In spite of this books like *Shui Hu Chuan*
(Water Margin), which immortalized revolt against bad government, were
still written, and there were still painters like Mi Fei and Shih T'ao who in
their work revolted against the traditional. By contrast, the volcanic islands
of Japan, in which millions lived crowded together in a cramped, narrow
space, had developed from early times a tendency toward the explosive, and
had extended certain traditions already existing in China. There was for
example the tendency to concentrate movements into a precise fraction of
a second, which one finds in judo, in sumo wrestling, in Japanese archery,
and so on, or to produce the surprise effect that one finds in the Kabuki
theater. Furthermore there is the ritual calm of the Noh play and the tea
ceremony. And even the tea ceremony, which unfortunately is in danger of
turning into a mass performance for modern tourists, shows dramatic styliza-
tion of all movements.

Ma Yüan was one of the masters on whom Sesshū modeled himself. The
juxtaposing of a work by each of these masters (Figs. 185–86) will give
an idea of what became of Sung-style painting during the course of three
hundred years and a transplanting from China to Japan. It is interesting to
see how the Japanese painting, with its grand simplifications, becomes at the
same time more manly and more decorative than its Sung paragon. And
this is not because Sesshū uses broader brush strokes, nor because of the flat
shaping lines like the cuts of a big axe. The simplification which has taken
place in the Japanese painting does not, in fact, reflect an inner impoverish-
ment but the introduction of something like an urge to the dramatic. There
is a boisterous energy at work, using jagged, broken brush strokes to paint
the distant mountain under a sky heavy with snow, a method which is in
sharp contrast with the misty lyricism of Ma Yüan. One is actually tempted
to put this on record as a definition: to talk of Ma Yüan as lyric and of Ses-
shū as dramatic, of the Chinese as placid and the Japanese as explosive. To
what extent fundamental distinctions between the two styles of painting are
thus indicated is a question that must be left open, particularly because—
as we have already stressed—one can find examples of Chinese art which
suggest a Japanese treatment and vice versa. But for the time being, and as
long as no authoritative study of the styles of the two countries exists, such
tentative hints and suggestions may be of service to those who seek a clearer
understanding of the problem.

With Sesshū, who lived much later than Ma Yüan but felt himself to be
contemporary with him in style, the brush stroke seems to slash and parry

like a dagger stroke. Particularly impressive is the wonderful ability of the Japanese artist to simplify, and this simplifying proves to be of a kind entirely alien to that of the Chinese artist: it is more strident. The Chinese artist's method of simplification is an act of contemplation, while that of the Japanese seems to be a demonstration. Both artists are experts in technique, and it is fascinating to follow in both paintings the slashes and thrusts of the brush right up to the last.

The woodblock print is one branch of art where the difference between the Chinese and the Japanese is especially noticeable and can be appreciated even by someone who is just beginning to study Oriental art. Admittedly, there are some prints in Japan which have been influenced by Chinese prints, but these are not typical. If we set the two styles of prints against each other, the fundamental contrast should not be hard to discover. The Japanese print (Fig. 187) has developed a technique and a style in which the original design, with its lines and brush strokes, is covered over and disappears. Here the principles of woodblock design have been so thoroughly worked out that gradually the pictures came to be designed with the engraver and printer in mind. The relationship of lines, shapes, tones, and planes now has a very largely decorative purpose. The line, originally pulsating with the life of the brush, has become a mere area contour and shows little evidence that it was ever produced by brush and ink. One notices in the Japanese print a general air of abstractness.

As we have said, there do exist in Japan "imitative" prints also, which faithfully follow the original designs in their brushwork and colors. But quite early the Japanese masters began to adapt their designs to the material they were working in—wood. Of course it would be wrong to consider "imitative" prints as aberrations. Those in China, for instance—the ones which were intended primarily as illustrations for books on the art of painting, like *The Mustard-seed Garden*—had necessarily to stick very closely to the originals, to their brush strokes and colors. Moreover, the print never grew in China into an independent art form with its own rules. It always remained a handicraft, though certainly a highly developed one. In Japan the print was at first looked down on by the cultured as a cheap form of popular art, as a means of illustration, and as a poster art (advertising sumo wrestlers and actors). Later the art of the print became an independent genre, and much excellent work was produced. Of course, seen from our modern vantage point and after having become a recognized art through the efforts of its later practitioners, many of the earliest prints are today rightfully considered of top artistic quality. The fact that the art of the print was not very much appreciated until

"discovered" by the West does not detract from its importance. This independent art is an extremely faithful expression of the Japanese character. It not only shows the Japanese delight in their materials, but also offers opportunities for artists to produce those elaborate and rich simplifications of essentials which they like so much. For there is a taste in Japan for the ornate, the decorated, the pleasantly grotesque, and the striking effect (which is not the same thing as crude ostentation). Quite apart from the question of the relative values of prints in China and Japan, the woodblock print itself is perhaps the most typical expression of the difference in the national characters, and as such it deserves further study.

A marked contrast to the Japanese print is represented by the Chinese art of the print as we know it from *The Mustard-seed Garden* and the *Ten Bamboos Studio* and as it has come down to us in the traditional letter paper of contemporary painters (Fig. 188). The original brush marks, the track of the ink, and the color still remain on the block. The engraver tries to copy the original sketch down to the finest flying white or the subtlest iron-wire lines. In consequence the Chinese print often looks less like a print and rather like a water color. This is all the more so because the Chinese printers give the colored areas an extremely lively texture by working the colors into the block with the flat of the hand before the print is made. Thus again, in the print rather than in painting, an essential difference between the two countries evolves: the Chinese try to maintain the vibrant texture of the line, while the Japanese try to extract from the stroke and the shading the greatest possible decorative effect.

The two landscapes seen in Figs. 189–90 illustrate the difficulty which an untrained observer, or even an expert, can experience in distinguishing between a Japanese and a Chinese painting. Certain similarities in the technique and style of the two paintings will be at once apparent. One is tempted to assume that the Japanese Unzen, who came from Kyushu and represented the Southern school in the Edo period, modeled himself on Mo Shih-lung. This is all the more likely since Unzen himself was a scholar painter and representative of the so-called Southern school, and Mo was one of the two Chinese painters and art theorists responsible for the distinction between the Northern and Southern schools and for the partial identification of the Southern school with the scholar-painters. We know that in almost every period the Japanese were both lovers and imitators of Chinese painting. There have been times in the history of Japanese painting—especially during the years when the so-called *Nanga* or *Nansoga (Nan hua* or *Nan-tsung-hua* in Chinese, literally "Southern painting" or "Southern-school painting") was introduced

(see pages 192–97)

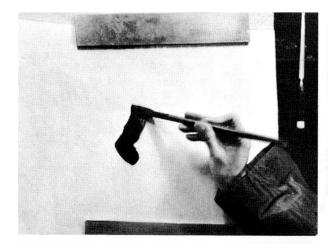

144–47. P'u Ch'üan demonstrating how slant of brush increases in transition from writing to painting: actual writing, perpendicular brush painting calligraphic-like leaves, brush almost perpendicular; splashed-ink technique, brush noticeably slanted; painted wash, brush extremely slanted.

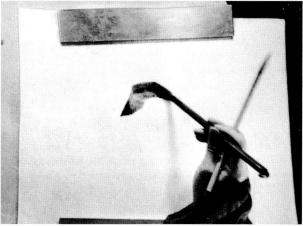

148. Pictographs from early Chinese bronze inscriptions. From Chiang Yee's Chinese Calligraphy.

149. Seal writing: inscriptions from the T'ang period. From Chiang Yee.

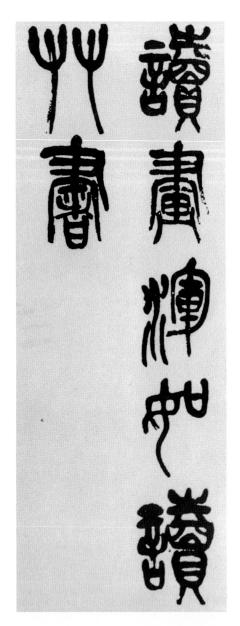

151. Seal characters in the true brush style. From Chiang Yee.

150. Iron-wire seal style, in which the brush imitated seal writing, by Teng Shih-yü. From Chiang Yee.

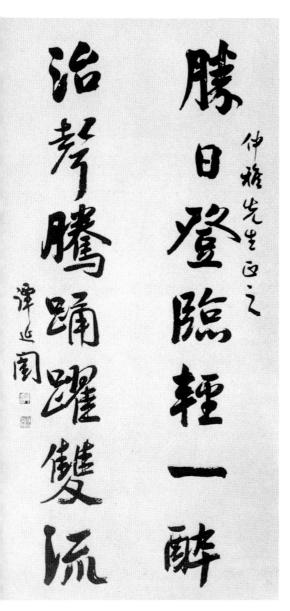

勝日登臨輕一醉

治聲騰踊躍雙流

仲梁先生正之

譚延闓

152. *Characters in the clear brush style still used today. From Chiang Yee.*

153. *Characters in grass writing. From Chiang Yee.*

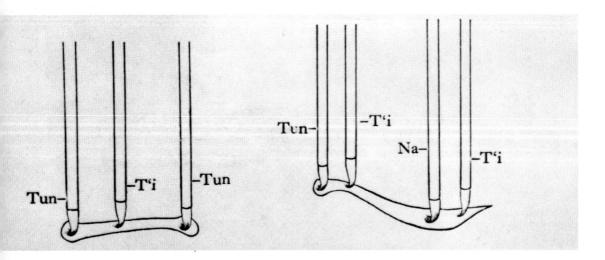

154. Brush technique for calligraphy: from a calligraphy copybook. From Chiang Yee.

155. Path for the tip of the brush indicated: from a calligraphy copybook. From Chiang Yee.

異品殊葩共翠柯嫩紅拂拂
醉金荷春羅幾點畫丹陛雲
縷重縈浴絳河玉鑑和鳴鴛
對舞寶枝連理錦成棐東
君造化勝前歲吟繞清香故
琢磨

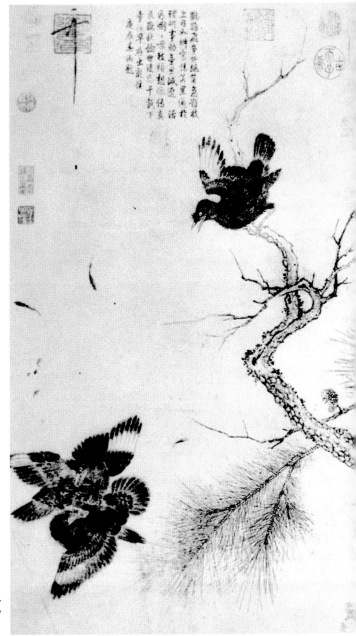

156–57. *Calligraphy and painting by Emperor Hui Tsung (Sung). From Chiang Yee and courtesy Ōtsuka Kōgeisha.*

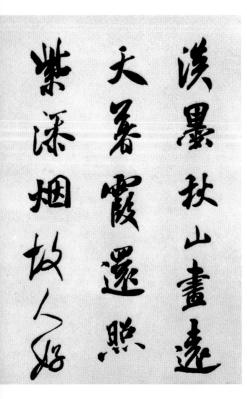

淡墨秋山畫遠
天暮霞還照
紫深烟故人好

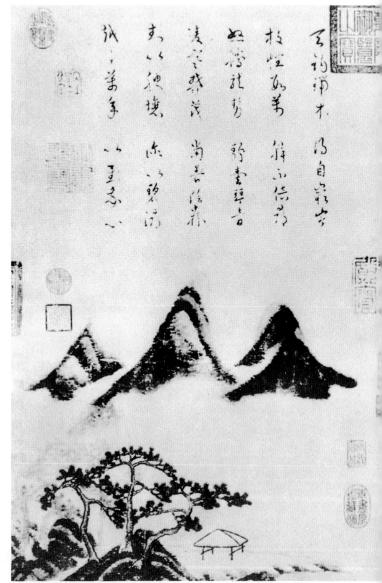

158–59. Calligraphy and painting by Mi Fei (Sung). From Chiang Yee and courtesy Ōtsuka Kōgeisha.

酒斟時須
滿十分浮

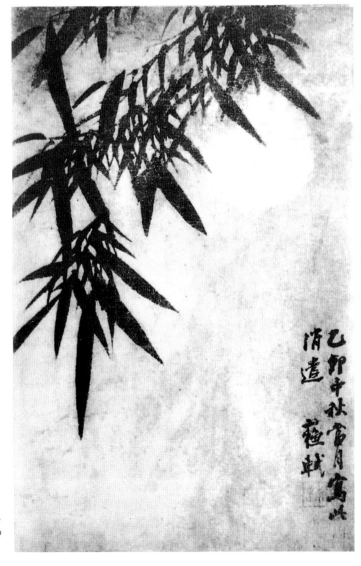

160–61. *Calligraphy and painting by Su Tung-p'o (Sung). From Chiang Yee and courtesy Ōtsuka Kōgeisha.*

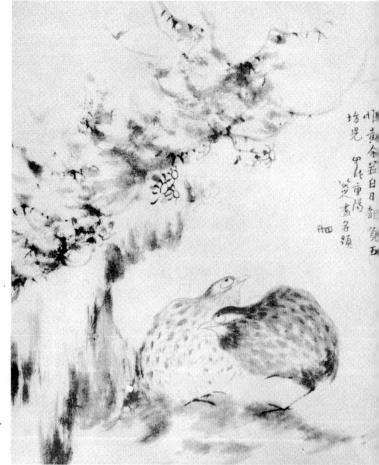

162–63. *Calligraphy and painting by Pa-ta Shan-jen (Ch'ing). Sumitomo collection.*

■ *ABSTRACT AND CONCRETE*
(see pages 197–99)

164–65. Stone formations approaching the abstract. From Ten Bamboos Studio.

*166. A Japanese abstraction in stone, by Teshigahara Sōfū (modern).
Courtesy of the artist.*

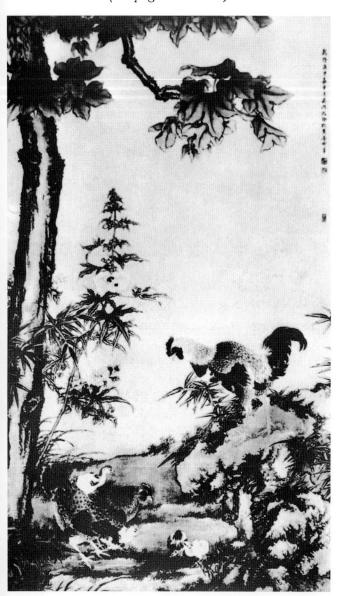

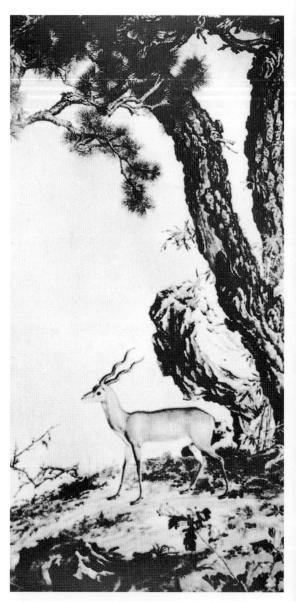

167. Chinese influences still strong in a "Western style" painting by a Chinese: Tree and Chickens, by Shen Ch'üan (Ch'ing). Courtesy Ōtsuka Kōgeisha.

168. Western influences still strong in a Chinese-style painting by a Westerner: Pine and Antelope, by Castiglione (Ch'ing). Courtesy Ōtsuka Kōgeisha.

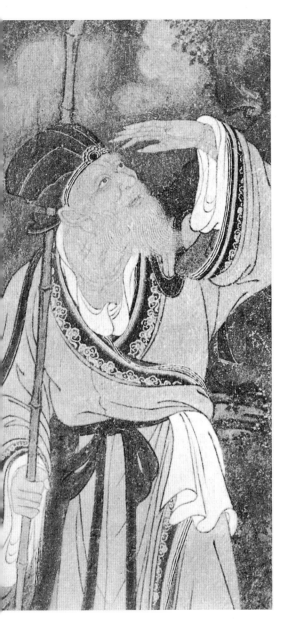

169. *Last echoes of Graeco-Buddhist art in a Dürer-like portrait: detail from a Fa Hai Ssu mural, probably Ming period.*

170. *Western influence very evident: Old Man Smoking a Pipe, by Chiang Chao-ho (Republic). Author's collection.*

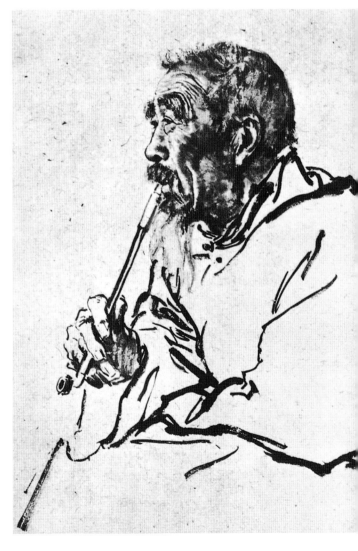

171. Another example of Western-inspired realism: section of a lost sketch for a lost mural on "The Horrors of War," by Chiang Chao-ho (Republic).

172–73. Japanese-Chinese contrast: (UPPER) *Seascape, by Sesson (1504–89);* (LOWER) *Seascape, by Li Sung (1166–1243). Courtesy Ōtsuka Kōgeisha.*

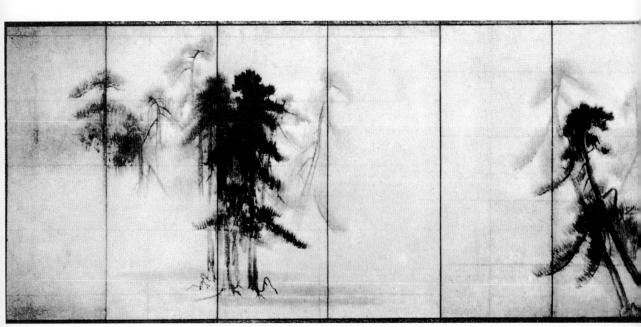

174–75. Chinese-Japanese contrast: (UPPER) *Landscape, by Hsia Kuei (1180–1230), courtesy Ōtsuka Kōgeisha;* (LOWER) *Screen with Pines, by Hasegawa Tōhaku (1539–1610), National Museum, Tokyo.*

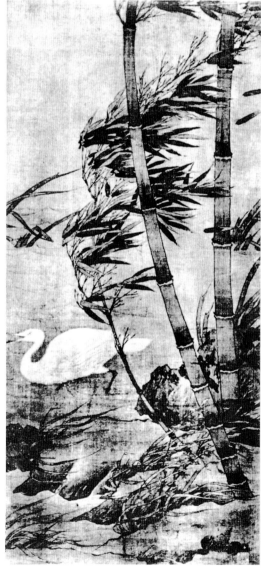

176–77. Japanese-Chinese contrast: Kanō-school painting in Nijō Palace; (LOWER) *Bamboo and Stork, by Ts'ui Po (Sung), courtesy Ōtsuka Kōgeisha.*

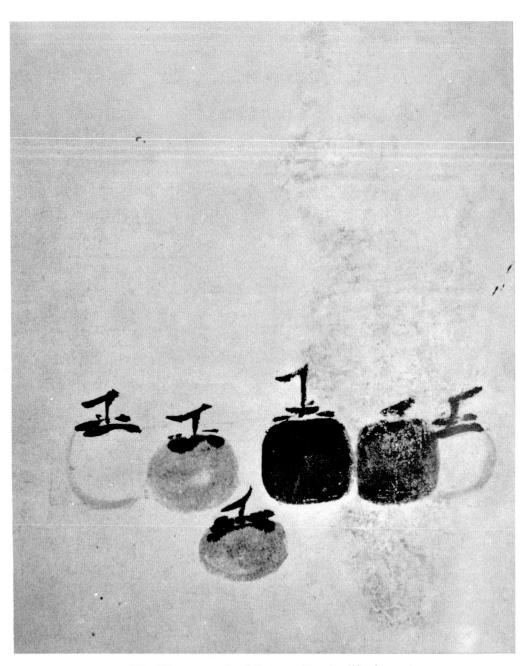

*178. Chinese example of Japanese-like simplification:
Persimmons, by Mu Ch'i (Sung). Ryūkō-in, Kyoto.*

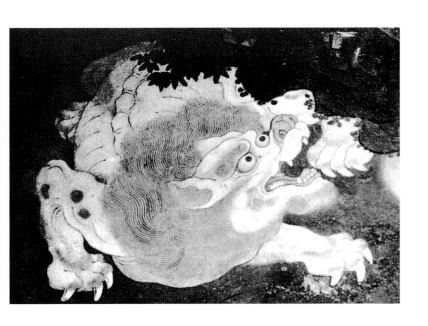

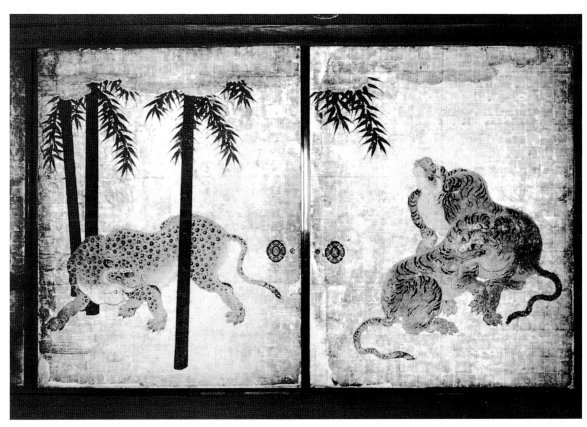

179–80. Chinese-Japanese contrast: (UPPER) Lion, from a Fa Hai Ssu mural (probably Ming); (LOWER) Leopard and Tigers, Kanō-school painting on a door in Nijō Palace.

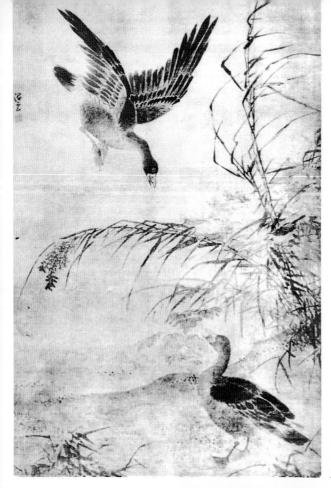

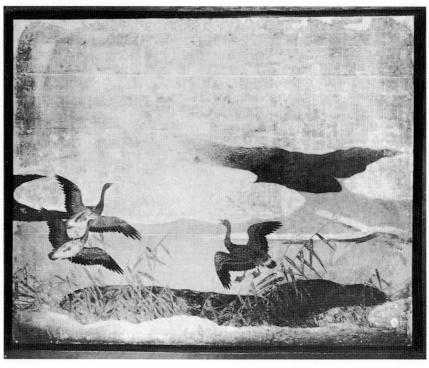

181–82. Chinese-Japanese contrast: (UPPER) *Wild Geese in Reeds, by Wang Hai-yün (c. 1500), courtesy Shina Meiga;* (LOWER) *Kanō-school painting on a panel in Nijō Palace*

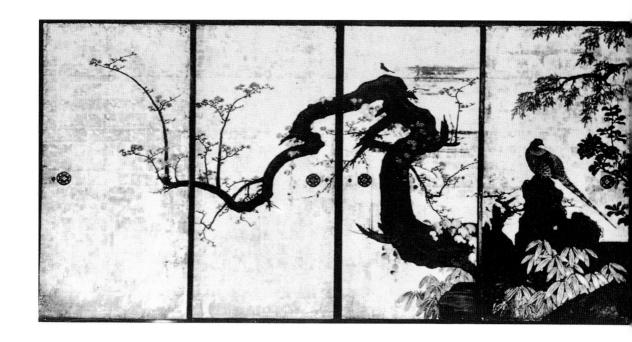

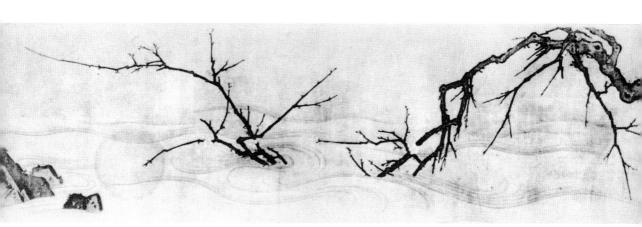

183–84. Japanese-Chinese contrast: (UPPER) painting on sliding doors by Kanō Sanraku (1559–1635), Tenkyū-in, Kyoto; (LOWER) Branch Over a Brook, by Ma Lin (Sung), courtesy Ōtsuka Kōgeisha.

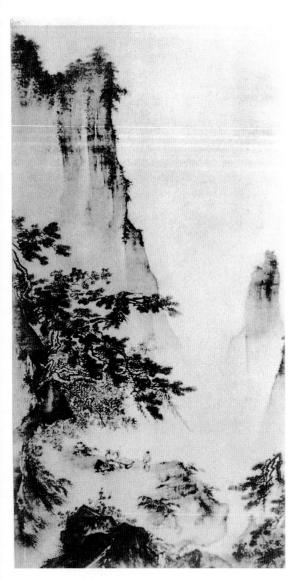

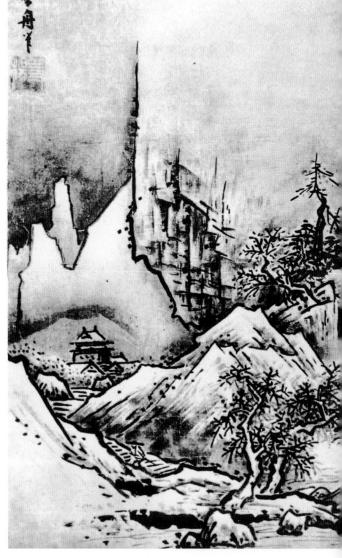

185–86. Chinese-Japanese contrast: (LEFT) *Landscape, by Ma Yüan (c. 1190–1224), courtesy Ōtsuka Kōgeisha;* (RIGHT) *Winter Landscape, by Sesshū (1420–1506), National Museum, Tokyo.*

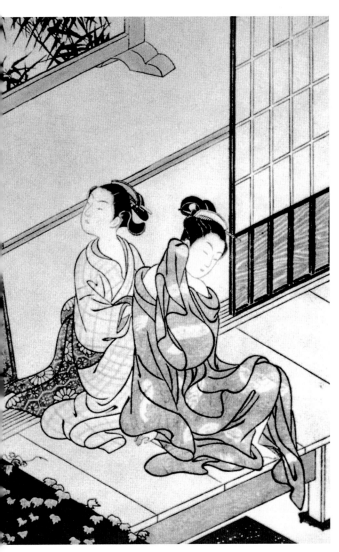

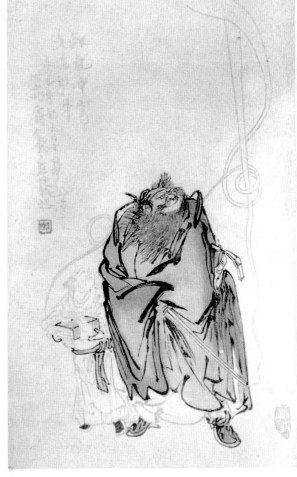

187–88. *Japanese-Chinese contrast in woodblock prints:* (LEFT) *from* "*Eight Interiors,*" *by Harunobu (1724–70);* (RIGHT) *writing paper by Hsü Yen-sun (Republic). Author's collection.*

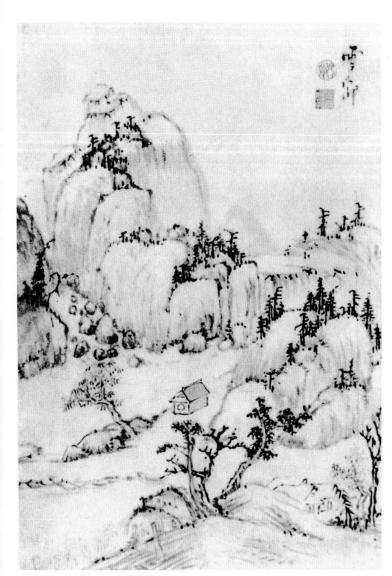

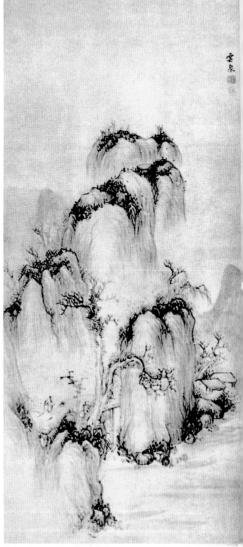

189–90. Chinese-Japanese contrast: (LEFT) *Landscape, by Mo Shih-lung (1567–1601), courtesy Ōtsuka Kōgeisha;* (RIGHT) *Autumn Landscape, by Kushiro Unzen (1759–1811), courtesy Tōyō Bijutsu.*

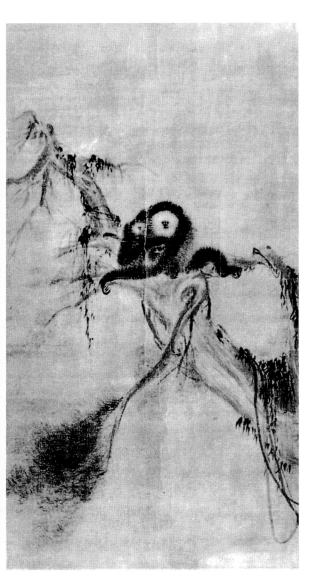

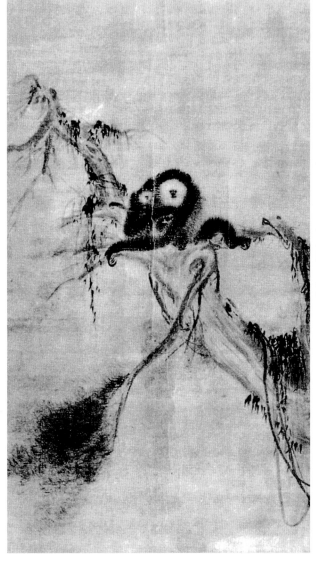

191–92. Chinese-Japanese contrast: (LEFT) *Gibbons, by Mu Ch'i (Sung), Daitoku-ji, Kyoto;* (RIGHT) *copy of Mu Ch'i's Gibbons, by Yokoyama Taikan (1868– 1958), National Museum, Tokyo.*

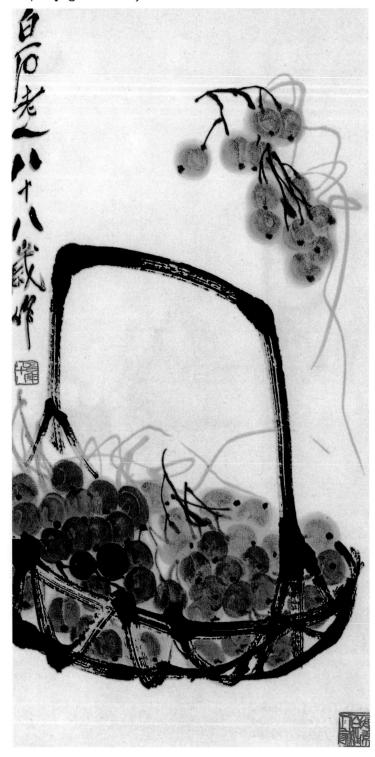

193. Grapes, by Ch'i Pai-shih (Republic). Author's collection.

194. A forged Ch'i
Pai-shih. Author's
collection.

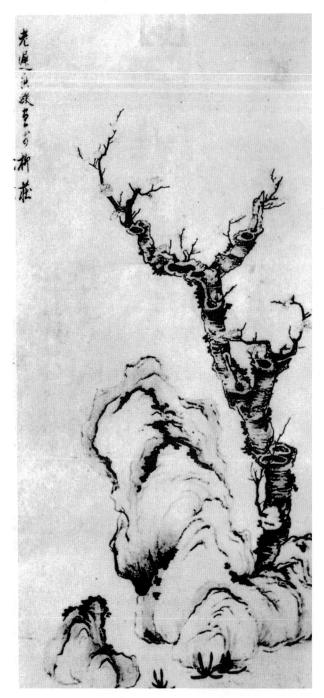

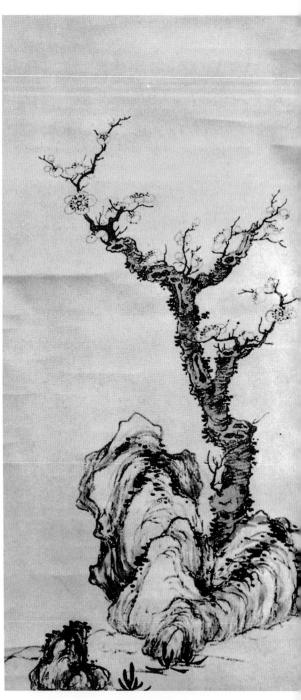

195. *Plum Blossoms, by Ch'en Hung-shou (Ch'ing). Courtesy Ōtsuka Kōgeisha.*

196. *A copy of Fig. 195, by Tseng Yu-ho (Republic). Auhor's collection.*

■ *MOOD*

(see pages 256–57)

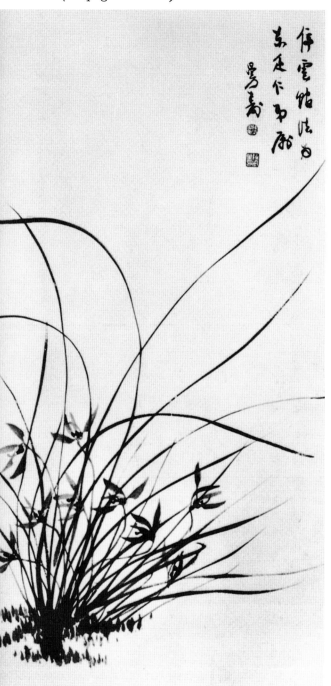

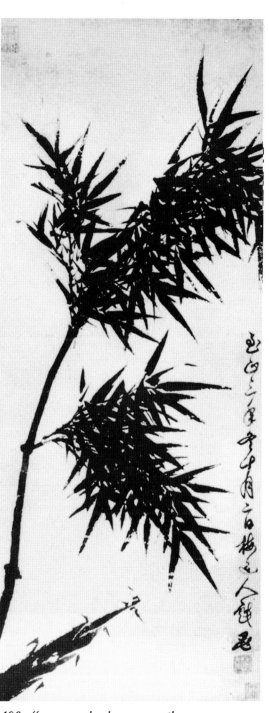

197. *"When happy, paint the iris..."*
Iris, by Ch'en Hung-shou (Ch'ing).
Courtesy Ōtsuka Kōgeisha.

198. *"... and when angry, the*
bamboo." Bamboo, by Wu Chen
(Yüan). Courtesy Ōtska Kōgeisha.

■ FINGER AND RULER PAINTING

(see pages 257–59)

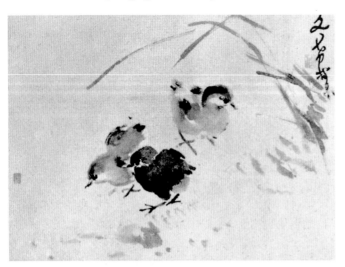

199. Finger painting: Birds in Grass, by Ch'en Wen-hsi (Republic). Author's collection.

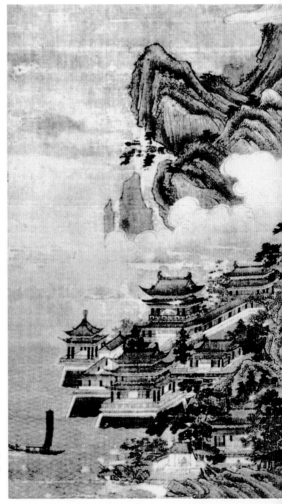

200. Boundary or ruler painting: Palace by the Sea, by Hsia Ming-yüan (Yüan). Courtesy Ōtsuka Kōgeisha.

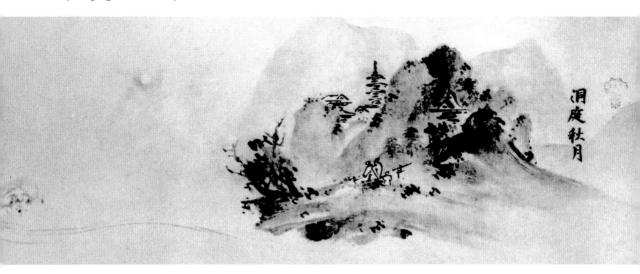

201. Autumn Moon on Tungting Lake, by Sesson (1504–89). Courtesy Geien Shinchō.

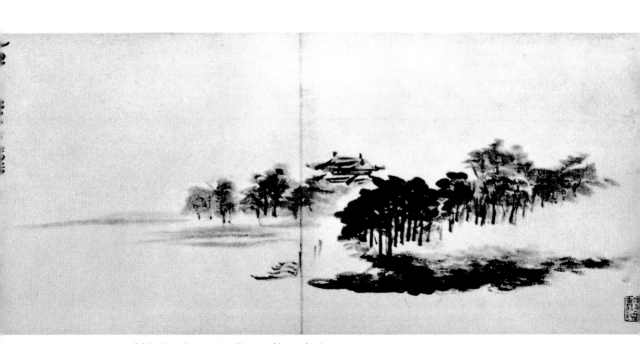

202. Landscape, by Huang Shen (Ch'ing). From a collotype reproduction.

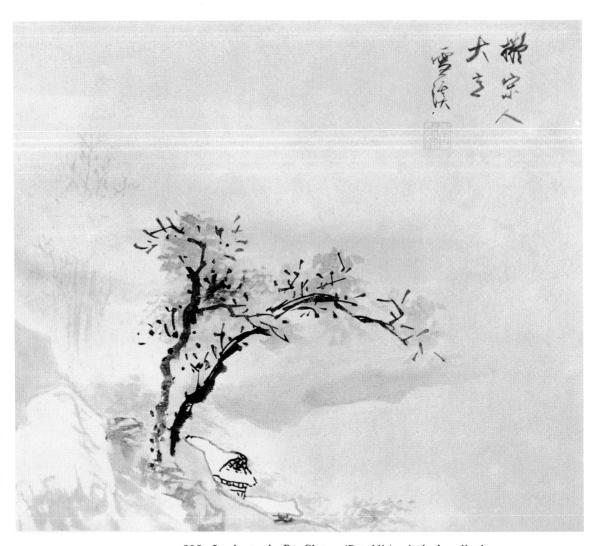

203. Landscape, by P'u Ch'üan (Republic). Author's collection

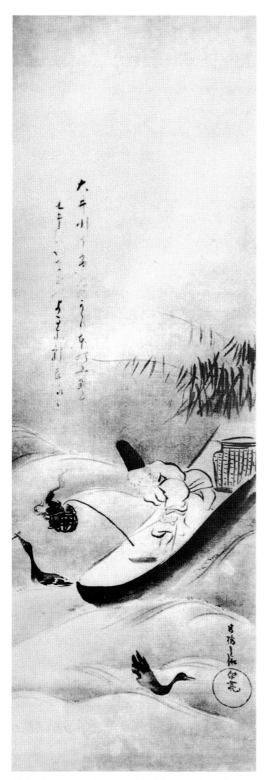

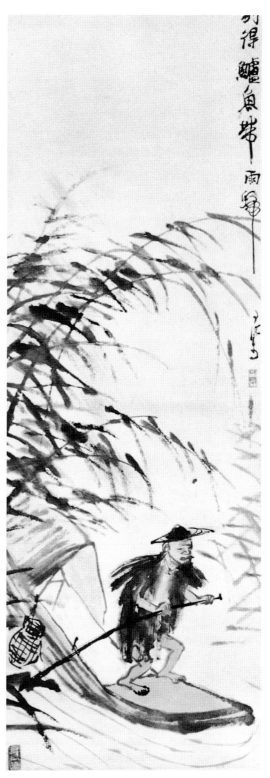

204. *Cormorant Fisher, by Kōrin (1658–1716).*
Courtesy Tōyō Bijutsu.

205. *Fisherman in Reeds, by Li K'o-jan (Re-*
public). Author's collection.

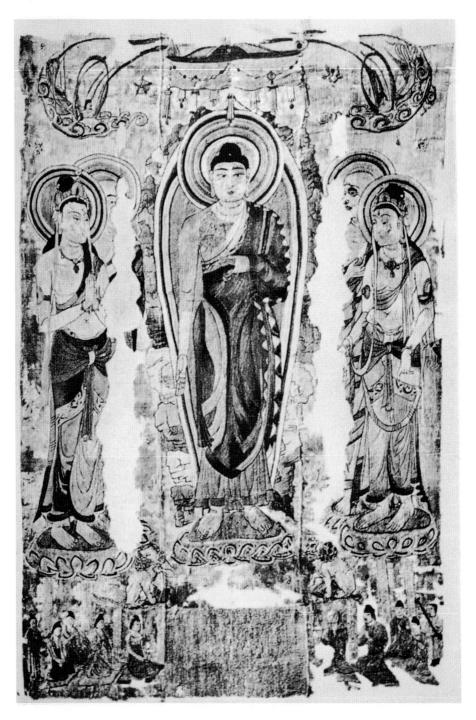

206. Silk embroidered banner. From Stein's Ruins of Desert Cathay.

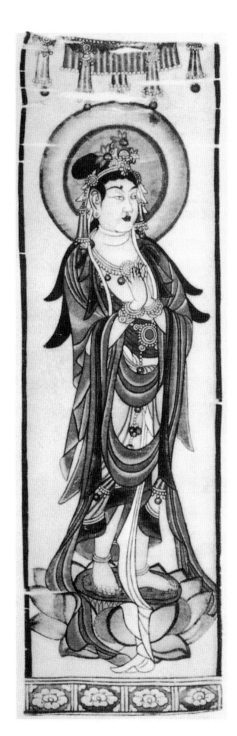 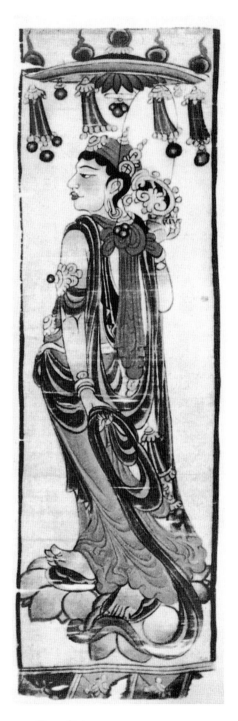

207–8. Paintings on silk gauze. From Stein.

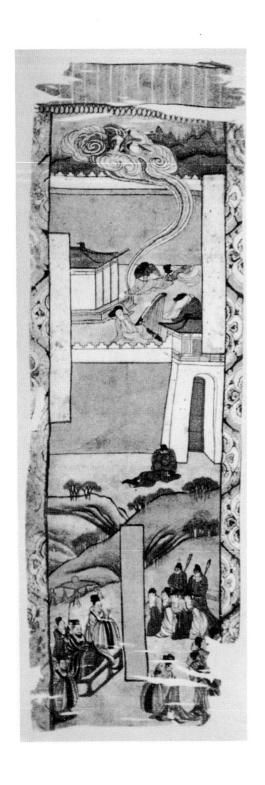

209–10. Banner paintings. From Stein.

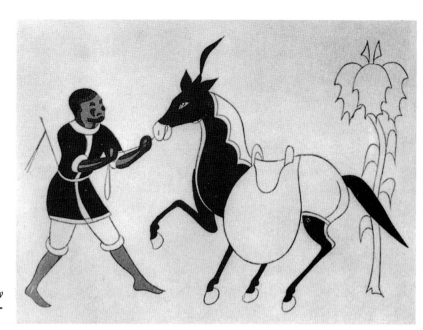

211. From Cave 288, copied by Tuan Wen-ch'ieh. From a wood-block reproduction.

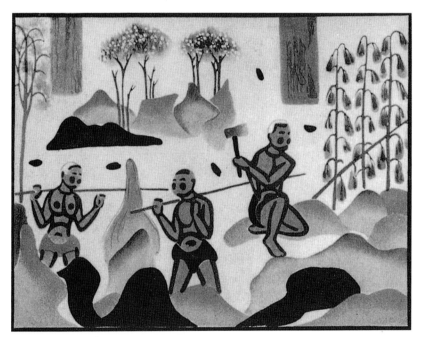

212. From Cave 302, copied by Tuan Wen-ch'ieh. From a woodblock reproduction.

213. From Cave 296, copied by Shih Wei-hsiang. From a wood-block reproduction.

214. From Cave 519, copied by Tuan Wen-ch'ieh. From a woodblock reproduction.

215. From Cave 208, copied by Tuan Wen-ch'ieh. From a woodblock reproduction.

216. From Cave 322, copied by Shih Wei-hsiang. From a woodblock reproduction.

217. From Cave 172, copied by Fan Wen-tsao. From a woodblock reproduction.

218. From Cave 61, copied by Li Ch'eng-hsien. From a woodblock reproduction.

—when it was the highest ambition of many Japanese painters to reproduce the style of Chinese models. The imitations were sometimes so close that they could hardly be distinguished from the Chinese originals, either in the style itself or in composition and idea. The greater the external resemblance between a Chinese and a Japanese painting, the more necessary it becomes to make a detailed study of all aspects of the technique of painting in order to penetrate through surface resemblances to the real differences which lie underneath.

Now perhaps it will become possible to discern the fundamental differences between these two paintings. In the Japanese one, there is a greater degree of concentration, a stronger emphasis or underlining of the elements of Chinese painting, and it makes no effort to conceal the conscious intentions of the painter, which are hidden in the Chinese painting. If one can imagine the Chinese painting as having been squeezed into the same width as the Japanese, one can see how much more concentrated are the effects of the latter. One must not, of course, accept this as a recognized method of comparison; it is only a trick of the eye.

In many cases it will naturally be possible to identify a painting by its signature. In doing this, however, one dodges the question of artistic judgment, which is, after all, the whole point. Signatures, anyway, have no value when one is dealing with a forgery, and almost every painter who has won even a limited interest among collectors and connoisseurs has also won the interest of the forger.

There are, of course, masterly legitimate Japanese copies of Chinese paintings which the artists admit to be such. Note, for example, Yokoyama Taikan's excellent copy (Fig. 192) of a Mu Ch'i painting (Fig. 191). But there also exist extremely efficient Japanese forgeries of Chinese paintings.

As we have already suggested (page 122), the Japanese tend to treat traditional techniques with a greater freedom; this shows itself in many ways. A recognition of this difference in attitude may make it easier to distinguish between typical Chinese and typical Japanese styles. The urge among Japanese painters to shake off the chains of a tradition that they have sometimes felt to be a burden has frequently become apparent. And it is one of the typically Oriental paradoxes that the Japanese, normally so strongly bound by tradition, should thus in painting have broken away with greater success than the Chinese, who are normally less bound to tradition or, one might even say, indifferent to it. (The latest development—the application of Marxism to Chinese art—must, for many reasons, be passed over here without comment.)

Among the various ways in which Chinese techniques have been carried further along more original lines in Japan, the following at least ought to be mentioned:

1. The more common use of the split brush. This technique was occasionally used by Pa-ta Shan-jen and is often used by Li K'o-jan (Fig. 248), but in Japanese painting it became a recognized procedure at an early date. We find it, for example, in the Kanō school in the work of Naonobu (Fig. 108) among others.

2. The mixing of techniques. For example, Kanō Naonobu (Fig. 108), as well as others, often executed shaping lines like big-axe cuts with a split brush and combined is with the flying-white technique. (See also page 120.)

3. *Tarashi-komi,* or the drop technique. This is seen particularly in the work of Sōtatsu and Kōrin (Fig. 104) and it is frequently found nowadays, though not always used with the same mastery and restraint as in the past. (See also page 122.)

4. *Nijimi,* or letting the ink run (Fig. 105). This technique is probably a fairly recent development and, as already suggested, is somewhat akin to Tâchism. But it is still part of a painting method where the movement of the brush is firmly controlled. As the control of ink is relaxed while that of brush is retained, new and interesting aspects of an ancient ink and brush technique have evolved. It is interesting to note that, in art courses in some grade schools in Japan, the *nijimi* technique is taught in connection with instruction on brush handling. From this one may gather that the modern possibilities of this technique are recognized, and yet at the same time the close link with tradition is emphasized. (See also page 123.)

It would be wrong to underestimate these Japanese contributions to the old brush and ink techniques. When one recalls the revolutionary impact on Chinese painting technique of such methods as Mi Fei's dot technique, or Ni Tsan's dry brush, or Shih T'ao's shaping lines, and remembers how difficult it was to break away from the tradition or to try anything new, only then can one measure the liberating effect which these Japanese techniques must have had. One may assume that sometime in the future, when intercourse between Japanese and Chinese culture will again be feasible, these modern Japanese techniques will in their turn have some effect on the traditional painting techniques of China, in many ways so rigid. And the influence will be a beneficial one. Before the political upheavals of 1949, there were signs of this happening in China, and now one notices that, after many years of neglect,

the traditional school is once more coming into favor. This is certainly linked with a policy which wants to reinterpret the achievements of the past in a new light. Nevertheless it has also something to do with the quite recent recognition of the great possibilities of an art form in which realism plays only a subordinate role, and in which many unexpressed emotional elements and symbols of great power are inextricably rooted.

Although in the course of this necessarily brief comparison of Chinese and Japanese art certain fundamental differences will have become clear, it has also become obvious how difficult is the task of expressing and summing up these differences in definite terms. The obstacles increase where an outward similarity is nothing but the cover for deeply founded contrasts based on completely divergent national characteristics. It is easy to see—and state— the differences between a painting of the Yamato school and a typical Sung painting. However, when the differences are hidden under the technical similarities of certain brush strokes or ink methods, the distinction becomes one of subtleties. The Japanese as a nation and Japanese artists as individuals have proved again and again that they have an amazing power of transmutation, of assimilation, of appropriation, so that anything they accept becomes, sometimes in a very short period of time, absolutely and unalienably Japanese. This fact makes it compulsory to delve deeply into this highly intricate question of how and where Japanese artists have made a foreign importation their own in the deepest sense, and in what way this transmutation has become manifest. Perhaps this brief attempt will induce others to deal with the problem on the basis of a sound sociological analysis and, with the instruments of exact definition of impulses and responses, to determine how they came about and what forms they created.

■ 6 ■ *GENUINE OR FALSE* The Chinese, with their great veneration for famous names of the past, are quite as interested as Westerners in establishing whether a given painting was actually painted by such and such an artist, nor have the art dealers been reluctant to exploit this veneration to their own advantage. And yet the question of whether a given painting is genuine or false is a very complex one in China, and far more difficult to answer than in the West.

There are two main reasons behind this difficulty. The first is the Chinese attitude toward copying. In the Chinese view, a painting which is known to be a copy of an old master is quite as much a "genuine" painting as is the

original. True, there may be a great difference in the prices of the copy and the original, but the painting that is obviously derived from another, faithfully echoing the composition of the original, is nevertheless a genuine painting, to be judged on its technical skill. Provided it is well done, such a painting is in no sense considered a plagiarism but an independent work of art.

The last of Hsieh Ho's six principles (see page 109) is often translated: "Copy the old masters." This principle has certainly been followed by the majority of Chinese painters, at least during the period of their apprenticeship. (It should be pointed out, however, that the principle has also been rejected quite explicitly by other painters, for example by Mi Fei and Shih T'ao.) There have even been painters who became masters almost entirely by copying old paintings, without having had teachers at all. They learned how to handle the brush by writing with it, and for the rest, they armed themselves with numerous books on painting.

As a result of this Chinese attitude, copying has been both the blessing and the curse of Chinese painting. There is not thought to be anything despicable in tracing over a painting, stroke for stroke; and to make a free reproduction of some famous painting is thoroughly honorable. All kinds of copying— tracing, exact reproduction, free interpretation—have special Chinese names, and these names show how various the methods are and what an accepted place they occupy in the Chinese painting tradition.

The second difficulty, closely allied with this attitude toward copying, lies in the exceedingly fine distinctions of Chinese painting techniques, in the Chinese conception of the fundamental importance of the brush stroke. Hence the difference between a genuine original and a masterly copy is often very subtle and minute, so much so that even an expert can be misled. The earlier the painting, the more hazardous the problem becomes. The usual practice in China is for a number of experts to examine a painting together. They will probably discuss it at enormous length before they venture a decision as to whether it indeed is the work of the painter to whom it has been ascribed. Western experts are rather more venturesome. They often seem to decide after only a few moments of screwing up their eyes in front of a Chinese painting: "Ah, not a doubt of it—a genuine Shen Chou!"

As a result of the tradition of copying and the great difficulty in distinguishing between original and copy, many paintings which were assumed to be originals became famous in Western and Chinese museums until they were finally discovered to be contemporary or later copies—for example, Ku K'ai-chih's "Admonition of the Imperial Instructress," in the British Museum, or Wang Wei's "Waterfall" (Fig. 100). Not only were honorable copies

often mistaken for originals, but numerous deliberate forgeries from the centuries-old forging studios of China have also found their way into museums and histories of art.

This same opinion has been advanced by many authorities. To name but a single example, a few years ago in Tokyo I attended a lecture on Chinese painting by Professor Y. Yashiro, the well-known Japanese scholar, during which he set forth this same view. Afterwards his sponsor complained that the professor's lecture, although extremely interesting, had dealt a hard blow at the collectors, who would now be forced to suspect the authenticity of many of the paintings in their collections.

One can see, then, why such a tremendous confusion exists over what is genuine and what is false in Chinese art. It drives us to one fundamental conclusion: a painting must be judged primarily on its artistic merit, not on its attribution. And this of course presupposes an extensive knowledge of the techniques of brush and ink.

Some years ago, in an unpublished manuscript that I had the opportunity of seeing, a Chinese scholar wrote: "It is high time that all the unprofitable discussions which go on about the genuineness or otherwise of a Chinese painting came to an end. We should take it for granted that all the paintings which appear on the Chinese market are imitations, with only a few genuine ones thrown in as exceptions to prove the rule. *Quisque preasumitur malus donec probetur contrarium* may be a deplorable principle in law; but in the no man's land of Chinese art it is an excellent means of making order out of chaos. We should always let ourselves be impressed by paintings whose beauty is beyond question, whether they are genuine or false, original or copies."

This is a refreshing attitude in view of the widespread and again paradoxical tendency in China to prize highly a painting which is clearly genuine and as clearly bad, and to appreciate artistically but undervalue financially a painting which is good but obviously not an original by a famous master. This tendency, which is also common in Japan, has led to many well-executed paintings by unknown artists being given the forged signature of some celebrity, though the name and the picture do not accord with each other. Such a painting may then come on the market just cheap enough to attract the layman by its supposed bargain value. But it will not tempt a buyer who is really an expert in art, for although he may appreciate the painting in itself, he cannot ignore the jarring discord that evidently exists between the famous signature and the artistic style—any more than he can ignore the price, which is obviously too cheap for a genuine painting by a renowned artist.

These considerations ought to make the experts more humble—and

furthermore, make them realize that only a ceaseless study of methods will pave the way to an understanding of whether a painting is good or bad, in the Chinese interpretation. This, reasonably enough, will often be found to coincide with the question of whether it is genuine or false.

Now we are ready for the two paintings reproduced here. They are contemporary paintings and have been chosen because they are examples in which a clear decision can be made as to whether they are good or bad, genuine or false. The first (Fig. 193) is a genuine Ch'i Pai-shih, painted in 1948, when the master was eighty-eight. Its genuineness is attested not so much by the signature as by the masterly brushwork and ink control and by the taste with which the grape basket has been arranged on the flat surface. These qualities are all lacking in the second painting (Fig. 194). Although this carries the same signature and seal, it is a bungled painting. To name but a few of its many faults, its brush strokes are weak, especially in the basket; the stems of the grapes are all but nonsensical; the arrangement of the grapes is monotonous; and the entire design is flat and shapeless. One further indication, though not readily apparent to the average Western expert, is the signature itself; here the well-educated Chinese, practically without needing to compare it with a genuine signature, would have no hesitancy in deciding that it was little more than a poor forgery.

It is fairly easy to come to a decision regarding these two paintings, since they were chosen for the very reason of their obvious qualities of genuineness and falsity. But in most cases one does not have both the genuine and the false available for comparison, and instead must look at a single painting and pass judgment. Here the problem becomes infinitely more complex, and one's only recourse is to the study of the minutest nuances of brush strokes and ink usages.

In the case of these two paintings, obviously what happened was this: Ch'i Pai-shih, like other Chinese painters, went through a succession of periods: a landscape period, a figure period, a bird period, a wisteria period, and during each period he used to play endless variations on a single theme. Hence the public was accustomed to seeing quite similar pictures by him showing the same subjects. So when his grape-basket period became generally known, the forgers felt comparatively safe in reaping the benefit of the master's fame, just as they had done with all his earlier periods. Perhaps they were even able to get hold of a genuine painting which he had carelessly discarded and to use it as a model in their desire to pick some of the crumbs from his table. However it came about, the fact remains that grape-basket forgeries such as this began to pop up everywhere in the painting markets,

with Ch'i Pai-shih's signature on them. Many visitors to the exhibition halls of Central Park or the antiquaries' street Liu Li Ch'ang came across a Ch'i Pai-shih which looked genuine to them and proudly carried it off home, when just a little knowledge of brush techniques would have put them on their guard and further study would have made them realize that the painting bore all the marks of a downright forgery.

■ 7 ■ ORIGINAL OR COPY

WE HAVE SEEN THAT THIS PROBLEM OF deciding whether or not a painting is genuine makes it essential for the connoisseur to study brush and ink technique. Nothing, perhaps, will better convey the importance of this study, so little understood in the West, than a comparison between an original and a copy. The original chosen for our example (Fig. 195) comes from the seventeenth century, while the copy (Fig. 196) was done as an exercise by a young Peking artist who now paints and teaches in Hawaii. Although Miss Tseng has faithfully copied the original, the work is still stamped with her own personality.

Most reproductions in Western publications are so much reduced in size and so indistinct that only a general impression of the over-all composition is given, while the essence of the original is largely lost. In Chinese art, this "essence" lies neither in the subject nor in the composition, but in the execution; and it is precisely this quality which is often sacrificed in the reproduction. However, in the paintings reproduced here, one can follow all the details of brush handling and ink work. In the copy, which frankly claims to be nothing more than an exercise, even the minutest movements of the brush are visible. Note the extremely lively texture of the flat surfaces, the emphatic, even dramatic, quality of the general outlines. Here is a talented painter using her brush with great skill. But no matter how faithfully she tried to copy the original, she could not (or perhaps would not) avoid giving the painting something of her own personality, as a close comparison of the two paintings makes clear.

In China, as already stated, there does not exist a dichotomy between technical and aesthetic values, between form and spirit. So there can be no question of the importance of technique being underrated. The idea, which is sometimes put forward in the West, that it is the total effect of the painting which counts, finds no acceptance in China. A Chinese can go into ecstasies over the disciplined grace and power of the brushwork in a painting, but he

will be equally ravished by a masterful handling of the brush which is less spectacular and does not call attention to itself. His own experience with the writing brush makes him specially perceptive in this matter, and he follows lovingly each movement of the brush, bold or subtle. In short, if the brush-work, the technique, of a copy is as good as that of the original, then in Chinese eyes it too has justified itself as a work of art.

■ 8 ■ *MOOD* IT IS SAID OF THE SUNG PAINTER KU TSUN-CHIH THAT whenever he went into his tower to paint he pulled the ladder up after him in order to cut himself off completely from mundane influences. He rubbed his ink only when the weather was fine and the wind still, so that his brush would not get contaminated with dust or dirt. On the other hand, the T'ang painter Kuo Sheng is said to have needed noise to get into the mood for his painting. He had to have musicians blow trumpets and beat calfskin drums before he could put his brush to work.

The point of these stories is that the Chinese painter must be in the right mood to paint and, conversely, that he can only truly express his own moods in his painting. In the first story, the tower is a symbol of concentration and the weather a symbol of mental purity. In the second story, the beating of drums and blowing of trumpets may also have had the connotation of driving away evil spirits.

Incidentally, the story of Ku's tower suggests that it was early in the history of Chinese art when the painter stopped working out of doors and became a studio artist. Ever since, the Chinese artist, with few exceptions, has aimed not so much at a realistic imitation of the world around him, but rather at the expression of a mood or feeling experienced in the solitude of his studio —summoning up his memories of the visible world and reacting to that world. As was remarked earlier, take away the romantic connotations from Words-worth's definition of lyricism as "emotion recollected in tranquillity" and this also becomes a good definition of Chinese studio art.

In their fondness for expressing even the deepest of artistic tendencies in epigrammatic form, the Chinese have naturally not been taciturn on this central problem of art, the expression of mood. Their epigram in this case is a kind of signpost which gives warning that painting and mood must be in accord: "When happy, paint the iris; when angry, paint the bamboo." This is true not only in its deeper sense but also literally. A calm, steady hand—which depends on a calm, steady mind—is in fact essential for rendering the

long elegant leaves of the iris (Fig. 197), while the sharp confused leaves of the bamboo (Fig. 198) seem always to have been flung down in irritation by a nervous jerky hand.

■ 9 ■ *FINGER, BRUSHLESS, AND RULER PAINTING*

IN CHINESE PAINTING there has long existed an urge to get as close as possible to the painting surface and to bypass as many as possible of the physical processes which obtrude between eye, heart, and painting surface. This has led at times to a complete abandonment of the brush in favor of parts of the artist's body, producing strange forms of painting and even some true oddities. But since this phenomenon does arise from a genuine problem of painting and, at least in finger painting, has resulted in some remarkable works of art, it is deserving of brief notice.

The techniques of Chinese painting form in themselves a unique attempt to overcome technical difficulties by assiduous study and to achieve thereby an apparent immediacy of expression. (Paradoxically, this has also made it possible for expressionless art and mere virtuosity to flourish.) It is small wonder, then, that sometimes Chinese painters have not been satisfied with the freedom given by a mastery of technique and have tried to bridge the narrow but profound gulf which must always in the end separate the painter from his work. Driven by this desire, which has also perhaps something in common with Ch'an philosophy, Chinese painters have painted with their own hair, their tongues, or their fingers.

The problem is actually a universal one. In a lecture which Gustaf Gruendgens gave in March, 1954, on the subject of "The Theater and Modern Art" (printed in the *Frankfurter Allgemeine Zeitung,* April 3, 1954) the same problem was noted. Quoting the famous German writer Lessing as a modest personality in comparison to a certain fictitious type of painter, it is explained that the modest artist Lessing "found the way from the birth of a work of art to its realization a very long and painful one. He made his fictitious conversation partner, the painter Conti, say: 'We do not paint immediately with our eyes! On the road from the eye through the arm into the brush, how much is lost!' And then Lessing himself stuck out his chest—a rather more modest chest, though—and replied: 'If I say I know what has got lost, and how it got lost, and why it had to get lost, I am as proud of this, or even prouder, as I am of everything that I don't lose. From the former I learn

more than from the latter—that I am really a great painter but that my hand often is not.' "

In China, what gets lost on the way from the eye (and in the case of the Ch'an painters, from the heart) through the arm and into the brush is much more minute and more difficult to recognize than it is in the technically ponderous art of the West. But although the Chinese painter is in fact and in spirit closer to his painting surface and actually has a greater chance of achieving immediacy (not that he always succeeds in achieving it), he has still been dissatisfied, and has even tried to do without the brush. One can think of Western parallels to this—painting with a palette knife, with the fingers, or with the tube.

Some Chinese painters have dipped their own hair in ink and painted with that. The "brush" control in such cases was obviously not very great. More common are the painters who have tried to paint with their tongues. When one thinks of the parallel between a tongue movement creating tones and a brush movement creating forms, then tongue painting seems, from the point of view of immediacy, to be not quite so eccentric.

Lastly, finger painting has won for itself quite a firm place in the history of Chinese painting, and there exist a fair number of works produced by this technique which are quite presentable. Obviously, in finger painting it is the qualities of the ink which predominate rather than any brushlike effects. The modern finger painting by Ch'en Wen-hsi (Fig. 199) shows this clearly. Here the ink has sparkle and liveliness, while the "brush stroke" completely lacks fineness and richness, for all the skill displayed in the use of the broad flats of the fingers and the sharp nails. We can hardly talk any more of an inner texture. In other words, in finger painting the painter "has ink" but "lacks brush." Another example of finger painting, showing how forceful an impression the technique can produce, is seen in Fig. 236.

The Chinese painter has never been afraid of using simple devices to help him solve his artistic problems. One example of this is the technique—admittedly not a very important one—which the Chinese call *chieh hua*. This is usually mistranslated into English as "boundary painting." Perhaps "ruler painting" would be a more accurate description of the technique, since a ruler is actually used. For example, a ruler has certainly been used for a number of the lines in Fig. 115. And in Fig. 200 the palace architecture was ruled into a freehand landscape. The complicated beam joints in the roof, the pillars, and the gables have all been drawn with a ruler, giving the painting a rather stiff, textureless quality.

This technique has always been looked down upon by the critic-scholars,

as well as by true painters, as being an "artisan" approach. Nevertheless, painters of repute have used it from time to time.

▪ 10 ▪ *SIMILAR MOTIFS AND DIFFERENT PERIODS*

IT IS VERY SIGNIFICANT THAT Japanese painters who modeled themselves on the Sung techniques, Sesshū and Sesson especially, did not cling exclusively to the style which was later usually associated with the Northern school, that is, with Ma Yüan and Hsia Kuei. The painting by Sesson (Fig. 201) shows that he was also a master of the splashed-ink technique which derived from those Sung painters who belonged to the Southern school. This painting not only suggests the Southern school but also comes near to what is called scholar-painting (in Chinese *wen jen hua,* in Japanese *bunjinga)*. It has the technical brilliance, the reckless generosity of style that one associates with scholar painting. And it is precisely this ability to use both styles (as the great Chinese masters also could) that makes the difference between literary and academic painting so uncertain and has caused so much confusion in the criticism of Oriental art. Chinese art critics usually went further than this distinction between literary and academic painters and introduced the additional classification of artisan painter *(kung jen),* using the idea of "anti-literary" to cover both the academicians and the artisans.

Huang Shen, working in the scholar-painter tradition in the eighteenth century, had the same technique of handling his brush as Sesson and his Chinese models, only with greater freedom (Fig. 202). In the language of the art critics, he handled his brush with literary nonchalance. Nevertheless, one can see in this painting the virtuosity of his dot technique, which meant that he could put his painting on paper with great speed.

It is interesting to note that the ink painting by P'u Ch'üan seen in Fig. 203 seems to have more in common with Sesson's painting than with Huang Shen's. This is because P'u has tried to capture the spirit of the Sung painters, and he can be said to have succeeded in this. P'u Ch'üan, who still lives in Peking, is one of the leading young landscape painters of China. This small painting seems to get very close to Japanese painting, but its rejection of dramatic effects in favor of mood still discloses its Chinese background.

Although there seems to be very little that is Chinese in the work of a painter like Kōrin, many of the techniques which he uses can be traced back to Chinese models. And the fact that the general impression is purely Japanese

must be regarded as a result of this special use of these techniques. For example, the style of working in planes is present in the Kōrin painting of Fig. 204 in the boat and in the headgear of the cormorant fisherman. The general motif is certainly familiar; it recalls the famous fisherman painting by Wu Chen and also one by Kung Kʻai. But it would be difficult to find a better illustration of the fact that the motif is only incidental and that in Oriental painting more than in any other kind, it is the execution which is decisive. One is again reminded of the parallel between painting and music; for a motif of painting passes before our eyes in its myriad variations in much the same way as we listen many times to a familiar piece of music rendered by different musicians. It has been said that Chinese art has comparatively few motifs. This is true, but it is only important in those cases where the Chinese painter considers originality to be his main aim. In reality, however, it is almost always the power and delicacy of the execution which is considered important. Compositions are repeated time after time, in painting as in music. The execution, the keyboard technique (the brush stroke), the sound of the strings (ink tones), the orchestration (brush and ink technique)—all these determine whether or not a well-known composition has been rendered well. A Chinese painting is really two things at the same time: a new composition and a creative rendering.

If we now look at the second painting in this group (Fig. 205), all this will become clear. It is a modern interpretation of the same old theme: the fisherman among the reeds. The painting is by a contemporary Peking artist, Li Kʻo-jan. It is painted on unsized paper, with a very loose, flowing brush technique. And although it uses traditional methods as well, it has many modern characteristics which make it a work of the twentieth century—especially since it contains a slight tendency to the *nijimi* effect discussed on pages 123 and 250.

■ 11 ■ *TUN HUANG AND THE ORIGINS OF CHINESE PAINTING*

WE HAVE ALready stated that this book is not a work on the history of Oriental art. A historical survey has been excluded here, not because it is unimportant but because it is already well known, having been dealt with in numerous other works. The historical details which will be given in the following pages are merely suggested as a means of linking up the themes with which this book is really concerned.

■ WALL AND BANNER PAINTINGS. Chinese painting has shown a continuous and uniform development from early influences which, though untraced or difficult to ascertain, have proved to be extremely strong. Parallel with this development, it has also been able to create an extraordinarily splendid and unified art, and in addition has assimilated many foreign elements. This great art embraces nearly two thousand years of time. Its scope has been relatively narrow, but its roots have gone very deep, and it has produced a richness of forms and achievements of great and lasting value which cannot be ignored.

Wall and banner paintings were the earliest forms of Chinese painting or, more accurately, the earliest forms of which we have any record. For it is quite possible that there might have existed genuinely painted pictures which have not been preserved. These would have been contemporary with the semipictorial representations on early bronzes and with bas-reliefs on such tombs as that of the Wu family in Shantung, dating from the second century, which we have left out of our account.

The walls of cave temples, which always lured people of early times with their mysterious gloom; the walls of emperors' and noblemen's palaces in the many centers of culture of early China; the walls of temples and monasteries —all these walls beckoned to anonymous artists and craftsmen (often probably monks) and offered their tempting surfaces to the painters' skill. On them they depicted the old symbolic figures of the Taoist, and later the Buddhist, pantheon.

On the banners carried in processions or at festivals, and on the draperies which hung from the pillars of the temples, all the pictorial richness of Buddhist iconography could be expressed. One can still clearly recognize the Indian origin of many of these early works. A closer look will reveal Hellenistic elements as well. Hellenism traveled the immense distance from Greece through Bactria and Bamiyan to Gandhara (where it mixed with Indian elements), and from there across the Hindu Kush, through Turkestan eastwards to the gates of China. Men like the Germans A. von. LeCoq and Albert Gruenwedel, like the Englishman Sir Aurel Stein and the Frenchman E. Chavannes, have followed in the footsteps of this migrating art and checked its route. Over the sandy deserts of Turkestan to the very portals of China came those ambassadors of Hellenic and Indian art and religion. And even then China was an ancient country, with fifteen hundred years of history and periods of political and historical greatness behind it.

Tun Huang, in northwestern Kansu, is the place where, during the first eight centuries A.D., more than four hundred cave temples and monasteries

were painted with Buddhist images and scenes. It was a stage on the great silk route where, as caravans rested and goods were exchanged, worlds of thought met. A city of temples grew up in the rock face, and in these temples pilgrims and merchants, camel drivers and caravan guards lighted butter lamps on the brocaded altars to show their devotion to this religion from India, Buddhism. When war and unrest later flowed over China, the caves were abandoned, most of them being sealed up by faithful monks, and then largely forgotten. In at least one case precious art objects and manuscripts were further concealed by being sealed into a niche within a cave chapel. Although knowledge of the caves' existence survived as a vague tradition, they were rediscovered and brought to the attention of the art world only half a century ago, and it was found that the dry climate and the careful work of stonemason and builder had preserved this extraordinary treasure of paintings and manuscripts, many over 1,500 years old, in wonderful condition. Several centuries of artistic development are reflected in the cave paintings, which include many from the early periods of Chinese painting history. In them one can trace not only the general development of Chinese art, but also the emergence of distinctive types of painting within this art.

The banners shown in Figs. 206–8, preserved by a happy stroke of fate, are all from Tun Huang. This fact does not in itself prove that they are of Chinese workmanship. There are still so many elements present in them which bear witness to the origins of this art that one would hesitate to call them Chinese at all were it not for the presence of certain Chinese features too—notably the painting of the rocks around the central Buddha. In the banners of Figs. 209–10, however, the Chinese elements are quite unmistakable. Clothing as well as furniture, architecture as well as landscape, are already definitely Chinese in character, and one is tempted to date these paintings fairly late, even as late as the Sung period. When one compares these scenes from the life of Buddha with the corresponding scenes in the Ajanta caves of central India, one realizes the distance this art has already traveled from its Indian beginnings. For we have here not only the Chinese technique of making the brush strokes, but also fundamental principles in Chinese painting, such as that of composition. The composition here is already much more highly developed than in the Ajanta paintings, with their multitudes of figures. Since these banners are in fact ascribed to the T'ang period, they cannot be considered to be early forms of Chinese art.

■ PROVINCIALISM. Although Tun Huang was situated on the great route along which trade and ideas passed from East to West and from West to East, it was still only a provincial center of art, far away from the flourishing main cities. This provincialism is suggested by a certain stiffness of the forms, as well as by a backwardness in technique. For this reason, works from Tun Huang appear to be about a hundred years earlier than city paintings of the same date. The disparity in time is obvious, for example, in a comparison of the silk banners of Figs. 207–8 and the hollow-tile painting of Fig. 7. These tiles, painted in color, are usually ascribed to the third century and are therefore probably several hundred years earlier than the silk banner. But how much more vigor they have in their forms, strength in their characterization, liveliness in their expression than do the much later, and necessarily more conventional, banners! One may conclude that the essential techniques of the brush developed quite independently in China and that the Western influence was limited to the iconographic form. Brush technique, which plays only a minor role in the banner painting, is already highly developed in the tile painting. Here it displays its capabilities in swelling and narrowing, in wet and dry brushwork, which in the course of Chinese painting history was to acquire such subtlety and elasticity of function. Of course, along with this obvious difference in quality between the two paintings, one has also to consider the difference in painting surface, in sociological conditions—to say nothing of the individual skill of the two artists. The tile, with its smooth surface and relatively small size, inspired the early master to a calligraphic elegance that shows itself in the sweep and the varying pressures of the brush stroke, while the banner, on the other hand, is not such a favorable surface for this kind of brush stroke.

■ TUN HUANG COPIES. No complete list of the Tun Huang paintings exists. The reproductions which have appeared in various works have often been only unsatisfying black-and-white photographs. Moreover, it becomes more and more difficult to compile a complete list because in recent years further caves have been opened which are also covered with paintings.

The paintings of Tun Huang, executed over a period of six hundred years from the fourth to the tenth century, actually constitute a remarkable treasure house of Chinese Buddhist painting and iconography and of the development of style and technique. In addition, the paintings are a mine of information on cultural history. We can draw on them for our knowledge of building styles, tools, and conveyances, of fashions in dress, habits, and customs. Nowhere else can we find knowledge so reliable and in such profusion.

During the Second World War, in the 1940's, a number of Chinese painters and archeologists went to live in Tun Huang and devoted themselves to the task of copying the wall paintings. It was planned to publish reproductions of these copies after the war was over. The printing of color reproductions was delayed, however, when the civil war absorbed all the energies of the nation. Only Chang Ta-ch'ien, one of China's greatest living landscape painters, actually published at his own expense a number of the copies he had made in Tun Huang. Since Chang, however, was mainly interested in the later works—that is, from the T'ang period onward—the earlier works, which are so fundamental and so interesting, remained neglected.

The majority of the painters who worked in Tun Huang stayed on in China after the Communist revolution had been successful. The rich material produced has been exhibited in foreign countries, including the Soviet Union and India. Meanwhile, a number of portfolios containing Tun Huang reproductions have appeared under the Communist regime. Some of these latter are shown here. They are reasonably faithful copies, the colors of which correspond more or less with those of the originals. And, since they are printed on matt paper and use mineral and vegetable pigments, they give a very good idea of the originals.

Fig. 211 has been ascribed by archeologists to the Northern Wei period of the fourth or fifth century. This means that the painting comes from a period in which Buddhist sculpture flourished in China under the Tartar Wei dynasty. It shows a purely linear style of art which, in comparison with the tile painting of Fig. 7 looks early and primitive, though it is actually later in date. The flat treatment and the extreme stylization of the forms was taken up again in later centuries. Many contemporary painters, incidentally, have been inspired by the Northern Wei style.

The woodcutters (Fig. 212) belong to a slightly later period, the Sui dynasty at the end of the sixth century. Already there is a suggestion of something like perspective in the slight differentiations in size and in the different planes of color. The trees have those stylized forms which we find again much later, for example, in Indian and Persian miniatures, but which also figure in the Chinese painting tradition as a method of deliberate aesthetic simplification. The movements of the woodcutters are well observed, but the faces are only conventionalized suggestions, similar to those often found in modern painting.

Dated about the same period (but perhaps a little later) is the magnificent painting of a farmer plowing (Fig. 213). The team of oxen is held in the traditional balance of contrasting brightness and darkness. The dark furrows, the peacock, the decorative forms which can be interpreted as snake and

tortoise (that ancient Chinese motif of feminine and masculine), the shapes of tree and leaf already observed in a painterly way, and the extremely effective and modern-looking composition—all these are fascinating clues to an early art of which we still know relatively little. The latticework in the background between the trees may be taken to be a stylized bamboo thicket. This is suggested first by the sticklike bamboo reeds and, second, by the shape of the leaves, which—for all the formal manner of their execution—still bear some resemblance to this plant.

The hunting scene (Fig. 214) is essentially painted in two tones of blue and white. The graceful liveliness of the game, the sweeping lines of the horses (which we find much later in the brush technique of China and of Japan), the disposition of the foliage in the total composition (the stylized forms of which remind us of the much later Indian and Persian miniatures), and the placing of the mountains in distinct layers still unrelated to each other—these are the essential characteristics of this wall painting, as they were also of the previous one from the Sui period. (One should mention here that all these illustrations show only details from larger scenes, so that each composition should really be considered only as part of a larger complete composition.)

Turning to Fig. 215, we seem to enter a landscape which is quite different and shows a far more advanced state of development. Although experts have ascribed this painting also to the Sui period, the distant mountain landscape shows a technical skill which relates it to far later works. And the diminishing scale of the boats and figures show that the period was beginning to get a firm hold on the idea of perspective. Moreover, the brushwork in the plane areas is of a kind which anticipates flying white. It is not easy to say what this river landscape is actually about. But the unusually vigorous painting of the figures, in spite of their simplified outlines, indicates an attitude of prayer or worship in all of them. Quite possibly the subject is the appeasement of the river spirits.

The boat haulers (Fig. 216) are ascribed to the early T'ang period of about the seventh century. This is a masterly painting, showing all the features of Chinese painting which had been developed at that time. Even assuming that the Tun Huang paintings were a little behind the times in the general development of Chinese art, clearly showing their provincial and artisan character, we can still gauge from this wall painting what a high standard painting had reached in that golden period of Chinese history. Few authentic paintings from that period have come down to us, and expert opinion tends more and more to a later dating of those paintings which previously were

thought to be from the Tʻang period. For this reason, the Tun Huang paintings are all the more remarkable and valuable, since they can be dated fairly accurately and are so well preserved. This is the period when the great Wu Tao-tzu lived, but none of his works can be identified with any certainty. His name is mentioned in connection with many paintings, such as those incised into stone plates, from which rubbings can be made (Fig. 250). His style is described in many treatises, and we can get a certain idea of his paintings, especially from the temple frescos, without, however, being quite sure that the famous peculiarly plastic style of Wu really looked like these.

One may make allowances for the fact that the modern copyists, who are experienced artists skillful in the traditional techniques, let many things slip unawares into their copies which would not have been current in the Tʻang period. But even so, there are certain special characteristics of this picture which we can be fairly certain were known at the time the original was painted. For instance, the way in which the steep banks are outlined suggests that a very sophisticated brush technique was being used, a conclusion which is supported by the spirited breaking up of the surface of the water. The interplay of the two figures, the balancing of individual features, and the composition as a whole involve, in fact, all those principles of painting which were most highly developed in the Tʻang and Sung periods.

The caves of Tun Huang are enlivened by hundreds of flying devas or heavenly spirits (tʻien shen in Chinese, a Buddhist term similar to Christian angels) such as those of Fig. 217. From such devas one can draw fairly reliable conclusions about the style of the Tʻang period. This style was, as we have noted, probably not very different from that of Wu Tao-tzu. He had, of course, a much greater mastery of it, painting with a force and a grandeur which impressed his contemporaries as something quite new and a great step forward in art; but to us, looking back across nearly 1,500 years, he seems to represent a quite normal stage of its development, carrying further certain elements which were already quite familiar in his time.

The farm scene of Fig. 218 is ascribed to the Sung period, to the tenth century at the earliest. There does not appear to have been any real progress made during the intervening centuries, but this is likely to be due to the provincial conservatism in ideas of painting of the monks and craftsmen of Tun Huang. The period in which this painting was done was that in which Chinese painting reached its peak of technical perfection and in which technical problems had been so thoroughly mastered that the painters could concentrate upon refinement—and this many hold to be the beginning of a decline. The scenes of rice cultivation which are shown here are perhaps of special

interest to the sociologist, since they show the farmer's tools—plow, scoop, broom, table—his ox-team, and the garments of the period. But one would scarcely imagine from these scenes that this painting was done at a time when, in the cultural heart of China, problems of perspective, composition, and technique had so far been mastered that they had come to be simply recognized preliminaries to the work of artistic creation; when they no longer stood as obstacles to the painter, but as the means by which he could freely represent the external world as he wished.

■ 12 ■ *THEMES, MOTIFS,*
AND PERIODS

■ BUDDHIST MOTIFS. It was a long journey that Buddhist painting themes and motifs traveled, from India across Turkestan and China to Japan. They passed, incidentally, through the area in which Western and Eastern, Hellenistic and Indian art met, and created, as we have noted, the so-called Graeco-Buddhist style in what is now the Afghan region of Gandhara. Hence it was that Buddhist motifs acquired Hellenistic vestments before wandering eastward along the same route by which Buddhist religion came to China. A. von LeCoq has described this route. The solitude of nature, the wildness of the mountains, the rigor of the desert have evidently all played their part in preserving both the artistic forms of earlier artists during the centuries that the paintings were being created and also the actual paintings themselves as they exist for us today.

The wall painting from the cave temple of Dandan-Uiliq in Turkestan (Fig. 219) is clearly related to the frescos of Nara, and was probably painted at about the same time. The Amitabha of the Hōryū-ji in Nara (Fig. 220) gives unmistakable evidence of the source of its motif, as a comparison of the two paintings shows. One must, however, recognize that the mudra may have a different meaning and that the desert artist obviously had to allow for irregularities in the surface of the cave wall.

In Figs. 221–23 we have three paintings, all with Buddhist motifs, but how different they are in style and treatment! The first painting shows the historic Buddha, Sakyamuni, rendered by an eighth-century artist. Here the strong ink line that typified the T'ang period is still to be seen, but already the swelling of the brush strokes presages the disintegration of the pure line and points to the broken-ink techniques that are to come. The second painting,

from the tenth century, shows the second Ch'an patriarch in contemplation as he rests his arm on a tiger. Here a painterly—and at the same time conceptual, even symbolic—breaking up of the line suggests a highly personal approach, quite unlike the formalized approach of the T'ang paintings. In the third painting, from the thirteenth century, we find a favorite subject of Ch'an Buddhism—the seventh-century poet-monk Shih-te, with his companion Han-shan; as usual, Shih-te holds a broom symbolizing wisdom and "the power to brush away every speck of sorrow." This grotesque group, painted in a flashing, cavalier manner, demonstrates that the painter had now discovered how to create expression by the use of ink.

■ CHARACTERIZATIONS. In the work of the Sung painter Liang K'ai (Fig. 224), the bold brush stroke predominates, but with genuine modesty it is concealed under an extreme compression and preserves an almost calligraphic linearity in spite of an obvious tendency toward a painterly breaking up of the line. Only in rendering the trunk of the willow tree—the decorative element in the painting, with its symbolic value of modesty—does Liang K'ai allow his skill free rein.

The restrained self-discipline of Sung painting, as represented in Liang K'ai's work just cited, is no longer valued in the Ming period, as represented by Fig. 225. Here the brush stroke dissolves into the ink planes, and linear elements are limited to only a few features of the painting. The ink predominates over the brush stroke, and no literary or aesthetic considerations hinder the Ming (Yüan?) painter from making a show of his technical prowess.

Kao Ch'i-p'ei, of the Ch'ing period (Fig. 226), seems to have inherited much from his Sung forebear Liang K'ai, though with less severity, less concentration. His work looks rather coarser, but it is still recognizably the work of a master.

A tendency toward strong characterization made its appearance early in the history of Chinese painting, as seen in the tile paintings of Fig. 7, in which individual types were rendered with concentrated simplicity. This trend, not without humor even in the earliest periods, has often taken a turn toward the grotesque particularly in depictions of monks and priests, whose special way of life seems to have provoked the artists. It is a trend not confined to any single period of time, and several examples will be found in following sections.

The broad brush stoke, the disintegration of the pure line ("ink breaking"), has been firmly established as part of the Chinese painting technique since the Sung period. In Figs. 227–28 we can observe a clear stylistic and technical

relationship between the painting of Mu Ch'i (Sung) and of Yin T'o-lo (Yüan), although the tendency to the grotesque is more marked in the latter. The technical and stylistic details of these two earlier paintings are carried even further in the painting of a wandering monk by the Ming painter Chang Hung (Fig. 229); here the linear element is almost entirely dissolved in the ink planes, whereas in the earlier paintings it still existed, in spite of the broadening of the stroke and the breaking of the line.

Grotesque characterizations or exaggerations have, as mentioned above, been a favorite subject in Chinese art. In the work of Kuan Hsiu, of the Five Dynasties period (Fig. 230), the grotesque was still painted in a linear way. The eighteen Lohan incised onto stone plates in a temple near Hangchow, which are usually ascribed to Kuan Hsiu, are famous all over China and carry the grotesque almost as far as it will go. Compared with those of Kuan Hsiu, the works of later artists such as the Sung-period Mu Ch'i (Fig. 231) look almost restrained, although they, and still later examples also, use distortion in a brilliant manner.

We come now to three paintings from the same period, the Sung. What a world of difference there is between them, however: in the technique they use, in their expression, and in their way of emphasizing brush and ink for the purpose of characterization!

With Ma Lin (Fig. 232), the ink predominates; as the Chinese put it, Ma Lin has ink. His ink usage is masterly, because he has learned how to use the ink's capacity to express things. Of course, the ink is sterile without a brush, and linear elements are certainly not entirely absent. But it is the various qualities of the ink—in shading, tones, and texture—which determine the whole character of the painting. We notice, too, that the leaves are dotted onto the lightly stroked twigs; there is, in other words, no real brush stroke but only a slight touch of the brush on the painting surface. Ma Lin's landscape style belongs to the so-called Northern school. But this painting showing Han-shan and Shih-te rather gives the impression of belonging to the Southern school (if one finds it necessary to talk in these terms at all). This only proves that the differences between the two schools are not differences of quality (as the "Southern" art critics stated they were). The fact is that great painters often use both styles.

Liang K'ai's painting of Hui-neng (Fig. 233) makes an effective contrast to Ma Lin's painting in that it puts the real emphasis on the brushwork. In Ma Lin's work, the ink usage is brilliant, while in that of Liang K'ai it is the brush usage that is outstanding. Liang K'ai definitely has brush, as the Chinese say. The qualities of the brush are here directed to a work which is

essentially linear. And even the tree trunk, which is merely hinted at, is done in strokes.

Yen Tz‘u-p‘ing (Fig. 234) has both brush and ink. The linear and the painterly, the lines and the ink planes—both of them recognized methods of painting in China—have between them created this Bodhidharma sunk in meditation. Bodhidharma was the Indian monk who brought Ch‘an Buddhism to China and to whom the discovery of tea is attributed in the charming legend of the cut-off eyebrows. After sitting Yoga-wise for many years, so the story goes, the Bodhidharma became troubled by his eyebrows, which had grown so long that they hung right down to the ground. So he cut them off, and the wind carried them away to the fields, where they took root. And from the hairs of his eyebrows, the first tea bushes grew.

These three paintings, with their very different techniques, suggest one thing: it makes no difference whether the emphasis in a painting is on the use of the ink or on the use of the brush, the master is master of both. Whether the one method or the other predominates in a painting and to what degree, does not affect the quality of the painting—in a masterpiece, both are always present.

■ BIRDS. The well-known motif of a bird on a branch is shown here in three different versions, two by Chinese painters and the third by a Japanese. They are all three very skillful artists, with undoubted technical ability. The Sung painter Mu Ch‘i, many of whose masterpieces are preserved in Japan, paints his myna bird on a pine trunk (Fig. 235) with the brilliant restraint of a monk, using the painting almost as a means of religious contemplation. He is not trying to show off, nor to impress the onlooker. Here perhaps, and in a few similar examples, we have something which is rather rare: a painter who paints not for the public but for himself, as a means of self-enlightenment or of objectifying his thoughts. In this way, a highly introspective painting is created, which, because it does not try to impose itself on anyone, conveys the essence of the Ch‘an spirit.

From the Ch‘ing period, about five hundred years later, comes the painting by Kao Ch‘i-p‘ei seen in Fig. 236. Although far less compressed and introspective, the painting again reveals a certain restraint in its technique.

Finally, in Fig. 237, we have the famous seventeenth-century Japanese version of a bird on a branch by Miyamoto Musashi, also known as Niten. It has all the intensity of a sword thrust. The artist was a disciple of Zen (that same Buddhist sect we have frequently mentioned by its Chinese name of Ch‘an) and a fencing master, and his work has all the precision which one

might expect of a brilliant swordsman. This Japanese painting is undoubtedly more dramatic than the two Chinese versions. And perhaps in the stronger visual impact which it makes one can see something of the difference between the styles of the two countries. And yet it is at the same time understandable that a painter like Mu Ch'i, whose perfect technique will be at once apparent to the connoisseur, found his spiritual and artistic home in Japan rather than in China. In fact, the Chinese art historians have had very little to say about him in their writings.

The bird motif set against a simple background of grass or trees seems to have held an endless fascination for the Chinese painter (often probably for symbolic or allegorical reasons). The next three paintings reproduced here, although having much in common, show three quite different conceptions of the motif. The painting of the myna bird (Fig. 238) is by Mu Ch'i. The kingfisher on the lotus branch by Pa-ta Shan-jen (Fig. 239) is remarkably similar in character to Mu Ch'i's bird, but the painting is on the whole more playful and light. Pa-ta Shan-jen, a member of the Ming imperial family, watched the fortunes of his family decline but remained faithful to it even under the rule of the Manchu barbarians, the conquerors from the north. He led a monastic life, withdrew into solitude, and tried to keep the world at a distance by putting strange inscriptions on his door. He did not concern himself much with the strict traditions of painting, and often ignored them altogether. In spite of this, we do not find in his work any strong urge toward originality. His deviations from tradition are, rather, the unconscious result of an individual painter who painted not for the public but, in the true Ch'an spirit, for himself. He tried to sort out in his own mind his relationship to the world and to life by means of brush and ink. His paintings therefore often appear rather whimsical; they do not pretend to be great paintings, but they still make a forceful and immediate impact on the observer.

The two birds under palm leaves by the contemporary painter Lin Feng-mien (Fig. 240), executed with thick, bold sweeps of the brush, seem at first sight to be quite alien to the preceding two paintings. Lin studied in Paris and was strongly influenced by Western art in matters of technique and ideas. He is separated from Mu Ch'i by eight hundred years and from Pa-ta Shan-jen by three hundred. Yet even at such distances of time, and notwithstanding great technical differences, Lin was never able to discard tradition completely. His brush technique is certainly coarser and makes no use of the subtler capabilities of traditional painting methods. There is in his work a lightness of space, a reduction of detail to the bare minimum, and a lively sense of aesthetic balance resulting from the interplay of planes and tones. Mu Ch'i and

Pa-ta Shan-jen were both monks; and the latter, both in his own time and later, was considered rather eccentric. Lin is nothing but a painter, though, and literary or philosophical elements intrude into his work only insofar as he belongs, like everyone else, to the spiritual current of his time.

The three paintings of Figs. 241–43 also prove to be quite instructive. Two of them are Chinese, and one Japanese. Pa-ta Shan-jen, who lived in the transitional period between the Ming and Ch'ing dynasties, and the twentieth-century Chinese painter Ch'i Pai-shih are both popular in Japan, where one finds, in fact, what are probably the best collections of the former's paintings. In comparison with these two Chinese paintings, Sesson's painting of a camellia and wagtail is done in a broader manner, but it was presumably composed in a similar spirit. The Chinese paintings seem to be more nervous, and perhaps more cunning in their use of ink. Sesson, however, achieves a wonderfully convincing balance of shapes and planes. He has a quality which is "individual," in the sense of belonging to one nation; and this "Japaneseness" can be recognized after some practice, when one learns to understand the greater forcefulness, in general and in detail, of Japanese painting. The delightful modern master Ch'i Pai-shih is so taken with his own skill that he almost carelessly brushes the wire cage over the myna bird.

■ SYMBOL AND REBUS. Certain motifs recur time after time in Chinese painting, not only because, as already mentioned, every artist tries to play new variations on the old themes, but also because these themes have a symbolic value in addition to their real meaning. Thousands and thousands of cranes and pines, like Taki's copybook sketch (Fig. 244), have in the course of centuries sprung from the brushes of Chinese painters, partly because the artists wanted to paint a pine or a crane, but partly also because they wanted to express by it the idea of longevity. For this is what cranes and pines symbolize in Chinese painting. One might, for instance, give such a painting to one's friend as a birthday present, to wish him long life.

Many such symbols take the form of a rebus, when a word is capable of having different meanings, though pronounced in the same way. For example, the bats shown in Fig. 245 take on the meaning of happiness, since both words are pronounced *fu* in Chinese. At the same time, the five bats also represent the five "blessings": long life, prosperity, health, virtue, and natural death. In this particular case, the five blessings are linked with five peaches. Since the peach, too, is a recognized symbol of longevity, these five peaches are a fivefold wish for long life.

Finally, in Fig. 246, Yün Shou-p'ing has started with the old theme of the

"Three Friends of the Cold Season" (pine, bamboo, and plum blossom) and has extended it by adding water and moon to mean the "Five Pure Things." Water and moon are both extremely rich in symbolic associations in China.

It is not easy to determine the meaning of a Chinese painting from the symbolism it contains. There are many paintings whose real significance can only be grasped by those who have a very wide and profound knowledge of Chinese history and literature. For not all symbols are like a rebus, nor are they always used with the same connotations. Symbols are often altered to suit an individual case, which makes them all the more difficult to interpret. There is for example a painting by Pa-ta Shan-jen which shows a myna bird on a branch and carries the inscription: "The myna bird understands the language of man and does not care whether the wind blows or the sun shines." Here, by the symbol of the linguistically-minded myna bird, Pa-ta Shan-jen, offspring of the Ming emperors, avows his independence from the Manchus who had usurped the throne of the Middle Kingdom.

It is impossible here to cover the whole of this subject of picture language in Chinese painting. The list of Chinese symbols which is given in Appendix 3 is necessarily incomplete with regard both to the number of items included, and to the descriptions themselves. For the world of Chinese symbolism is enormously rich, and every single symbol is likely to have numerous meanings. But the list may at least be of some assistance and, especially for the student of Chinese animal and flower painting, may open up a new dimension. It has often happened that a particular motif of Chinese painting, repeated in countless variations for many centuries, has lost its original meaning, which has either been changed or even forgotten entirely. The three accompanying paintings will illustrate this point. In Fig. 247 the original symbolism of the boy-and-water-buffalo motif is still fully present. The tiny boy leading the primitive figure of the huge animal symbolizes the conquest of the powers of nature by weak human beings. At the same time there is a contrary suggestion of the omnipotence of nature in relation to the human being, who can only occasionally subdue its vast strength. Man and beast are still relatively small compared with the grandeur of nature.

When we turn to a modern version of this motif (Fig. 248), we find the earlier symbolism to be only superficially present. In this painting by Li K'o-jan, who is still living in Peking and has tried to adapt himself to the new ways of thinking, the symbolism is definitely subordinate to the purely artistic need to create, by a skillful use of technique, recognizable forms based on the visible world. With Li, ink usage is particularly highly developed, and his manner of painting planes shows a remarkable control of brush and ink.

Finally, the symbolism disappears entirely in the painting by Hsü Pei-hung (Fig. 249), who until his death in Peking in 1954 preferred that his name be written in the French way, Péon Ju. In this painting we are concerned only with the portraits of water-buffalo, which are admittedly extremely well executed. The technique is no longer purely Chinese, and it hardly reflects the earlier conflict between man and nature—unless one assumes that the conflict is transferred to the viewer of the painting, standing fascinated by the furious glare of the buffalo.

The weakening of symbolism into allegory, as we have seen it expressed in the paintings just discussed, seems to be a feature of the development of Chinese painting (as it may be also in other cultures). The tortoise and the snake in the rubbing after Wu Tao-tzu (Fig. 250) are ancient symbols of masculine and feminine, Yang and Yin; this symbolism is reinforced here by the constellations charted on the tortoise's shell. Tortoise shells were used in early China by priests and soothsayers for fortunetelling. In the painting of Fig. 251, dated roughly five hundred years after Wu's painting, symbolism has vanished. A rich allegory has been introduced instead, and only the pair of pheasants remains from the old Yang and Yin contrast. All other elements are also intended to be allegorical. For example, the peony is a rebus for love. The early universal principle of the identity of opposites has given place to an earthly banality about the opposition between the sexes. This does not in itself determine the quality of the painting, but it does disclose the changes of a primitive concept during the process of being thought about by thousands of minds and of being painted in thousands of works.

Among the ways in which the feminine principle of water in a Chinese landscape is set against the masculine principle of mountain, the waterfall is one of the commonest. This is probably connected with the fact that a waterfall not only expresses the feminine principle in landscape, but is also a philosophical symbol of a different kind—that is, in Grosse's words, a "symbol of the endless flux of all things in this world, in which the forms are always the same but the contents are in continuous change." In the majority of paintings of this kind, human beings are lost in contemplation of the waterfall, be they scholars, as in Fig. 252 and, presumably, also in Fig. 253, or else resting woodcutters, as in Fig. 254.

Although not strictly germane to our present subject, there is another interesting point that arises from a comparison of the latter two paintings. Shih T'ao (also known as Tao Chi) is one of the few Chinese painters who have again and again advocated breaking away from the old models and painting without regard for conservative rules. In contrast to paintings pro-

duced by his contemporaries, Shih T'ao's work often shows a successful effort toward independence. Looking back on them from our present standpoint we realize, however, that in numerous ways Shih T'ao was simply carrying further traditions which already existed. Chang Ta-chien began as an imitator of Shih T'ao, and many details about his composition and technique recall Shih T'ao. Indeed, some of his own paintings have even been sold as genuine Shih T'ao work. Chang now lives in America, and although he is still a master of all brush and ink techniques, his political exile has somewhat weakened his power over the ancient means of artistic expression.

The remarks in this section represent but a very cursory treatment of an interesting and wide subject. It has heretofore been dealt with by several authors from the viewpoint of symbolism and rebus and less from the problematic angle of how these have found representation in painting. A study of great or representative works of Chinese painting dedicated purely to the symbolism they contain would be an important contribution to better understanding and would open the way to a new appreciation of that art.

■ LANDSCAPES IN MANY STYLES. Chinese painting exerts a tremendous pull even on painters who have learned in the West to paint in other techniques and to other aesthetic standards. This becomes obvious if one compares two early paintings—one from the Sung period (Fig. 255) and one from the Yüan period (Fig. 256)—with a modern landscape (Fig. 257). The modern painting is undoubtedly coarser and flatter. It does not apply the subtleties of Chinese brush technique and seems to aim only at a powerful effect. And yet one can still recognize that same feeling about composition, about the principle of mountain and water, which distinguishes the older paintings and gives them their meaning. About a thousand years lie between Fan K'uan and Lin Feng-mien, and no one can expect the modern painter to experience the same relationship to nature as the Sung painter or to express it in the same way. But a tradition must indeed exert a tremendous power if a painter, deliberately trying to break away from it, is caught, as he is here, in its invisible pull. One must assume that for a Chinese artist of today, or of the future, it will remain difficult to break away completely from the tradition, unless of course he is wrenched away from it by political directives and forced into forms of expression which are banal, without roots, and purely utilitarian in purpose.

Winter landscapes in particular have been for the Chinese painter an opportunity to symbolize the puny human race confronted with the majesty of nature. In a snow-covered landscape, where there are fewer lines and larger

plane masses, the relationship of man to nature can be expressed in a concentrated form. The solitary rider of Fig. 258 is shrunken into virtual invisibility as he follows his lonely path under the grandiose backdrop of mountains, although he is somewhat consoled in his solitude by the sight of the inviting roofs of a temple snuggling into a fold of the mountains.

In the second winter landscape (Fig. 259) a feeling of cosiness is secured in spite of the forbidding knife-edged mountains with their flat masses of snow. The curtain of the carriage has been opened; the servant is busy with the door-catch; the group has reached its destination. Here the winter landscape has become a background indicating the season. In Fig. 260, however, meaning has changed into mood. The painting could be called simply "Snow." Mountain and tree have drawn closer together, and the snow-smothered farmer's hut looks almost comfortable.

Although several hundred years separate the two paintings seen in Figs. 261–62, they seem to be linked by some inner relationship, as well as by a certain technical resemblance. Both Ni Tsan and Pa-ta Shan-jen are highly individualistic painters, and their landscapes always impress the viewer as simple and often fairly empty. They share a preference for a clear primary axis around which their pictures are built, and they like to suggest rather than to analyze in detail. Both of them give plenty of scope to the free exercise of imagination by leaving large areas untouched by the brush—in the case of Ni Tsan by using a dry brush, and in the case of Pa-ta Shan-jen by using broad sweeping brush strokes.

As has been mentioned, identical motifs take on different characters during the course of the years. The Ma Yüan landscape seen in Fig. 263, with its airy expanses inviting almost unlimited play of idea and imagination, is, in the Ming painting by Hsü Lin (Fig. 264), squeezed to a bourgeois narrowness. The group of pine trees obstructs the view into the distance, and the feeling in Ma of a bottomless abyss has in Hsü diminished to a mere rushing stream just a few feet away. Nothing could better demonstrate the transition from Sung to Ming. The fragrant Sung lightness seems to have vanished; the technique becomes stiffer. In short, from the Sung style has emerged a Ming mannerism. And yet, at the same time, the two paintings in question show technical similarities almost as striking as the dissimilarities of their expression.

Figs. 265–67 call attention to how all the familiar techniques and methods of painting are still employed in the often small-scale landscapes of the Ch'ing period. In the landscape by Wang Chi-fan the stroke techniques seem to be somewhat similar to those of Kuo Hsi or Tung Yüan, though

without their urge toward grandeur. In the painting by Yün Nan-tien (Yün Shou-p'ing) the graceful rocks and mountains are rendered in dry broken lines reminiscent of Ni Tsan. The flying-white technique is used in the opened-up shaping lines, while splashed ink is applied in the dotting of the middle-ground as well as in the fir tree of the foreground. The mood of the picture recalls Kuo Hsi of Sung. And finally in the landscape by Kung K'ai, which is painted in the manner of Mi Fei, little remains of Mi's detached attitude to the world. The foreground road-crossings (or are they streams?) lie too close to the foot of the mountains, and the mountains themselves give the impression of narrowness rather than grandeur.

Occasionally a certain tendency toward abstraction, encouraged in a way by the simplifying and concentrating Chinese brush techniques, becomes evident in Ch'ing-period painting. The painters are less concerned with expressing recognizable appearances than with the interplay of forms. With Kung Hsien (Fig. 268), who loved grotesque trees anyway, this tendency leads to a writhing of thorny tree shapes among inquisitive groups of rounded rocks strewn with plum-shaped dots. With Kao Ch'i-p'ei (Fig. 269) the abstract tendency has perhaps not gone quite so far, but it shows in the dark clusters of strokes which are evidently supposed to represent groups of pine needles, and these seem very abstract in contrast to the extended rock and mountain shapes that seem to hang down into the painting. Finally in the painting by Wang To (Fig. 270), one senses in the rhythms of the hardly identifiable tree (cedar?) an attempt to picture the rhythms of dance.

Pa-ta Shan-jen (born about 1620) and Shih T'ao (flourished about 1660–1710) were contemporaries and shared the same outlook. Both rebelled against ancient rules and created original paintings which, in their own time, must have appeared to be protests—though, seen now from a historical distance, they take their place in the stream of tradition. Both were monks, and by their work they infused new life into the old Ch'an methods. Shih T'ao painted mainly landscapes, and Pa-ta Shan-jen was best at small paintings of birds and fish which were strongly abstract in character, though he also painted many landscapes. The shaping-line techniques of both painters are original and owe hardly anything to the conservative forms. Or so it seems at first sight. In fact, however, the shaping lines used by Pa-ta Shan-jen (Fig. 271) bear a certain resemblance to shaping lines like rolling billows of cloud, while behind the nervous spirals of Shih T'ao (Fig. 272) one may recognize shaping lines like veins of lotus leaves. These resemblances should not be exaggerated, but at least they indicate that even a painter like Shih T'ao, who advocated in his brilliant critical writings a complete abandon-

ment of tradition, and in his own time appeared as an original force, still finds a place in the flow of a great tradition. The banks of this stream may fade out of sight in the distance, but the islands which lie in it are constantly regenerated and given new shapes by all the wealth of material swept down by the current.

As seen in Fig. 273, Ch'i Pai-shih liked to paint his landscapes—unfortunately all too rare—with a relatively dry brush and light ink, accentuating in heavy ink only rocks and rooftops. In his own way, Ch'i Pai-shih is quite as original as the two Ch'ing painters we have just considered, and he cares just as little as they about effect. Unlike these two, however, he is neither a Ch'an philosopher nor a scholar, though fundamentally his manner of painting is similar to scholar painting. Here again we come across one of those paradoxes, frequent in Chinese painting, which make categories and distinctions in painting appear so arbitrary. Ch'i was, first and foremost, a painter and produced his poems only to harmonize with his paintings, or made his poems the subjects of his pictures. To him, the writing was always less important than the painting.

The Yüan painter Chao Meng-fu, who was probably never forgiven in China for having been a sort of court painter to the Mongol usurper Kublai Khan, was considered to be a realist, and confined himself to imitating the great masters, especially in the horse paintings which have made him famous. The landscape of his shown in Fig. 274 suggests something quite different, though: the ability to paint in forceful generalizations, reducing the scene to its simplest elements. This surely limits the "realistic" quality of the work (although it has some color), and it also emphasizes a more profound quality which we see reflected in the interplay of the bright and the dark, of the planes and the lines. There may appear to be no immediate connection between this painter and Shih T'ao, but there are in fact many deep links between them. The interplay of lines and dots has become more nervous, and the picture seems to vibrate. One feels something of the same kind in the Huang Shen landscape of Fig. 275. His pictures are especially popular in Japan, and although not a true scholar-painter in the narrow sense of the word, he painted what are considered to be scholar paintings. The important point about this often fruitless and rather arbitrary distinction between painters remains, however, not whether a man is a good scholar, but whether he is a good painter. The final test is, after all, the quality of the work as a painting.

■ CONTRASTS AND SIMILARITIES. The detail shown here from a wall painting in the Temple of Fa Hai Ssu near Peking (Fig. 276) is from the eighteenth

century, while the nude figure by Chiang Chao-ho (Fig. 277) is from the twentieth century. The two make a startling contrast. In the past, Chinese painting did not go in for painting nudes at all, except for the *ch'un hua,* the "spring paintings" of erotic content. But the twentieth century has brought many changes in this respect, just as it has in the interpretation of light and shade. The shaping lines in the Chiang painting are shadings derived from illumination. In line, in the use of color, in decoration, and in symbolism, the wall painting of Fa Hai Ssu is fully traditional, while the nude by Chiang turns its back not only on the onlooker, but also apparently on tradition. Nevertheless, traditional elements can still be recognized—at least in the technique—in the brushwork of the contours.

In Figs. 278–79 we again have two paintings of different periods using similar motifs. The earlier shows an old man sipping tea, holding the cup in hands characterized by the long fingernails of an aristocrat, while the other presents a professor-like figure smoking a cigarette as he awaits his tea. The two paintings, at first sight, seem even more different than the two hundred years between them would warrant. Huang Shen was a scholar-painter under the Manchu emperors, while the contemporary Yeh Chien-yü here reveals his beginnings as a caricaturist under the Republic. Besides the similar motifs, artistically speaking, the backgrounds of the paintings also rather resemble one another: in the first case the calligraphic background is appropriate for the scholar-painter Huang Shen, and in the second case we have a background of a bamboo thicket. The earlier painter expresses by traditional methods a mellow wisdom and a calm detachment. The contemporary painter introduces a note of irony. The war has driven the professor, together with his whole university, from Shanghai or Peking into the country's interior, perhaps as far as Szechuan. He wears straw sandals, for there are no shoes to be had, and anyway the sandals are more comfortable. He is probably dreaming of the joys of the coastal towns.

In Figs. 280–82 again we find three paintings with a similar motif, that of people carrying things. But what a difference there is between them! In the one by the Yüan painter Yen Hui, Liu Hai is shown with the three-legged toad. Liu Hai was a Taoist adept, a magician of unusual powers and the master of a three-legged toad about which many tales of good fortune and mischief are told. The next picture, by the unknown Sung artist who painted the monk Hsüan Tsang on his way back from India laden with the holy writings of Buddhism, is permeated entirely with the same Chinese world of belief and symbolism. And Hsüan Tsang, like Liu Hai, stirs up in every Chinese memories of stories and visions, of adventures and symbols, such as

those related in Wu Ch'eng-en's popular novel about the monkey, *Hsi Yu Chi* (Account of the Journey to the West), still so vividly remembered in China. The third painting in this group shows a Tibetan girl carrying fruit baskets; it is by Yeh Chien-yü. In comparison with the first two, it is pure reportage, without any symbolic or narrative content. We can see what kind of sandals and leggings she wears, how she binds her sash, and how she ornaments herself; how the baskets are made and how the poles (in a manner different from the Chinese) are stuck through the holes in the wickerwork. Although the technique and the brushwork still reflect many of the traditional methods, yet this art is very far removed from the paintings of the past, with their wealth of associations. And since we are here dealing with someone engaged in toil, the painting comes closer to our personal experience. It approaches what in China, as in other places, is called "socialist realism."

A final comparison should now be made, or rather suggested, so as to mark certain tendencies which have developed in Chinese painting. The two landscapes of Figs. 283–84 exhibit a certain outward similarity in their wealth of mountain shapes. The first is by the Yüan painter Huang Kung-wang, reputed to be one of the four great painters of his period. The scene is well designed, rather airy, and completely lighthearted in character; the rocks and mountains were painted with a relatively dry brush and the trees with a wet brush, providing a refreshing contrast of bright and dark, of the straight and the bent. In the second, by the Ch'ing painter Wang Yüan-ch'i, too many details have been squeezed into the painting. The artist is one of the "four Wangs" of the Ch'ing period (Wang Shih-min, Wang Chien, and Wang Hui are the other three) and wrote the vast *Encyclopedia of Painting and Calligraphy* under the Emperor K'ang Hsi. It looks as though something of this encylopedic spirit has entered into the monotonous delineation of mountain shapes: the scholar and encyclopedist seems to have gained the upper hand over the painter.

■ *BUDDHIST MOTIFS*

(see pages 267–68)

219. Wall painting from Dandan-Uiliq, Turkestan. From Stein.

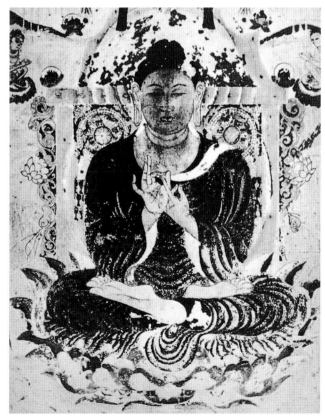

220. Wall painting from the Hōryū-ji, Nara.

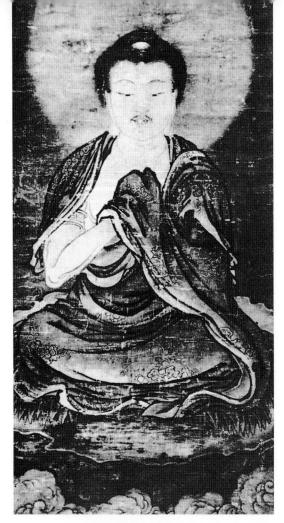

221. Sakyamuni, by an unknown T'ang artist. Courtesy Ōtsuka Kōgeisha.

222. The Second Ch'an Patriarch, by Shih K'o (Sung). Courtesy Ōtsuka Kōgeisha.

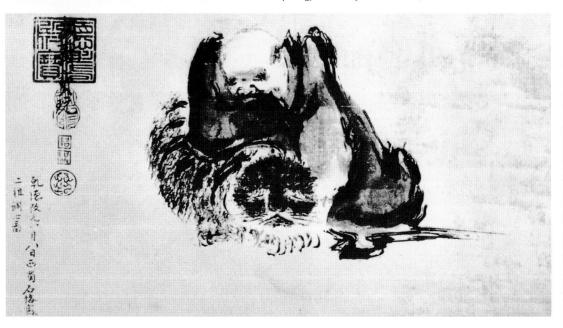

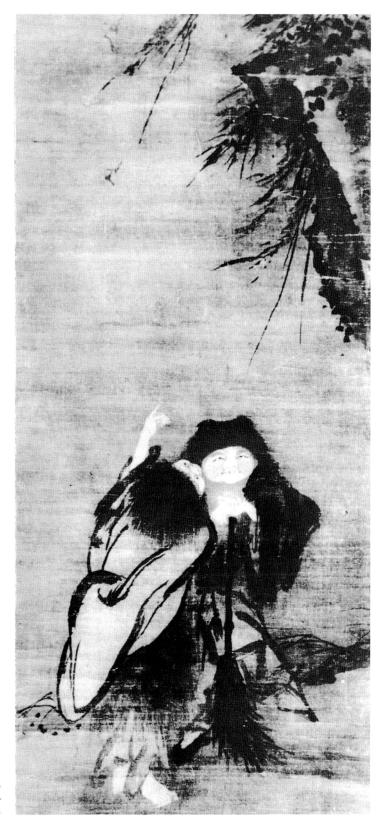

223. Shih-te and Han-shan, by an unknown Yüan artist. Courtesy Ōtsuka Kōgeisha.

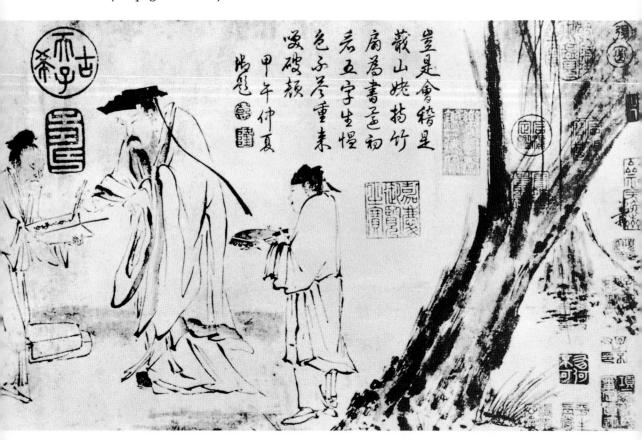

224. Scholar and Attendants, by Liang K'ai (Sung). Courtesy Ōtsuka Kōgeisha.

225. *Chung Li, a Taoist Immortal; by Hsü Chen (Ming). Courtesy Ōtsuka Kōgeisha.*

226. *Chung K'uei, Guardian Against Evil Spirits; by Kao Ch'i-p'ei (Ch'ing). Courtesy Ōtsuka Kōgeisha.*

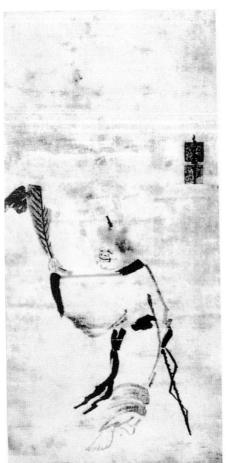

227. Monk, by Mu Ch'i (Sung).
Courtesy Ōtsuka Kōgeisha.

228. Monk, by Yin T'o-lo (Indara),
Sung period. Courtesy Ōtsuka Kōgeisha.

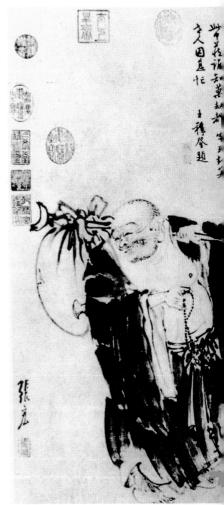

229. Pilgrim Monk, by
Chang Hung (Ming).
Courtesy Ōtsuka Kōgeisha.

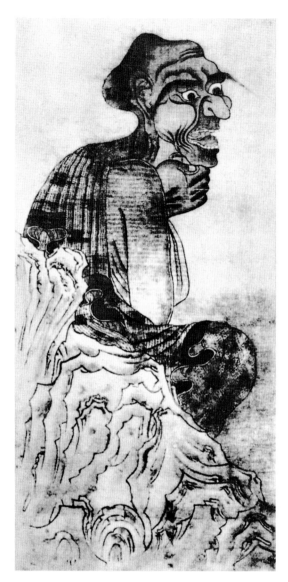

230. One of the Eighteen Lohan, by Kuan Hsiu (Five Dynasties). Courtesy Ōtsuka Kōgeisha.

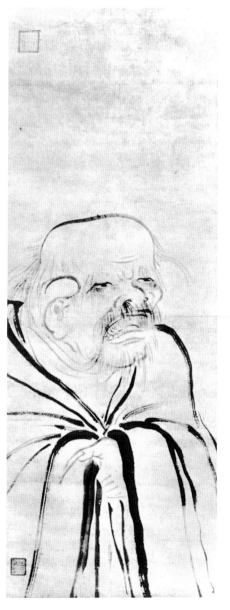

231. Monk, by Mu Ch'i (Sung). Courtesy Tōyō Bijutsu.

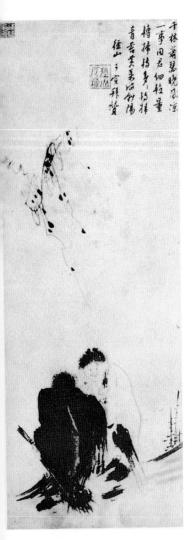

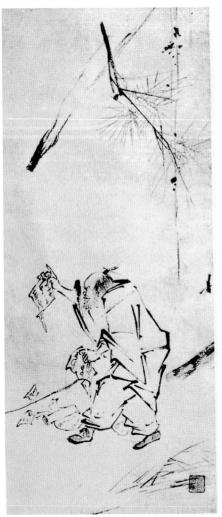

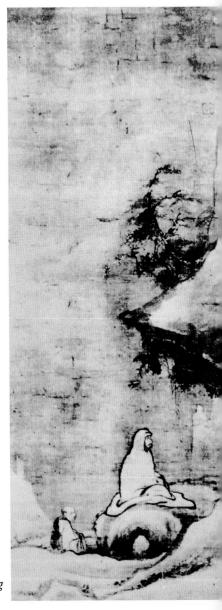

232. *Han-shan and Shih-te,
by Ma Lin (Sung). Courtesy
Ōtsuka Kōgeisha.*

233. *Hui Neng, the Sixth
Ch'an Patriarch, by Liang
K'ai (Sung). Courtesy Ōtsuka
Kōgeisha.*

234. *Bodhidharma, by Yen Tz'u-p'ing
(Sung). Courtesy Ōtsuka Kōgeisha.*

■ *BIRDS*

(see pages 270–72)

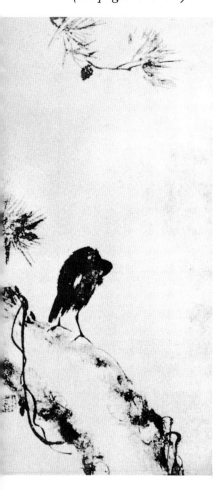

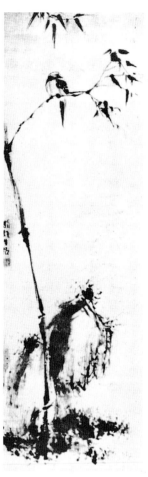

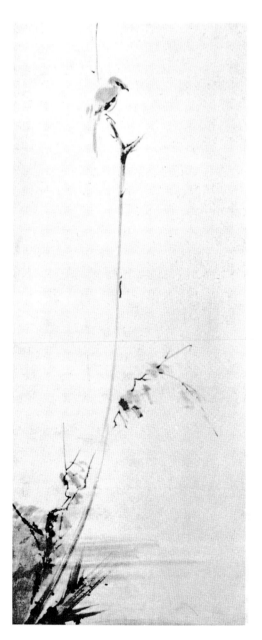

235. *Myna Bird on a Pine Tree, by Mu Chʻi (Sung). Courtesy Ōtsuka Kōgeisha.*

236. *Bird on a Bamboo Branch, finger painting by Kao Chʻi-pʻei (Chʻing). Courtesy Ōtsuka Kōgeisha.*

237. *Bird on a High Branch, by Miyamoto Musashi (1584–1645). Nagao Museum, Kanagawa.*

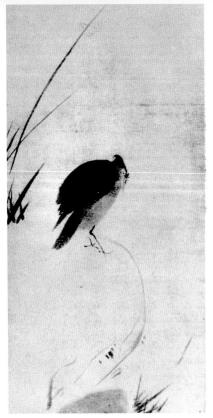

238. *Myna Bird, by Mu Ch'i (Sung).*
Courtesy Ōtsuka Kōgeisha.

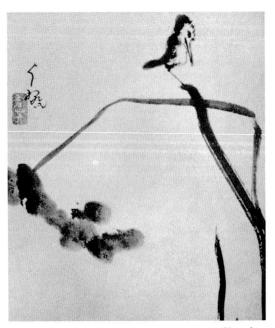

239. *Kingfisher on a Branch, by Pa-ta Shan-jen*
(Ch'ing). Sumitomo collection.

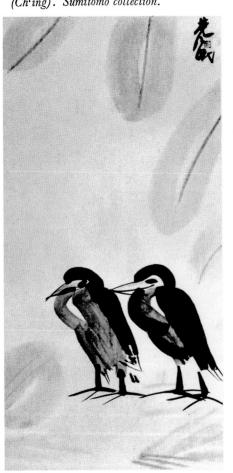

240. *Birds Under Palm Leaves, by Lin*
Feng-mien (Republic). Author's collection.

241. *Sleeping Bird, by Pa-ta Shan-jen (Ch'ing).*
Sumitomo collection.

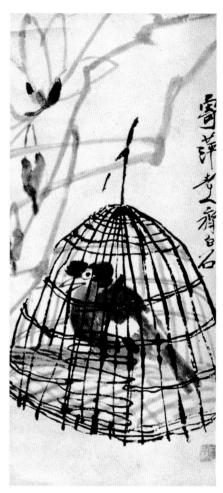

242. *Myna Bird in Cage, by Ch'i Pai-shih*
(Republic). Author's collection.

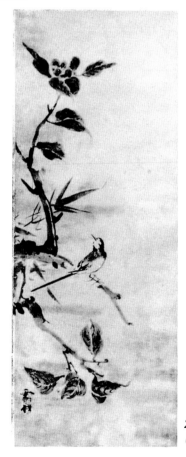

243. *Camellia and Wagtail, by Sesson*
(1504–89). Courtesy Ōtsuka Kōgeisha.

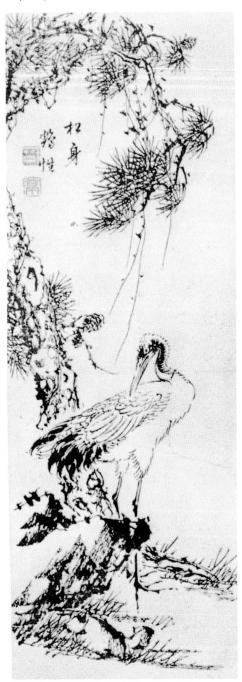

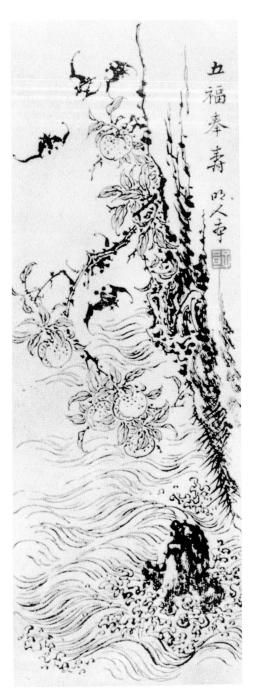

244. *Longevity symbols: Crane under Pine Tree, by Taki Ken (1829–1902). From Gasan.*

245. *Bat rebus for happiness: The Five Blessings, by Taki Ken (1829–1902). From* Gasan.

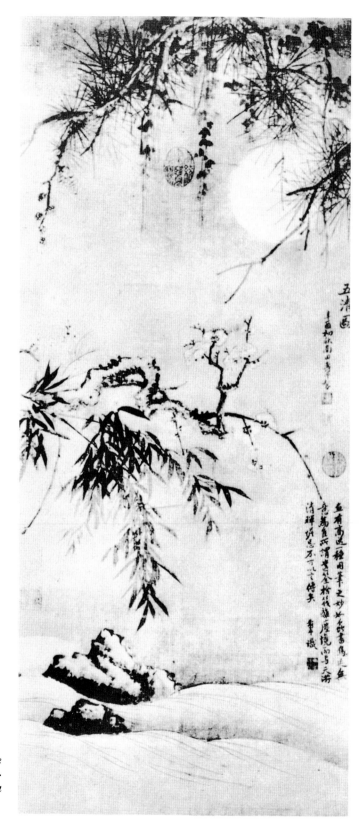

246. *Symbols from nature: The Five Pure Things, by Yün Shou-p'ing (Ch'ing). Courtesy Ōtsuka Kōgeisha.*

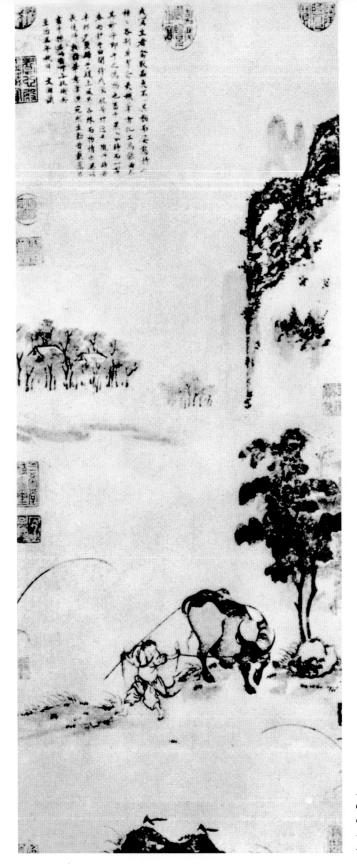

247. Symbolism in pure form
of man conquering nature: Boy
and Water Buffalo, by Ch'i
Hsü (Sung). Courtesy Ōtsuka
Kōgeisha.

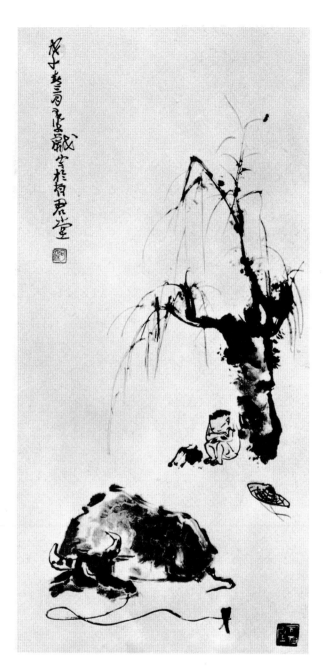

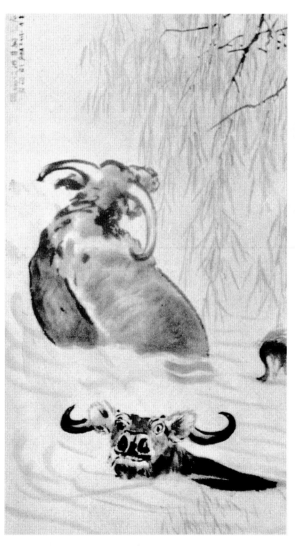

248. *Symbolism in weakening form: Boy and Water Buffalo, by Li K'o-jan (Republic). Author's collection.*

249. *Symbolism lost: Water Buffaloes, by Hsü Pei-hung (Republic). Artist's collection.*

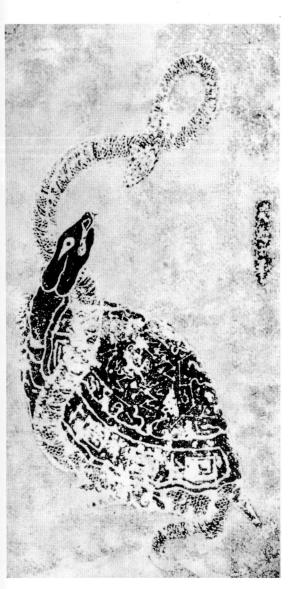

250. Yang and Yin symbolized: Tortoise and Snake, rubbing after Wu Tao-tzu (T'ang). Courtesy Ōtsuka Kōgeisha.

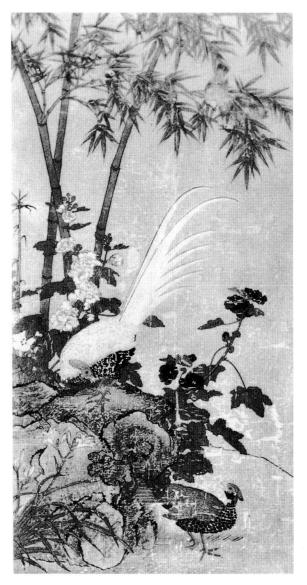

251. Yang and Yin symbolism reduced to allegory: Two Pheasants, by Wang Jo-shui (Yüan). Courtesy Ōtsuka Kōgeisha.

252–54. *Human beings dwarfed by a
waterfall symbolizing the endless flux of
all things within unchanging forms:*
(TOP LEFT) *Scholar by a Waterfall, by
Hsia Kuei (Sung), Courtesy Ōtsuka
Kōgeisha;* (TOP RIGHT) *By a Water-
fall, by Chang Ta-ch'ien (Republic),
private collection;* (BOTTOM) *Resting
Woodcutters by a Waterfall, by Shih
T'ao (Ch'ing), Sumitomo collection.*

SYMBOL AND REBUS ■ 297

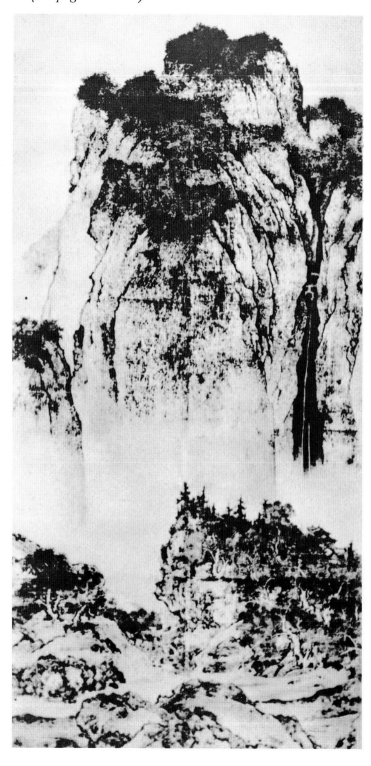

255. *Landscape, by Fan K'uan (Sung). Courtesy Ōtsuka Kōgeisha.*

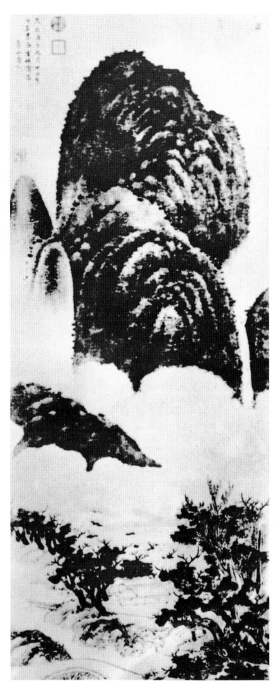

256. *Landscape, by Kao K'e-kung (Yüan). Courtesy Ōtsuka Kōgeisha.*

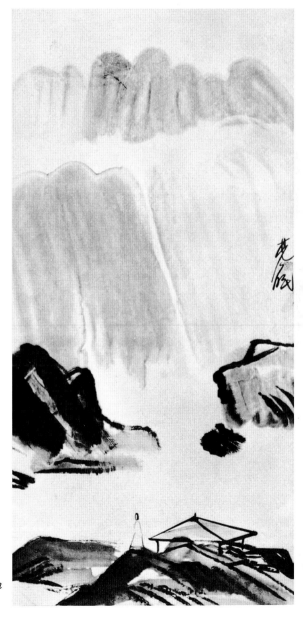

257. *Landscape, by Lin Feng-mien (Republic). Author's collection.*

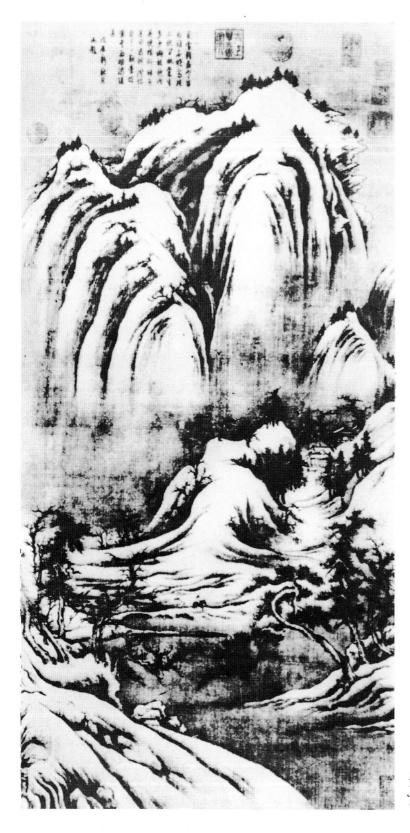

258. Winter Landscape, by Chü Jan (Five Dynasties). Courtesy Ōtsuka Kōgeisha.

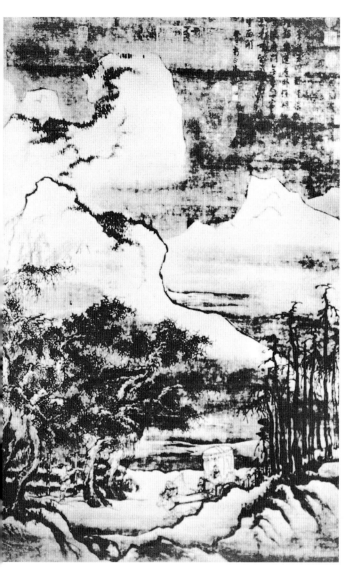

259. *Winter Landscape, by Yen Hui (Yüan). Courtesy Ōtsuka Kōgeisha.*

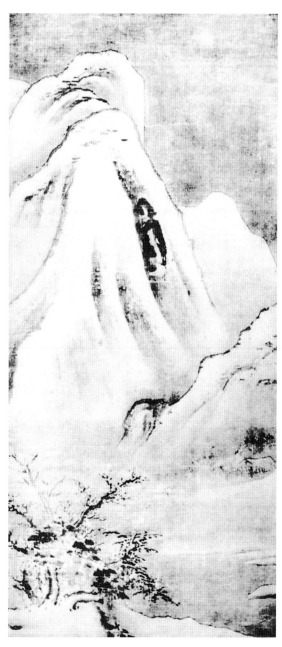

260. *Winter Landscape, by Kao Jan-hui (Yüan). Courtesy Ōtsuka Kōgeisha.*

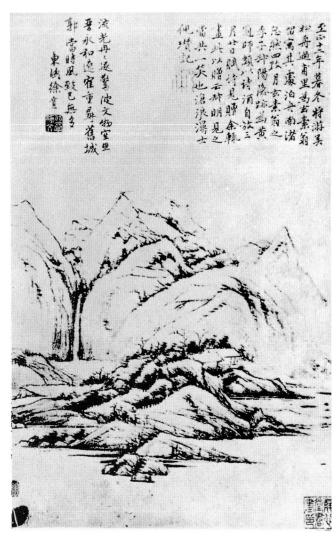

流光毋遠驚波文物室里
吾永和逸崔重昇舊城
郭當時風致已無多
東坡徐賁

至正十三年暮冬將游吳
松舟過甫里高出素翁
留寓其家泊舟南渚
忽然四政月去素翁之
季云郵陽凜跡為黃
冠師頗亢詩酒自放三
月苦課待見贈余頼
畫此以贈云卿明見之
當共一疢也滄浪漫士
仙瑣記

261. *Pavilion by a River, by Ni Tsan
(Yüan). Courtesy Ōtsuka Kōgeisha.*

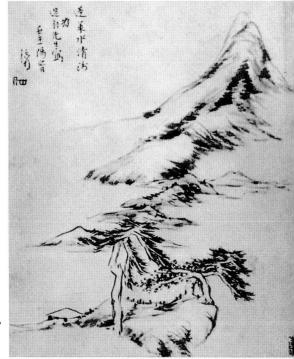

蓬萊水清淺
劫自光生寫
八大山人

262. *Pavilion by a River,
by Pa-ta Shan-jen (Ch'ing).
Sumitomo collection.*

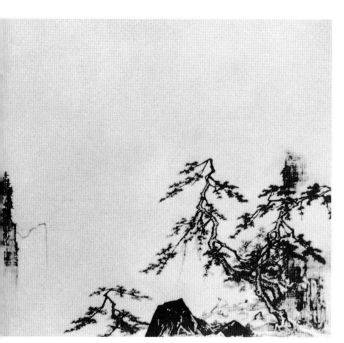

*263. Landscape, by Ma Yüan
(Sung). Courtesy Ōtsuka Kōgeisha.*

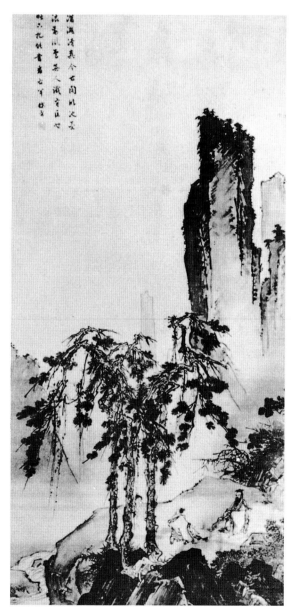

*264. Landscape, by Hsü Lin
(Ming). Courtesy Ōtsuka Kōgeisha.*

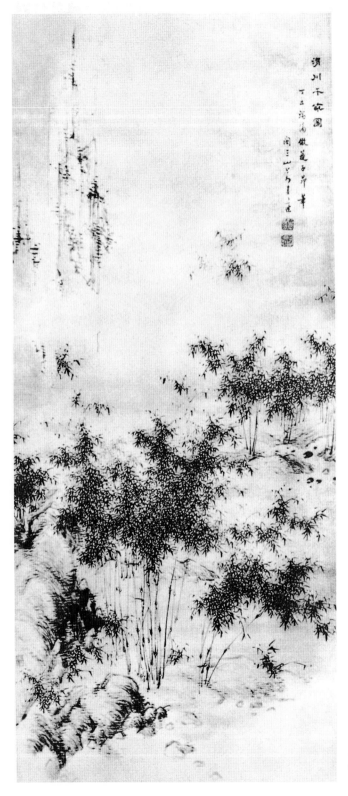

265. *Bamboo by the Wei-ch'üan, by Wang Chi-fan (Ch'ing). Courtesy Tōyō Bijutsu.*

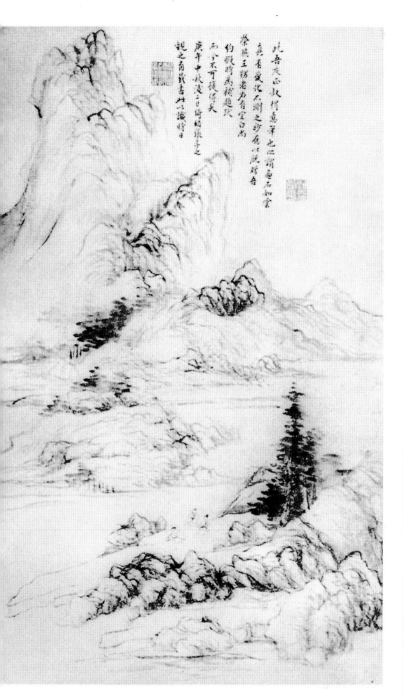

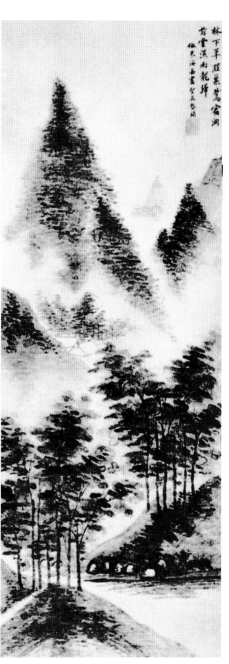

266. Landscape, by Yün Nan-tien
(Ch'ing) Courtesy Geien Shinchō.

267. Landscape in the Style of Mi Fei, by
Kung K'ai (Sung). Courtesy Ōtsuka Kōgeisha.

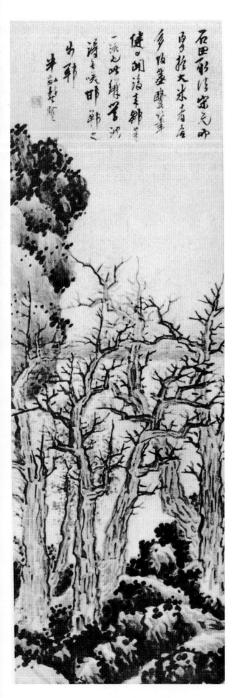

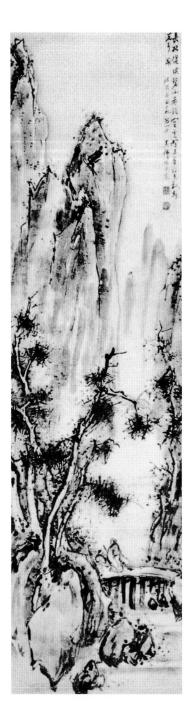

268. Trees in Winter, by
Kung Hsien (Ch'ing). Cour-
tesy Tōyō Bijutsu.

269. Conversation on the Bridge,
by Kao Ch'i-p'ei (Ch'ing). Cour-
tesy Geien Shinchō.

270. Group of Trees,
by Wang To (Ming).
Courtesy Geien Shinchō.

271. Landscape, by Pa-ta Shan-jen (Ch'ing). Sumitomo collection.

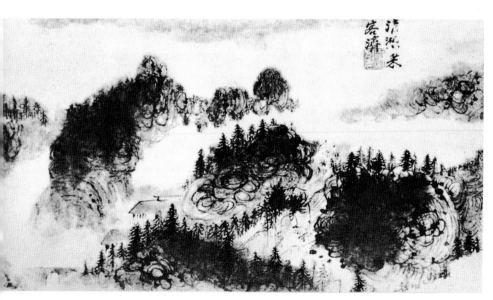

272. Landscape by Shih T'ao (Ch'ing). Courtesy Ōtsuka Kōgeisha.

273. Landscape, by Ch'i Pai-shih
(Republic). Private collection.

274. Landscape, by
Chao Meng-fu (Yüan).
Courtesy Ōtsuka Kō-
geisha.

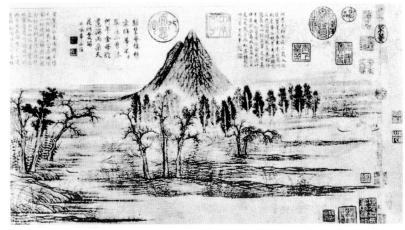

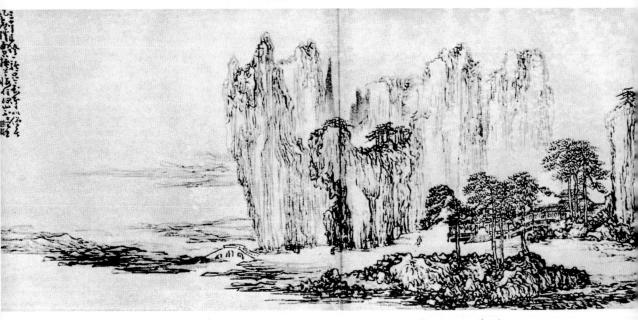

275. Landscape, by Huang Shen (Ch'ing). From a collotype reproduction.

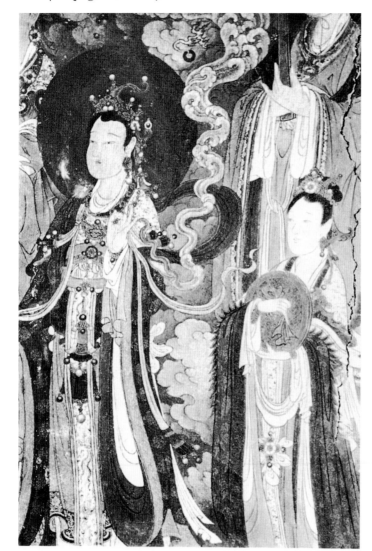

276–77. Traditional Buddhist figures vs. a nude: (UPPER) *Procession of Kuan-yin, from a Fa Hai Ssu mural (probably Ming);* (LOWER) *Nude, by Chiang Chao-ho (Republic). Artist's collection.*

278–79. Similar motif of man with tea: (UPPER) *Tea Drinker, by Huang Shen (Ch'ing), from a collotype reproduction;* (LOWER) *Afternoon Tea, by Yeh Chien-yü (Republic), artist's collection.*

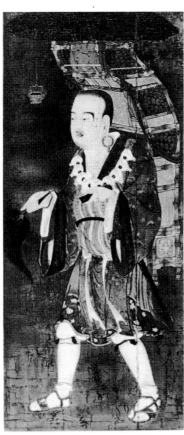

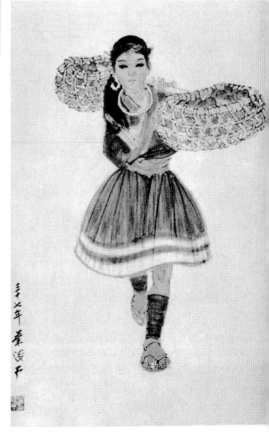

280–82. Similar motif of people carrying things: (TOP LEFT) *The Adept Liu Hai, by Yen Hui (Yüan), courtesy Ōtsuka Kōgeisha;* (TOP RIGHT) *Hsüan Tsang Returning to China, by an unkown Northern Sung artist, courtesy Ōtsuka Kōgeisha;* (BOTTOM) *Girl from West China, by Yeh Chien-yü (Republic), artist's collection.*

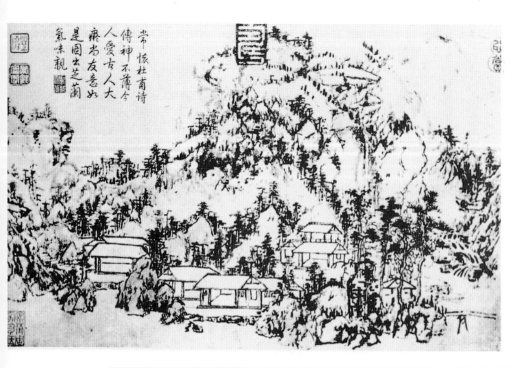

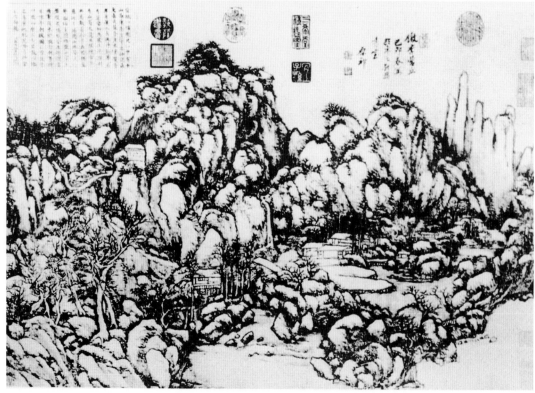

283–84. Well-designed vs. encylopedic landscape: (UPPER) *Landscape, by Huang Kung-wang (Yüan), courtesy Ōtsuka Kōgeisha;* (LOWER) *Landscape, by Wang Yüan-ch'i (Ch'ing), courtesy Ōtsuka Kōgeisha.*

■ 13 ■ CONCLUSION

IN CONCLUSION, I SHOULD LIKE TO REITER-
ate a remark made at the beginning of
Part Two. The notes in this second half of the book have had to be rather
short and fragmentary; they represent only a modest beginning of a reinter-
pretation of Chinese art from the technical point of view. It would be fatal,
however, if only that technical point of view were to be considered. It must
always be combined with an awareness of the deeper and wider meaning of
art in China as faithfully handed down through many generations to our
own times. I believe it has been made amply clear that the technical view-
point constitutes but one way of investigating an artistic phenomenon which
until now has to a certain extent defied Western efforts at understanding
principally because Westerners have insisted on applying their own standards
and principles to an art which, having different human and spiritual origins,
has pursued completely different artistic aims with completely different tech-
nical means.

It may well be that at the highest level the Oriental and Occidental
artistic visions approach each other very closely. However, to reach the
highest level of true understanding it seems essential to explore the roads
leading to it and to grasp the meaning of the spiritual landscape through
which such roads pass. Contrary to the opinion of many art lovers who have
never quite succeeded in reaching this highest level of oneness, Chinese paint-
ing is not esoteric. Their failure to achieve oneness frequently lies simply in
their belief that in both the East and the West a brush is just a brush, a brush
stroke just a brush stroke, a color just a color. Moreover, there has been an
inclination to regard art as something so elevated that it would be beyond
the dignity of a true art lover (who should move only in the realms of the
aesthetic, the spiritual, the revelatory) to inquire into such humble things as
painting techniques.

Unless this book has completely missed its mark, it should by now have
become clear that while a knowledge of painting techniques may not always
be prerequisite in judging a Western work of art, it is absolutely indispensible
for the Westerner who wants to understand Eastern art. It will also have
become apparent that the understanding and enjoyment of Far Eastern paint-
ing can be vastly enhanced by knowing how it is done, why it is done in just
this or that way, and what it may mean when it is done this way rather than
that. An art which seemed to radiate a somewhat strange and unreal beauty,
elusive and eternally untangible, may thus be finally conquered and loved in
its own right.

◾ APPENDICES

◾ 1 ◾ GLOSSARY OF ART TERMS
FOLLOWING ARE SOME OF THE more important technical terms used in Chinese art. For convenience, they have been arranged by categories in such a way that similar or contrasting terms appear together. Chinese terms are given in the column to the left and Japanese to the right.

SUBJECT MATTER

shan-shui hua	mountain and water (i.e., landscape) painting	*sansuiga*
{ *jen-wu hua*	people and things (i.e., figure) painting	*jimbutsuga*
{ *mei-jenhua*	beautiful-woman painting	*bijinga*
{ *ling-mao hua*	feather and fur (i.e., animal) painting	
{ *ts'ao-ch'ung hua*	grass and insect (i.e., small creature) painting	
{ *hua-hui hua*	flower-and-plant painting	
	flower-and-bird painting (comprising the three foregoing Chinese categories)	*kachōga*

MATERIALS

{ *pi*	brush	*fude, hitsu*
{ *mo*	India ink	*sumi, boku*
{ *pi*	brush	*fude*
{ *ch'ih*	paper	*kami*
{ *kan pi*	dry brush	*kappitsu*
{ *shih pi*	wet brush	
{ *chih pi* or *cheng pi*	upright brush	
{ *ts'e pi*	slanting brush	

315

ju pi	starting the brush stroke	
ch'u pi	finishing the brush stroke	
chung mo or *chiao mo*	heavy ink	
tan mo	light ink	
sheng ch'ih or *shou ch'ih*	unsized paper	
fan ch'ih	sized paper	

TECHNIQUES AND METHODS

shui mo	ink painting	*suibokuga, sumi-e*
she se or *cho se*	ink and color painting or color painting	*saishiki*
mo ku hua	boneless painting	*mokkotsu*
kou le hua	outline painting	
nung tan	dark and bright	*nōtan*
tan chung	light and heavy	
shen tien	deep and light	*bokushoku*
chuan chih	bent and straight	
p'o mo	splashed ink	*hatsuboku*
fei po	flying white	*hihaku*
kou or *lun k'uo*	outlines	*rinkaku*
ts'un	shaping lines (landscape)	*shun*
i wen	shaping lines (figures)	
jan, ts'a jan, hsüan, hsüan jan, t'u	various kinds of washes and their application	*kumadori*
tien	dots	*ten*
tien t'ai	moss dots	
miao or *pai miao*	outline drawing	*shira-e, hakuhyo*
shui ts'un	watered shaping lines	
	dripping technique (similar to foregoing)	*tarashi-komi*
	"blotting" or "blurring" technique	*nijimi*

PRINCIPLES

yung pi	brush usage	*yōhitsu*
yung mo	ink usage	*yōboku*
yu pi	to have brush	
yu mo	to have ink	
pi fa	brush method	*hippō*
mo fa	ink method	*bokuhō*
wu mo	no ink	
wu pi	no brush	
chang fa	composition	*kōzō*
yüan chin	far and near (i.e., perspective)	*enkin*
t'ien ti	heaven and earth (i.e., compositional distribution)	*ten-chi*
ch'in pi	gold outlines	
p'o mo	broken ink	*haboku*
lung mo	dragon veins (i.e., invisible compositional connectives)	
hsü shih	empty and filled (i.e., a balancing of planes)	
ch'iu ho	hill and valley (i.e., spatial distribution)	
pin chu or *chu k'o*	host and guest (i.e., compositional balance)	

k'ai ho	open and shut (i.e., compositional interrelation of parts)	
liu tsung	holding tight and releasing	
shun ni	keeping up with and slackening off	
ch'i fu	rise and fall	
pa ch'i	obtrusive demonstration of technical prowess	
mo hsi	ink play	

<div align="center">STYLE, ETC.</div>

wen jen hua	scholar painting	*bunjinga*
hua chia hua	painter painting	
kung jen hua	artisan painting	
{hsieh yi	spontaneous style	
{kung pi	careful style	
pei tsung hua	Northern-school painting	*hokuga*
nan hua or *nan tsung hua*	Southern-school painting	*nanga, nansoga*
{su	ordinary	
{ya	elegant	
{han lin	woods in winter	
{mao lin	woods in leaf	
yin yang	feminine and masculine, positive and negative	*inyō*
{yin wen	seal with raised characters	
{yang wen	seal with incised characters	
{k'ai shu	formal, stiff, correct calligrapy	*kaisho*
{hsing shu	semi-cursive calligraphy	*gyōsho*
{ts'ao shu	grass (i.e., running or cursive) calligraphy	*sōsho*
{kao yüan	high distance (perspective)	
{p'ing yüan	level distance (perspective)	
{shen yüan	deep distance (perspective)	
yen t'ai	inkstone	*suzuri*
t'u chang	seal	*han*
{chuan chou	hanging (i.e., vertical) picture scroll	*kakemono, kakejiku*
{shou chuan	hand (i.e., horizontal) scroll	*makimono*
shih chuan	rock-nose, central rock projection	
chang kai	last stroke, enclosing line	

■ 2 ■ CHRONOLOGY

INCLUDED IN THE FOLLOWING TABLE, ARRANGED chronologically by Chinese dynasties, are the names more frequently encountered in Chinese art history. Japanese artists mentioned in this book are likewise listed, being indicated by italics.

SHANG (YIN), ca. 1766–1122 B.C.

CHOU, ca. 1122–221
 Laotzu, 6th cent.
 Confucius, 6th cent.
 Chuangtzu, 330–270

WARRING STATES, ca. 481–221

CH'IN, 221–206

WESTERN HAN, 206 B.C.—A.D. 25

EASTERN HAN, A.D. 25–220

SIX DYNASTIES, 220–589
 Ku K'ai-chih, ca. 344–406
 Hsieh Ho, late 5th cent.

SUI, 581–618

T'ANG, 618–759
Wang Wei, 698–759
Chang Hsüan, fl. 713–42
Wu Tao-tzu, 8th cent.
Li Ssu-hsün, 651–716
Yen Li-pen, d. 673
Han Kan, 8th cent.
Li Chao-tao, late 8th cent.
Li Chen, fl. 780–804

FIVE DYNASTIES, 907–60
Kuan Hsiu, 832–912
Ching Hao, 9th/10th cent.
Kuan T'ung, early 10th cent.
Li Ai-chih, early 10th cent.
Li Sheng, early 10th cent.
Kuan T'ung, early 10th cent.
Tung Yuan, middle 10th cent.
Shih K'o, middle 10th cent.

NORTHERN SUNG, 960–1127
Chü Jan, fl. 960–80
Li Ch'eng, late 10th cent.
Fan K'uan, ca. 990–1030
Hsü Tao-ning, 10th/11th cent.
Kuo Hsi, 1020–90
Su Tung-p'o (Su Shih), 1036–1101
Li Lung-mien, 1040–1100
Mi Fei, 1051–1107
Su Kuo, 1072–1123
Chao Ta-nien, fl. 1080–1100
Emp. Hui Tsung, 1082–1135
Ts'ui Po, late 11th cent.

SOUTHERN SUNG, 1127–1279
Li T'ang, fl. 1100–30
Li Ti, ca. 1100–97
Mi Yu-jen, 1085–1165
Chao Po-chü, 12th cent.
Li Sung, 1168–1243
Hsia Kuei, 1180–1230
Mu Ch'i (Fa Ch'ang), ca. 1181–1239
Ma Yüan, 1190–1224
Yen Tz'u-p'ing, fl. late 12th cent.
Liu Sung-nien, fl. 1190–1230
Ma Lin, 12th cent.
Liang K'ai, ca. 1200
Ying Yü-chien, middle 13th cent.
Chen Jung, fl. middle 13th cent.
Yin-t'o-lo (Indara), 13th cent.
Kung K'ai, fl. ca. 1260–80

YÜAN, 1279–1368
Kao K'o-kung, 1248–1310
Chao Meng-fu, 1254–1322
Huang Kung-wang, 1269–1354
Wu Chen, 1280–1354
Ni Tsan, 1301–74
Wang Meng, 1308–86
Kao Jan-hui, 13th/14th cent.
Fang Ts'ung-i, fl. 1340–80
Yen Hui, 14th cent.

MING, 1368–1644
Shen Chou (Shen Shih-t'ien), 1427–1509
Shubun, until 1448
Sesshū, 1420–1506
Tai Chin, 15th cent.
Kanō Masanobu, 1434–1530
Shih Chung, ca. 1437–1517
Wu Wei, 1458–1508
Liu Chün, 15th cent.
Wen Cheng-ming, 1470–1567
T'ang Yin, 1470–1523
Lü Chi, fl. 1488–1506
Wang Hai-yün, fl. 1500
Sesson, 1504–ca. 1589
Ch'iu Ying, fl. 1522–60
Hsü Lin, early 16th cent.
Hasegawa Tōhaku, 1543–90
Kanō Eitoku, 1543–90
Tung Ch'i-ch'ang, 1555–1636
Li Shih-ta, ca. 1556–1620
Kanō Sanraku, 1559–1635
Mo Shih-lung, 1567–1601
Chang Hung, 1580–1660
Miyamoto Musashi (Niten), 1584–1645
Lan Ying, 1585–1664
Wang Shih-min, 1592–1680
Wang To, 1592–1652
Wang Chien, 1598–1677
Ch'en Hung-shou, 1599–1652
Kanō Tanyu, 1602–74
Sōtatsu, early 17th cent.
Ch'en Chia-yen, fl. early 17th cent.
Kanō Naonobu, 1607–50
Kanō Yasunobu, 1613–85

CH'ING, 1644–1912
Chu Ta (Pa-ta Shan-jen), 1626–1705
Wang Wu, 1632–90
Wang Hui, 1632–1720 (1717)
Yün Shou-p'ing (Yün Nan-t'ien), 1633–90
Kanō Tsunenobu, 1636–1713
Wang Chien-chang, early 17th cent.
Wang Yüan-ch'i, 1642–1715

Emp. Shun Chih, reigned 1644–62
Kung Hsien, fl. 1660–1700
Ogata Kōrin, 1658–1716
Shih T'ao (Tao Chi), fl. ca. 1660–1710
Kao Ch'i-p'ei, 1672–1734
Chin Nung, 1687–1764
Huang Shen, 1687–1788
Hakuin, 1685–1768
Lang Shih-ning (Giuseppe Castiglione), 1688–1768
Chiao Ping-chen, fl. 1680–1720
Cheng Hsieh, 1693–1765
Shen Ch'üan (Shen Nan-p'in), fl. 1725–80
Harunobu, 1724–70
Murayama Ōkyo, 1733–95
Shi T'ieh-sheng, 1746–1803
Shiba Kōkan, 1747–1818
Kushiro Unzen, 1759–1811
Chu Ch'eng, middle 19th cent.
Taki Ken (Katei), 1830–1901

REPUBLIC, 1912–49
Ch'i Pai-shih, 1863–1957
Yokoyama Taikan, 1868–1958
P'u Ju (P'u Hsin-yü), b. 1887
Kao Ch'i-feng, 1889–1933
Liu Hai-su, b. 1895
Hsü Pei-hung, 1896–1953
Hu P'ei-hung, early 20th cent.
Chang Ta-ch'ien, b. 1899
Ch'i Kung, 20th cent.
Hsü Yen-sun, 20th cent.
Yeh Ch'ien-yü b. 1907
Lin Feng-mien, b. 1901 (1906?)
Li K'o-jan, 20th cent.
Chiang Chao-ho, 20th cent.
Ch'en Wen-hsi, 20th cent.
P'u Chin (P'u Hsüeh-chai), born?
P'u Ch'üan (P'u Sung-ch'üang), b. 1912
Tseng Yu-ho, b. 1923

■ *3* ■ *ART SYMBOLISM*

THE FOLLOWING IS A SHORT LIST OF SOME OF the symbols more commonly encountered in Chinese art. See also the section on Symbol and Rebus beginning on page 272.

ANT. In Chinese characters, "the tidy animal"; virtue; love of fatherland; also egoism.

APPLE. The blossom symbolizes feminine beauty. Rebus *(p'ing)* for peace.

APRICOT. Feminine beauty. The seed symbolizes the shape of the human eye.

AXE. Go-between in a marriage; an allusion to a song from the *Shi Ching:* "One cannot fell a tree without an axe, nor arrange a marriage without a go-between."

AZALEA. Feminine beauty; medicinal plant.

BAMBOO. A great wealth of symbolism, including virtue, constancy, friendship even in adversity, longevity.

BAT. Happiness. Rebus for long life.

BEE. Diligence; thrift. Rebus *(feng)* for the granting of a princely title.

BO TREE. Perception; enlightenment; meditation; Buddhist tradition.

BROOM. Insight; wisdom. Attribute of the poet-sage Shih-te, who sweeps away all everyday cares with a broom.

BUFFALO. Zodiac sign. Spring; agriculture; man's subjugation of nature. In Ch'an Buddhism, the eternal principle of life, truth in action.

BUTTERFLY. Joy; tendency to love. See also under Cat.

CARP. Quarrelsome; soldierly endurance; youth; success in examinations. If the carp gets past the rapids of Lung-men (Dragon Gate), it changes into a dragon.

CAT. Defender of the silkworm; protection against evil spirits. Rebus *(mao)* for an old man over seventy; hence, good wishes for a long life. A cat chasing a butterfly, because of a rebus between butterfly and an eighty-year-old man: may a man who has reached his seventies also reach his eighties.

CHERRY. Feminine beauty.

CHRYSANTHEMUM. Autumn; friendliness; a pleasant life after retirement.

CICADA. Resurrection; happiness; eternal youth. A jade cicada is often put into the mouth of a dead person.

COCK. Zodiac sign. Symbolizes the five virtues of being literary, warlike, courageous, benevolent, and faithful. On a rooftop: a bad omen.

CORAL. Long life; promotion in official duties.

CRANE. A bird of mythical powers; messenger of the Immortals; carrier of souls to the Western paradise. Longevity.

CRICKET. Summer; courage.

DEER. Long life, because of the animal's power of finding the mushrooms that give longevity; profits from official position.

DOG. Zodiac sign. Dog's arrival: future wealth.

DOVE. Stupidity; sensuality; also faithfulness and love of children.

DRAGON. Zodiac sign. Imperial power; symbol of strength, kindness, change, and therefore life itself; alertness; protection; a godlike being.

DRAGONFLY. Summer; fickleness; weakness.

DUCK. With lotus: feeling of contentment. Pair of Mandarin ducks: marital faithfulness.

EAGLE AND FALCON. In Ch'an Buddhism: courage; power of vision; the fighting man.

FAN. Emblem of Chung Li-ch'üan, one of the eight adepts of Taoism. Cast-aside fan: a neglected wife.

FISH. Harmony and married bliss. Rebus *(yü)* for wealth and abundance.

FLY-WHISK. In Buddhism, the priestly function. In Taoism, leadership.

FOOTPRINT OF THE BUDDHA. Nirvana achieved. May also contain a number of other symbols.

FOX. Great wealth of symbolism, including supernatural strength; ability to change; magic; practical joking.

FROG. Three-legged toad: the unattainable. Emblem of the adept Liu Hai; symbol of earning money.

FUNGUS. Kind of mushroom, plant of immortality; grows best under virtuous rulers.

GARNET-APPLE. Hope of numerous progeny; numerous issue.

GOOSE. Marriage, because geese are always in pairs; wedding present.

GOURD. Mystery and necromancy; the universe in a nutshell. Emblem of Li T'ieh-kuai, one of the eight Taoist adepts.

HAND OF THE BUDDHA. A citrus fruit looking like a hand arranged in one of the Buddhist hand symbols; wealth.

HARE. Zodiac sign. Long life; the moon.

HORSE. Zodiac sign. Speed; endurance. See also under Monkey.

JASMINE. Feminine beauty; sweetness.

KINGFISHER. Magnificent beauty; married love, because they fly in pairs.

LION. Valor and strength as requisites of wisdom. Buddha on a lion throne: Buddha's teaching echoing through the universe like the roaring of lions.

LOTUS: Freeing of the soul through perception; summer; fertility; purity; completeness (growing in spotless beauty out of the swamp). Emblem of Ho Hsien-ku, one of the eight Taoist adepts, who holds a lotus-fruit cup.

LUTE. One of the four emblems of the scholarly pursuits of music, literature, chess, and painting.

MAGNOLIA. Feminine beauty; spring.

MAGPIE. Omen of good luck; announcer of guests; wedding, because of rebus *(hsi)* for happiness, particularly when

two magpies are shown *(shuang hsi, shared joy)*.

MIRROR. Married bliss; insight into the future.

MONKEY. Zodiac sign. Skill, but also a sense of fun; human *hubris*, but also superhuman abilities. In Ch'an Buddism, the human heart, suggested by the saying *Hsin yuan, i ma* (The heart is like a gibbon, the mind like a horse). The many gibbons shown in painting (e.g., Mu Ch'i) express the heart, i.e., the emotional life.

MOON. The essence of the feminine. The hare lives in the moon, where it distils the elixir of long life; the three-legged toad also lives in the moon.

MULBERRY TREE. Diligence; a comfortable home; love for children.

MUSHROOM. See Fungus.

MYSTIC KNOT. Immortality; the eight Buddhist commandments.

NARCISSUS. Happiness.

ORCHID. Love; beauty; elegance; refinement; many descendents; the perfect human being.

OX. See Buffalo.

PA KUA. The eight diagrams of the Book of Changes, still used by fortunetellers today. Protection against misfortune; wealth. Over the entrance to a house: happiness.

PALM. Withdrawn life.

PARROT. Sometimes, a warning for wives to be faithful to their husbands.

PEACH. Marriage; immortality; spring. The God of Long Life was born from a peach.

PEACOCK. Beauty; dignity; high rank.

PEARL. Protection against fire; magic powers. One of the eight precious things.

PEONY. Beauty; love; affection; spring; happiness.

PERSIMMON. Joy.

PHOENIX. Beauty; summer and sun; the emperor. Legendary bird which appears in times of prosperity and happiness.

PIG. Actually the wild boar. Zodiac sign. Richness of the forest.

PINE. Because of its evergreen quality, long life, faithfulness.

PLANE TREE. Self-discipline. Self-education.

PLUM. Winter; long life; together with pine and bamboo, friendship.

RAT. Zodiac sign. Shyness; malice; diligence; prosperity.

SHEEP. Zodiac sign. Love of children; withdrawn life (goat, ram).

SILKWORM. Diligence.

SNAKE. Zodiac sign. Flattery; malice; cunning. Also admired for its supernatural powers and its relationship to the dragon. Together with the tortoise, becomes a Yang and Yin symbol.

STARS. Very rich in symbolism. Great Bear: seat of the highest Taoist god.

SUN. Masculine principle; rulers of the earth. Sun dial: good government.

SWALLOW. Messenger of success or of love.

SWORD. Wisdom; insight; perception. A Buddhist symbol.

TIGER. Zodiac sign. Military prowess; scarer of evil spirits; god of prosperity; masculine strength.

TOAD. See Frog.

TORTOISE. One of the four mythical animals; symbol of the universe (the dome of heaven and earth over the waters); long life; winter. Since the tortoise can only fertilize through thought, children of unknown fathers are called tortoise eggs. River god. Bearer of memorial tablets.

UNICORN. *Ch'i-lin* in Chinese, *kirin* in Japanese. Happiness coming in moments of history; nobility of character;

good will (compounded of two elements, the masculine *ch'i* and the feminine *lin)*; perfect good. One of the four great mythical animals, the others being dragon, phoenix, and tortoise.

WATER BUFFALO. See Buffalo.

WILLOW. Buddhist symbol for modesty or feminine beauty.

WUTUNG TREE. The tree on which the phoenix alights.

■ BIBLIOGRAPHY

Binyon, Laurence: *The Flight of the Dragon: An Essay on the Theory and Practice of Art in China and Japan, Based on Oriental Sources.* Wisdom of the East Series, London, 1927
——: *Painting in the Far East.* 2nd ed., London, 1913
Bowie, Henry P.: *On the Laws of Japanese Painting: An Introduction to the Study of the Art of Japan.* New York, 1911
Chiang Yee: *The Chinese Eye: An Interpretation of Chinese Painting.* London, 1935
——: *Chinese Calligraphy: An Introduction to Its Aethetic and Technique.* London, 1938
Cohn, William: "Vergleichende Studie zur Malerei Japans und Chinas." *Cicerone,* XV, 1924
——: *Chinese Painting.* London, 1950
Contag, Viktoria: *Die Sechs berühmten Meister der Ch'ing Dynastie.* Leipzig, 1940
——: *Zwei Meister Chinesischer Landschaftsmalerei.* Baden-Baden, 1950
Diez, Ernst: *Shan Shui.* Vienna, 1943
Dörner, Max: *Malmaterial und seine Verwendung im Bilde. Neu herausgegeben von Professor Tom Roth und Dr. Richard Jacobi.* Stuttgart, 1954
Ecke, Gustav: "Comments on Calligraphies and Paintings." *Monumenta Serica,* III, 1937–38
Fei Cheng-wu: *Brush Drawing in the Chinese Manner.* London and New York, 1957
Ferguson, J. C.: *Survey of Chinese Art.* Shanghai, 1939.
Fischer, Otto: *Chinesische Landschaftsmalerei.* Munich, 1923
Franke, Herbert: "Yüan Treatises on the Technique of Portrait Painting." *Oriental Art,* III, 1950
——: "Zur Biographie des Pa-ta Shan-jen." *Asiatica,* Leipzig, 1959
Fuchs, Walter: "Rare Ch'ing Editions of the Keng-chih T'u." *Studia Serica,* Ch'engtu, 1947
——: "New Material on Chinese Battle Paintings of the Eighteenth Century." Japanese National Commission for Unesco, *Symposium Papers,* Tokyo, 1959
Glaser, Curt: *Die Kunst Ostasiens: Der Umkreis ihres Denkens und Gestaltens.* 1920
Göpper, Dr. Roger: *1000 Jahre Chinesischer Malerei: Catalogue of the Exposition.* Munich, 1959
Grosse, Ernst: *Die Ostasiatische Tuschmalerei.* Berlin, 1922
Harada, B.: *A Pageant of Chinese Painting.* Tokyo, 1936
Herberts, Dr. Kurt: *Die Maltechniken: Mittler zwischen Idee und Gestaltung.* Düsseldorf, 1957

Hirth, Friedrich: *Scraps from a Collector's Notebook*. Leyden, 1905
Hu P'ei-hung: *Shan Shui Ju Men*. Peking, 1920
Jenyns, Soame: *A Background to Chinese Painting*. London, 1935
Kümmel, Otto: *Die Kunst Chinas, Japans und Koreas: Handbuch der Kunstwissenschaft*. Potsdam, 1929
LeCoq, A. von: *Bilderatlas zur Kunst-und Kulturgeschichte Mittelasiens*. Berlin, 1925
Lessing, Ferdinand: "Über die Symbolsprache in der Chinesischen Kunst." *Sinica*, 1934–35
Levenson, J. R.: "The Amateur Ideal in Ming and Early Ch'ing Societies: Evidence from Painting": Chapter II in *Confucian China and Its Modern Fate*. Los Angeles, 1958
Lippe-Biesterfeld, E. A.: "Li K'ang und seine 'Ausführliche Beschreibung des Bambus.' " *OZ*, 1942–43
March, Benjamin: *Some Technical Terms of Chinese Painting*. Baltimore, 1935
——: "Linear Perspective in Chinese Painting." *Eastern Art*, III, Philadelpha, 1931
Moriya, Kenji: *Die Japanische Malerei*. Wiesbaden, 1953
Munsterberg, Hugo: *The Landscape Painting of China and Japan*. Rutland, Vermont, 1955
Noma, Seiroku: *Artistry in Ink*. Tokyo, circa 1957
Oi Motoi: *Instruction in Sumi Painting*. Tokyo, 1958
Petrucci, R.: *La Philosophie de la Nature dans l'Art d'Extreme Orient*. Paris, 1911
—— (trans.): "Mustard Seed Garden." *Encyclopedie de la Peinture Chinoise*, Paris, 1918
Rowley, George. *Principles of Chinese Painting*. Rev. ed., Princeton, 1947
Saito, Ryukyu: *Japanese Ink Painting*. Rutland, Vermont, 1959
Sakanishi Shio (trans.): *Kuo Hsi: An Essay on Landscape Painting*. Wisdom of the East Series, London, 1935
—— (trans.): *The Spirit of the Brush, Being the Outlook of Chinese Painters on Nature: From Eastern Chin to Five Dynasties*. Wisdom of the East Series, London, 1939
Salmony, A.: *Chinesische Landschaftsmalerei*. Berlin, 1921
Seckel, Dietrich: *Buddhistische Kunst Ostasiens*. Stuttgart, 1959
Sirèn, Osvald: *The Chinese on the Art of Painting*. Peking, 1936
——: *A History of Early Chinese Painting*. 1933
——: *A History of Later Chinese Painting*. 1938
——: *Chinese Painting, Leading Masters and Principles*. London, 1956
Soper, Alexander S.: "Some Technical Terms in the Early Literature of Chinese Painting." *Harvard Journal of Asiastic Studies*, XXI, 1948
——: "The First Two Laws of Hsieh Ho." *Far Eastern Quarterly*, 1949.
Shimada, S., and Yonezawa, Y.: *Painting of Sung and Yüan Dynasties*. Tokyo, 1952
Stein, Sir Aurel: *Ruins of Desert Cathay*. London, 1912
——: *Ancient Khotan*. Oxford, 1907
Speiser, Werner: *Meisterwerke Chinesischer Malerei*. Berlin, 1947
Taki Seiichi: *Three Essays on Oriental Painting*. 1910
Tomita, K.: "Brush Strokes in Far Eastern Painting." *Eastern Art*, III, Philadelphia, 1931
Tseng Yu-ho: "The Seven Junipers of Wen Cheng-ming." *Archives of the Chinese Art Society of America*, VIII, New York, 1954
Tsuda Noritake: *Ideals of Japanese Painting*. Tokyo, 1940
Waley, Arthur: *An Introduction to the Study of Chinese Painting*. London, 1923
Wang Fang-chuen: *Chinese Free-hand Flower Painting*. Peking, 1936
Werner, E. T. C.: *A Dictionary of Chinese Mythology*. Shanghai, 1932
Williams, C. H. S.: *Outlines of Chinese Symbolism*. Peking, 1931
Ueda Juzo: *Betrachtungen über Japanische Kunst*. Kyoto, 1958
van Gulik, R. H. (trans.): *Mi Fu: On Inkstones*. Peking, 1938
—— (trans.): *Scrapbook for Chinese Collectors (Shu Hua Shuo Ling)*. Beirut, 1958
——: *Chinese Pictorial Art as Viewed by the Connoisseur*. Rome, 1958
Yashiro Yukio: "Connoisseurship in Chinese Painting." *Journal of the Royal Society of Arts*, London, 1936
Yonezawa, Y, : *Painting in the Ming Dynasty*. Tokyo, 1956
Yetts, W.P.: *Symbolism in Chinese Art*. Leyden, 1912.

▪ INDEX

Note: Page numbers in italics refer to illustrationns.